Terence Donovan

Terence

Donovan

Edited by
Diana Donovan
David Hillman

Little, Brown and Company
Boston, New York, London

For Terry, Daisy and Daniel

It is not possible for me to express enough gratitude to the people who have helped me to make this book possible. David Hillman who has worked tirelessly over three years to create the book and Robin Muir who has been in charge of all the images in the Archive. My thanks must also be extended to Ed Victor and Maggie Phillips for encouraging and supporting me right from the start. Without these people this book would not have happened. It was a privilege for me to be able to work with them and I am extremely conscious of this good fortune. My thanks to them is unbounded.

Diana Donovan, September 2000

'Putters' look this way, no, this way – not at me you prat – excellent! That roughly describes the intellectual joust which accompanied the last occasion on which I was snapped by Terence Donovan. Immediately prior to that I'd been in his studio with a dozen colleagues representing the great, near great and would be great of the British Film Industry. Even that group shot had its moment.

I was perched on a camera case in the middle of the front row when, just as we all seemed settled, Terry started hissing at me to move to one side, then more, and then another bit. The colleagues around me started getting restive. It was as if I alone couldn't get it right. Eventually Terry settled me in a position peculiarly off centre, but he seemed content.

When it was over I, slightly truculently, asked him what had been going on – I was a bit embarrassed at being singled out for special treatment – 'Putters I am surprised, I always thought of you as bright. This was a double page spread, and I was trying to make sure you didn't get a staple through your face! – You owe me'.

Was that casual but fairly revealing incident driven by foresight derived from experience, a considerate professionalism, pure friendship or a combination of the three? The answer quite obviously is the latter. From my perspective that's what made Terry unique – he had the ability, or maybe the need, to offer all of himself, all of the time to whatever was at hand. An ever inquisitive student of life; 100% professional and 100% father, husband and friend.

The work celebrated in this book, like the photographer himself, is both world class and highly individualistic.

It cannot be often that such a complex set of paradoxical qualities find themselves at home in a single character:
Part intuitive artist, part thoughtful pragmatist.
Part technician, part visionary.
Gregarious and shy.
Transparent and opaque.
Confident and insecure.
Disciplined and whimsical.
Generous and careful.
Deeply judgmental and extraordinarily forgiving.
Smart and wise.
The list of qualities, many of which collide, is almost endless. They say that big men are frequently light on their feet; that being the case Terry was nothing less than 'Twinkletoes'. He was a subtle man, preferring a nod and a wink to any form of hearty handshake – true or false. He liked to leave his options open and was horrified by the notion of entrapment. A cautious realist, he invariably had 'Plan B' up his sleeve and you earned his admiration only if you had an even better wheeze on offer.

Leafing through an early proof copy of the book I was struck by a number of things: I had forgotten how staggeringly beautiful Julie Christie and Celia Hammond were, that I'd never before seen the photograph of Duffy in 1964 – that brought back a flood of memories, all of them good. Who would have believed that there was an unknown and better than ever shot of Cindy Crawford. I loved the unexpected and affectionate portrait of the late Ian Dury, but best of all for me was the image of Arizona – a Bill Brandt meets Truman Capote moment, only better! Several thousand years ago, Aristotle might have had Terry in mind when he said, 'We are what we repeatedly do – excellence then is not an act, but a habit.'

This book serves to establish beyond all argument that Terence Donovan made a habit of being an entirely excellent photographer. What it cannot show is that Terry also made a habit of being an entirely excellent human being. If you weren't lucky enough to know him I'm afraid you'll just have to take my word for it!

David Puttnam
September 2000

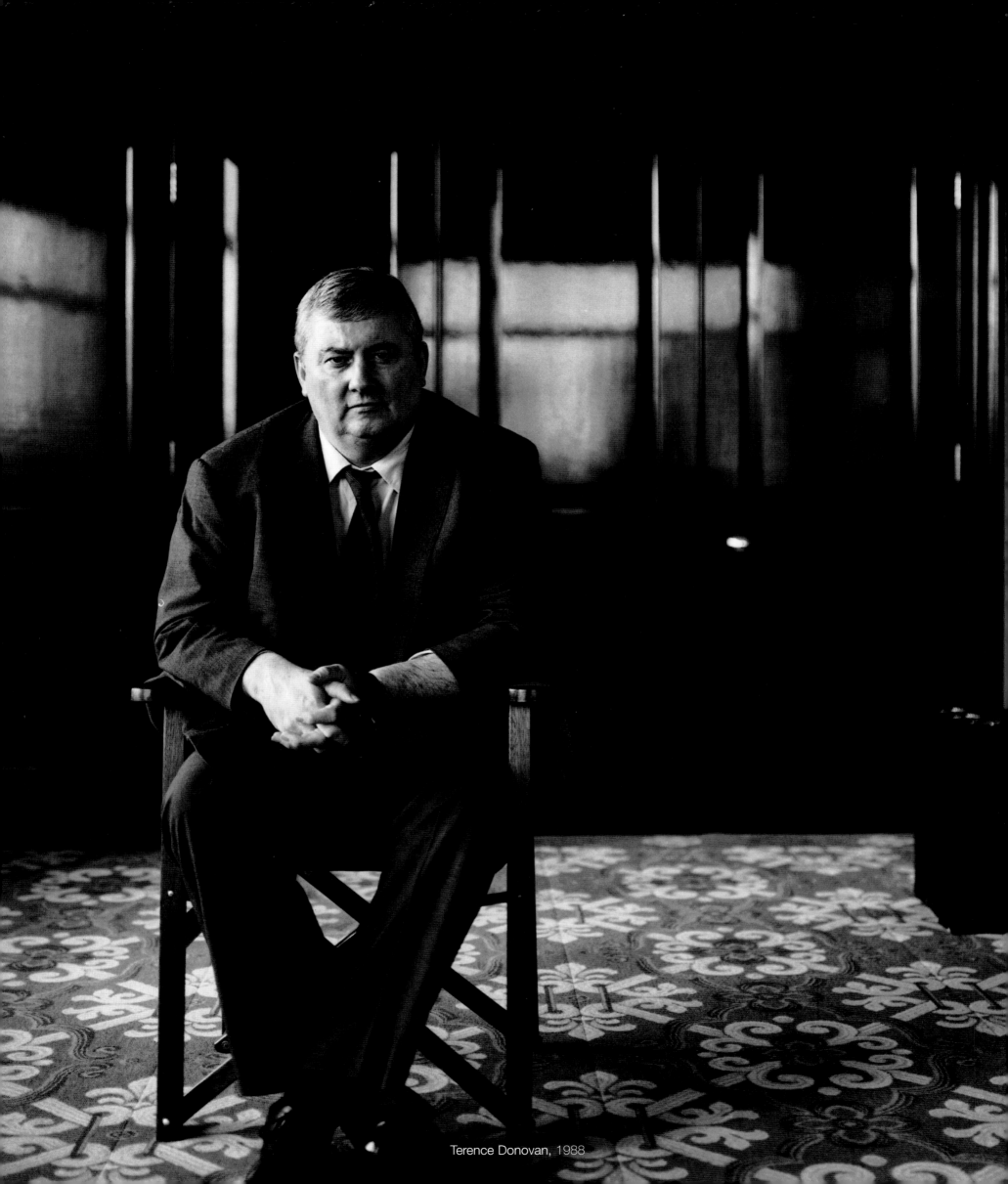
Terence Donovan, 1988

Terence Donovan died in 1996, leaving behind an archive of photographs spanning about forty-five years. During his lifetime he refused to look back, seldom allowing his work – especially his magazine work – a secondary life once it had appeared. His boxes of negatives from the fifties to the nineties were rarely re-opened once sealed up with string, though inside, each strip of exposures was carefully wrapped and numbered. His daybooks begin on 27 January 1959, the day he first opened a studio, and end in November 1996. Not just a ledger of expenses and fees, these slim, handwritten volumes form a personal history in miniature of newspapers, magazines, publishers, advertising agencies and other employers, locations, sitters, props, hair and make-up artists, fashion editors, taxi firms, film shot and cameras used, even exposure-meter readings, filter numbers and aperture settings. There are occasional scrawled notes about the weather, models and the merits of particular rolls of backdrop paper and prop-hiring firms.

'Photography is an instant fascination every time. When the fascination leaves me, I'll give it up.'

Despite his meticulous recordings (he also kept a detailed appointments diary), it was not at all in Donovan's nature to reassess the past, though his was a long career of variety, virtuosity and, right from the outset, considerable success. As a working photographer and as his diaries bear witness, he was always preparing for his next commission, juggling times and appointments according to the schedules of his subjects, the deadlines of magazines and the demands made by his own, often hectic, lifestyle. He was known to be thorough to the point of obsession, frequently working out the precise nature and composition of a picture days in advance.

'Fame,' Donovan told an interviewer, 'is suspect, dangerous material, all right for going through airports and things like that, but it's not something to pay too much attention to...Life is ephemeral and quick. I'll just play the show until the curtain comes down – graveyards are full of people who thought they were important.'[1] However, he did allow five pictures to run in *Appearances* (1991), Martin Harrison's

history of post-war fashion photography, a partial softening of his attitude towards the past and a wider realization perhaps that he had played more of a part in the genre's development than had previously been imagined – not least by himself.[2]

Donovan was at the top of his profession for over four decades, successfully reinventing himself in each – an iconoclast for the sixties, a film and documentary maker for the seventies; and for the eighties a giant name in advertising, conscious of forms of expression new to him, like the television commercial and the pop promo; by the nineties he was, at fifty-five, one of the acknowledged 'greats' of British photography, a Fellow of the Royal Photographic Society, a photographer of the royal family, an establishment figure and a household name. Shortly before he died, he had been appointed Visiting Professor at Central Saint Martin's School of Art. Though he embraced several disciplines, frequently at the same time, he never lost interest in still photography, which he had taken up at a young age. 'Photography fascinates me', he told a young Jean Shrimpton, 'Instant fascination every time. When the fascination leaves me, I'll give it up.'[3]

Terence Donovan is associated, almost indelibly, with London, the city in which he was born and where he preferred to work. Years later, when he had achieved international renown, he would still return to the East End – he was born in Stepney, the son of a long-distance lorry driver and a Woolworth's supervisor – to see his aunts and uncles and to revisit the familiar places of his youth. The Stepney he knew during the war and after was still much the same Stepney found and described by architectural writer Charles Jennings in 1999: 'The name just conjures up a vanished pre-war slumland', he wrote, 'a horrible ant-hill of poverty and shitty housing and social violence. It's nowhere you would ever choose to live: a place you'd never go back to...'[4] The difference, of course, was that Donovan chose to return regularly and the vernacular of the East End features repeatedly in his early fashion, advertising and personal photographs. In his daybooks he rarely wrote anything further than 'London' for the location of a shoot and it is impossible to determine exactly where he took his pictures, but in all cases the chaos of the streets and the play of light, shape and mood reveals defiantly that

1 Trevor Gett 'Never Out of Fashion' *British Journal of Photography* 13 February 1992
2 see Martin Harrison *Appearances* (Jonathan Cape, 1991) p.8 and pp.205-208
3 Jean Shrimpton *The Truth about Modelling* (W.H. Allen, 1964)
4 Charles Jennings 'Bleak Houses' *The Guardian* 9 January 1999

this is London, the city he knew better than most taxi drivers.

'I was eleven when I discovered London', he once said, 'I walked down Fleet Street. It wasn't a pearls-and-diamonds thing, any of that old junk. I just felt a wonderful sense of enjoying the city where I was born'.[5] Later still, when there were no aunts and uncles left to visit, he would drive for hours

'All I want is an amusing and interesting life… you get your cards and this space in time is called life and photography is a particularly interesting way of spending it.'

around the streets he grew up in, sizing up vistas to be photographed or to be kept in mind as future locations. By that time, the early nineties, he had made over two thousand television and cinema commercials and this had become his main source of income, but still-photography continued to obsess him.

And the East End is where, at least in the popular imagination, the 'Swinging London' of the sixties took shape, and against which highly-coloured backdrop the career of Terence Donovan flourished. A triumvirate of young London-based photographers, so the legend goes, burst onto the scene from out of nowhere, turning the fashion world on its head and launching a working-class movement of determination, ingenuity and artistry that swept all before it, fostered by a 'new wave' of stage plays and neo-Realist cinema. David Bailey, Brian Duffy and Terence Donovan, the oldest of them, born in 1936, ushered in the era of photographer-as-cultural-hero. Though they approached photography in utterly different ways, they remain as metaphors for a decade of soaring reputations and up-to-the-minute lifestyles. What can be said unquestionably about the three is that with their ambition and impetus, British magazine photography made more impact in the sixties than ever before. Coinciding with a boom in advertising,

'He is bitten with a driving ambition that does not allow him to rest.' Cecil Beaton

a burgeoning export market in pop music, art and fashion design, the rewards for still-photography became considerable and the outlets for expressing it became ever wider. New markets sprung up to cater to

a generation of young people, who appeared for the first time to have extra money to dispose of. *The Sunday Times* launched its colour supplement in 1962, followed two years later by the *Observer* and *Weekend Telegraph* magazines. *Nova* was launched in 1965 as 'A New Kind of Magazine to the New Kind of Woman' and *Queen* magazine revamped. *Man About Town* went through an incarnation as *About Town* before ending up simply as *Town*.

However, it is easy in this romantic and fast-paced context to forget that Donovan was by then firmly established as a photographer, having supported himself as a photographer's assistant since the age of fifteen. According to Cecil Beaton, Donovan 'caused such a stir' as he enlivened magazine photography.[6] His black and white pictures characterised by a grainy texture and loosely composed style reflected the realism of the films of directors such as Karel Reisz and Lindsay Anderson. At its roots, though, was the documentary tradition of the thirties and forties. In the context of fashion magazines, Donovan made clothes for young women desirable by portraying them in a recognisably 'everyday' milieu and as unlike as possible the clumsy replicas of their mothers' twinsets that they almost invariably were.

His models, as the decade progressed, assumed down-to-earth qualities and appeared approachable in a way that the mannequins of the fifties were resolutely not. He drew on his working-class roots, observing, without much regret, that he might 'reverse back to Stepney at any time'.[7] His nonchalance — masking a single-mindedness — partially contributed to a prevailing notion of the working class photographer as an existentialist 'anti-hero'. Donovan was beginning to assume the role of cult figure to the younger inhabitants of the city that oversaw his accelerating fortunes, played out among the gossip columns and features pages of daily newspapers and weekly magazines. 'Terence Donovan is a swinger!', ran a breathy piece in the *Evening News*, 'He believes that life is for living and that people sleep in bed too much'.[8]

He attracted notoriety for his 'Rabelaisian appetites'[9] as much as for the youthful exuberance of his images. Each of 'The Terrible Three' (a term coined with sly affection by Beaton for Bailey, Donovan and Duffy), was adroit at self-promotion — Donovan appeared

5 Frankie McGowan 'The Eastenders' *Evening News* undated archive cutting
6 quoted in Louise Greidinger 'Donovan A Master of the Lens' undated archive cutting
7 Greidinger op.cit.
8 David Wigg 'Young London' *Evening News and Star* 23 November 1965
9 Francis Wyndham notes to *David Bailey's box of pin-ups* (Weidenfeld & Nicolson, 1965)

credited as 'an engaging off-beat photographer' with Jean Shrimpton in a fashion story by Bailey for *Vogue*[10] – and good for wisecracking asides at any time: 'Before us', a triumphant Brian Duffy told Francis Wyndham of *The Sunday Times*,[11] 'fashion photographers were tall, thin and camp. We're different. We're short, fat and heterosexual', while Bailey observed that 'They – from Mars or wherever – said I couldn't be a fashion photographer 'cos I didn't have my head in a cloud of pink chiffon...'[12] Donovan was more philosophical: 'All I want is an amusing and interesting life...you get your cards and this space in time is called life and photography is a particularly interesting way of spending it'.[13]

His success appeared effortless but for Donovan it was the product of a rigorous self-discipline honed early on, which did not go unremarked by his contemporaries: 'He is bitten', reported Beaton, 'with a driving ambition that does not allow him to rest.'[14] He had stopped drinking in his twenties, had never smoked and as he thought he was 'getting too soft' allegedly lived for a time in his car (albeit a Rolls-Royce).[15] He called his photographic life a 'curious combination of precision and chaos'.[16] 'We [the three] didn't think about being rich or famous – all we wanted to do was to get on and do it'.[17]

His background, he once remarked, was 'reasonably rugged'[18] and he came to photography almost by accident: 'How did it all start? Well, the usual rubbish you know. Born in the East End, I spent most of the war in the cab of a large lorry travelling around England with my father – he was a truck driver. I went to about ten different schools because we were moving around so much, and then I decided to become a chef. I tried very hard to get into the School of Cookery in Vincent Square but that didn't work because I was too young. So as the only respectable job other than lorry driving or professional soldiering in our family was that of Uncle Joe, who was a lithographer, I decided to become a lithographer'.[19] As an eleven-year-old apprentice at the School of Photo-Engraving in Fleet Street in a class of twenty-five-year-olds, he studied lithography. In his spare time he went twice a week to the Bethnal Green Camera Club, held in a room above which a brass band rehearsed marching tunes.[20] He won the Stella Cup for beginners. There were occasional forays to Epping Forest and further out to the Isle of Wight, where he stayed for two weeks in a beach hut practising the craft of photography. He left the school to become a photographer's assistant at Gee and Watson, a blockmakers, and then to work firstly with Hugh White and then with Michael Williams at *Fleet Illustrated* for a year. He stayed there until called up for National Service.

As a military photographer he augmented his pay by producing mundane though tongue-in-cheek picture postcards, such as 'Catterick by Night' and photographing ordnance depots. 'I did my job in the army as conscientiously as if I was doing it now because I realised that if one allowed one's standard of craftsmanship to drop it would gradually ebb away...'[21]

He returned to *Fleet Illustrated* after two years away. Then he joined the team at John French, a leading fashion photographer, to assist Adrian Flowers and John Adriaan. A fascination with glamour motivated Donovan from the day he walked into French's studio

'Donovan was doing things that were edgy and original. He could do an amazingly complicated picture in a simple way.'
David Hillman

in Clerkenwell on the western edge of the City of London: 'The room glowed with a magical reflected light. The people in the room seemed to be illuminated in an exquisite way. The light was unlike anything I had seen before'.[22]

In 1959 he opened his own studio in Yeoman's Row, Knightsbridge. He started inauspiciously photographing a sponge cake but the studio was an overnight success.[23] In time, he relocated to the West End and his studio and office closed only in 1996, one of the last in a long tradition of Bond Street photographers.

Donovan was marked out for success early on. Visiting New York in the early sixties, he impressed his more established colleagues: 'He didn't have a camera or any pictures,' recalled the then *Vogue* photographer Jerry Shatzberg, 'but I knew he was a good photographer from the way he talked. He'd go into a bar and within a few minutes he'd be chatting to everyone.'[24]

By the mid-sixties, Donovan was earning a fortune, much of it from the emergent

10 *Vogue* September 15 1961 'Young idea'. The issue also marked Donovan's debut as a photographer for *Vogue*
11 Francis Wyndham 'The Modelmakers' *Sunday Times* Magazine 10 May 1964
12 quoted in Martin Harrison *David Bailey Black and White Memories* (Dent, 1983)
13 Alan Vines 'Terence Donovan' *British Journal of Photography* 28 January 1966
14 Cecil Beaton *The Magic Image* (Weidenfeld & Nicolson, 1975)
15 quoted in 'Yellow Dog' *Image* magazine 1973 Vol.3 No.3. His Silver Cloud II featured in *Men in Vogue* November 1965
16 Terence Donovan 'A Glimpse from Time' *Duncan Lawrie Journal* Autumn 1996
17 Terence Donovan to Lynn Barber 'Things I Wish I'd Known at Eighteen' *Express* magazine 1983
18 Lisa Armstrong 'Terence Donovan' *Vogue* March 1997
19 Vines op.cit.
20 see *What Camera Weekly* 9 August 1980 for further reminiscences of the Bethnal Green Camera Club
21 Vines op.cit.
22 quoted in *John French – Fashion Photographer* (Victoria & Albert Museum, 1984)
23 The shoot took place on 27 January 1959 and Donovan was paid thirty-seven guineas
24 Armstrong op.cit.

and lucrative discipline (in Britain) of advertising photography. Sent to interview him, one writer at first could see only the shiny Rolls-Royce, '...waiting in the Knightsbridge Mews'. His contemporary description of Donovan's studio gives an insight into one of the inspirations, perhaps, for the protagonist of *Blow Up*: 'The uncarpeted stairs led to a type of studio long familiar to readers of Greville and Hickey. Discarded coffee cups

'He called his photographic life a 'curious combination of precision and chaos'.'
Cecil Beaton

huddled against the skirting, sharing the floor with a couple of fencing masks, a plate piled high with lump sugar, two odd shoes, a birdcage and a lethal looking plastic seven-in-one automatic toy gun. A record deck was balanced diagonally on its cardboard packing case, a spent record revolving silently. The electrostatic speaker shared a crowded mantlepiece with a collection of dummy Guinness and empty milk bottles...'[25] Recalling the Knightsbridge studio in her first autobiography, Jean Shrimpton wrote that it 'is guarded by an efficient receptionist, and is piled high with the usual impedimenta and bric-à-brac a fashion photographer needs. The record player offered the latest Barbra Streisand...'[26]

Donovan pinpointed his locale by remarking frequently that he was always, when it came down to it, happier to be 'East of Aldgate', borrowing the title of a photo-essay by his friend Don McCullin.[27] His depiction of the chaos of the streets of London's East End, and the swathes of bombed-out, derelict terrain 'was vital', as the photographic historian Val Williams has written, 'to the construction of a new fashion iconography'.[28] The streets

'He certainly led from the front.' James Garrett

Donovan walked 'had a tough emptiness, a grittiness heightened by occasional pieces of rubbish rustling around in the wind'.[29] He brought the life of his times into the studio, getting his models to pose and to walk like the girls he knew, and in the process gave magazines and advertisers a new visual language of gesture and stance – a working class 'chic', coloured, especially in his early work, with a sombre, rainswept tint. Another

historian, Philippe Garner, comments that 'when Donovan started his career, British photography was, for the most part, stuffy and unadventurous. He was the opposite, intensely curious and ready to challenge conventions. His timing was perfect in bringing a raw but shrewd energy to the world of commercial photography.'[30] Angela Carter, writing in *Nova*, praised his 'urban speed and incisiveness.'[31]

At *Town* magazine, he was encouraged by Tom Wolsey, a young art director. He commissioned from Donovan, among other things, men's fashion stories and brought out of him a gritty, noir-ish style, which marked out the parameters for a future generation of men's fashion photographers. 'I was looking for shock tactics', Wolsey has said. 'Don McCullin, Donovan and the others provided this...'[32] His layouts were dynamic, vital and predictably for the sixties 'of the moment'. 'Tom was unquestionably the first man...to make me do things and let me appreciate what I was trying to do. He encouraged me enormously. It was certainly working for *Town* that really got me started and got me a name'.[33]

'Not so long ago', Donovan told a reporter in 1964, 'the only way you photographed [men's fashion] was on a shooting stick in Regents Park, sitting there. So I thought, right, we'll get on to this we'll go to the gasworks. You know – the obvious reaction to it...'[34] With a more portable 35mm camera replacing his Rolleiflex, he took his models out onto the streets; to East End parkland and to tenement buildings, or placed them, wreathed in steam, high on the platforms of the gasometers that still punctuate the east London skyline. He took them to the bomb-ravaged docklands and photographed them beside the still-working river that snaked its way into the heart of the city, with, as a backdrop, a thriving commerce now gone. He balanced them on the girders of steel-works and iron bridges, motifs of an age of industry that for a while found their way into contemporary fashion images as symbols of urban alienation. Much of Donovan's east London was reduced to rubble during the blitz and the structures of derelict or soon-to-be-abandoned industries pervade his early work, as they did his childhood. Later for a series for *Nova*, the emblematic new architecture for London was used as a backdrop, the 'brutal realism' of housing estates and tower blocks

25 Vines op.cit.
26 Shrimpton op.cit.
27 see *About Town* 1961. The expression subverts a shortlived wartime rumour that Air Marshall Goering had given his word never to drop bombs 'West of Aldgate' quoted in Andrew Sinclair *War Like a Wasp* (Hamish Hamilton, 1989)

28 Val Williams *Look at Me* Fashion and Photography in Britain 1960 to the Present (The British Council, 1998)
29 Terence Donovan unpublished article for *Tatler* c. July 1994
30 Philippe Garner to author 24 May 2000
31 Angela Carter 'Donovan's Dog' *Nova* October 1973

32 Jeanette Collins 'Town and Tom Wolsey' *British Photography 1955-1965 – Master Craftsmen in Print* (The Photographers' Gallery, London, 1983)
33 Vines op.cit.
34 Wyndham 'The Modelmakers' op.cit.

emerging from the rubble of destruction.[35]

Despite his affection for the working-class romance of the city, he was under no illusion that the fashion and advertising worlds were rich in creative possibilities and ripe for plunder. But an idyllic notion of his East End childhood never left him and barely six months before his death, he wrote: 'When I first printed my pictures I was eleven years of age. The darkroom was a cupboard some one and a half feet in depth and four feet wide – the very depth of a chimney breast. A red light was a luxury my budget didn't stretch to, so a red cloth over the bulb was used. Suddenly there would be the acrid smell of burning cloth fused with the special smell of hypo.'[36]

Donovan had a film director's vision, that of an auteur, since no-one would dare write the scenes for him. In the age of 'Youthquake', *Blow-up* and 'Neo-Dandyism' and the cross-fertilization of film stars, musicians and photographers, make believe, re-invention and the assumption of role-playing was for a time central to Donovan's vision, almost as much as the 'realism' that he is best known for.[37] For *About Town*, a carload of overcoats became a spy story, with long range angles and close-cropped surveillance shots. A suit story was a contemporary rendering of urban gangsterism, a part East End, part New York romance with getaway car, trilbies and toy submachine guns. Its tongue-in-cheek glamour and make-believe violence predated the artifice of the James Bond films and the grubby, rainy London of Len Deighton's Harry Palmer. He spent as much time outside the studio as in it, creating his own realities or distorting real-life by shooting the patterns and reflections through car windscreens, or shop windows, by double-exposure and by cropping or, as in a few instances, by framing the shot through his own thumb and forefinger. Shedding the studio-bound stylization of John French, he took instead as a reference point the tougher observational work of Bill Brandt and Roger Mayne, and their different visions of London. He undertook several vivid photo-essays for *Town* magazine, but he was never happy yielding the role of photographer and art director of his own pictures: 'I like the idea of being responsible totally for what's in the picture right down to what colour nail varnish the girl uses...' he explained. 'I tend to reduce my reportage

pictures to graphics. I don't really want to report on life...I'm quite happy to see a girl scratching her nose in a coffee bar and translate that via a model.'[38] In truth, as his photographs became more successful, he began to eliminate the lightness of touch that chance might play upon them: 'I like the artificiality of my photography'.[39]

Gradually he relinquished the portable 35mm format of his *plein air* pictures for the medium format and the plate camera again, the staple of the whitewashed studio environment. Evolving a crisp graphic style which marked out in the sixties and beyond a photograph by Terence Donovan, he would still take reportage for himself, but infrequently, for clients.

For *Nova*, perceived at the cutting edge of the magazine industry, he produced vivid photographs, many of them in colour. 'He was born to shoot for *Nova*', recalled David Hillman. 'We were talking about ideas rather than stitches and buttons. We were trying to shoot mood and Donovan was doing things that were edgy and original. He could do an amazingly complicated picture in a simple way'.[40] He began to

'You see, fashion photography is an act of theatre and you really have to love it.'

experiment regularly with colour, producing on several occasions grainy, impressionistic prints which, as Beaton again put it, predated by years 'the sort of crepuscular pictures made today by Sarah Moon'.[41] He employed other motifs and techniques, for example, the use of a ring-light that fashion photographers took up again years later.

Throughout his career, he worked editorially for a variety of magazines, from *Elle* and *Marie-Claire* in Paris to *Harper's Bazaar* in Milan and New York, as well as London-based magazines like *Vogue* and *The Sunday Times* Colour Supplement. For *Harper's Bazaar* he photographed the Paris collections twice yearly for almost a decade. With more of a budget at his disposal than offered by the British magazines, he was able to let his imagination run riot, constructing on several occasions Baroque fantasies in opulent hotels and chateaux throughout France. 'He felt more comfortable and confident in the studio', remembers Anna Harvey, who worked with him at Vogue, 'and he was technically

35 *Nova* March 1974 'Dressed Overall'
36 'A Glimpse from Time' op.cit.
37 on the cross-fertilization: Julie Christie has remarked that 'I'd done a screen test for *Billy Liar* and hadn't got the part. Then the director saw a magazine cover that Terence had taken of me and I landed my first film role. Who knows if I would ever have got into films if it hadn't been

for him' quoted in 'The Observer' *Tatler* April 1999
38 Vines op.cit. For Donovan's reportage see particularly 'The Lay About Life' *Man About Town* December 1960 and 'Strippers' *About Town* July 1961
39 Vines op.cit.
40 David Hillman quoted in Armstrong op.cit.
41 Beaton op.cit.

brilliant there, but to my mind he did some of his best work on location. His couture sittings at night in the Crillon in Paris, for example, were beautiful and unexpected. He wouldn't be in a rush to work outside the studio, but he was much more versatile and spontaneous then he ever let on.'[42]

In the 1980s Donovan diversified into commercials and pop promos. For television advertising he said his training in stills counted for virtually nothing and in truth worked against him: 'Your clients think you're going to take pictures that dissolve in the middle. In a still you're isolating time. In a film

'The real skill of photography is organised visual lying'

you're trying to recreate it and do the same thing as the Japanese do with flowers, put them in water and open them out...'[43] He had a talent for 'opening things out' and enjoyed directing complicated set ups against the clock, the more operatic in dimension his colleagues remembered, the better. 'He loved lavish sets', his friend and fellow producer James Garrett told *Vogue*, 'and he certainly led from the front'.[44] 'When Terry was working everything ran with military precision,' remembers his friend Brian Fraser, who worked closely with him for many years. 'Everybody knew what to do and when. This allowed him to free up his mind: 'Fuel my madness', he would say.'[45] Of film and commercials making he said, 'If there is a room, it is the hottest room and your head is always jammed against the wall...'[46]

In 1989 Donovan was nominated one of *Vanity Fair's* 'Men of the Decade' for his video to Robert Palmer's *Addicted to Love*, released in 1986. Styled by his friend Liz Tilberis, just before her appointment to the editor-ship of *Vogue*, the scarlet-lipped models clad in clinging Alaïa defined the look of the times yet again. 'All this happened

'Photography held no mysteries, for to him it was craft and he was the consummate technician.' Diana Donovan

before MTV', recalled Palmer. 'When I saw the video I was shocked. [Donovan] had planned the whole thing out. He filmed the girls separately from me and edited the two sections together. In the end it looked like

a photo-shoot from *Vogue*. It was camp, funny and glamorous at the same time'.[47] It remains probably the most copied of all music videos. Donovan parodied it himself for a commercial for Pepsi Cola.

He produced television versions of National Theatre plays for America's CBS network: *Early Days* with Ralph Richardson, *The Importance of Being Earnest* with Wendy Hiller and Stoppard's *On the Razzle*. He also made a feature film *Yellow Dog* (1973) written by Shinobu Hashimoto, Akira Kurosawa's scriptwriter, who had refused up till then to write scripts for anyone else. 'I think,' remarked Donovan, 'that there are only six basic stories and this is the one about a foreigner coming to a strange country.'[48] The film, concerning a Japanese policeman adrift in London, translated to critical if not popular acclaim the strands of urban alienation from his early stills.

Donovan was keenly sought for his intuitive sense of fashion that went, with years of experience behind it, beyond the mere depiction of clothes. His voracious instinct for the glamorous and his visionary approach to clothes made him a favourite with fashion editors across the globe. 'You see, fashion photography is an act of theatre and you really have to love it'.[49] He never forgot his role was to make clothes look desirable and the women wearing them exquisite and alluring. In his later years he was critical of fashion photographic trends that made the fashion element appear oblique or blurred or tried not to look like fashion photography at all. A surprising comment, as he had been in earlier years an enthusiastic experimenter: 'He was not just a technical wizard,' said Martin Harrison, 'but a groundbreaker. He produced prototype Sarah Moon and Deborah Turbeville work long before they did.'[50]

In keeping with his refusal to look back, he published only three books of his work. The first, *women throoo the eyes...*, published in 1964 was a parade of the beautiful women he had recently photographed (Sophia Loren, Susannah York and Julie Christie, among others).[51] With a text by Donovan, loosely written in a 'free association' style, it predated by around twenty years his second book *Glances*, another assemblage of beautiful women, mostly nude, with captions of a similar dream-like stream-of-consciousness. 'Fragments', he called it, 'of a semi fictional narrative'

42 Anna Harvey to author 24 May 2000
43 *Image* magazine op.cit.
44 Armstrong op.cit.
45 Brian Fraser to Diana Donovan
 19 May 2000
46 Julia Thrift 'Terence Donovan'
 European Creative Portfolio 1992
47 quoted in *Mail on Sunday*
48 *Image* magazine op.cit.

49 Thrift op.cit.
50 quoted in Armstrong op.cit.
51 *women throoo the eyes...*
 (Kynoch Press, 1964)

which he claimed were moments half-remembered that had escaped his camera. Images that 'skitter away untrapped' and which he now sought to reconstruct.[52] A year later, he published a book on judo technique, *Fighting Judo*.[53]

He was in thrall to the technique of photography – 'I spent eight years really grafting at the murderous task of learning and getting where I am'. He thought about it all the time 'in bath, in bed, when I'm eating, wondering about the different effects of various focal length lenses'.[54] He would painstakingly envision whole swathes of advertising photography down to the last detail, days, sometimes weeks, in advance. 'He was incredibly observant', wrote his wife Diana. 'He would notice things in the street or in a house or wherever he was that you or I would simply never register.'[55] Almost, as more than one commentator has remarked, as if he thought in pictures. This partly explains his astonishing productivity rate, and quite why clients, sitters, fashion editors and models suddenly realised the whole shoot was over, with so little film shot. He had a legendary ability to turn up early, avoid lunch and never to waste time on the mundanities of life. Famously he dispensed with the perennial question of what to wear in the morning by choosing from a large collection of different weighted but otherwise identical grey suits (from Doug Hayward), white or blue shirts and black shoes, from which uniform he rarely digressed.

He was a big man – 'the Falstaff of Fashion Photography' and 'without malice, trusted by his rivals' according to Francis Wyndham.[56] He was fond of off-the-cuff aphorisms, such as 'I can't help feeling that if you want to be a multi-millionaire it's better to start off as a dwarf with a club-foot and bad breath. There is a definite co-efficient between survival and success' and 'the real skill of photography is organised visual lying'.[57]

Donovan's interests were wide-ranging, perhaps in an effort to compensate for the years of disrupted schooling. 'The one thing I do know', he once told Brian Fraser, 'is that I don't know anything. It's all out there to be discovered'. At the same time a devotee of the philosophy of Zen Buddhism, he strove to clear his mind of whatever he felt he didn't need to know. He was passionate about the martial arts, particularly judo – he was a black belt, 1st dan. At one point he

owned a chain of dress-shops, a building contractors and an upmarket ironmongers in Chelsea; he was a restaurateur with his friend Terence Stamp and developed much later a passion for painting in a sweeping abstract style (he exhibited at the Albemarle Gallery in 1990). He said he was inspired to start painting 'by the random yet controlled shapes of water on stone'.[58] He is remembered by his colleagues, amateur and professional, for his quiet encouragement and practical help. 'He was incredibly serious and ruthless about photography', remembered Chris Moyse, his assistant from the late seventies, 'but capable of random acts of great kindness. He knew everything about photography but he made you learn it first.'[59] Photography held no mysteries, for to him it was craft and he was the consummate technician.

At his death in 1996 he had just completed a portfolio of 'Swinging London's' second incarnation for *GQ* magazine, 'National Anthems' – twenty-one portraits of rock 'n' roll heroes from Jarvis Cocker to Bryan Ferry, taken over three months. It turned out to be his requiem and reached the newsstands a week before his death. He died when fashion, music and art had swung round again to coalesce in an era which might have reminded him of the early days. His last published photograph was for *Vogue*, a grainy up-to-the-minute portrait of Clements Ribeiro, British fashion's latest star – hauntingly familiar, like the grainy up-to-the-minute portrait of Mary Quant and Alexander Plunket Greene he had photographed nearly thirty-five years previously. And, it should be added, with a regard for technique that the intervening years did nothing to diminish.[60]

'All you can ask from human life', he once told the *Express Magazine*, 'is to get up in the morning, do the best you can, go to bed at night, and be as fair and uncruel as possible'.[61] A fitting epitaph to which his friends and admirers will attest. One friend, Sandra Boler, remarked that 'he was constantly seeing new things',[62] which as a tribute might have pleased him as much for its simplicity as for its content and, of course, for the undeniable fact that it made no reference at all to looking back.

Robin Muir
September 2000

52 'Donovan's Brief Encounter'
 The Guardian 19 November 1983
53 Terence Donovan and Katsuhiko
 Kashiwazaki *Fighting Judo*
 (Pelham Books, 1985)
54 Vines op. cit.
55 Diana Donovan letter to Alistair McAlpine
 31 May 1997

56 Francis Wyndham *David Bailey's box of
 pin-ups* op.cit.
57 Terence Donovan 'Family Ties' *Over 21*
 Magazine July 1980
58 *The Independent* 10 October 1990
59 Chris Moyse to author, spring 1999
60 see *Vogue* July 1962 'Young Idea
 Whistles up Peacocks'
61 Barber op.cit.

62 Sandra Boler quoted in Armstrong op.cit.

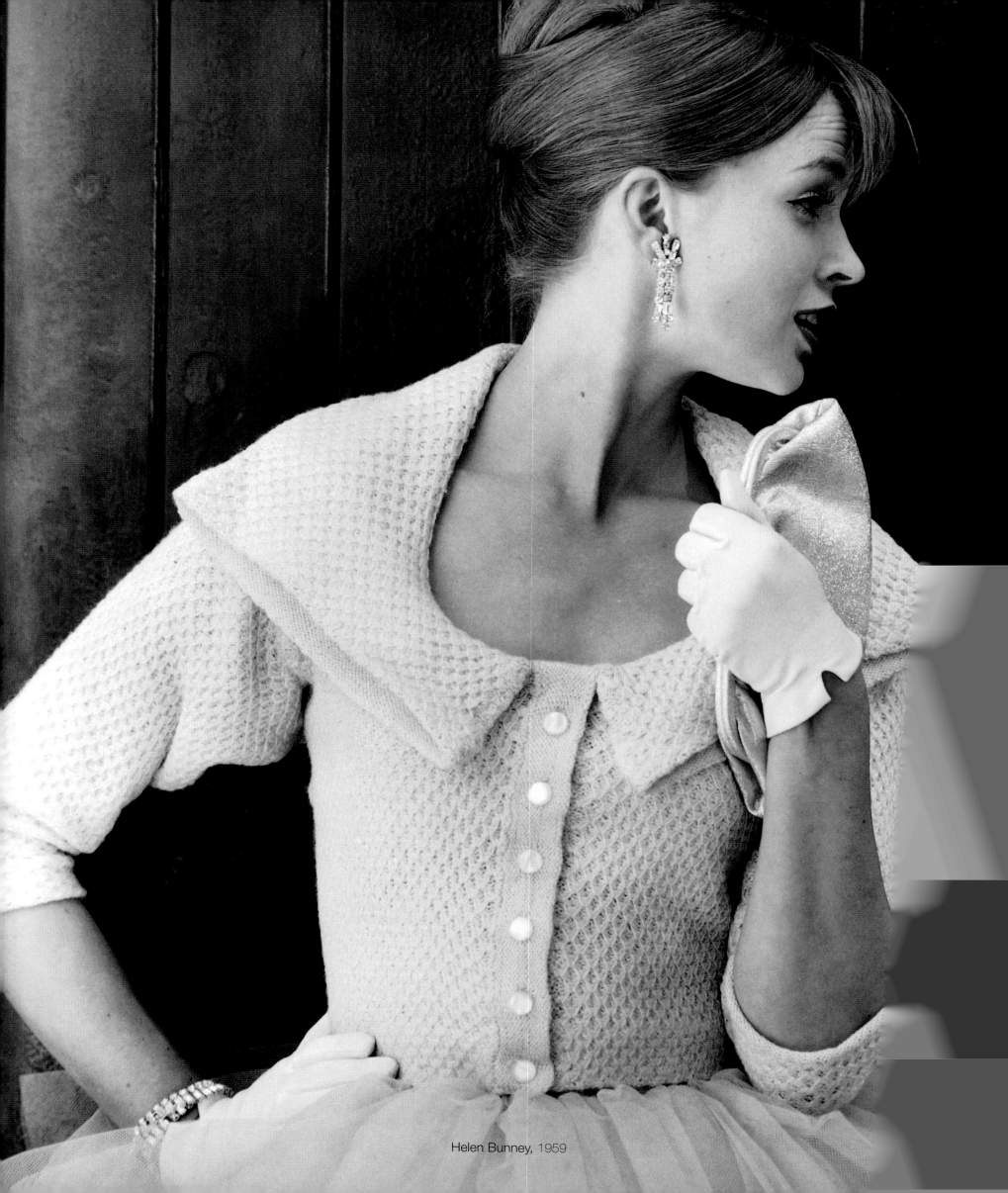

Helen Bunney, 1959

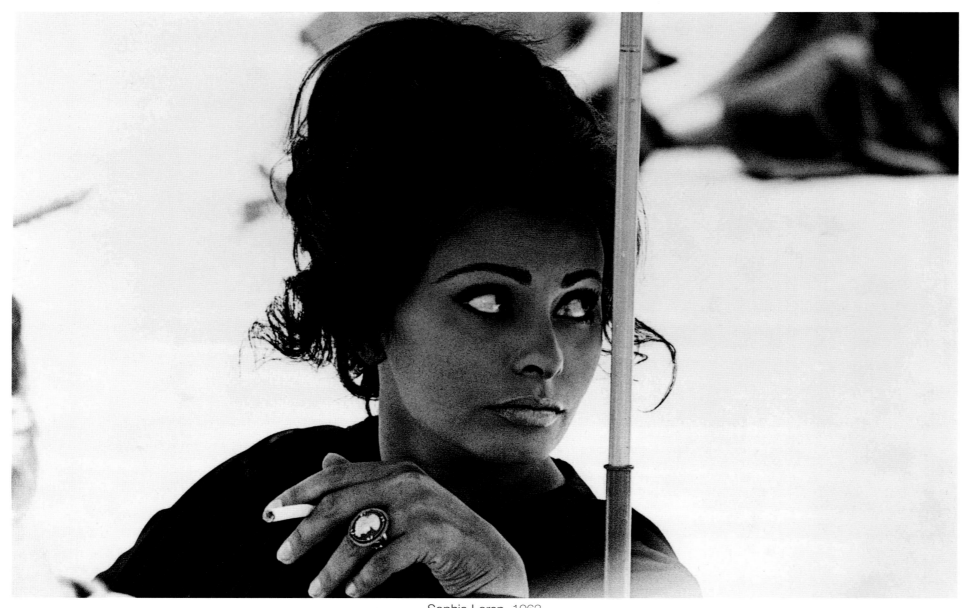

Sophia Loren, 1963

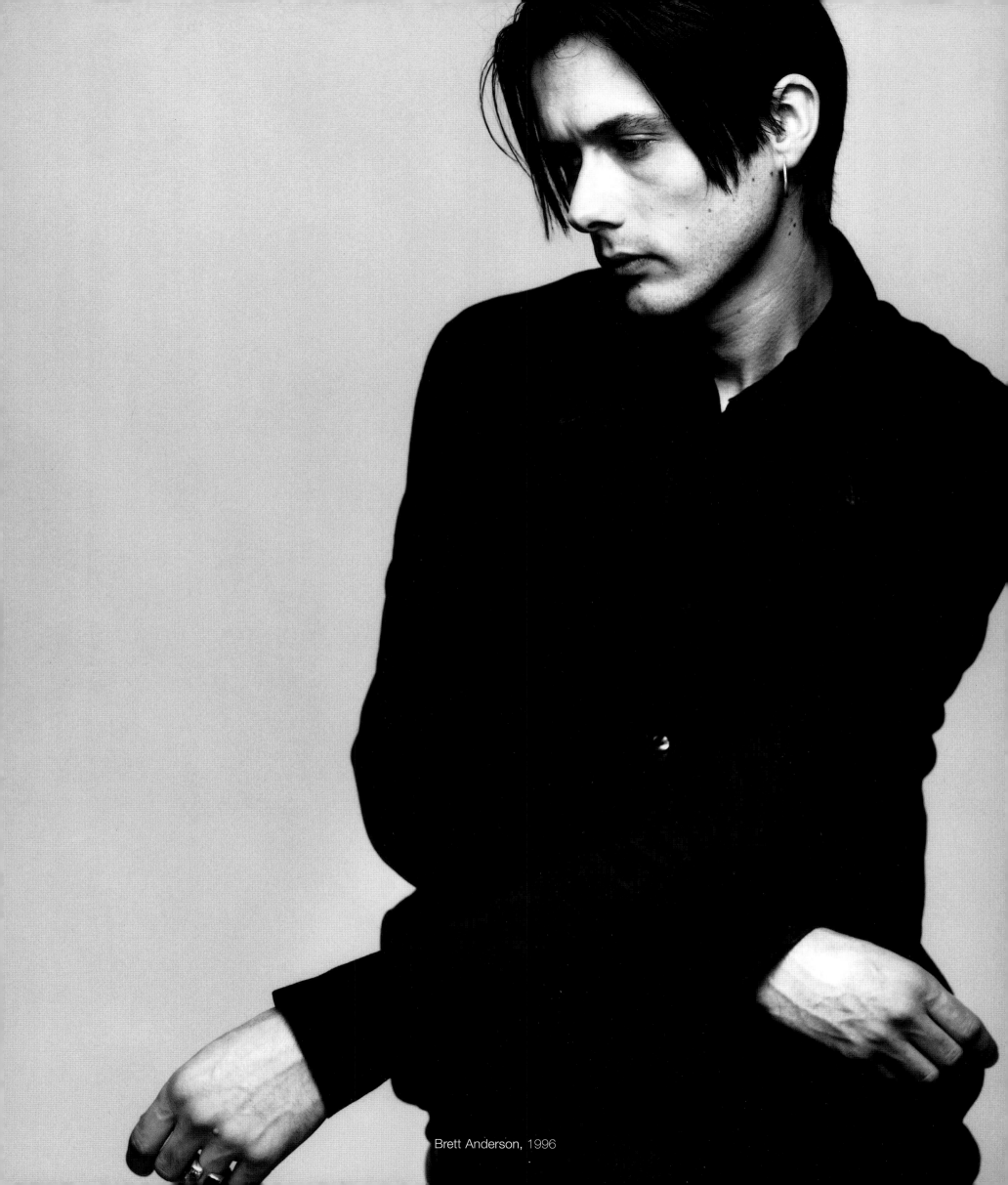

Brett Anderson, 1996

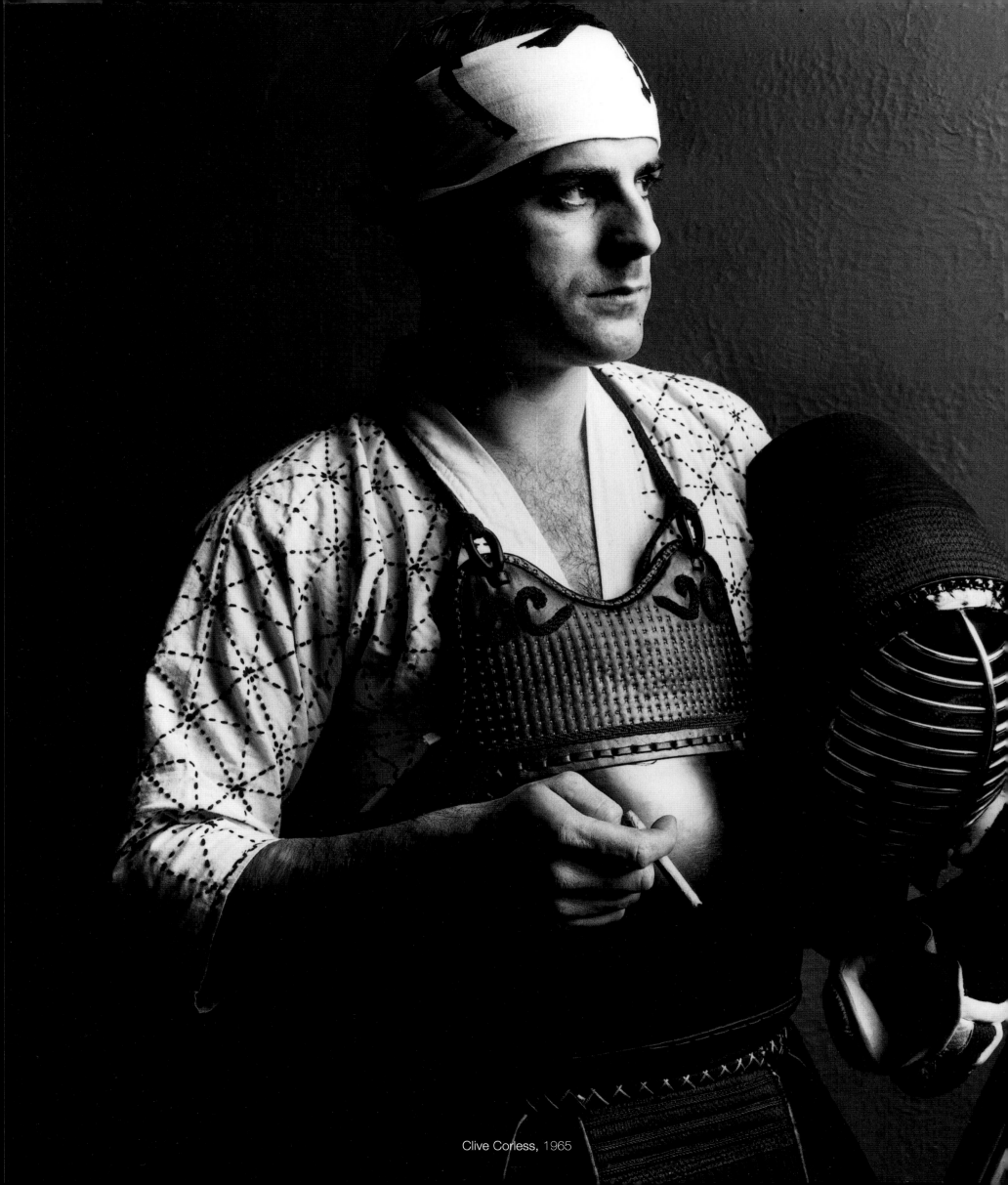

Clive Corless, 1965

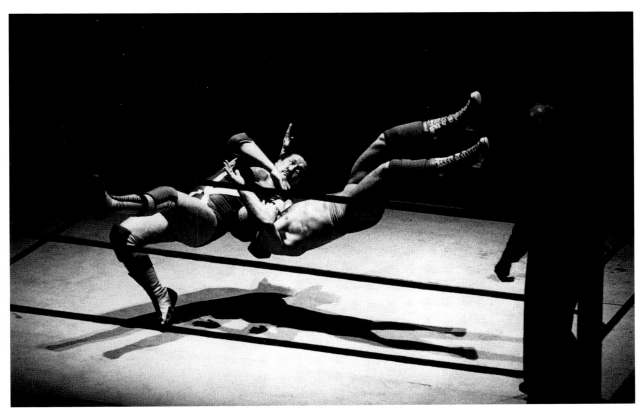

Kendo Nagasaki wrestling, 1991

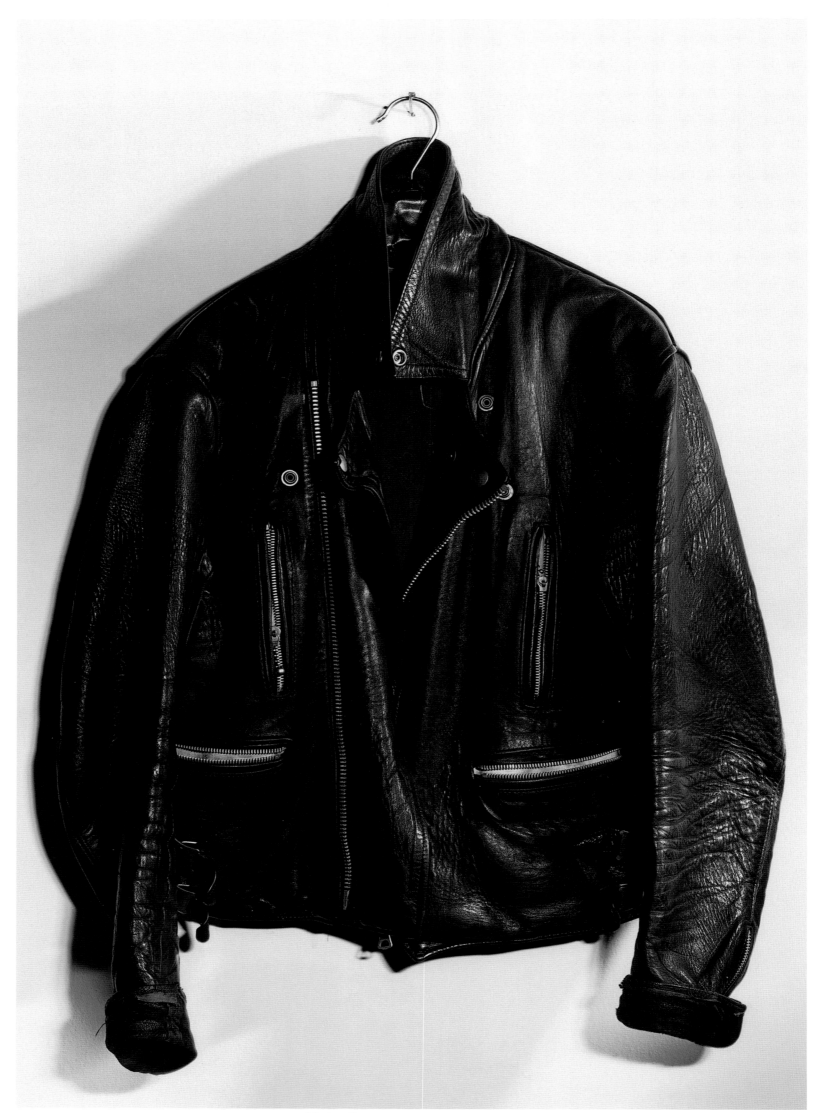

Marlon Brando's leather jacket, *1984*

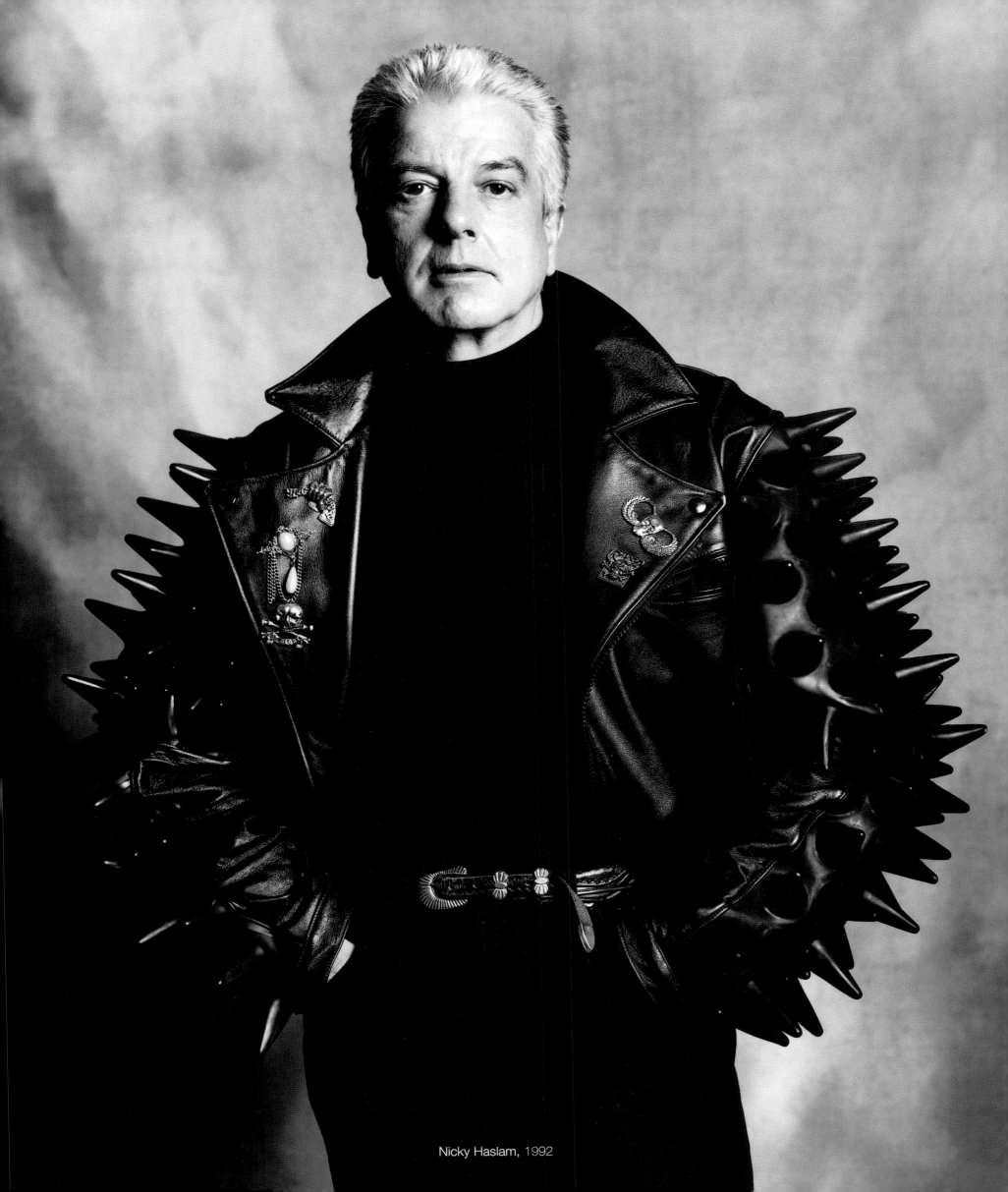

Nicky Haslam, 1992

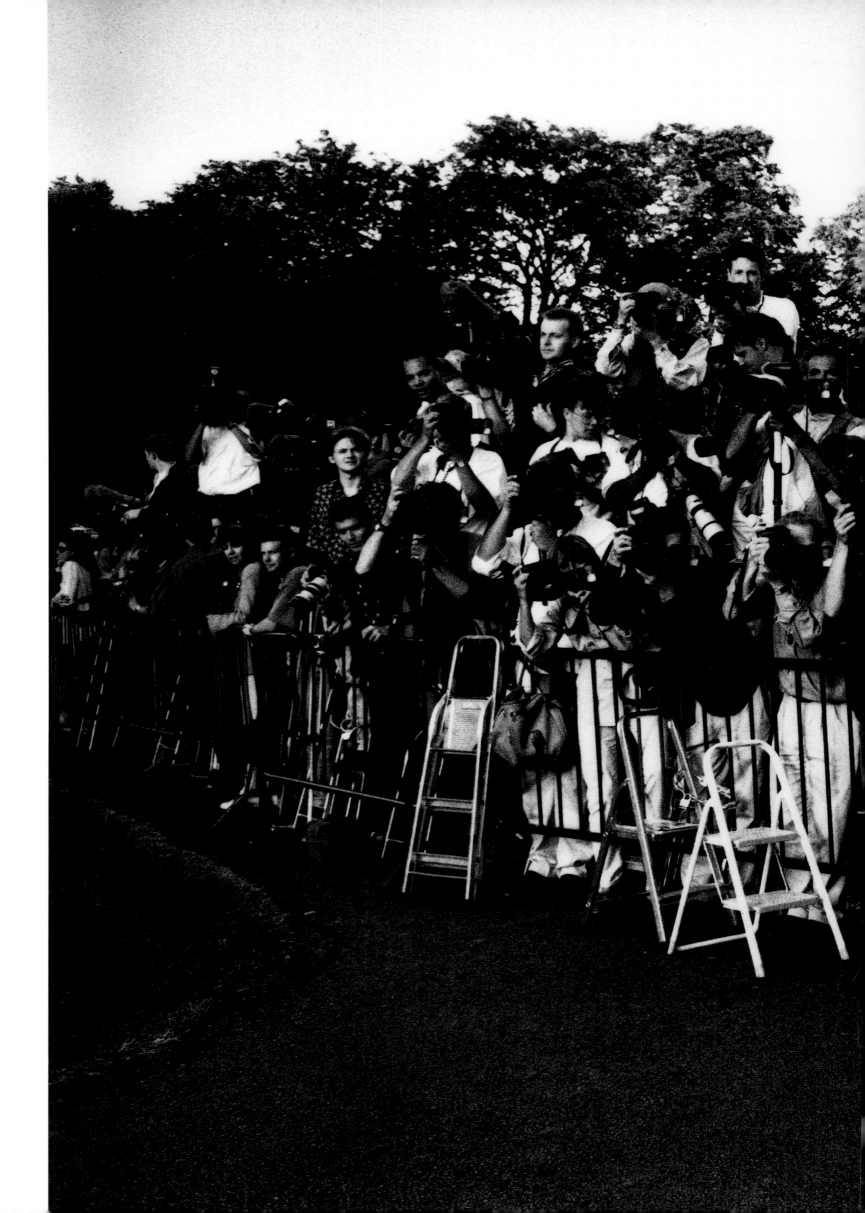

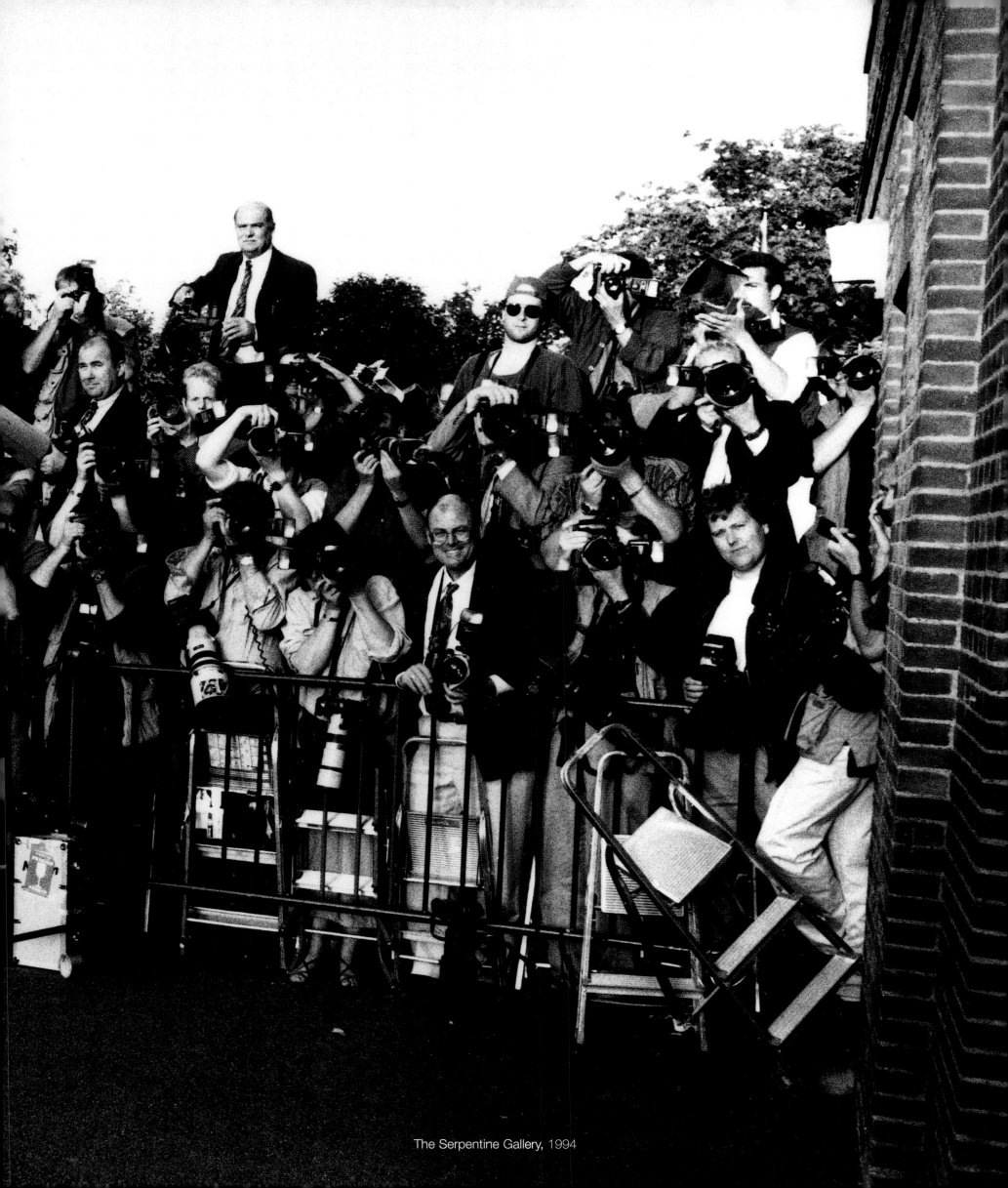

The Serpentine Gallery, 1994

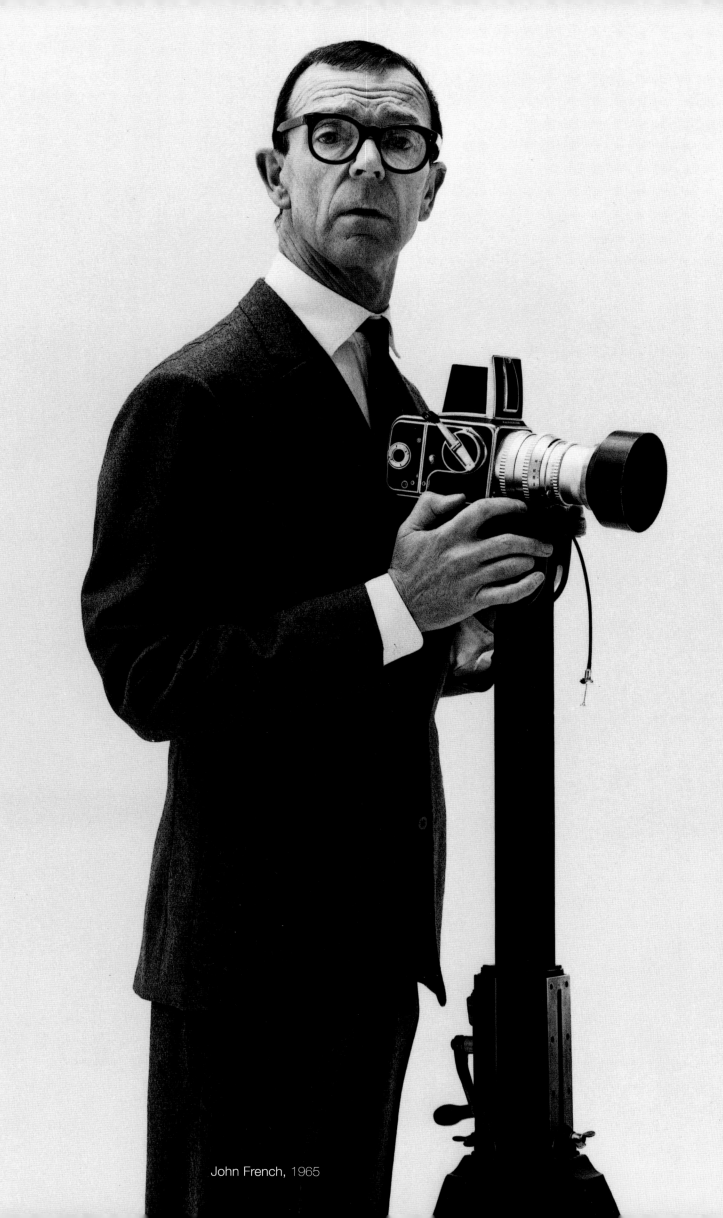

John French, 1965

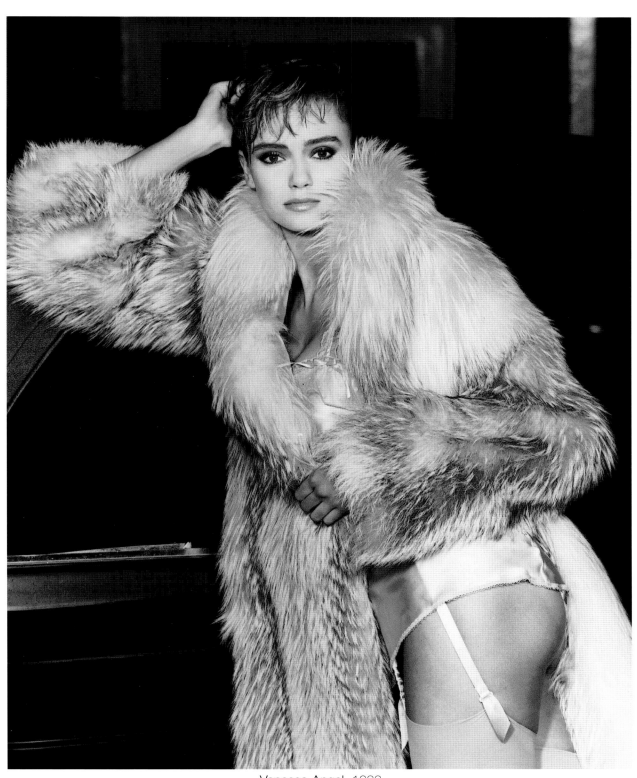

Vanessa Angel, 1983

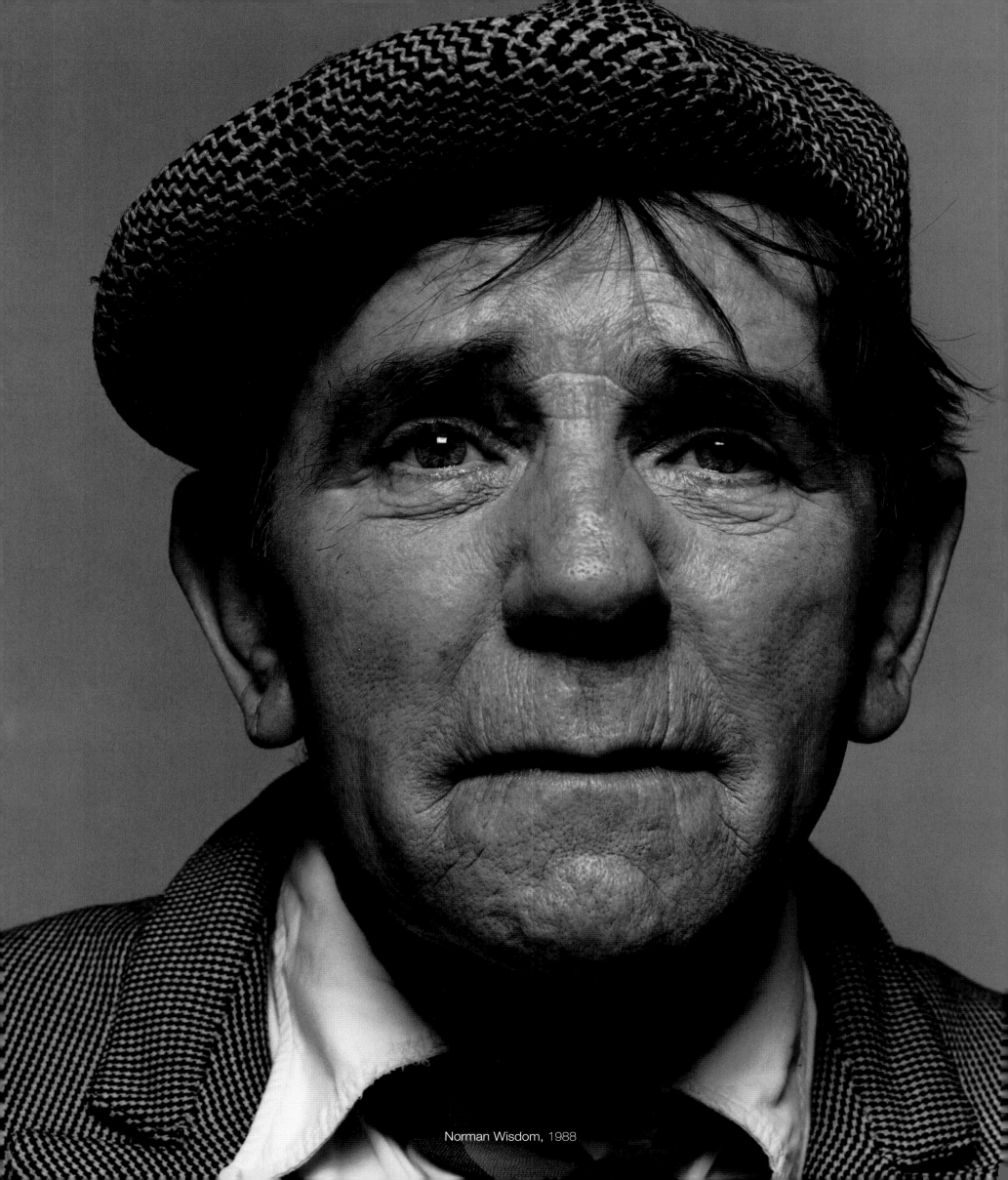

Norman Wisdom, 1988

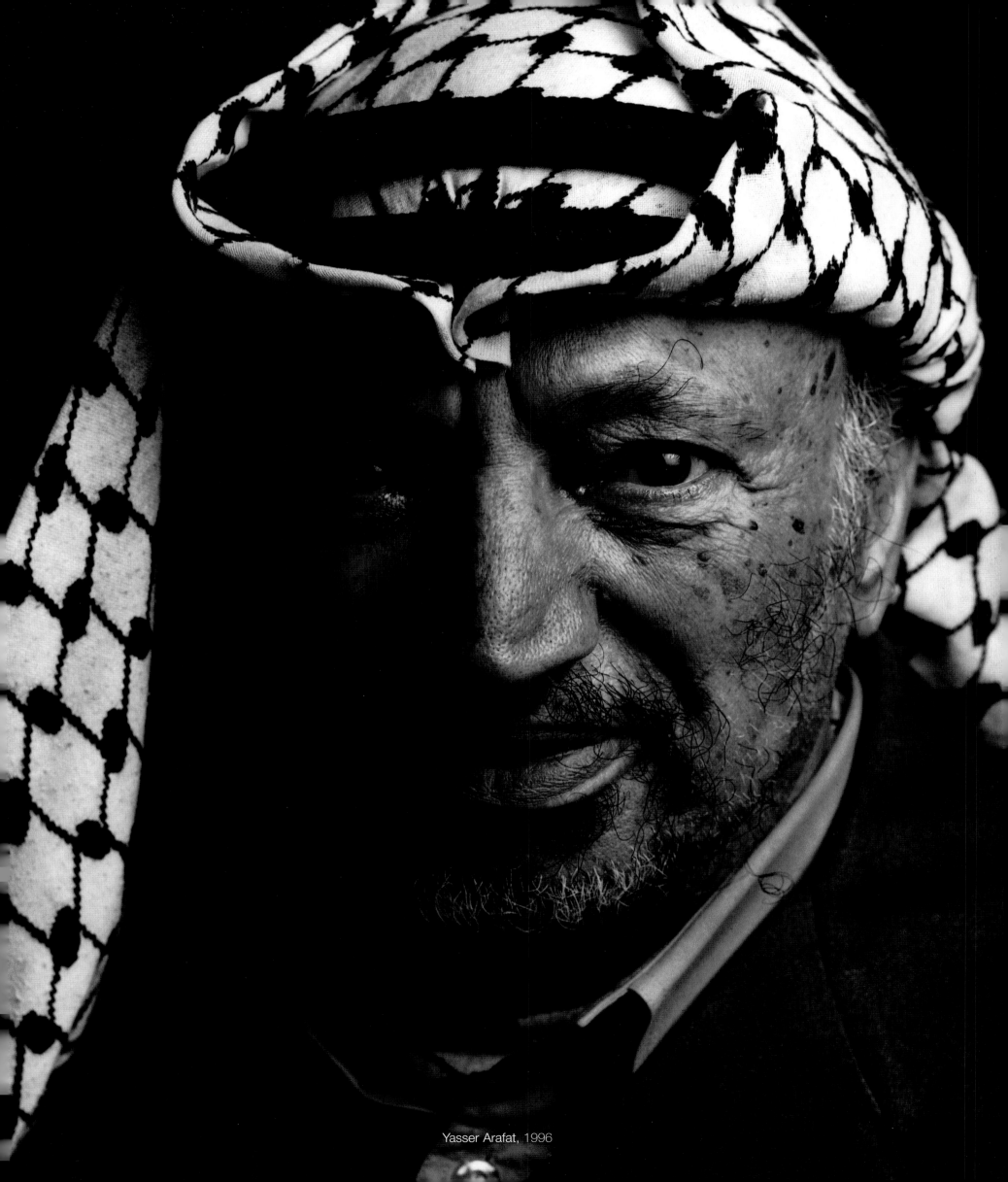

Yasser Arafat, 1996

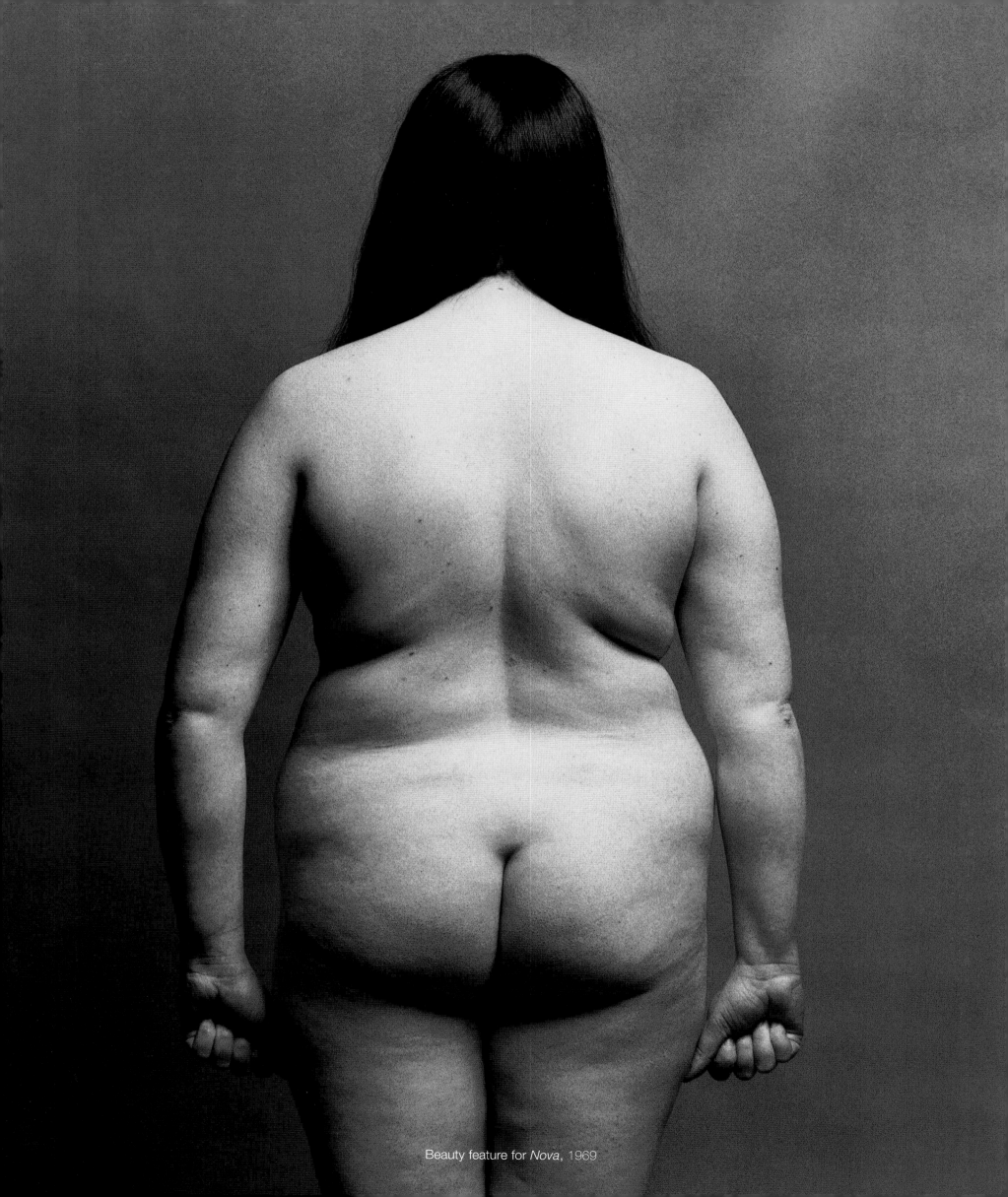

Beauty feature for *Nova*, 1969

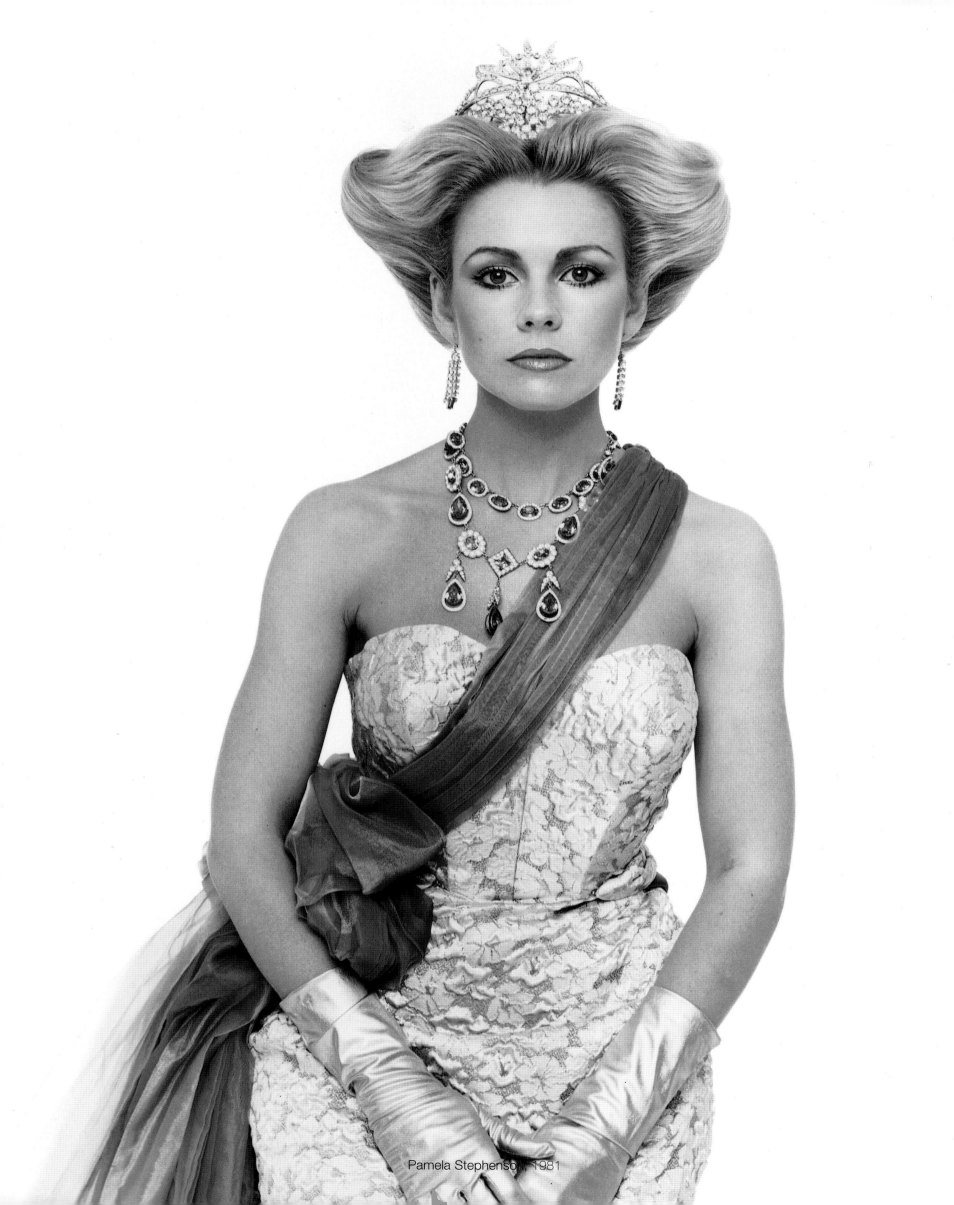

Pamela Stephenson, 1981

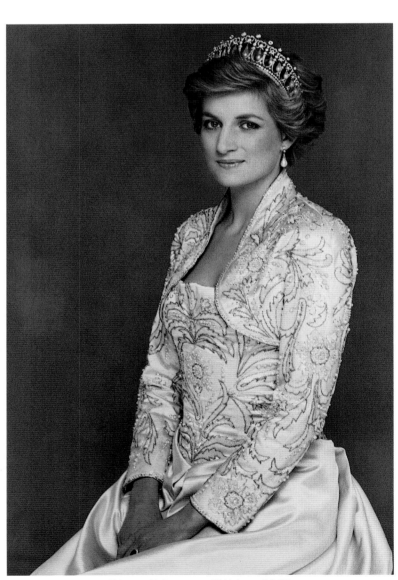

Diana, Princess of Wales, 1990

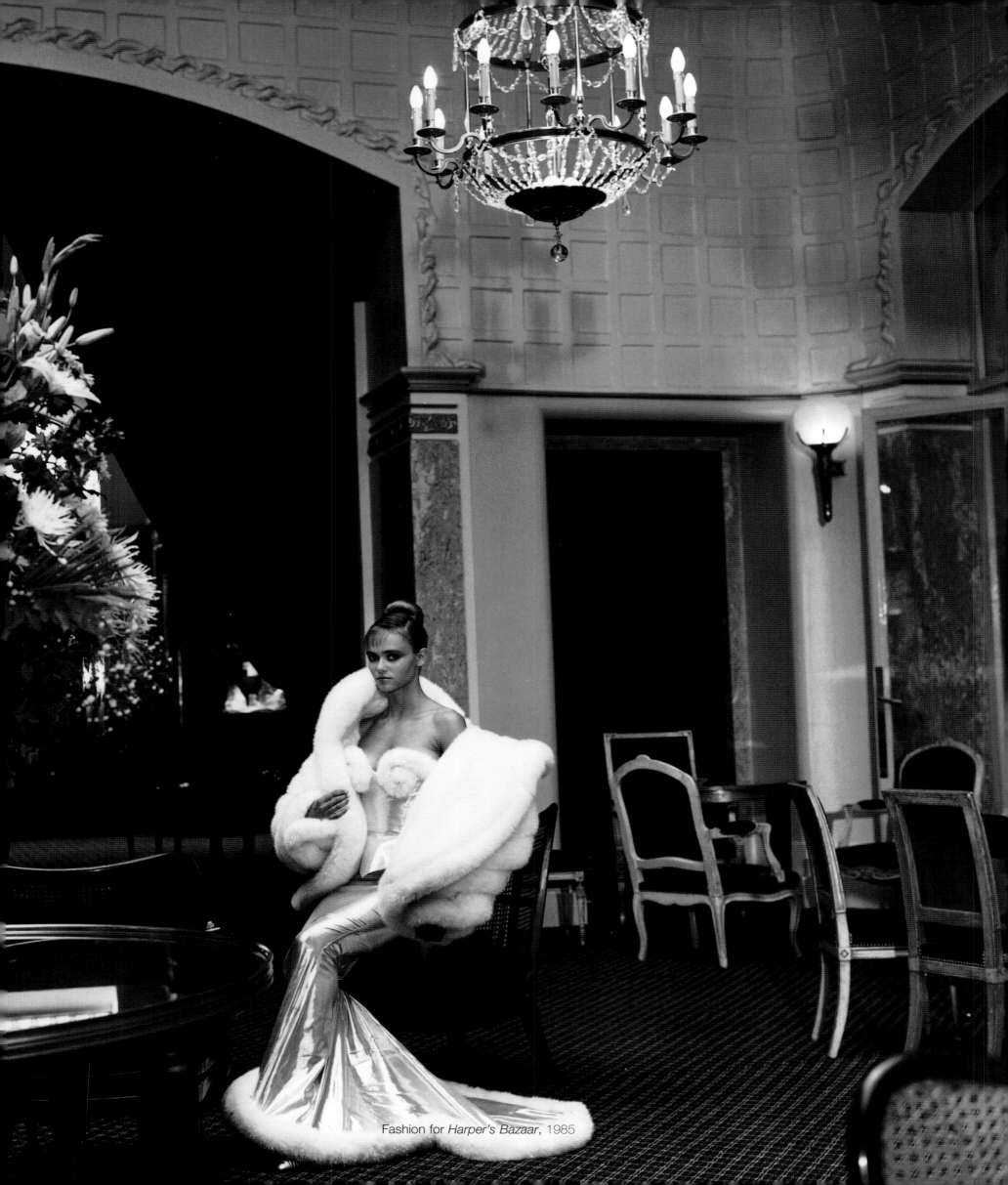

Fashion for *Harper's Bazaar*, 1985

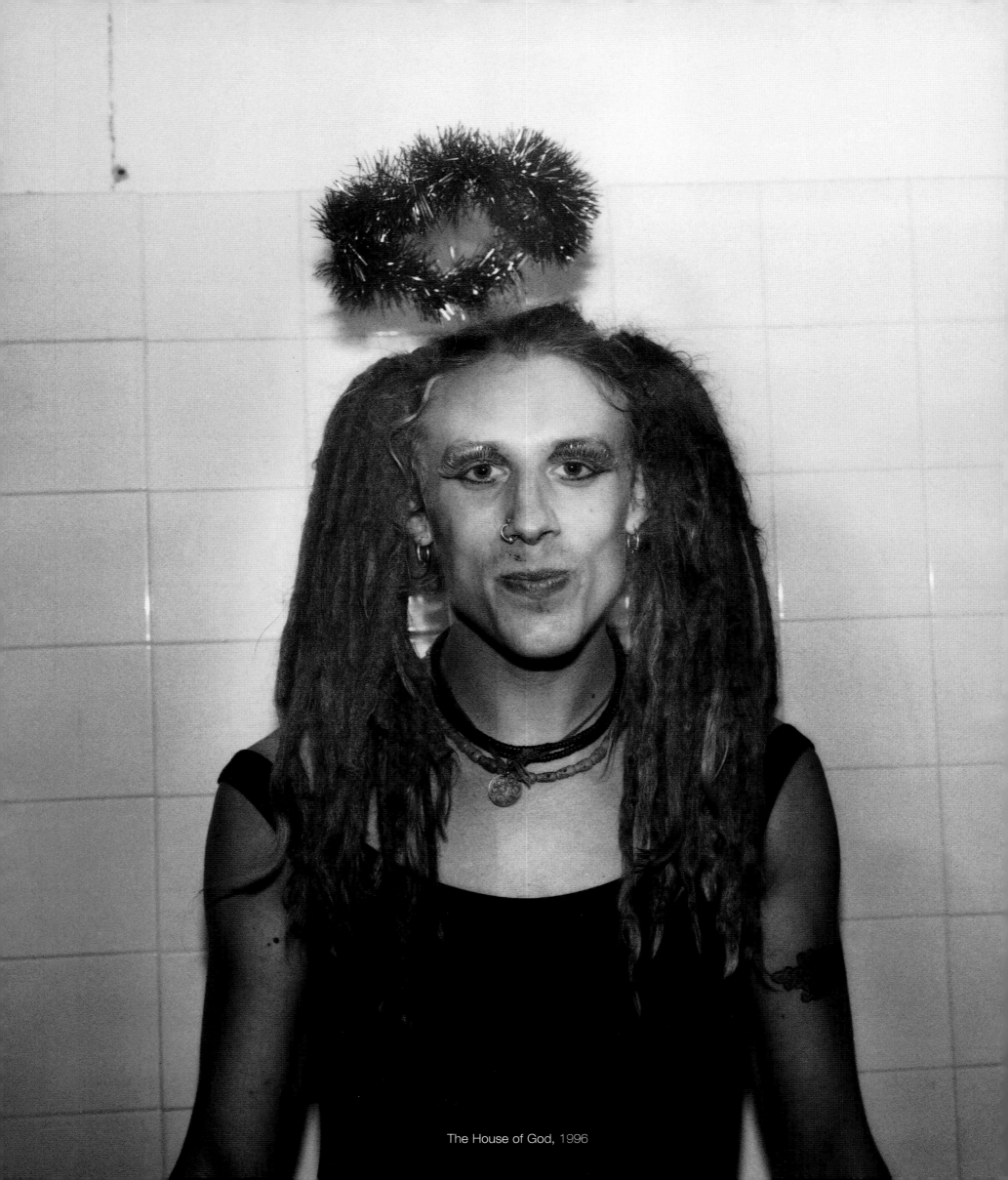

The House of God, 1996

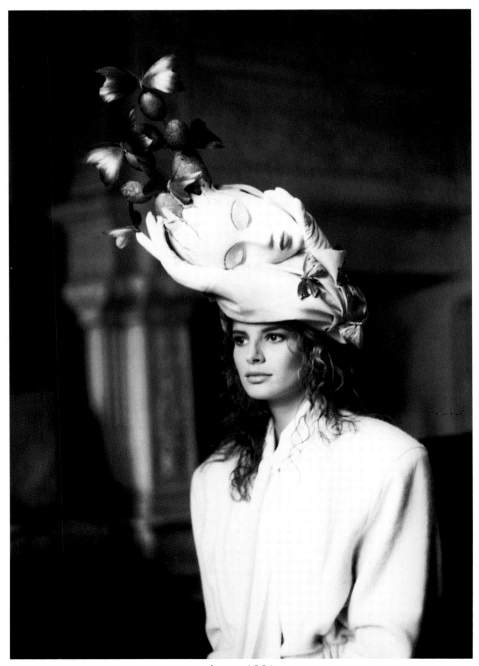

Anga, 1991

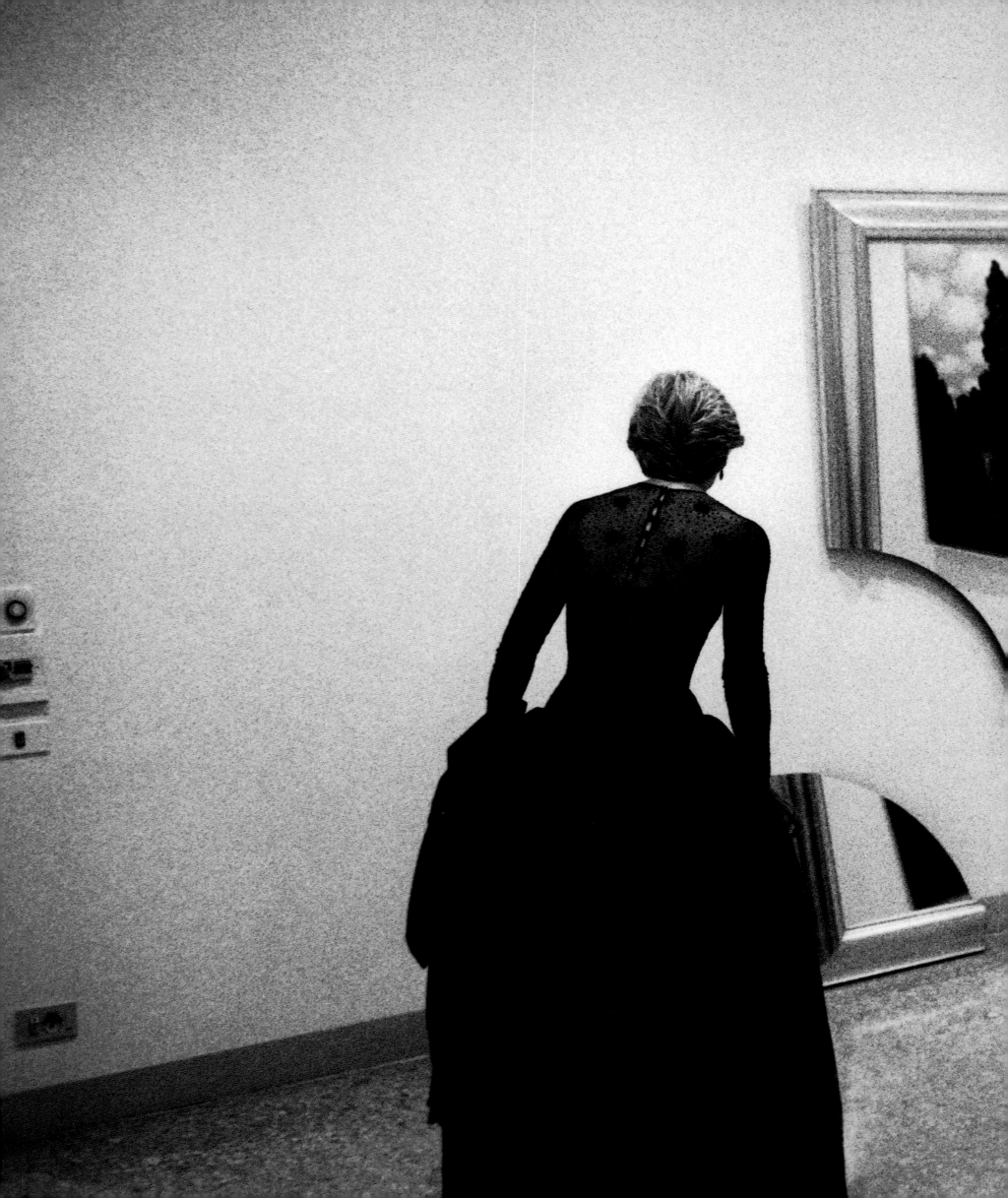

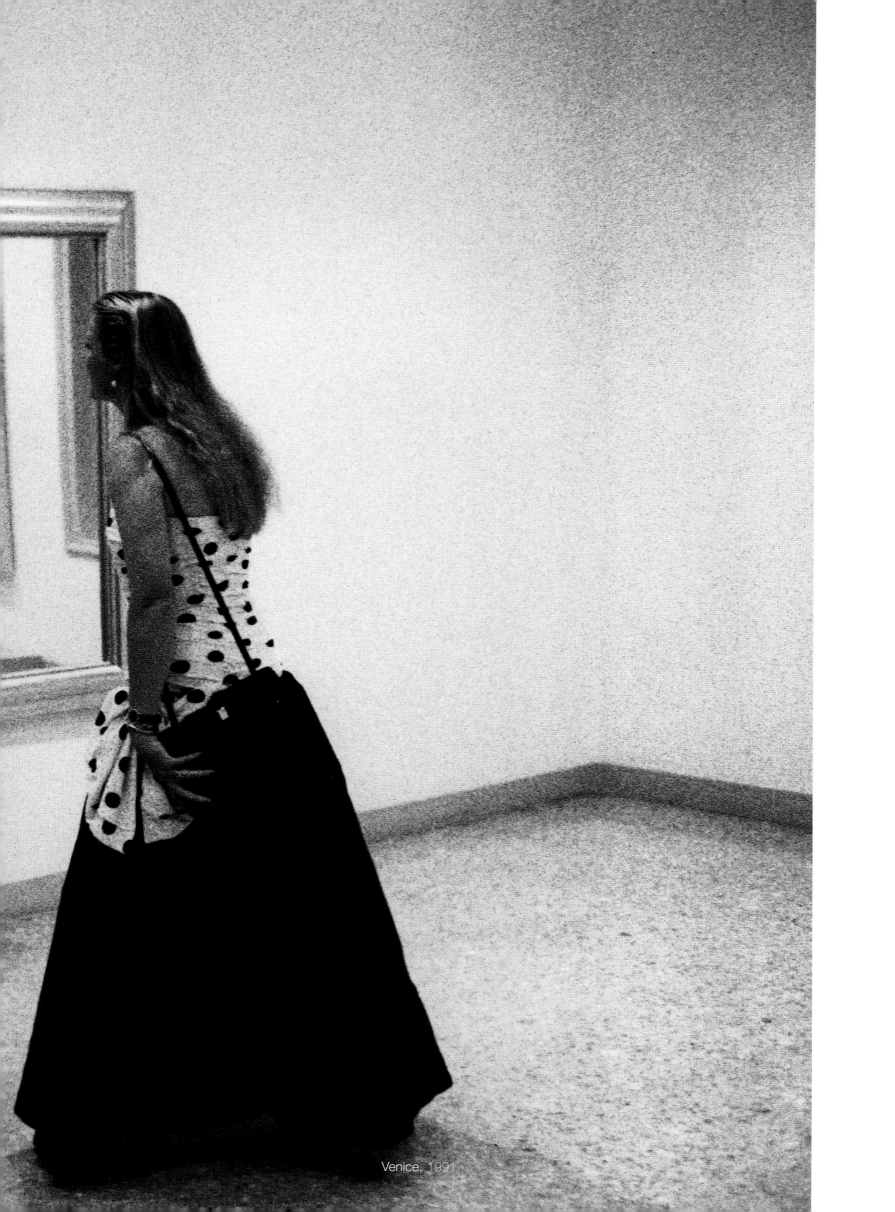

Venice, 1991

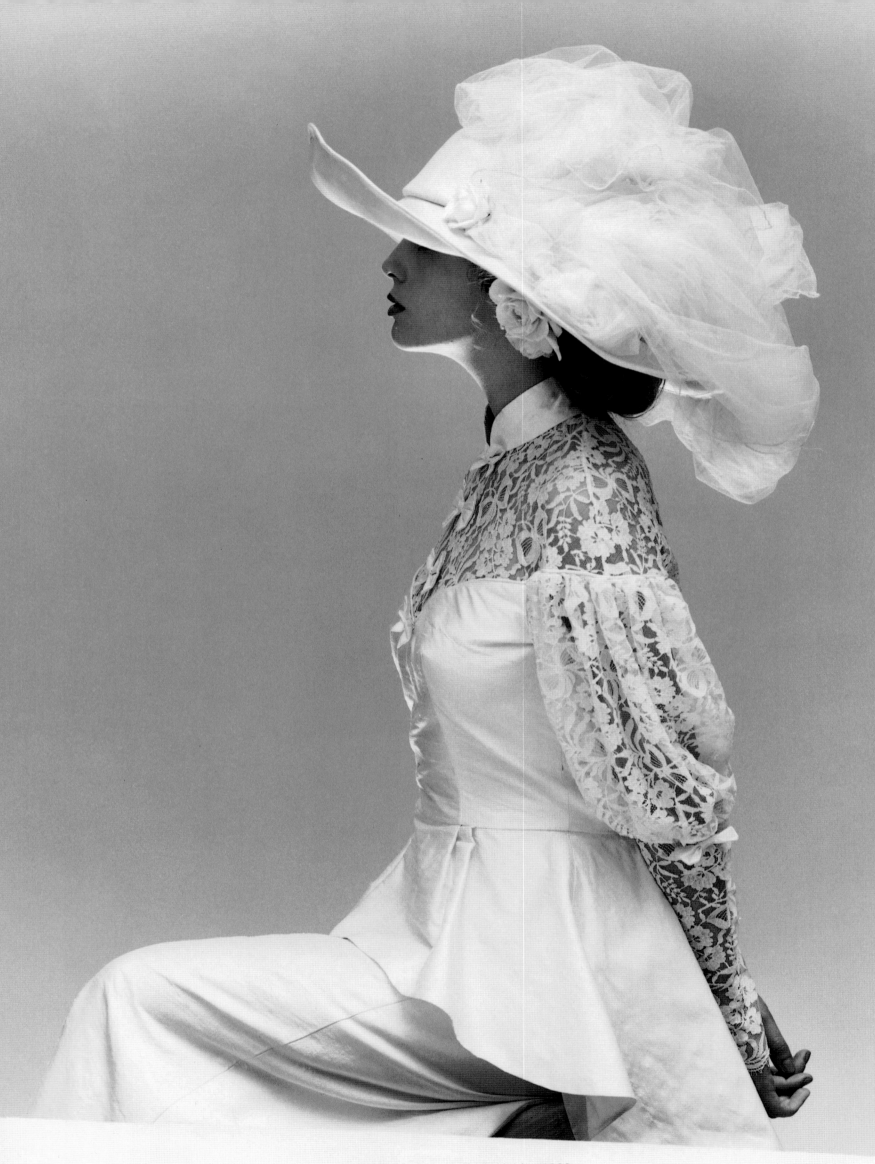

Emily Holder, 1986

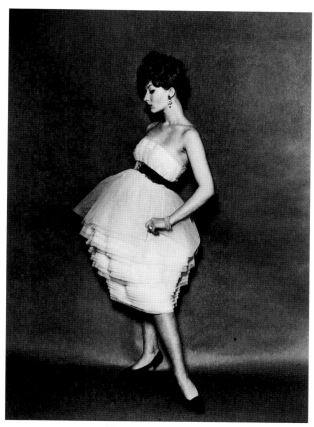

Liese Deniz, 1959

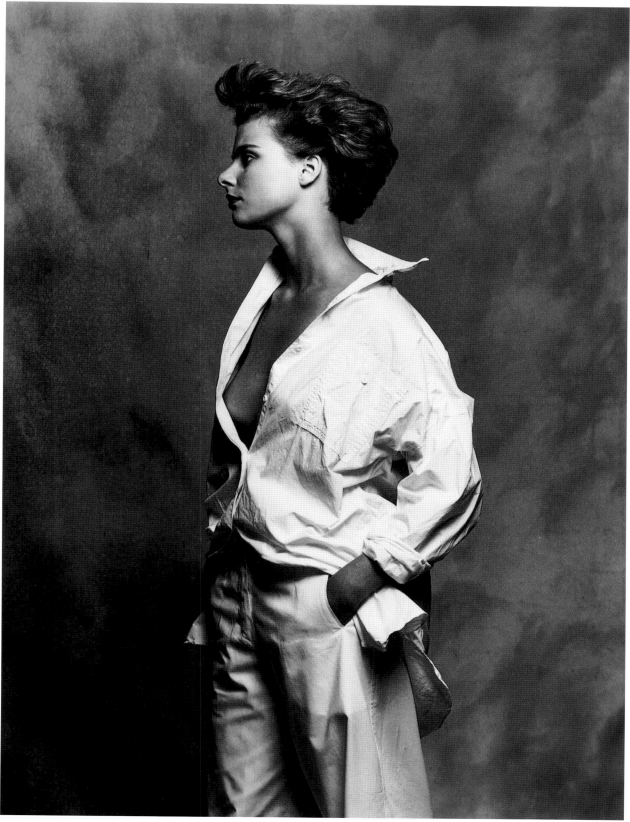

Marie Lindfors, 1984

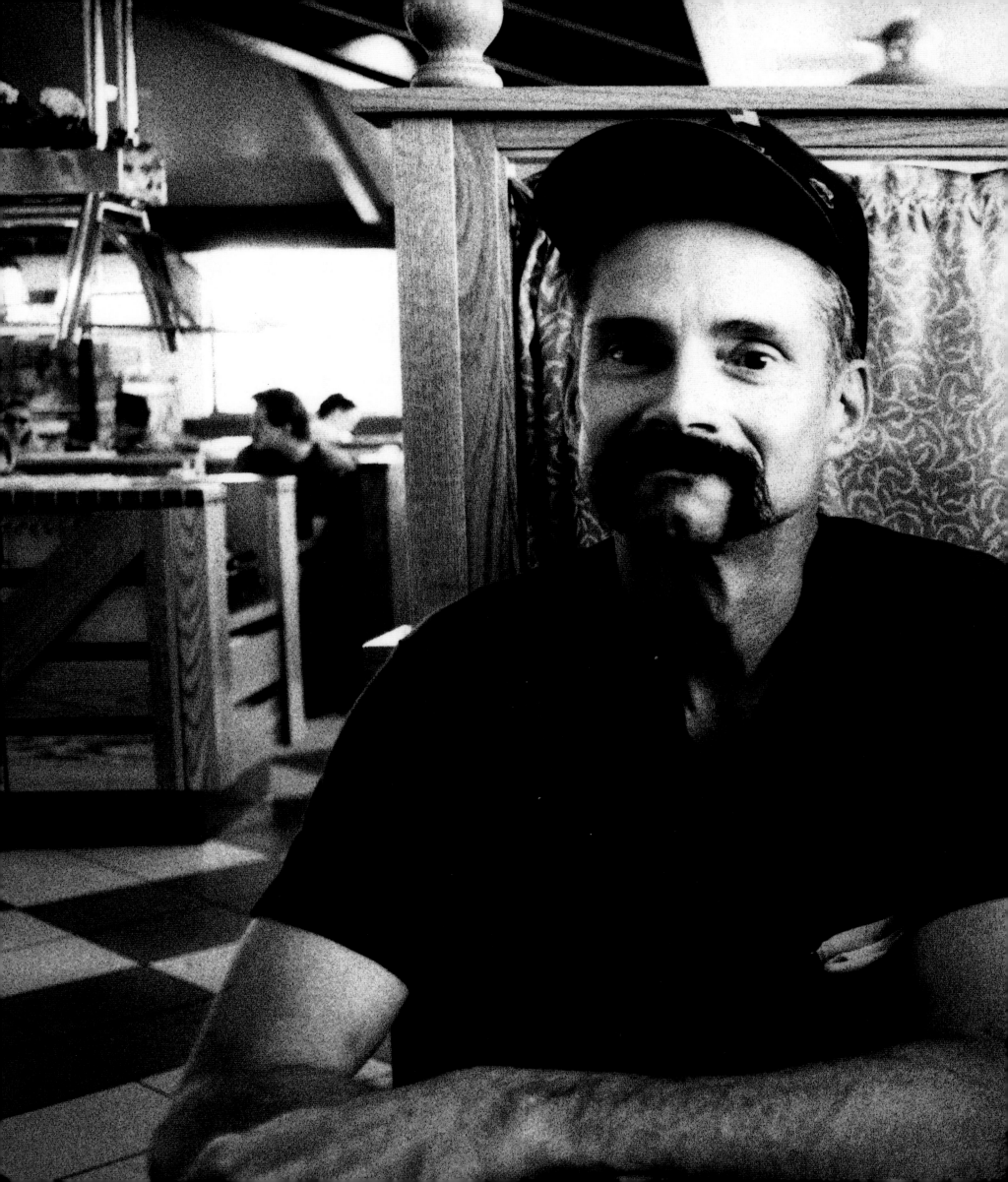

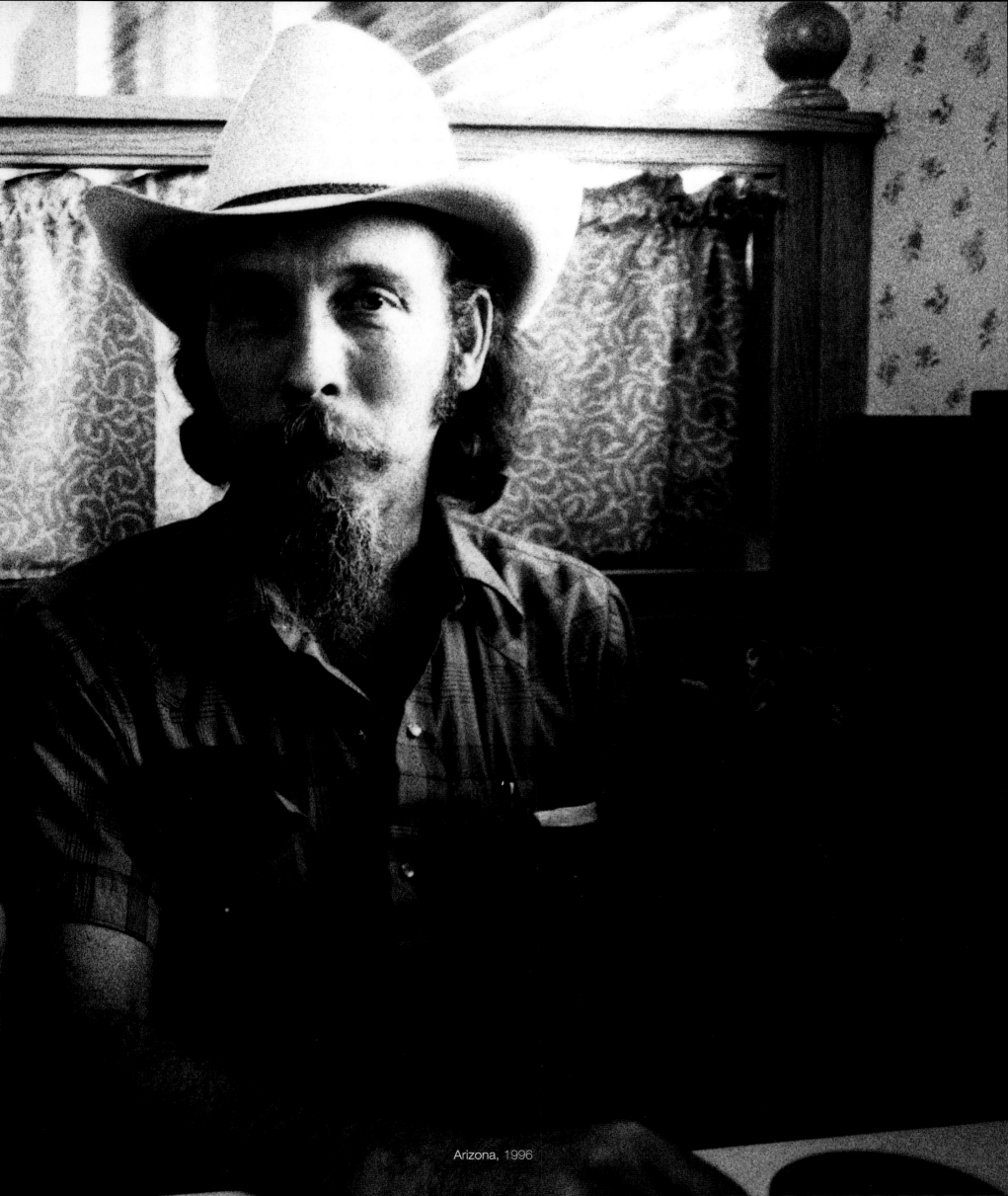

Arizona, 1996

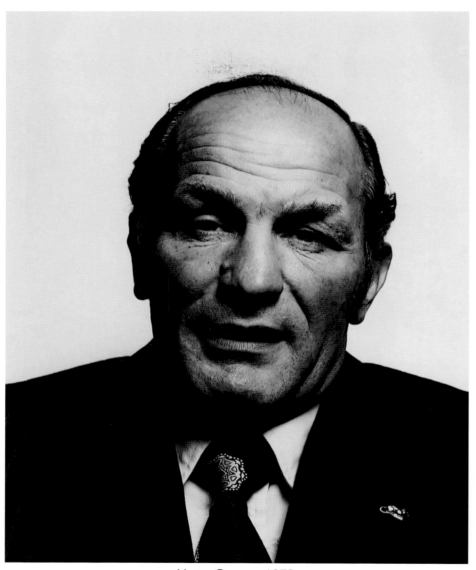

Henry Cooper, 1978

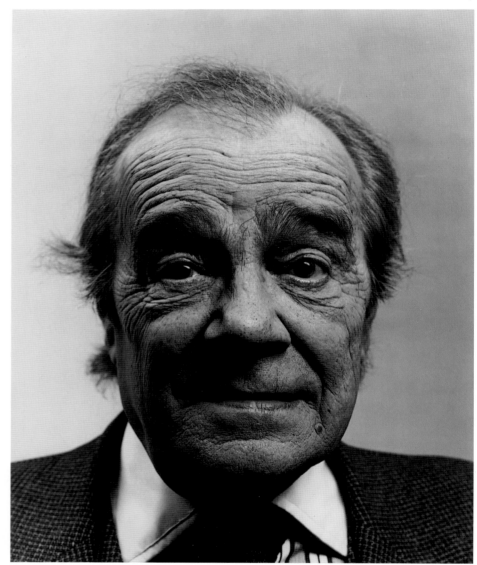

Max Wall, 1979

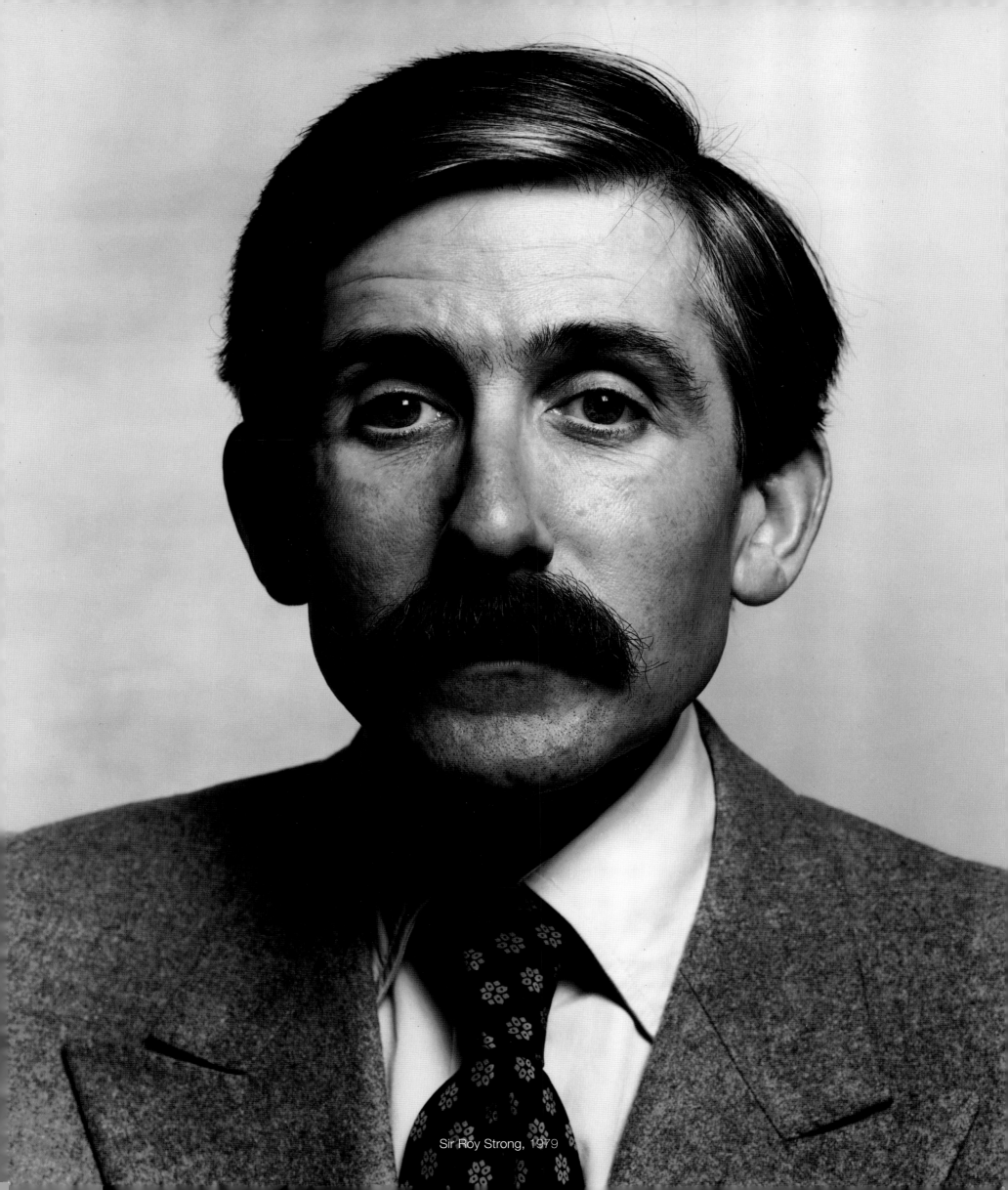
Sir Roy Strong, 1979

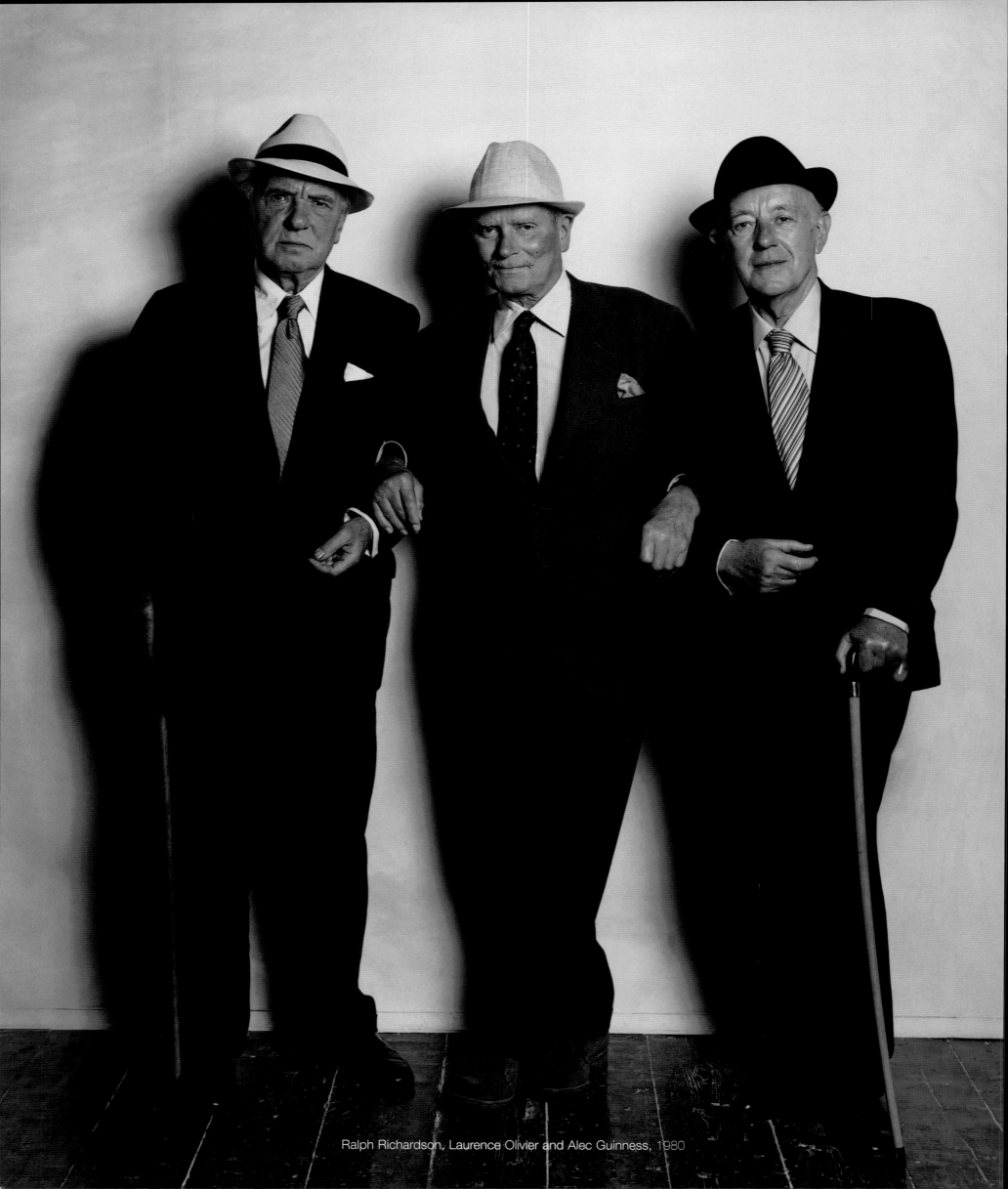

Ralph Richardson, Laurence Olivier and Alec Guinness, 1980

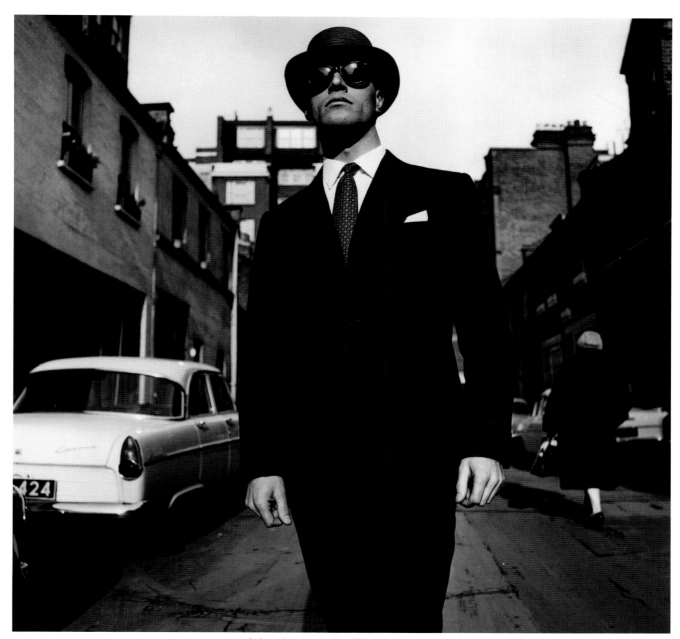

Advertisement for Terylene, 1960

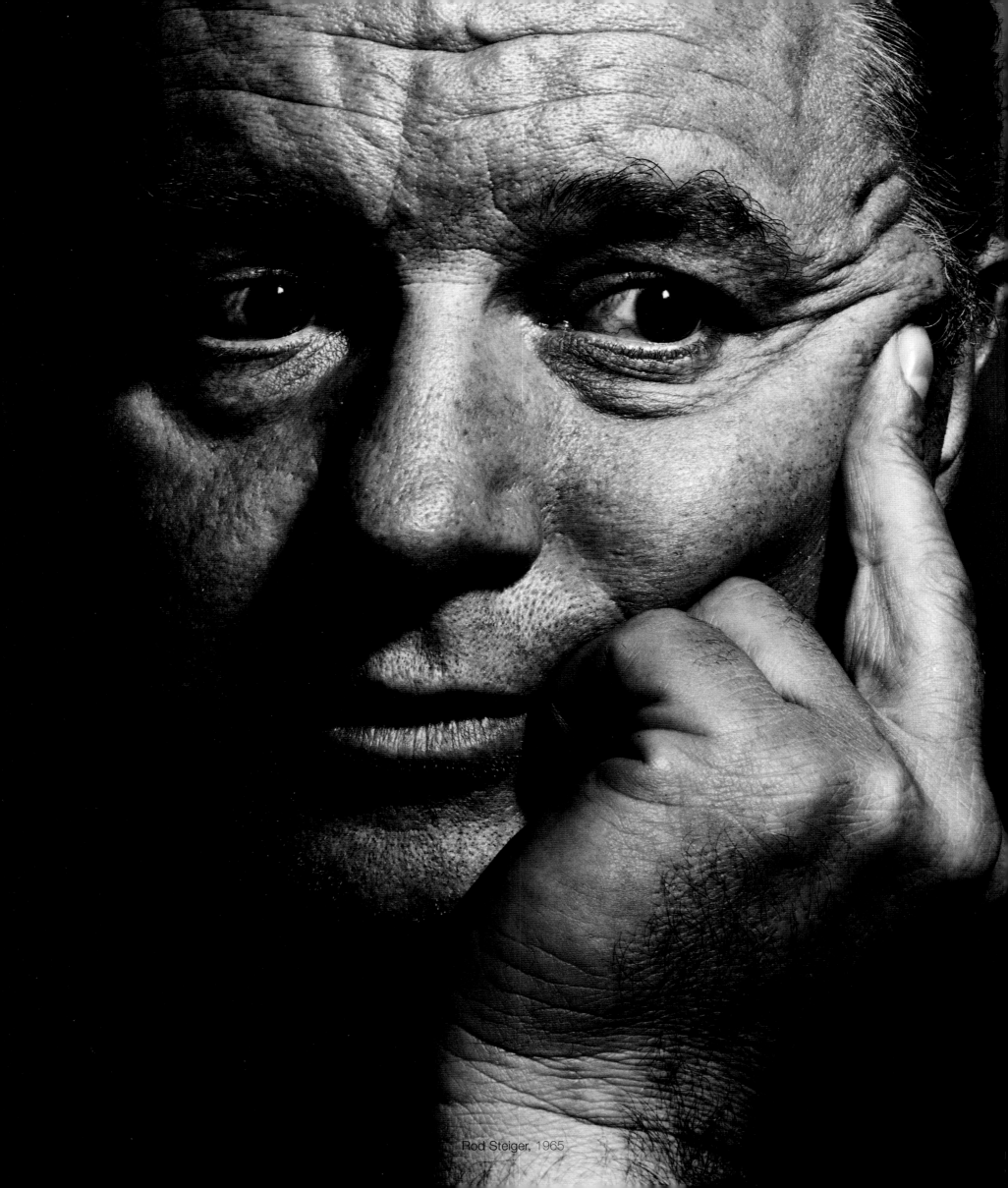
Rod Steiger, 1965

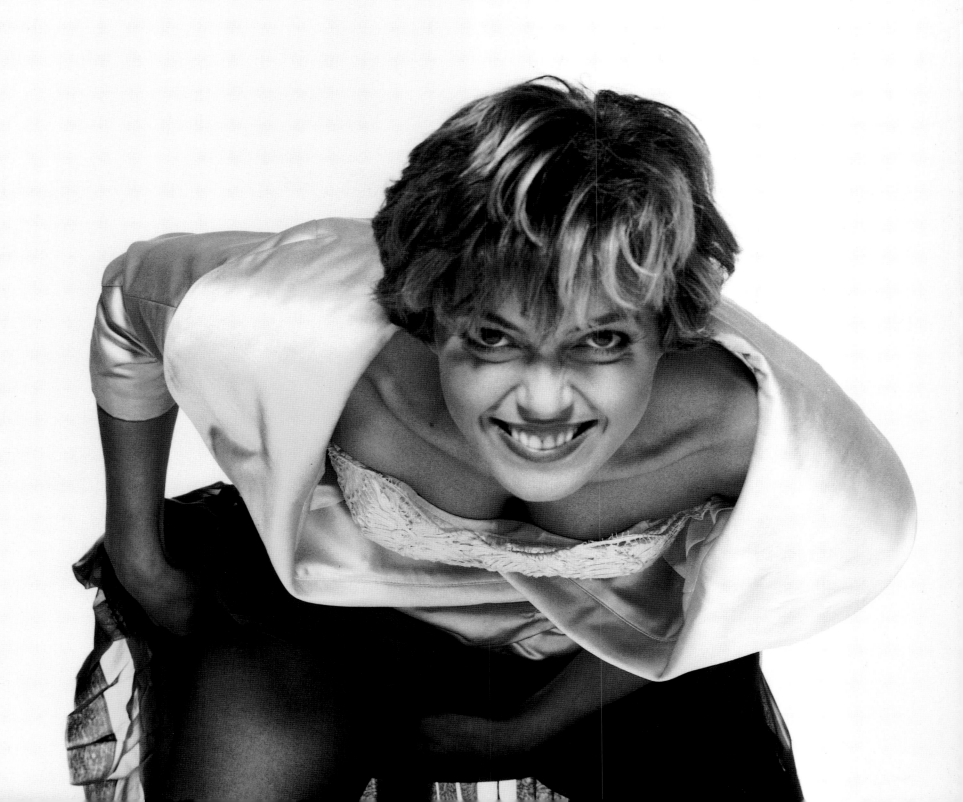

Greta Scacchi, 1988

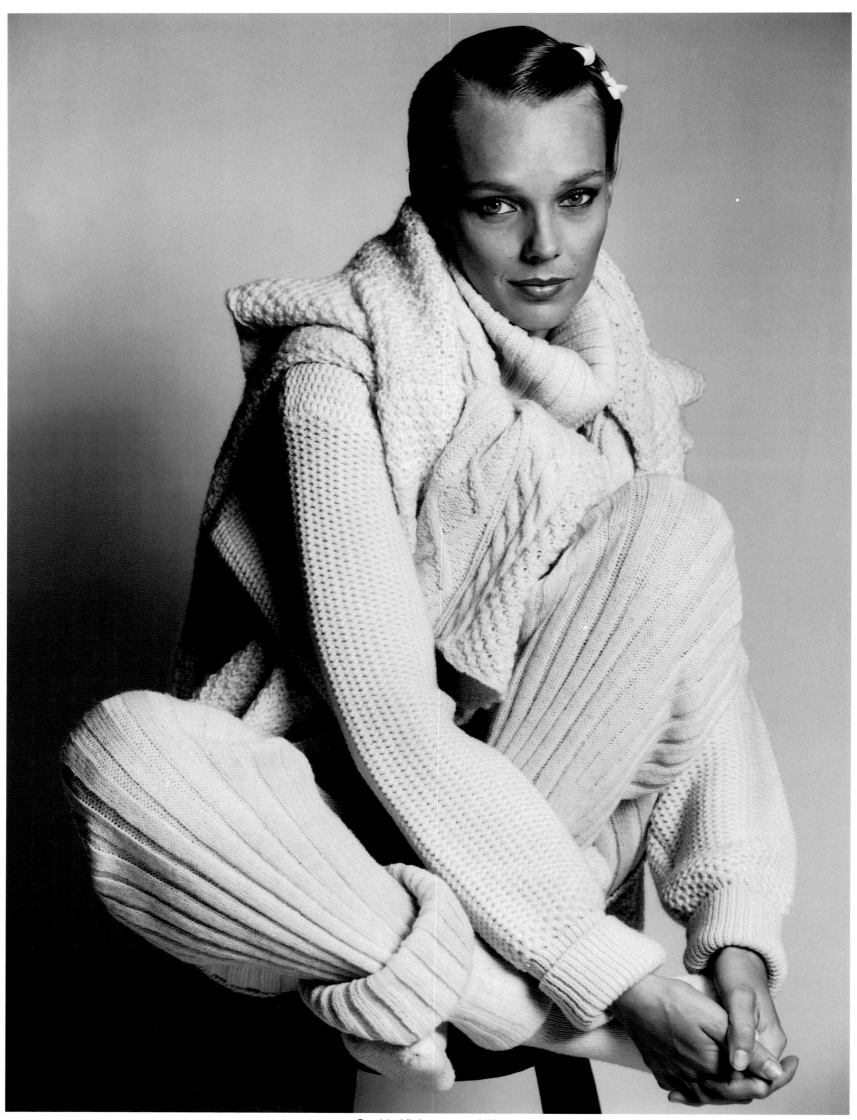

Sophie Kiukonnen, 1976

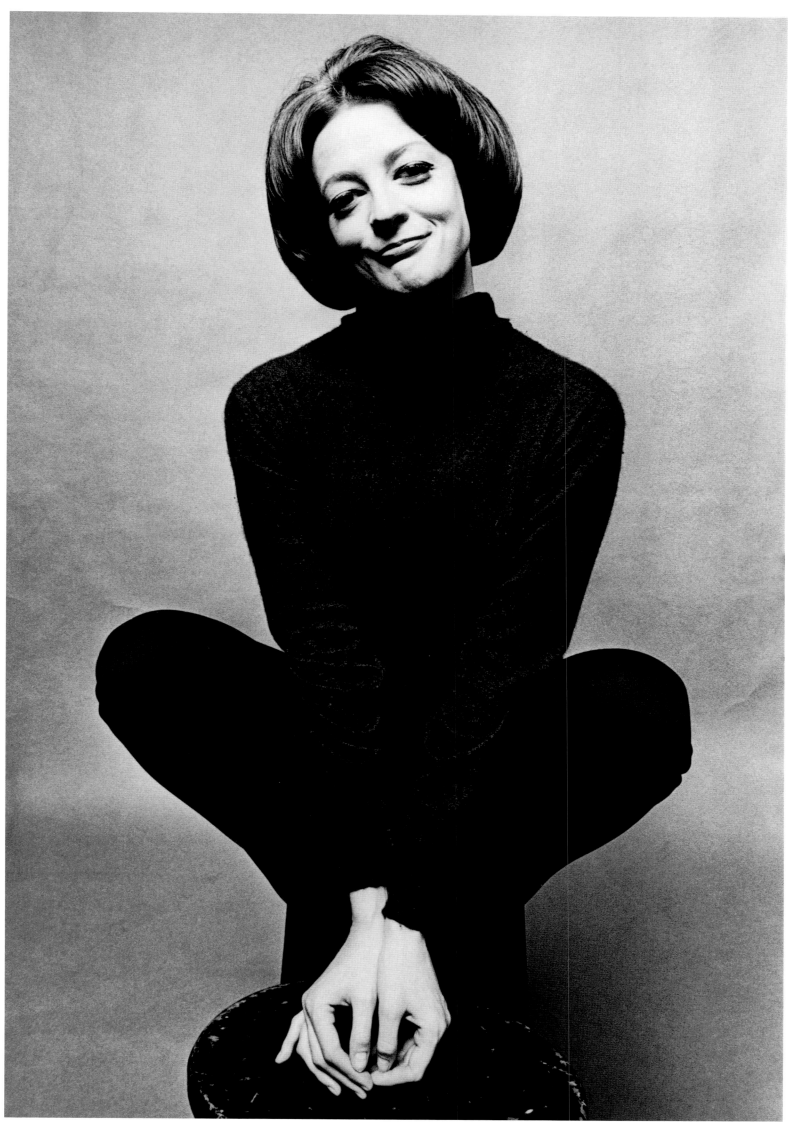

Maggie Smith, 1964

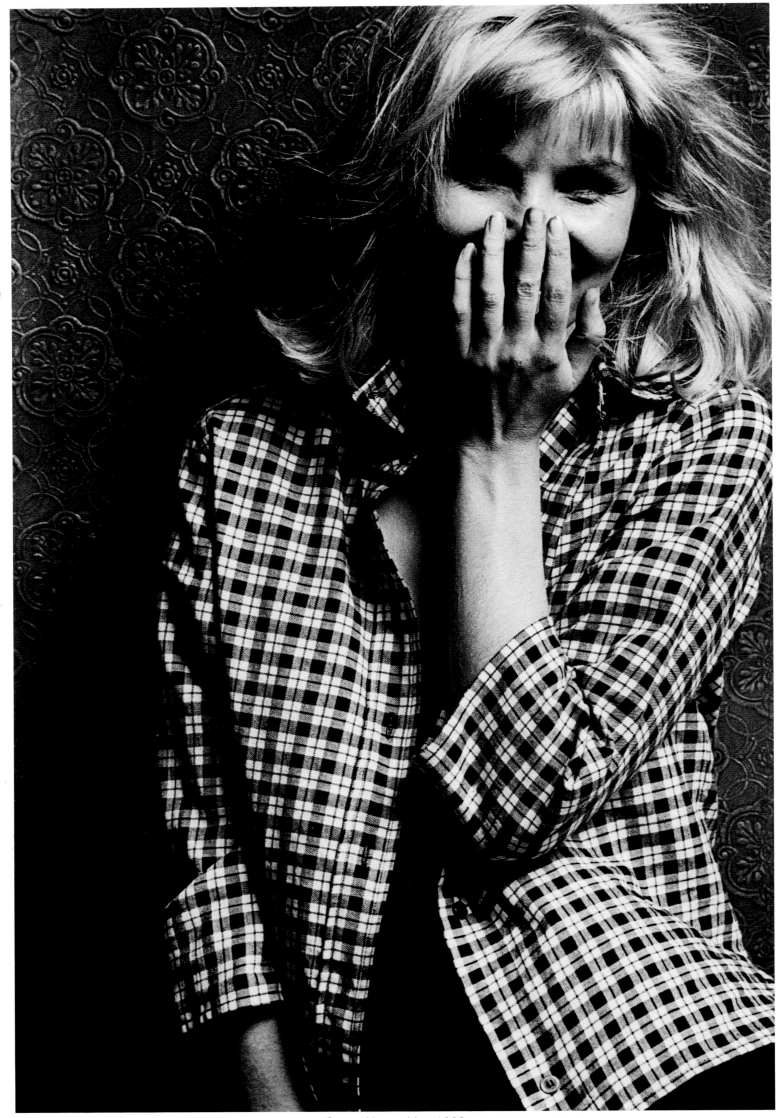

Susan Hampshire, 1963

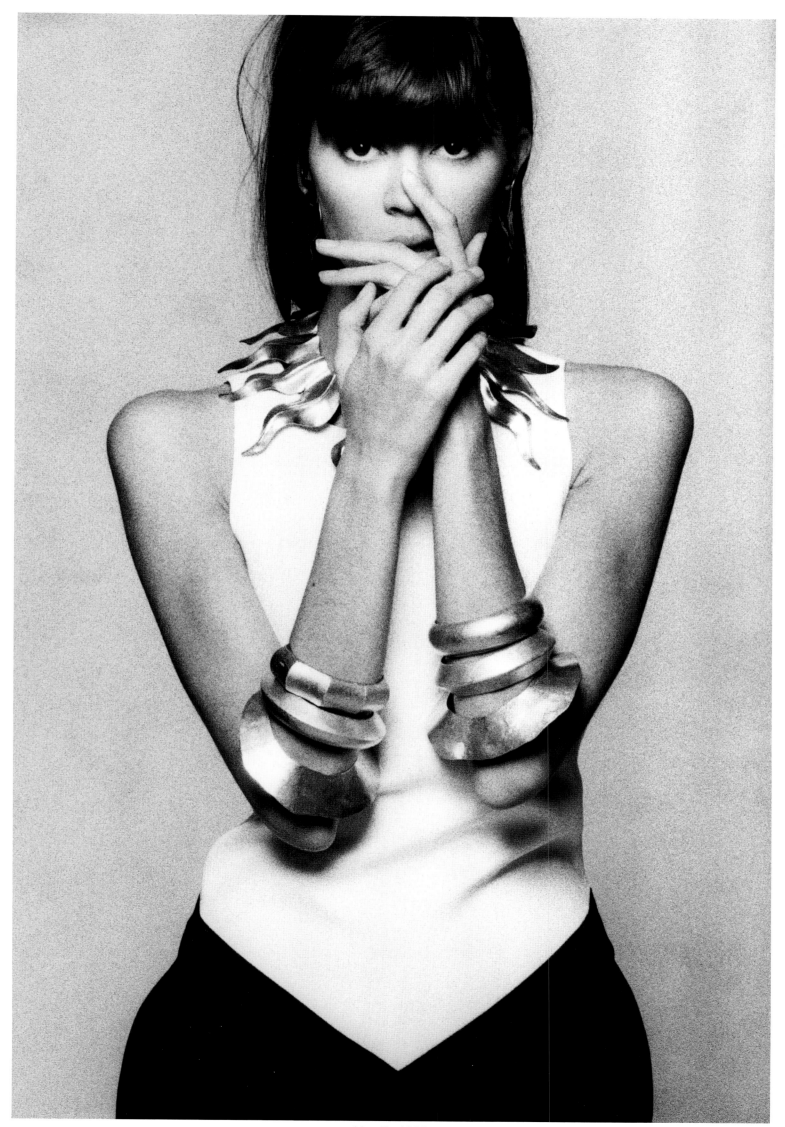

Lisa B, 1989

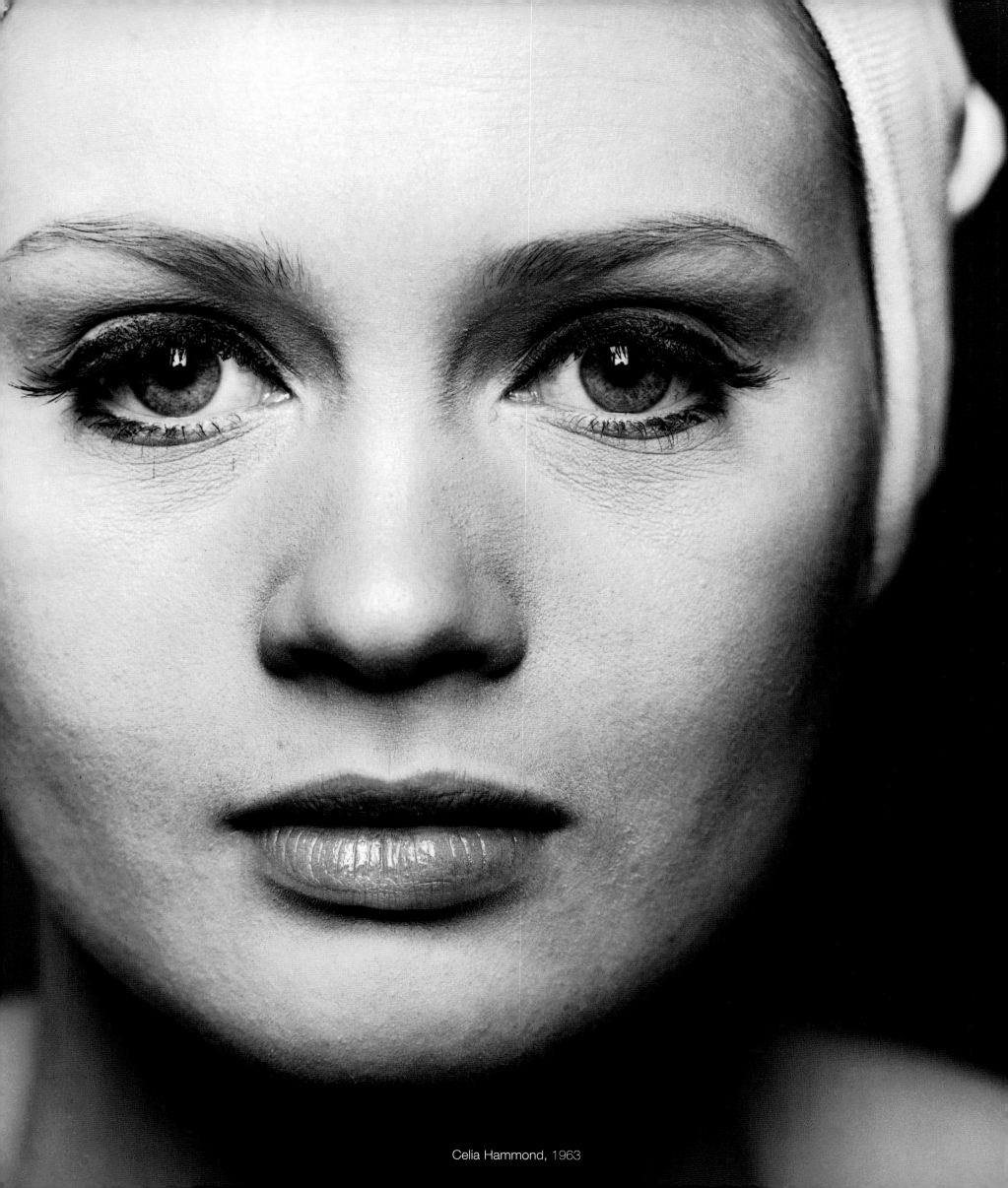

Celia Hammond, 1963

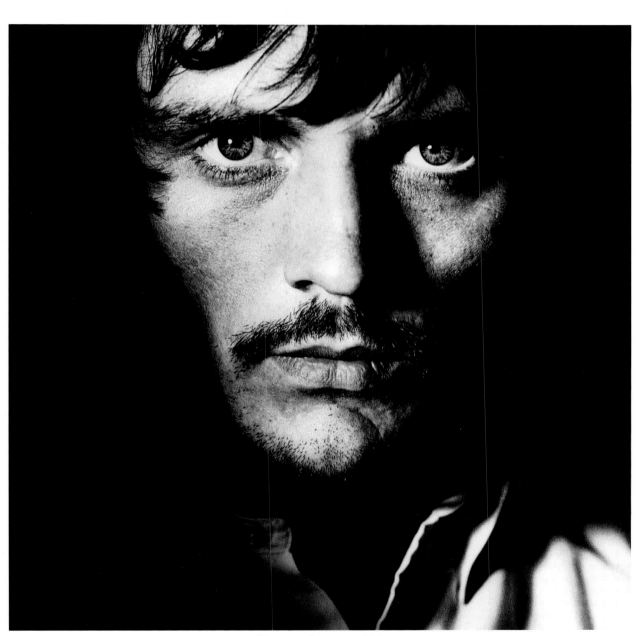

Terence Stamp, 1966

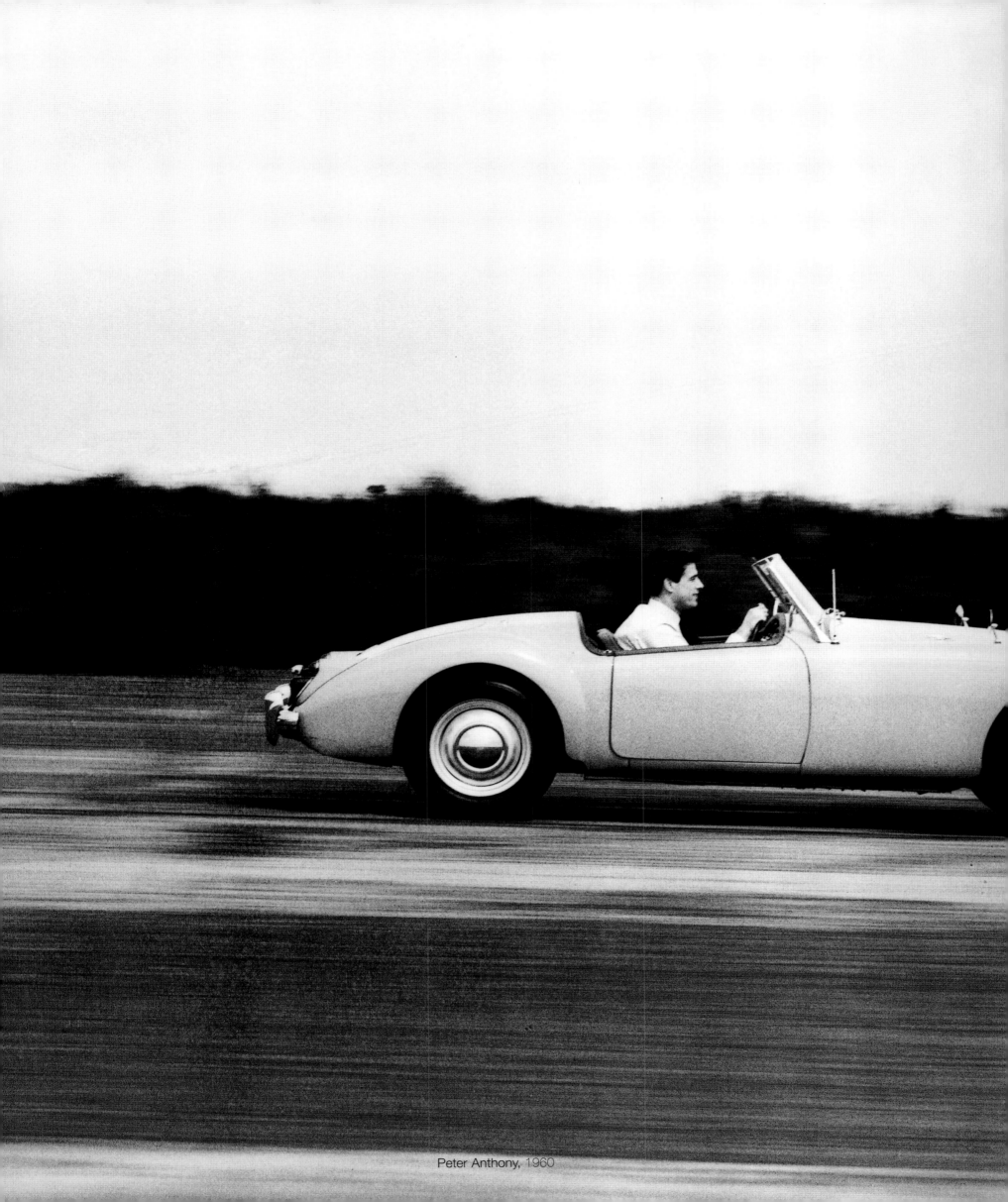

Peter Anthony, 1960

Nude, c.1976

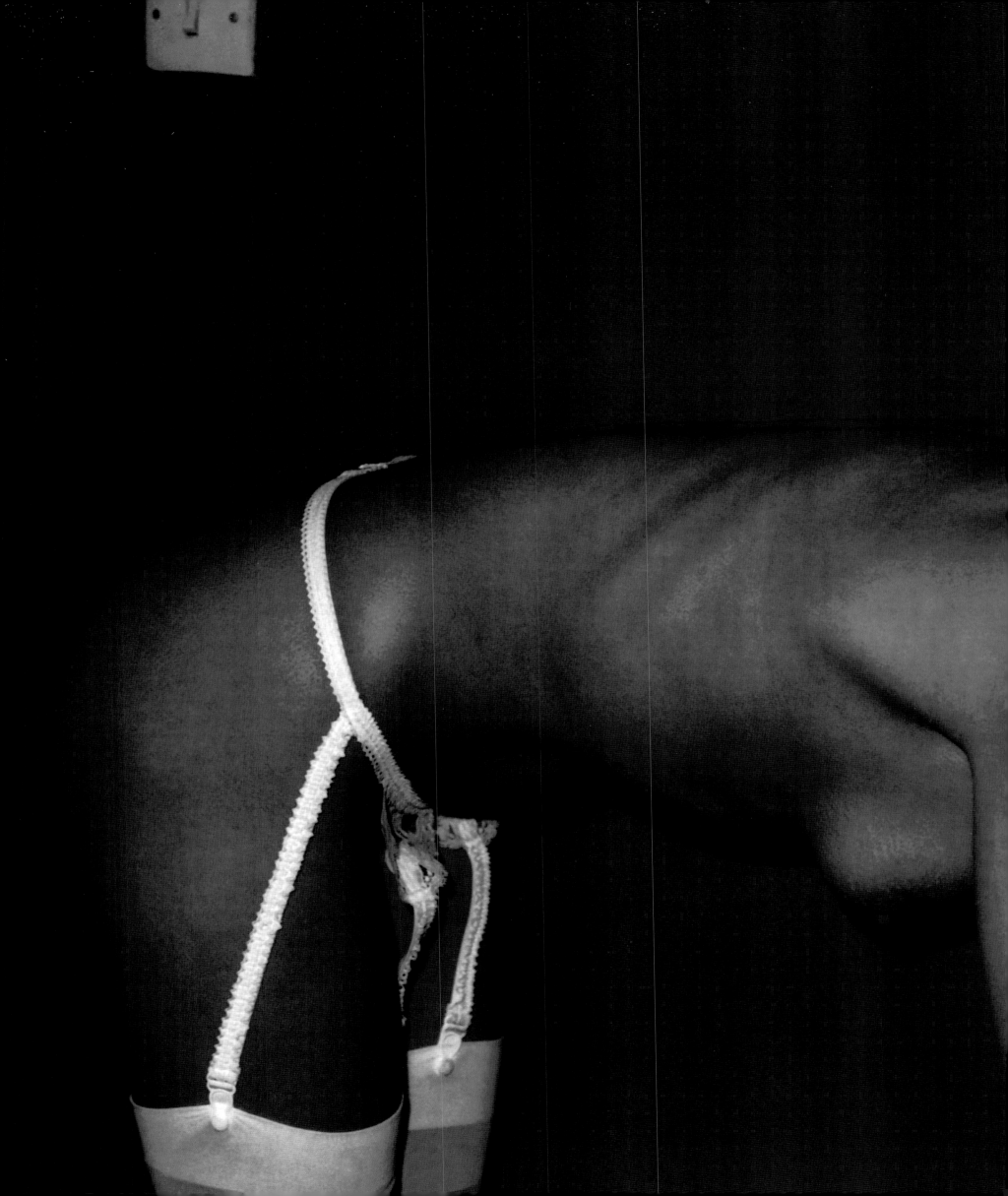

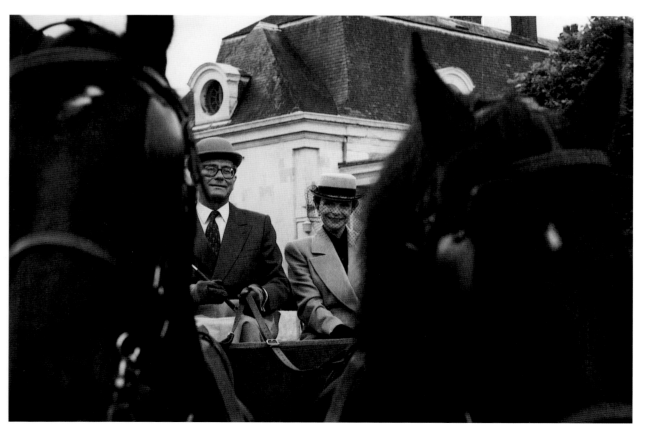

France, 1991

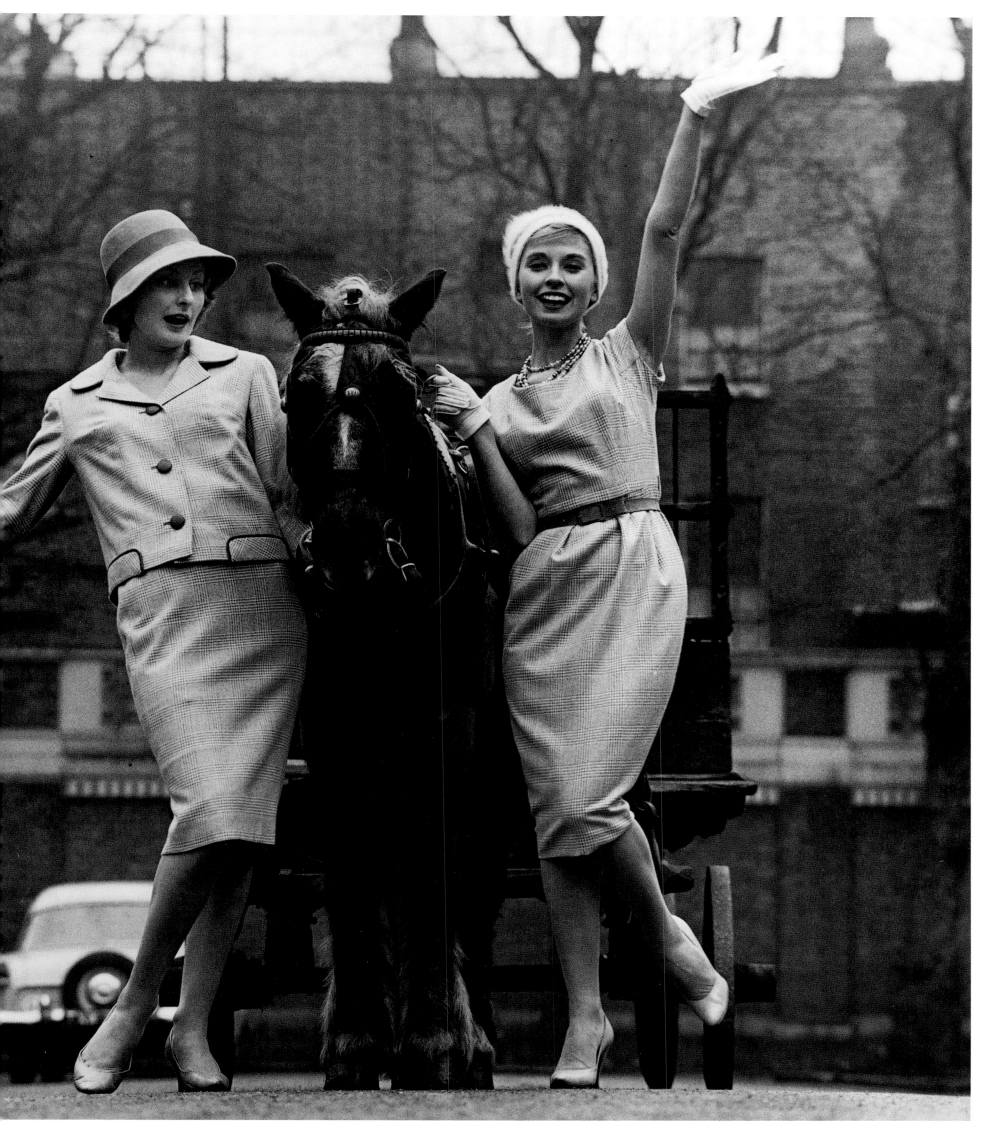

Advertisement for Simon of Knightsbrige, 1959

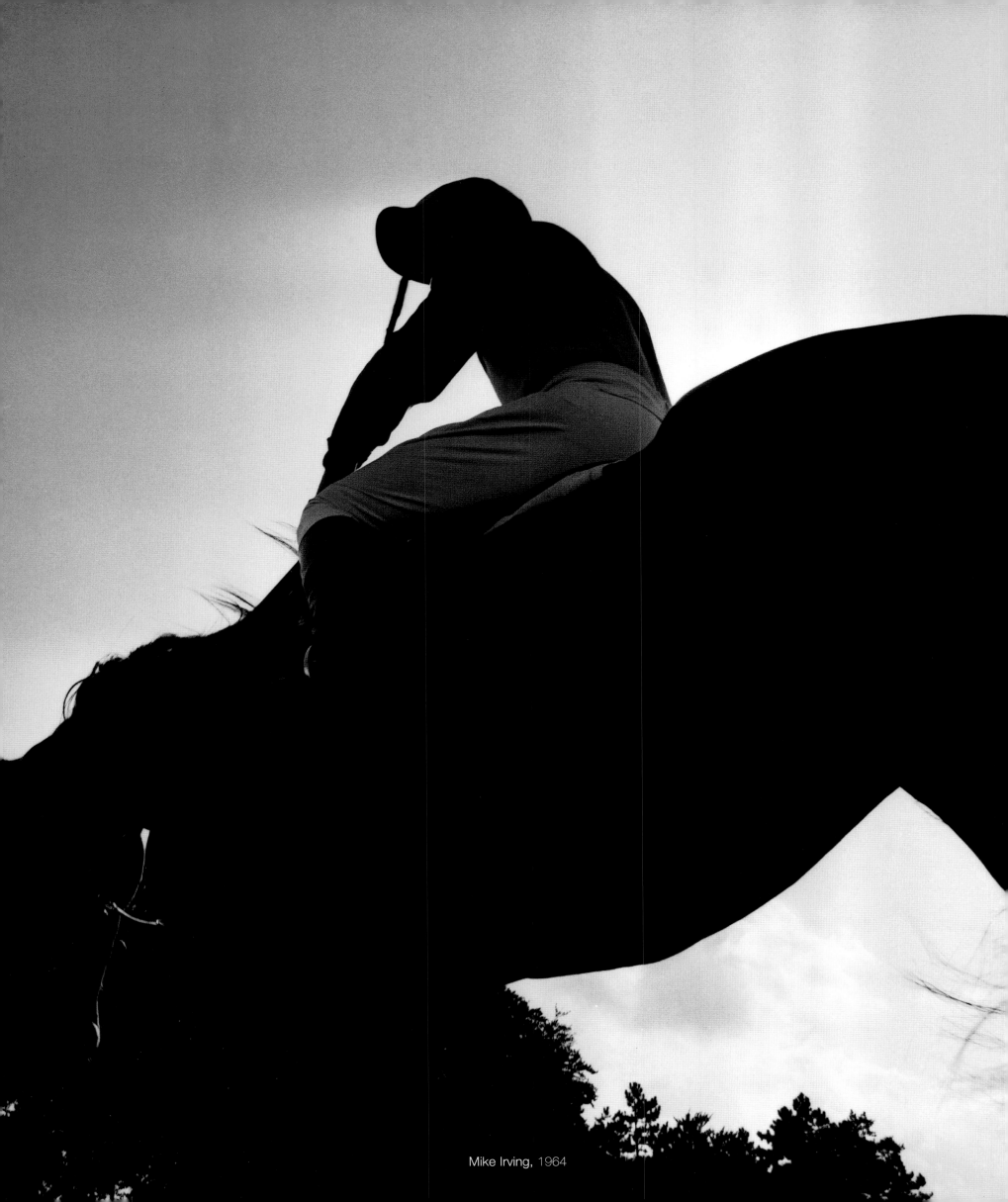

Mike Irving, 1964

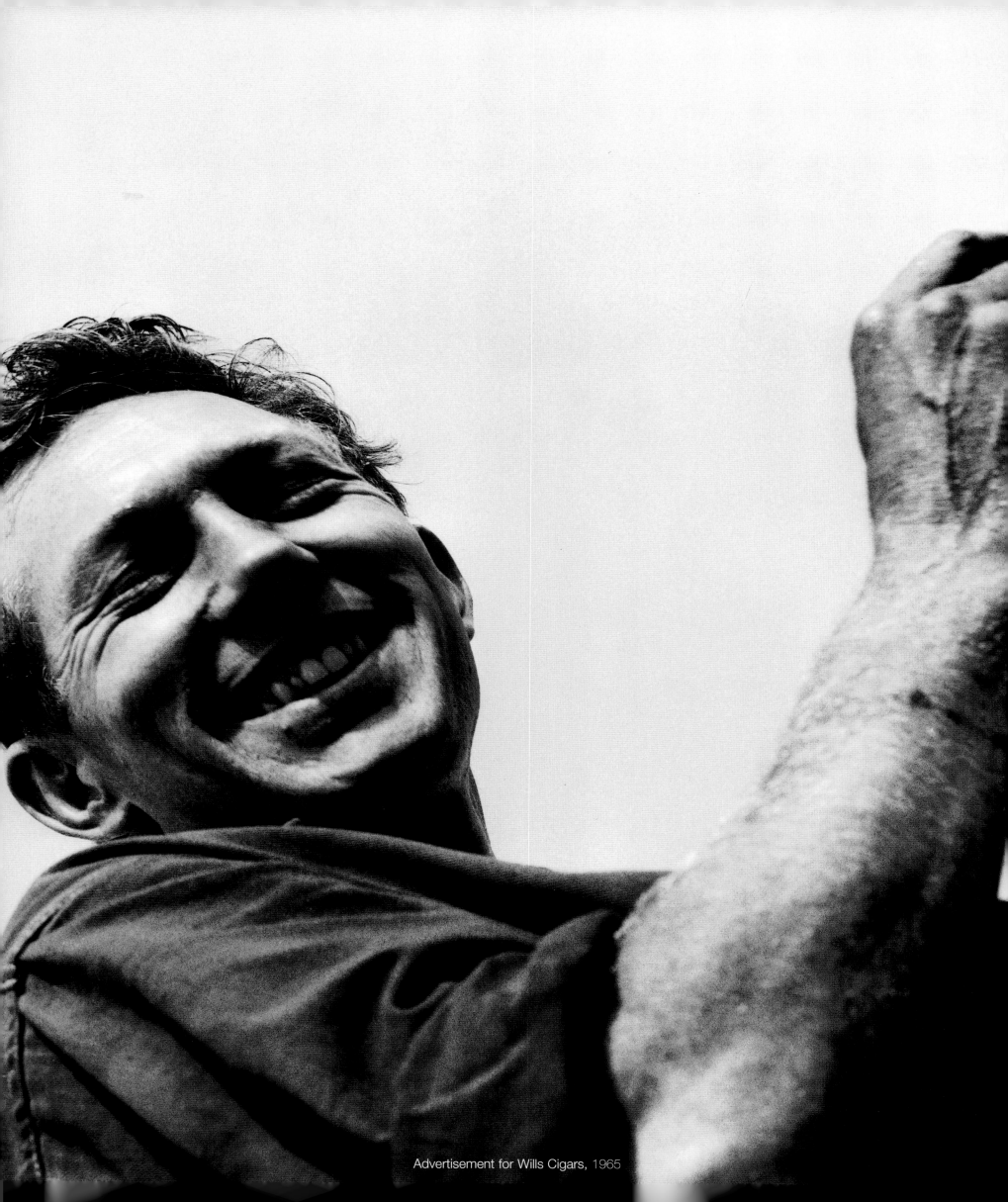

Advertisement for Wills Cigars, 1965

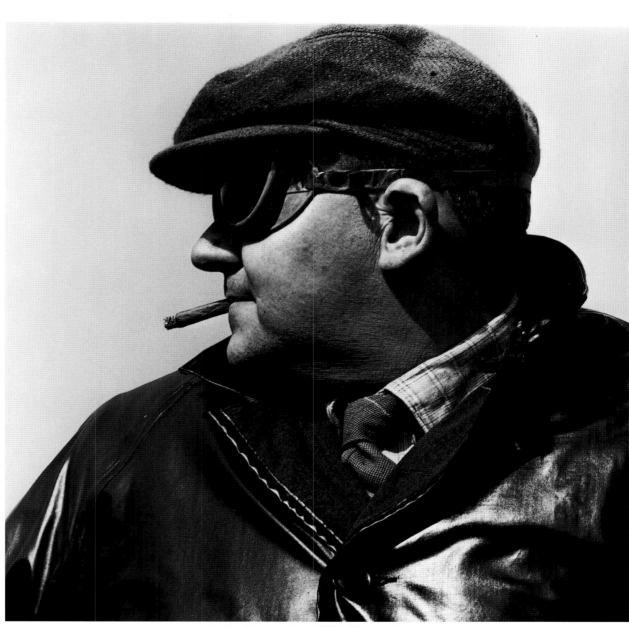

Advertisement for Wills Cigars, 1965

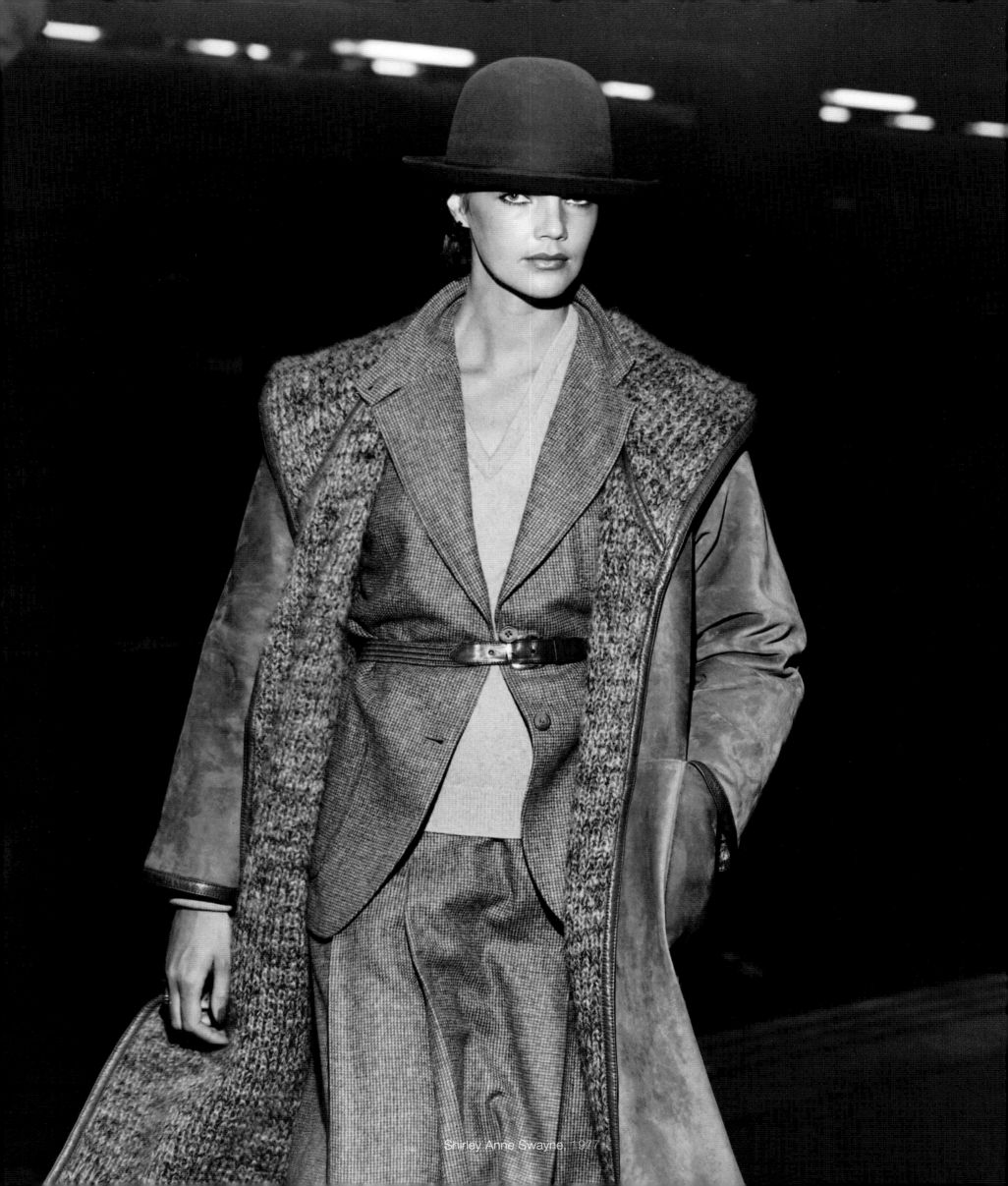

Shirley Anne Swayne, 1977

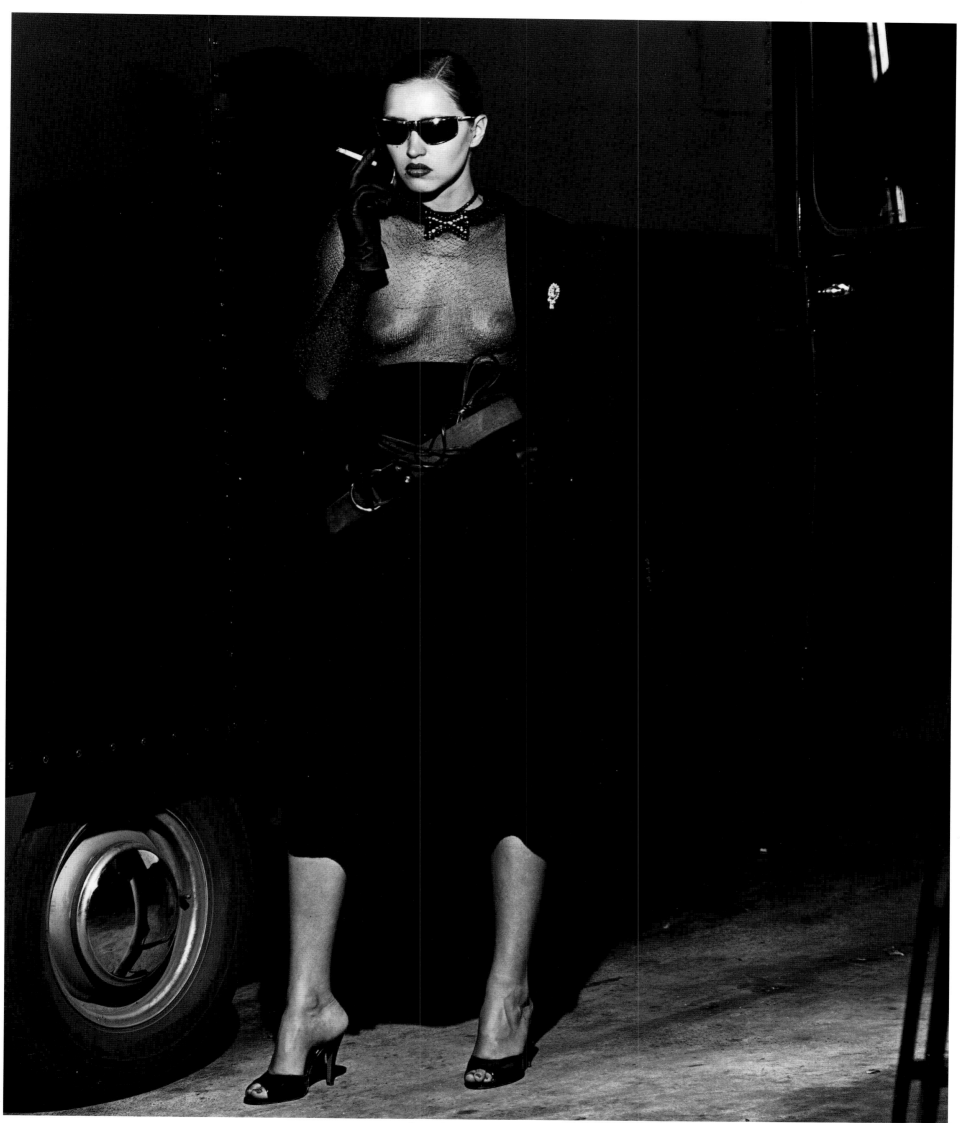

Josephine Florent, 1978

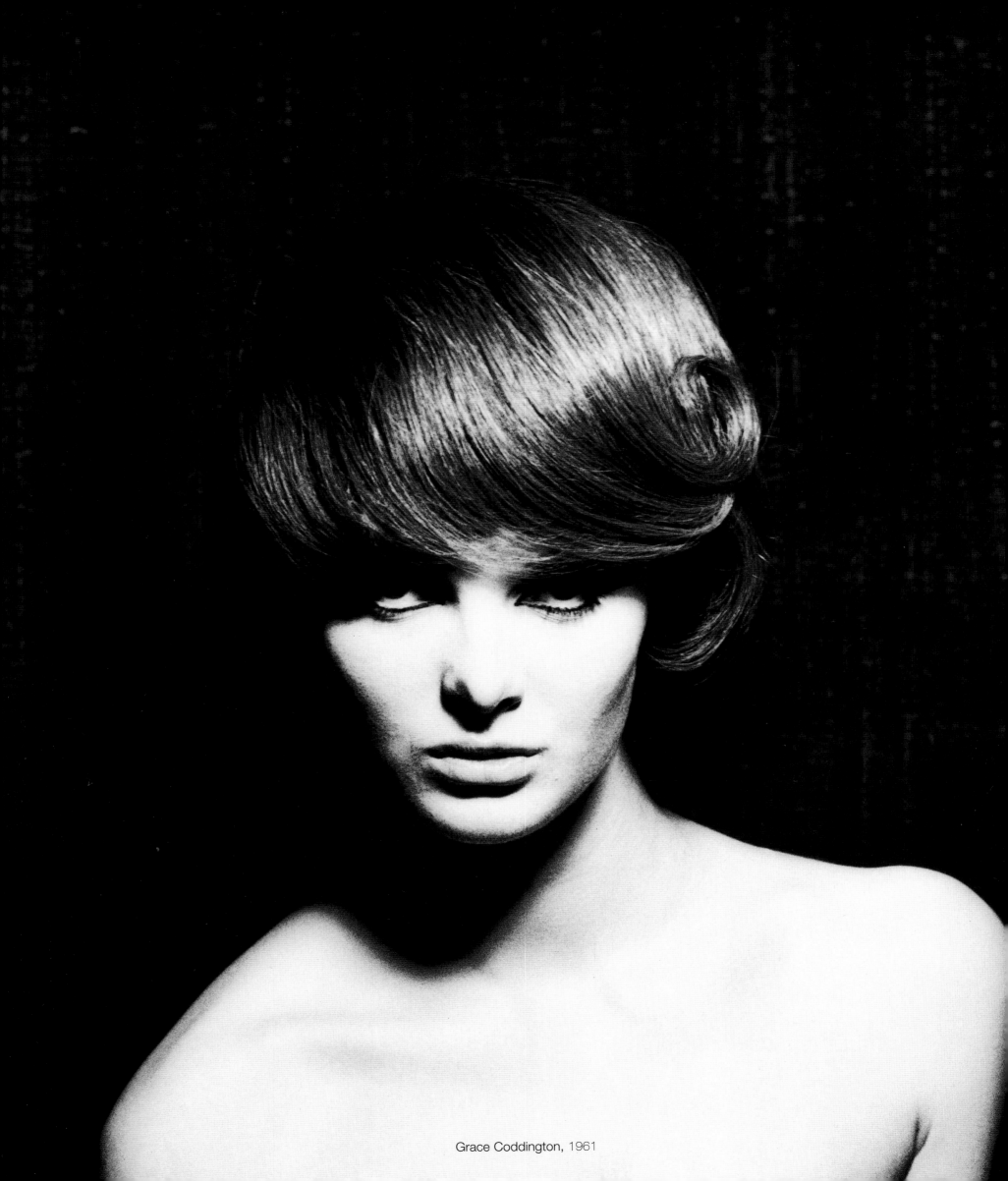

Grace Coddington, 1961

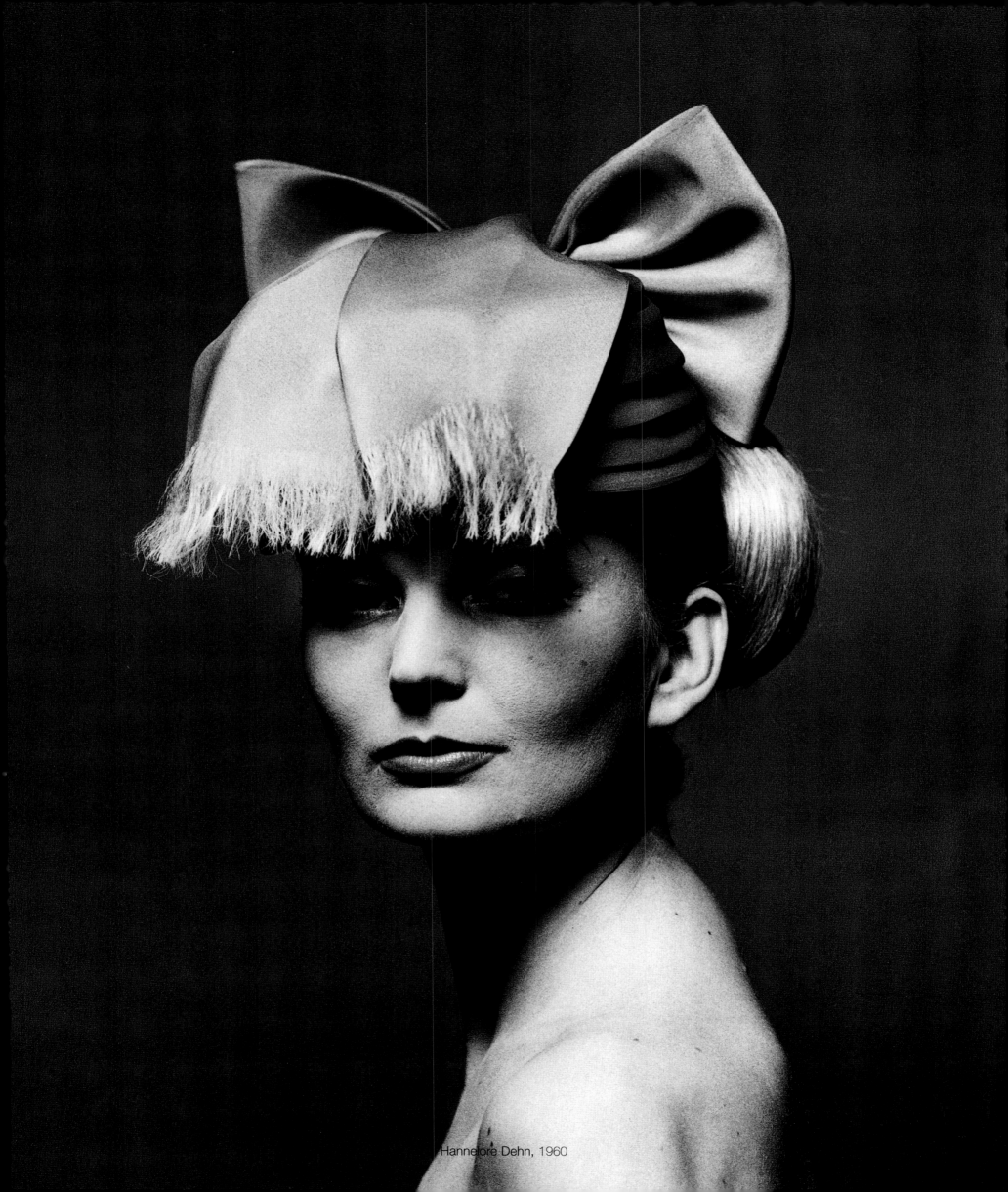

Hannelore Dehn, 1960

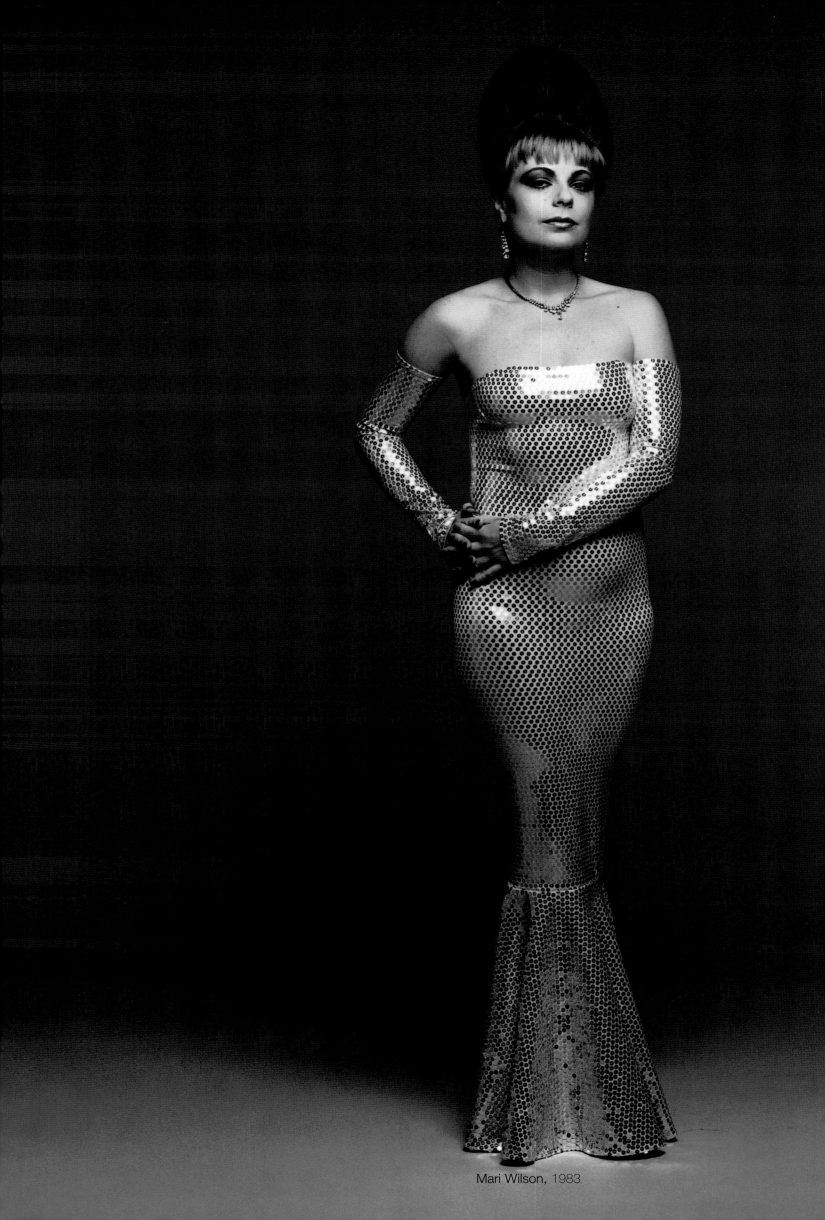

Mari Wilson, 1983

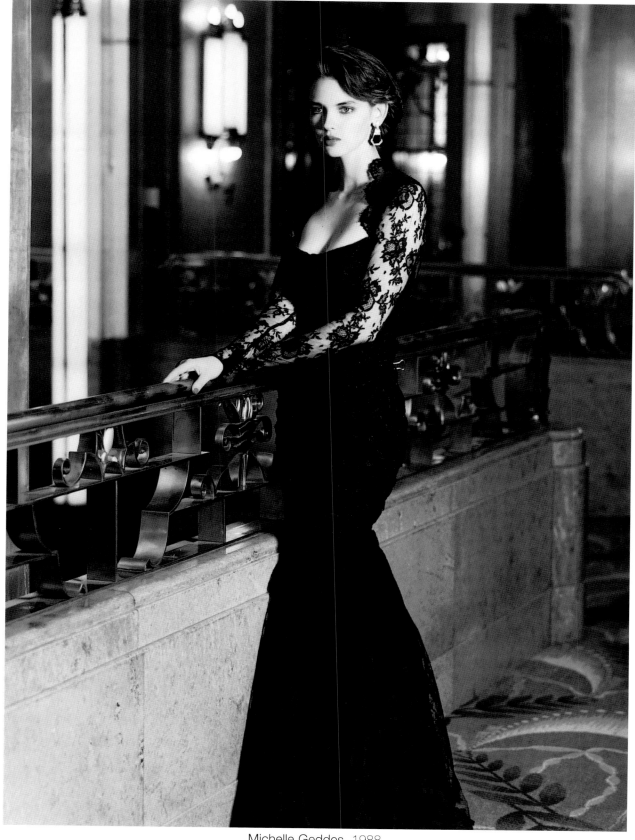

Michelle Geddes, 1988

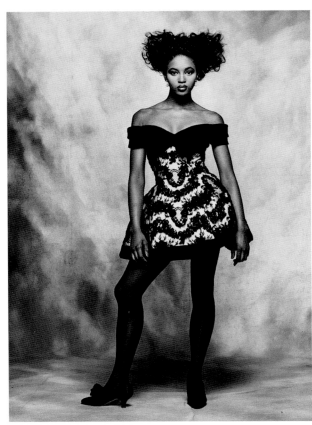

Naomi Campbell, 1988

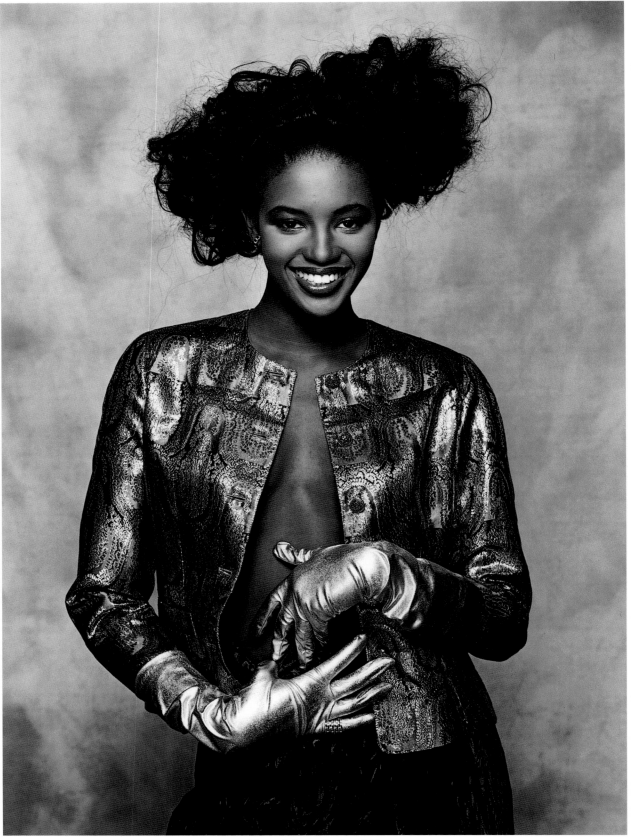

Naomi Campbell, 1988

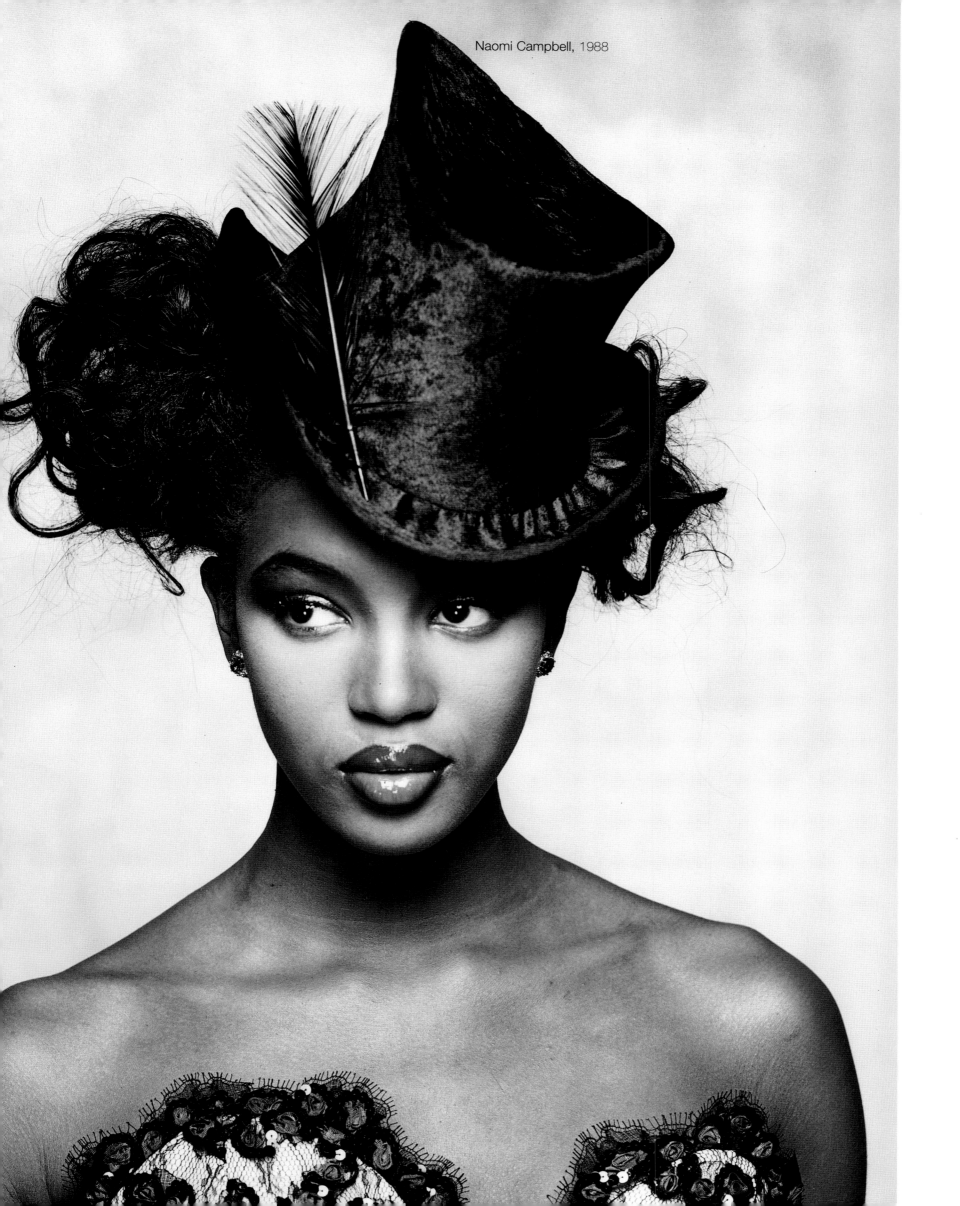

Naomi Campbell, 1988

Advertisement for *Bazaar*, 1962

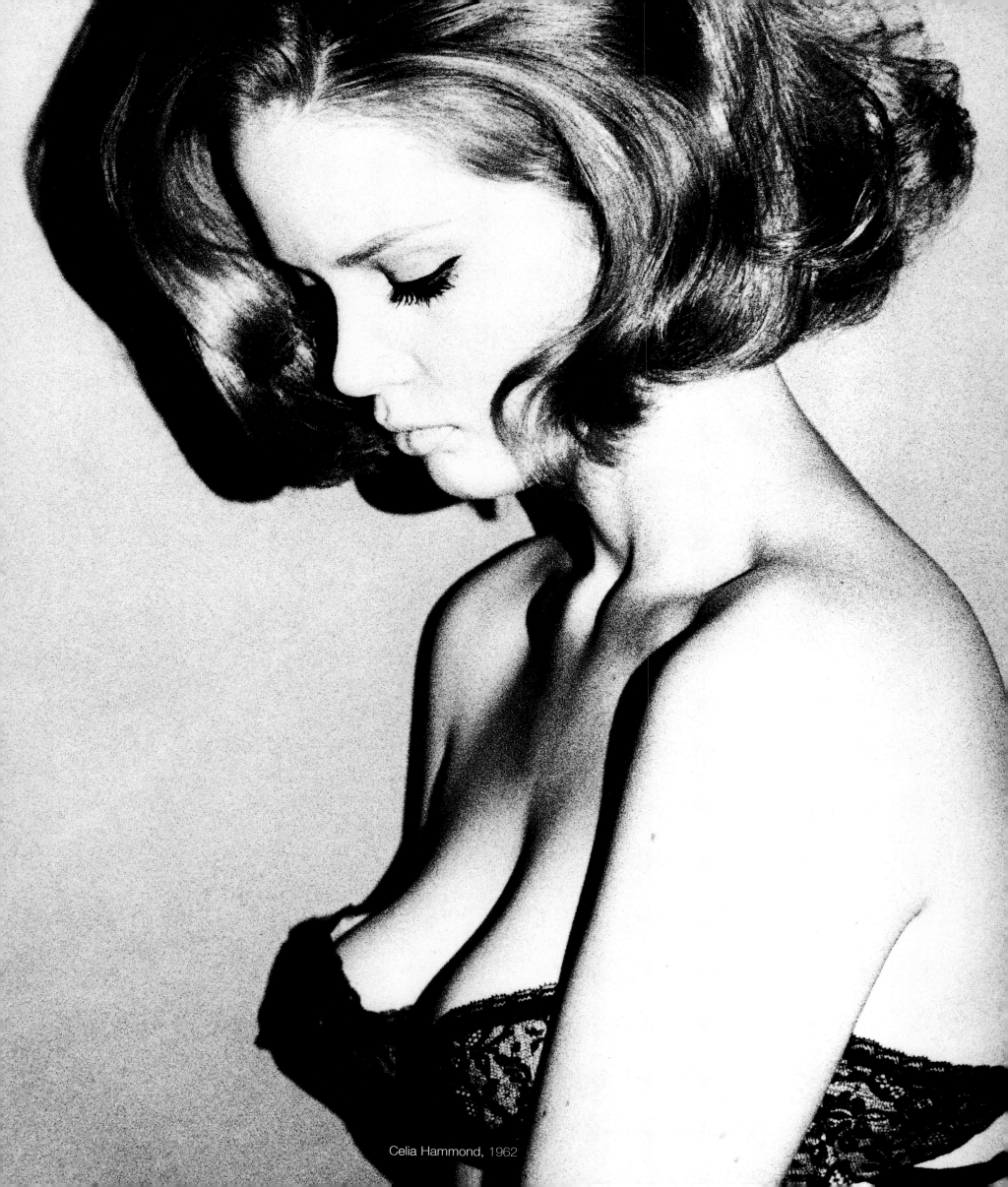

Celia Hammond, 1962

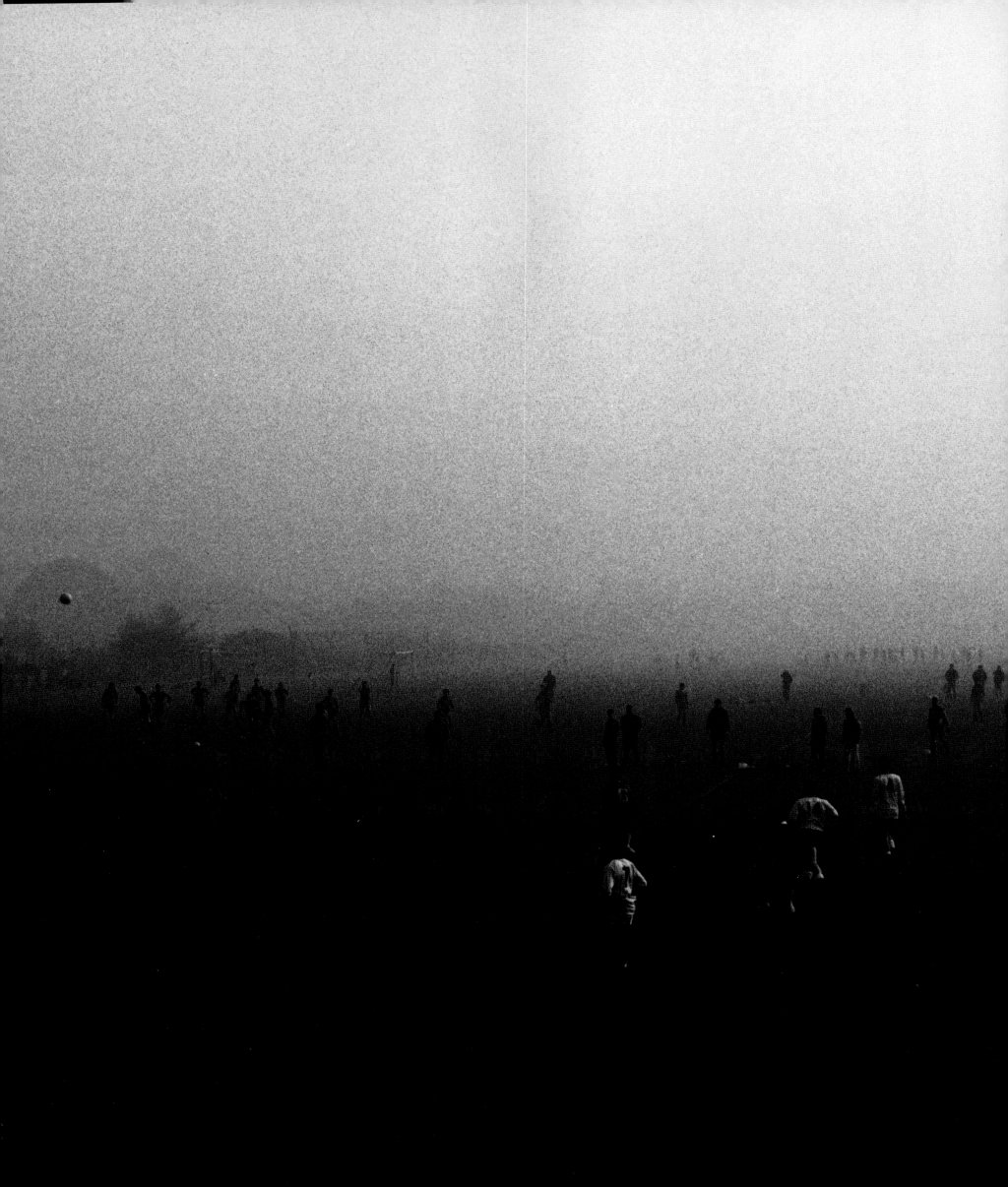

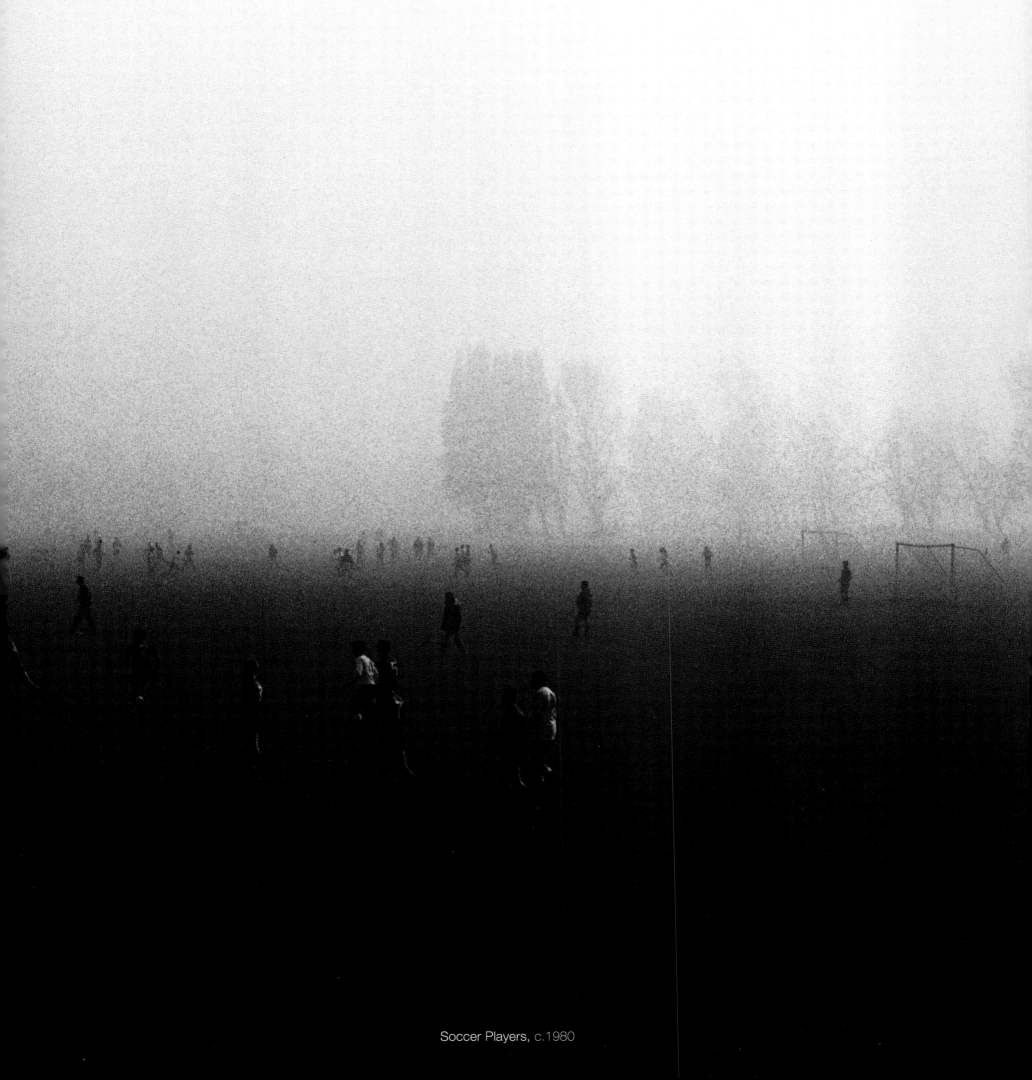

Soccer Players, c.1980

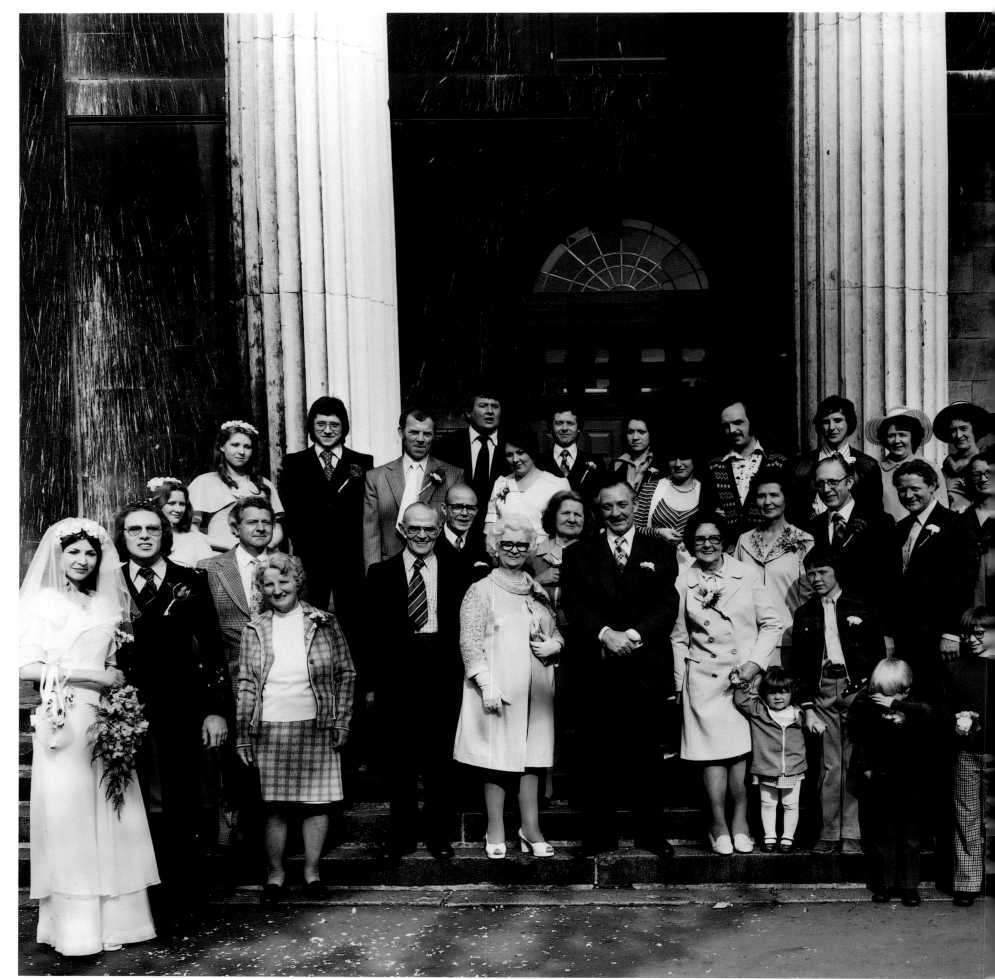

Susan Caselle's wedding, 1975

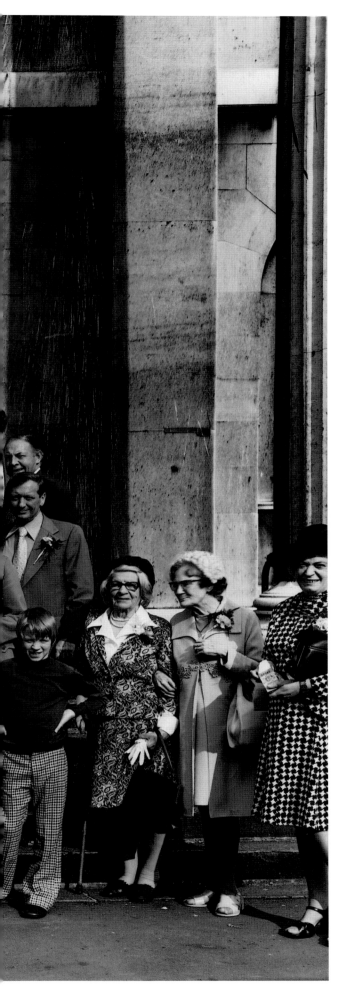

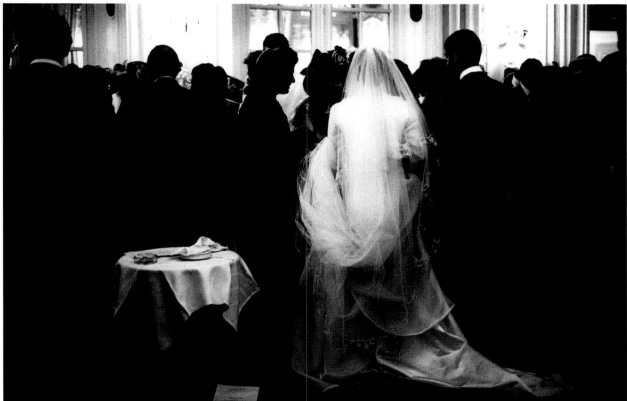

Laura Tikoo's Wedding, 1994

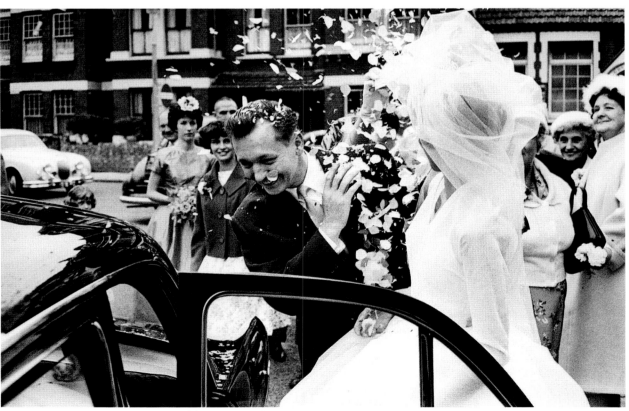

Margaret and Bill Donovan's wedding, 1960

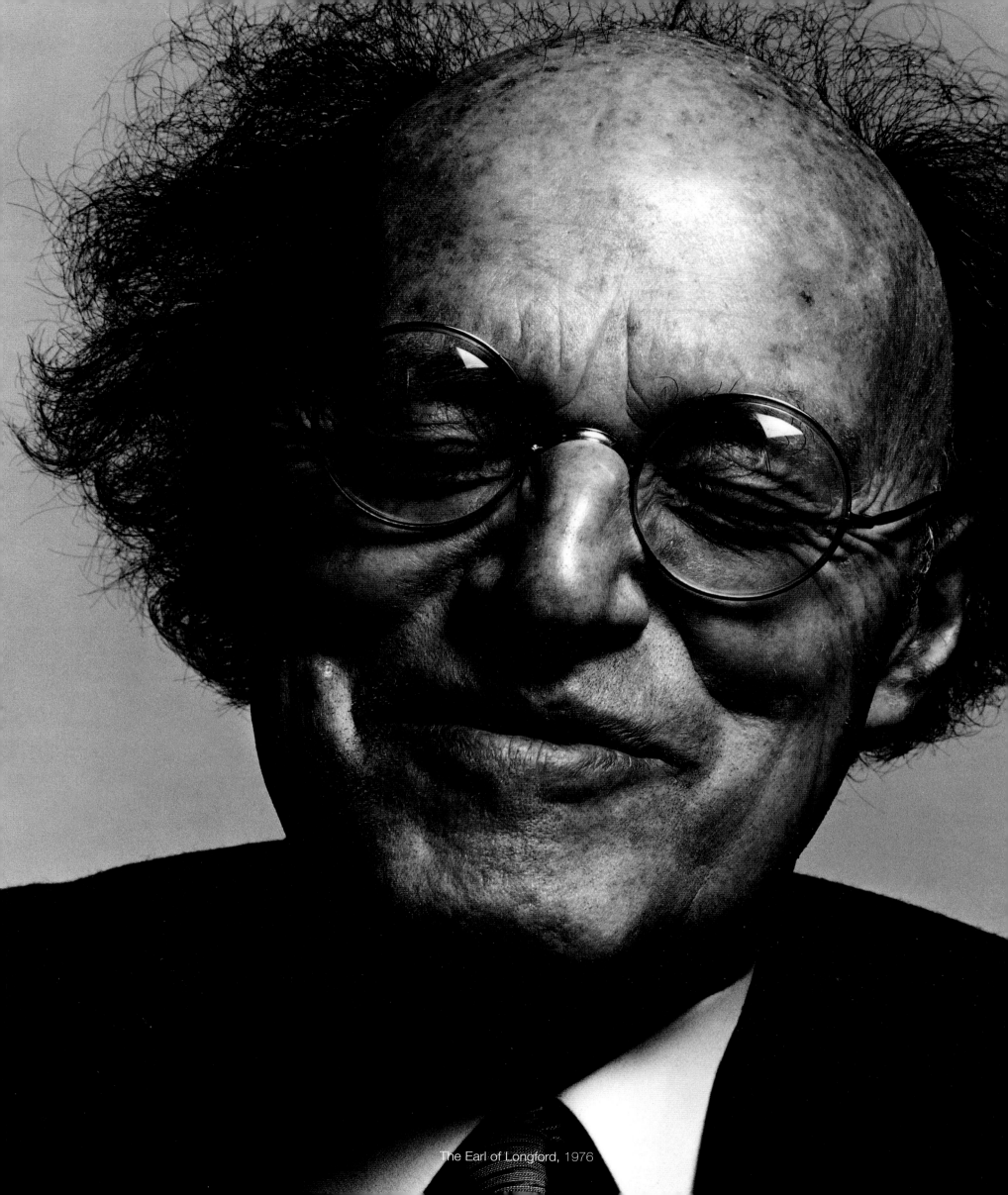

The Earl of Longford, 1976

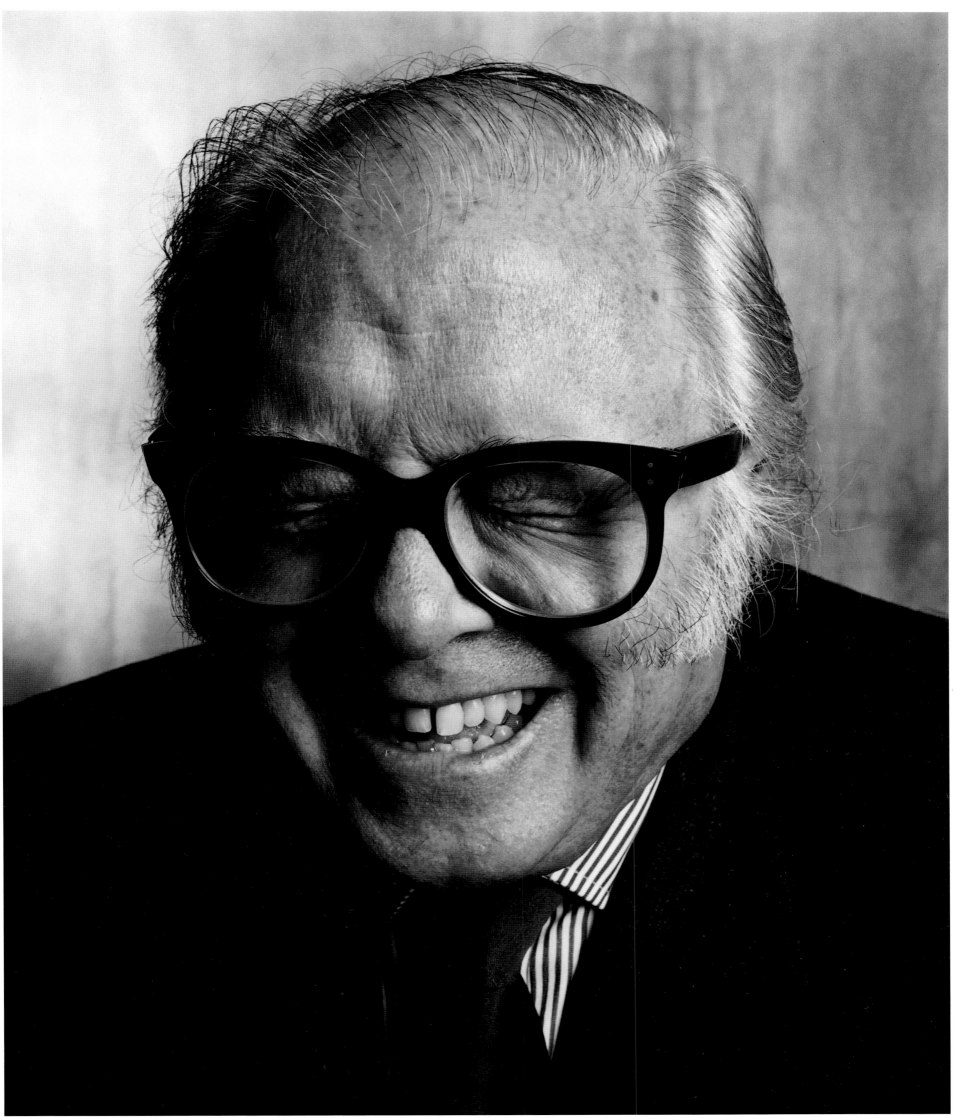

Richard Attenborough, 1987

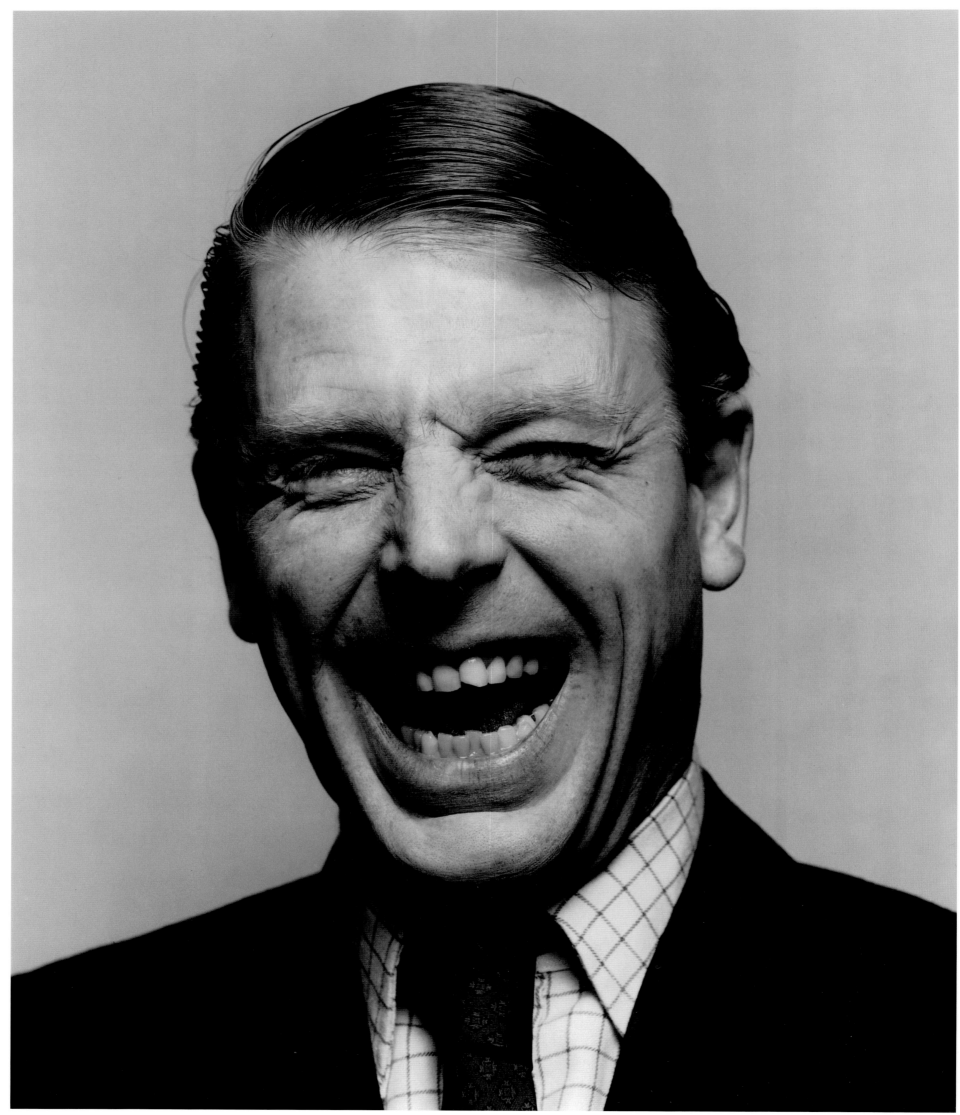

Edward Fox, 1979

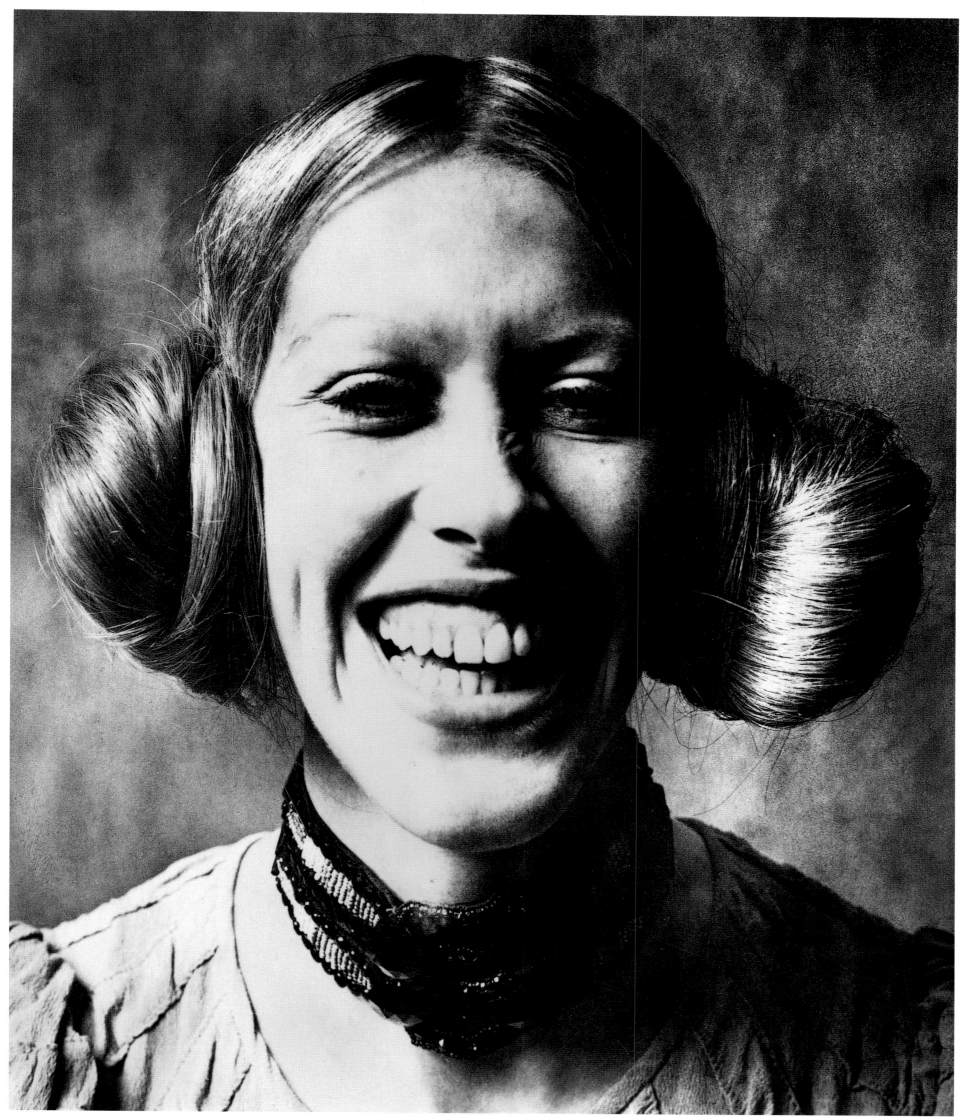

Jenny Gabor, *1970*

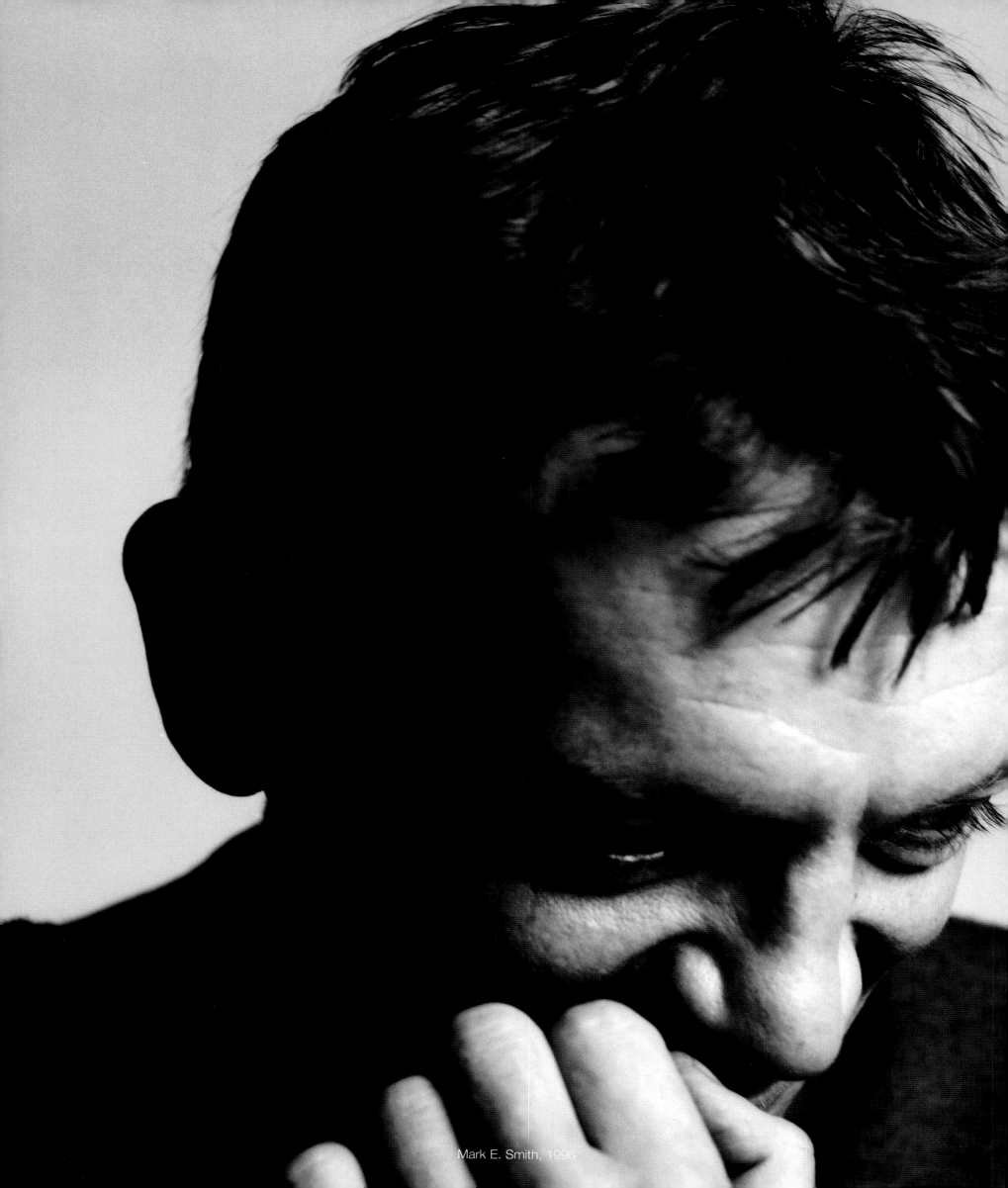

Mark E. Smith, 1996

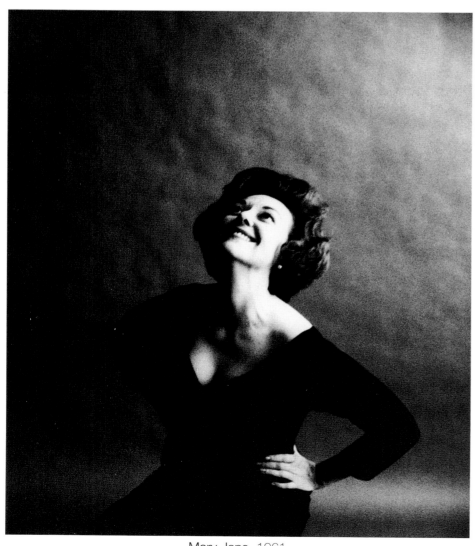

Mary Jane, 1961

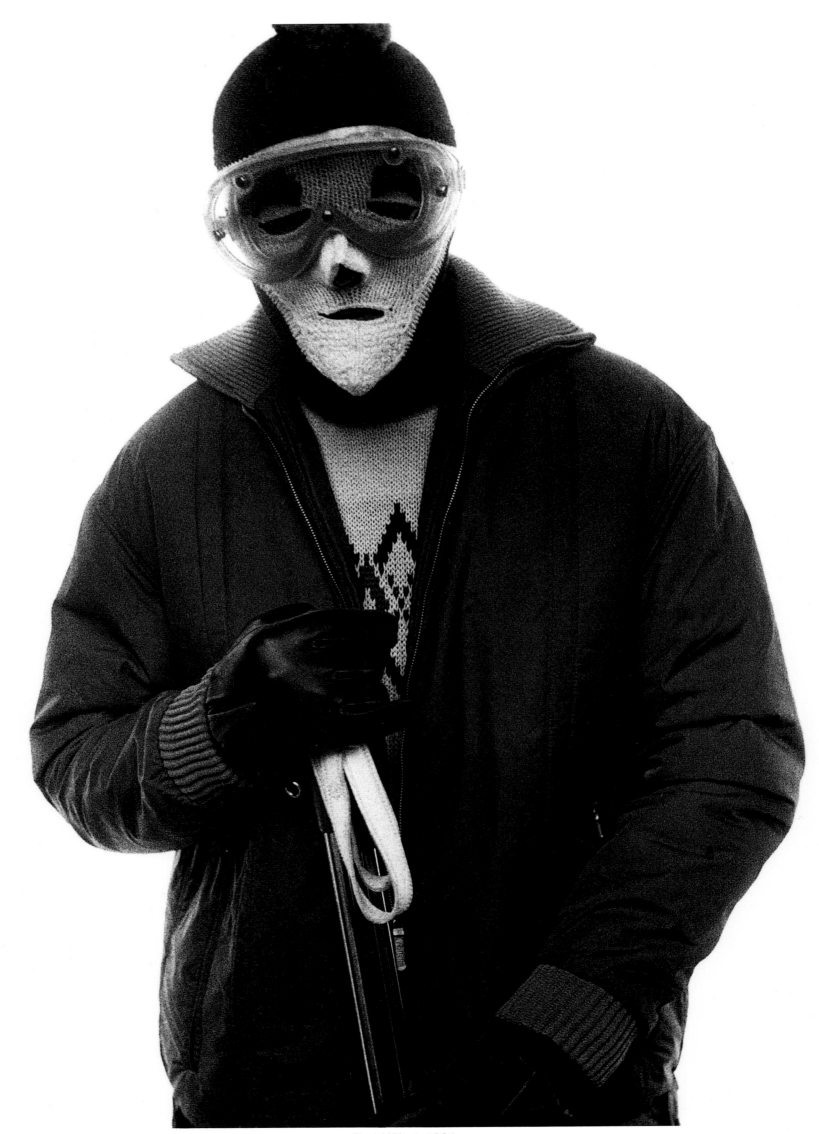

David West, 1964

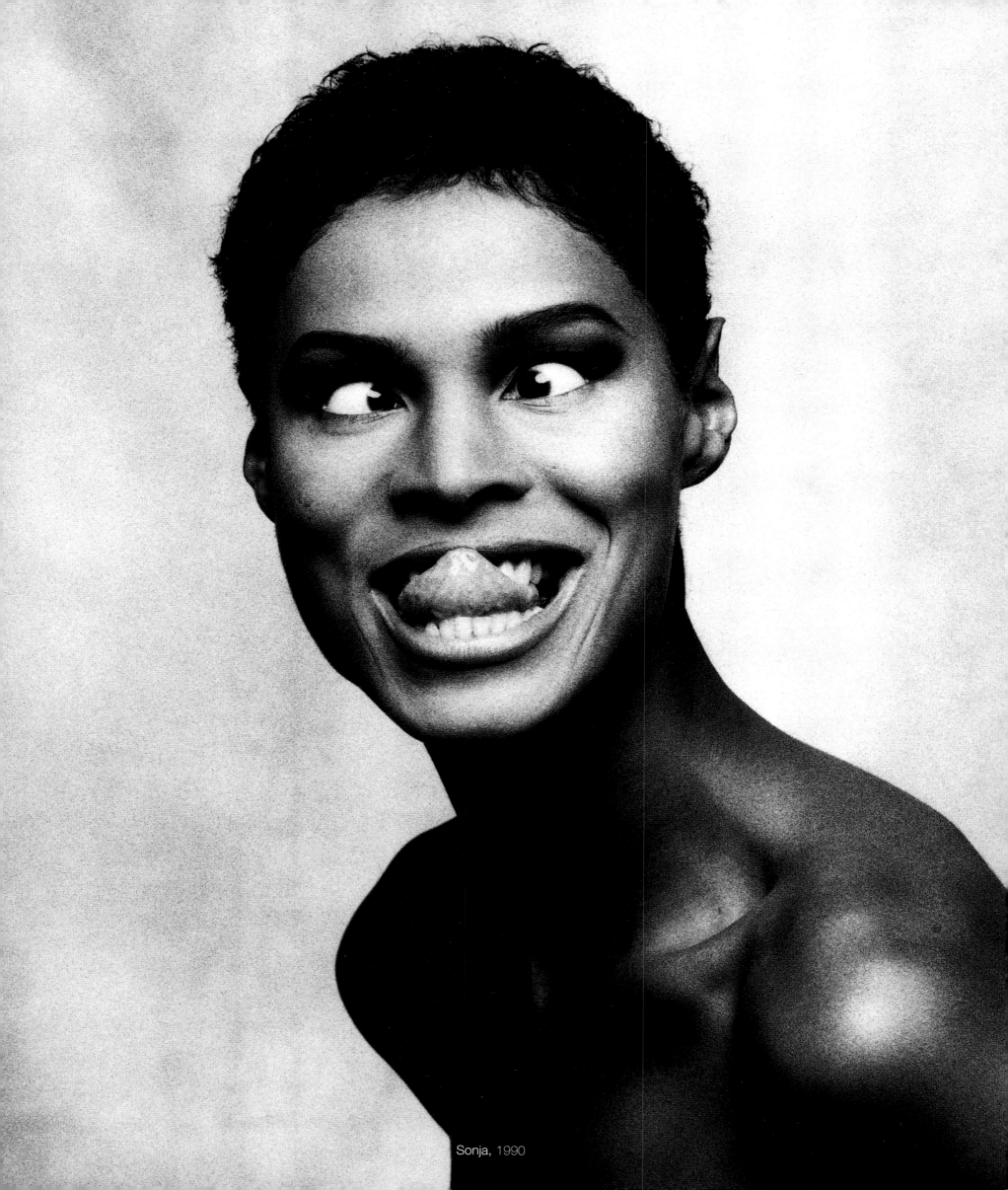

Sonja, 1990

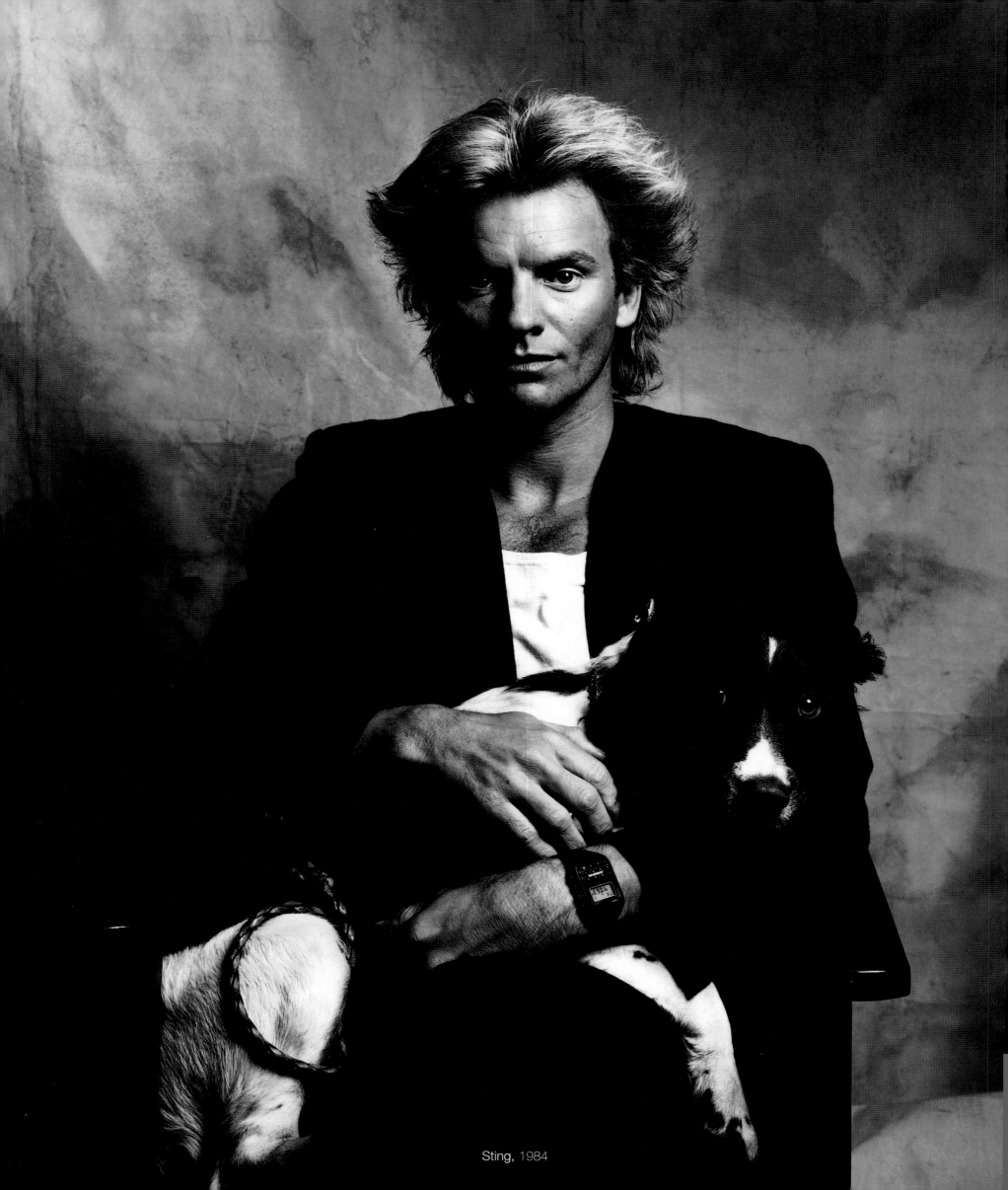

Sting, 1984

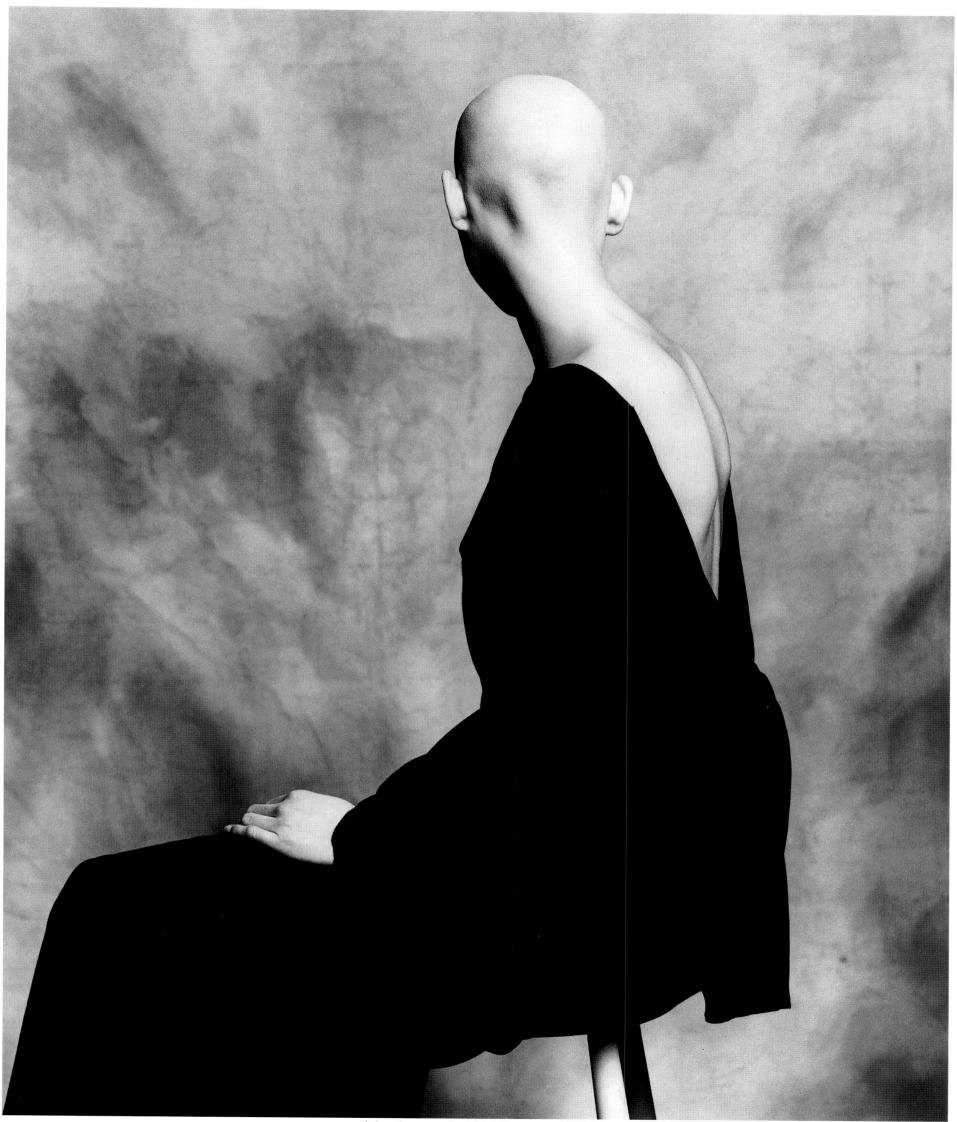

Advertisement for Vidal Sassoon, 1985

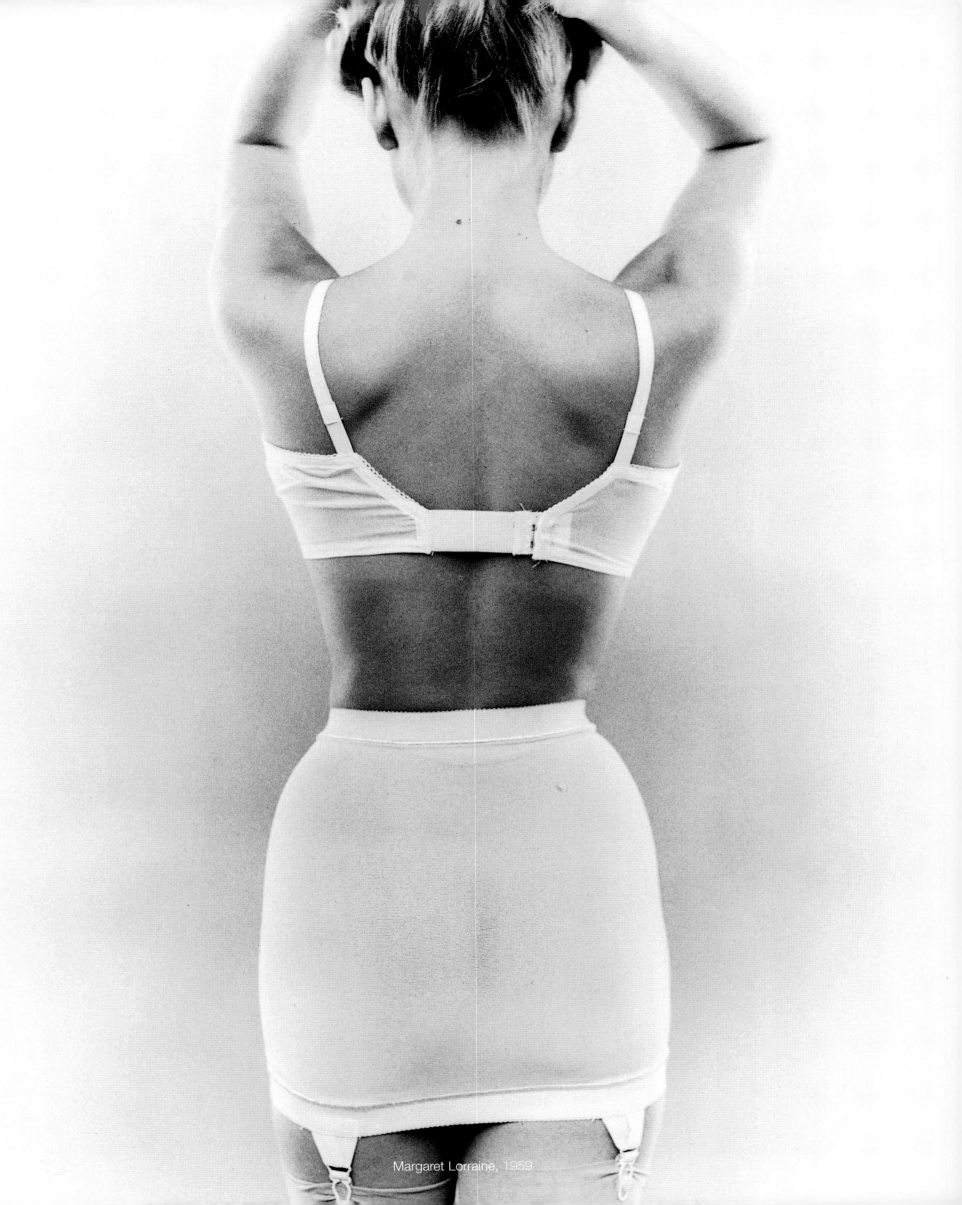

Margaret Lorraine, 1959

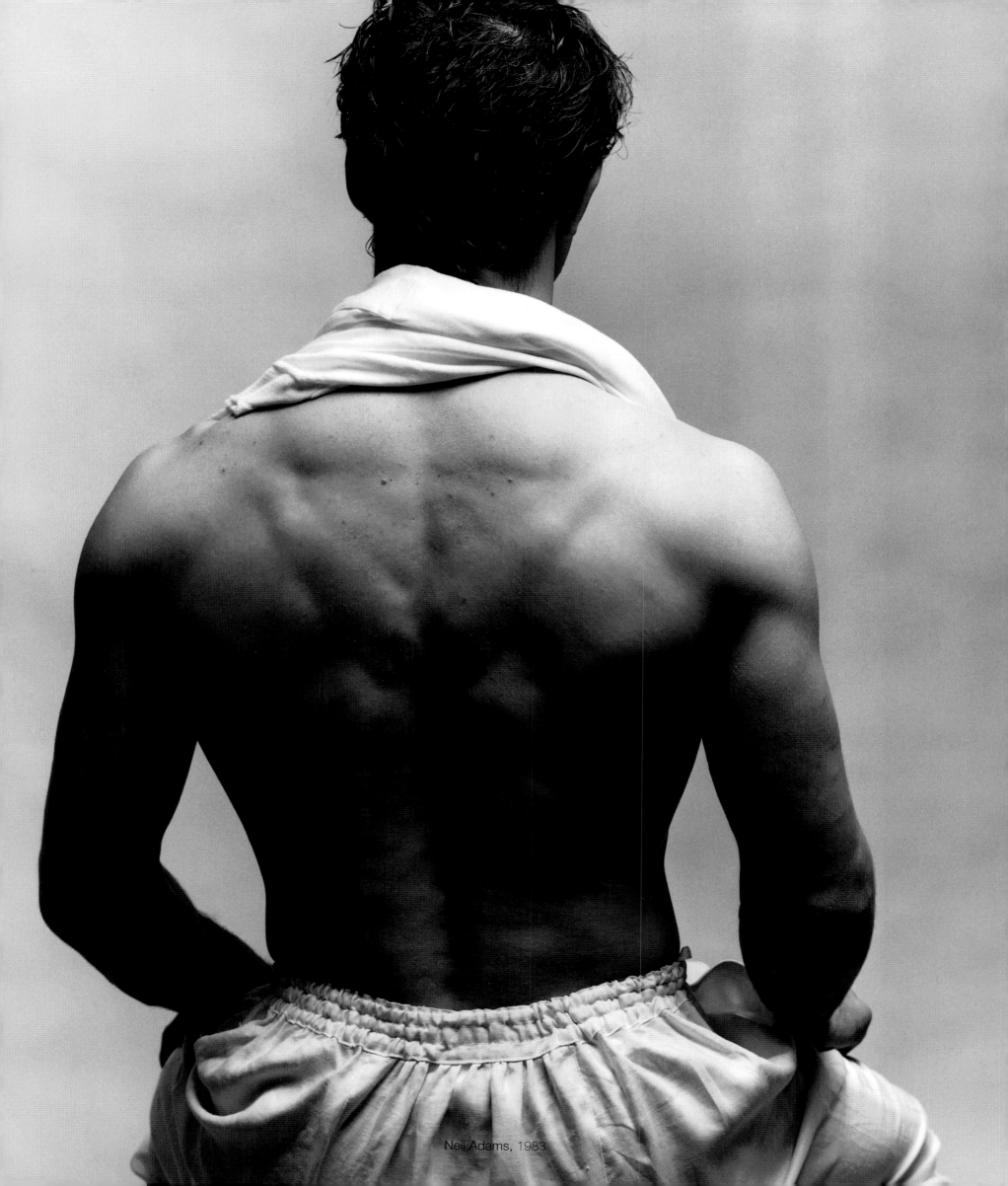

Neil Adams, 1983

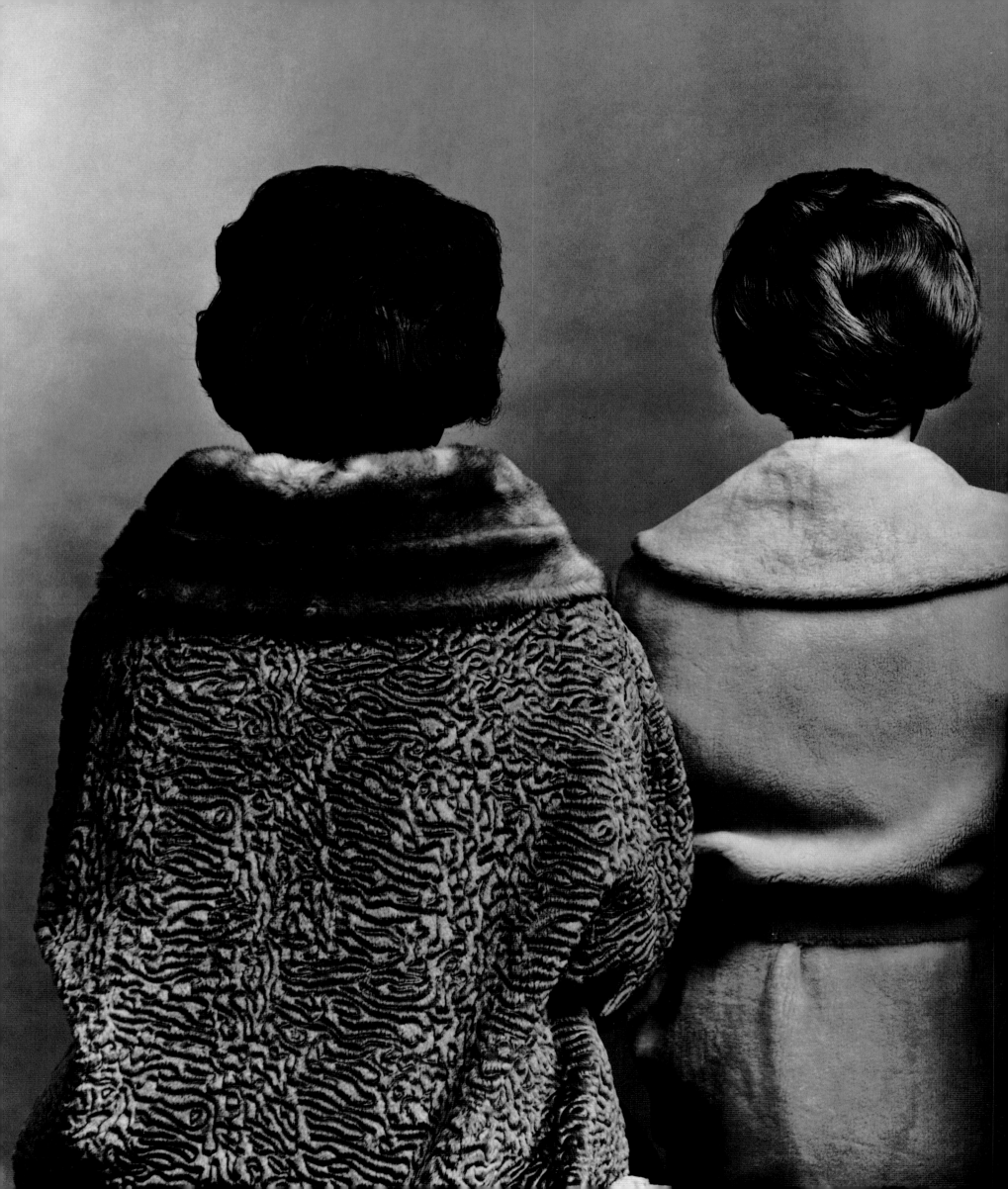

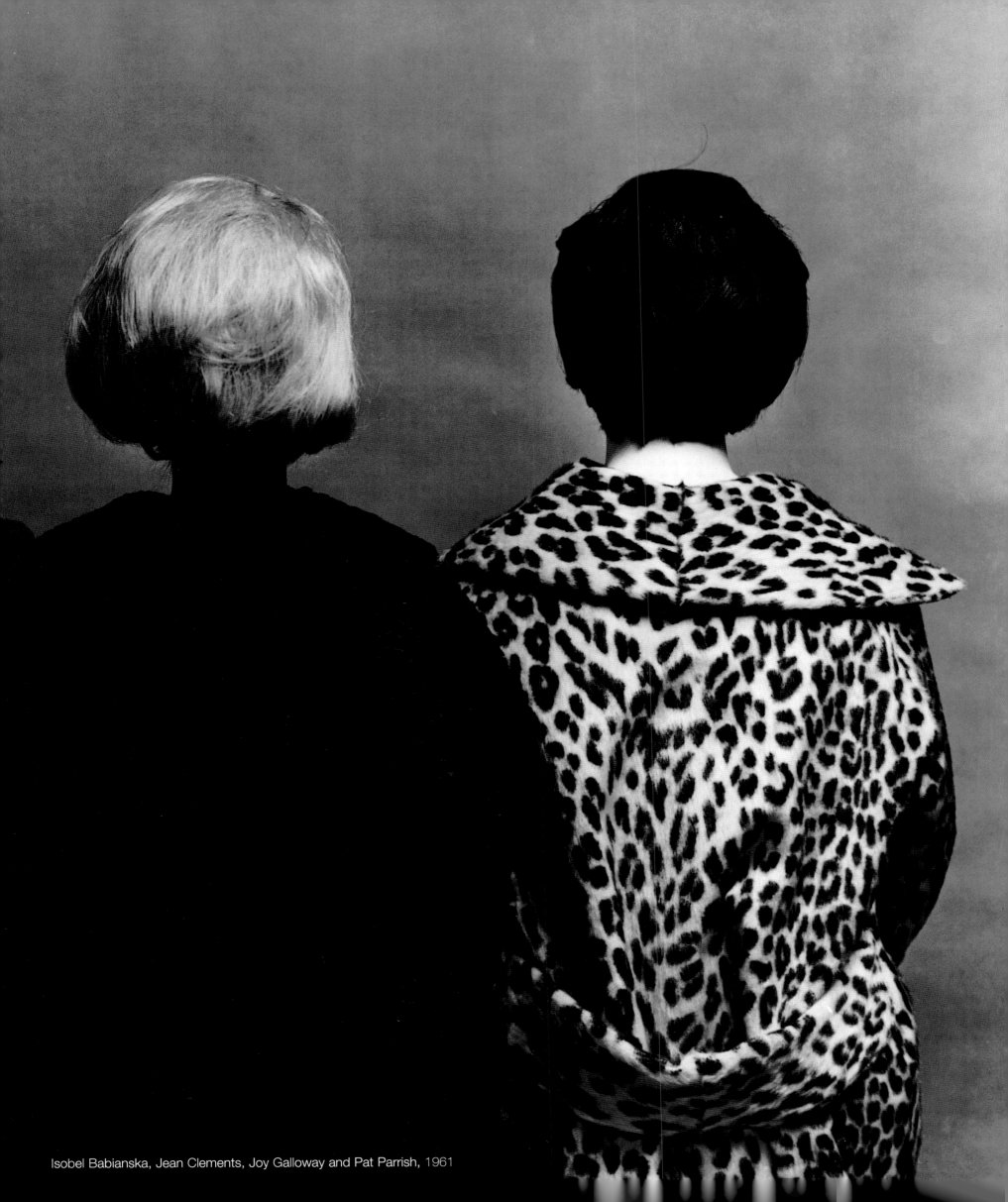

Isobel Babianska, Jean Clements, Joy Galloway and Pat Parrish, 1961

France, 1990

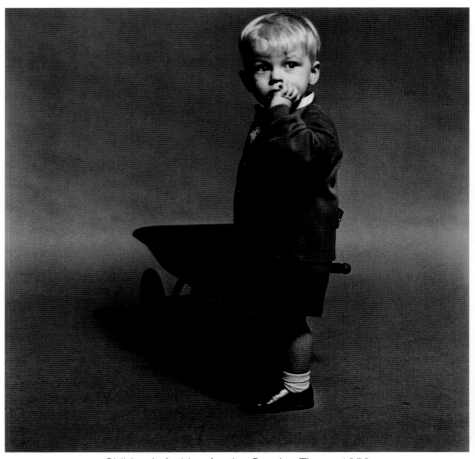

Children's fashion for the *Sunday Times*, 1959

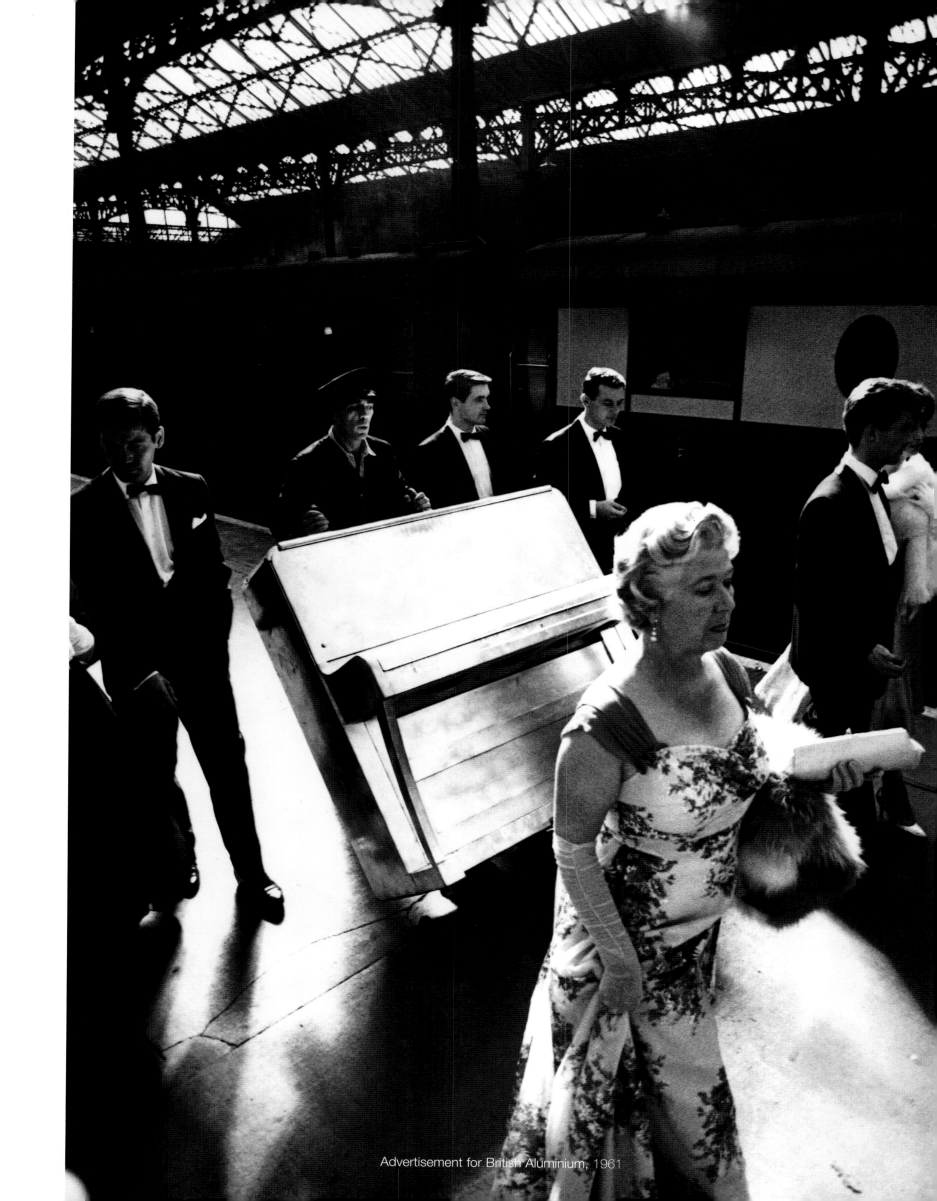

Advertisement for British Aluminium, 1961

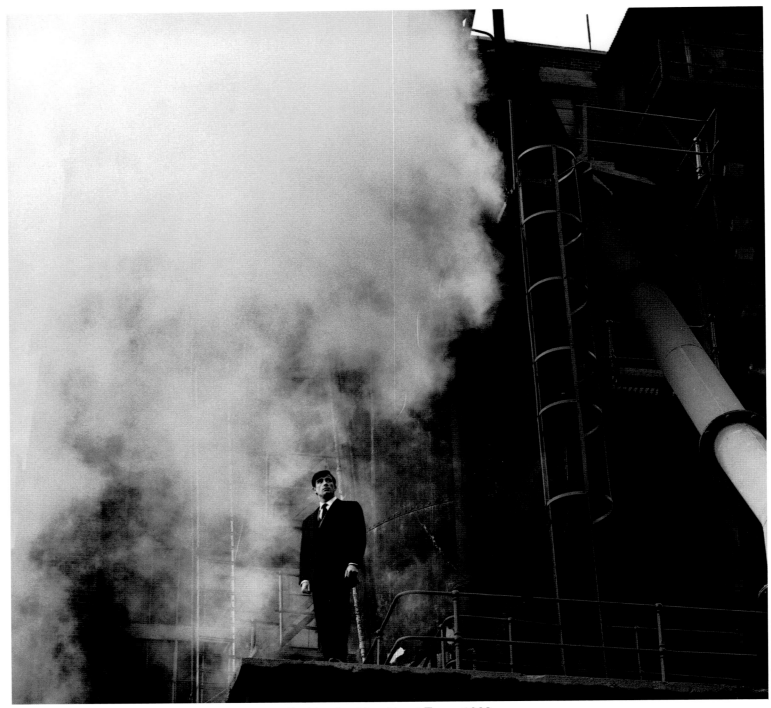

Fashion for *Man About Town*, 1960

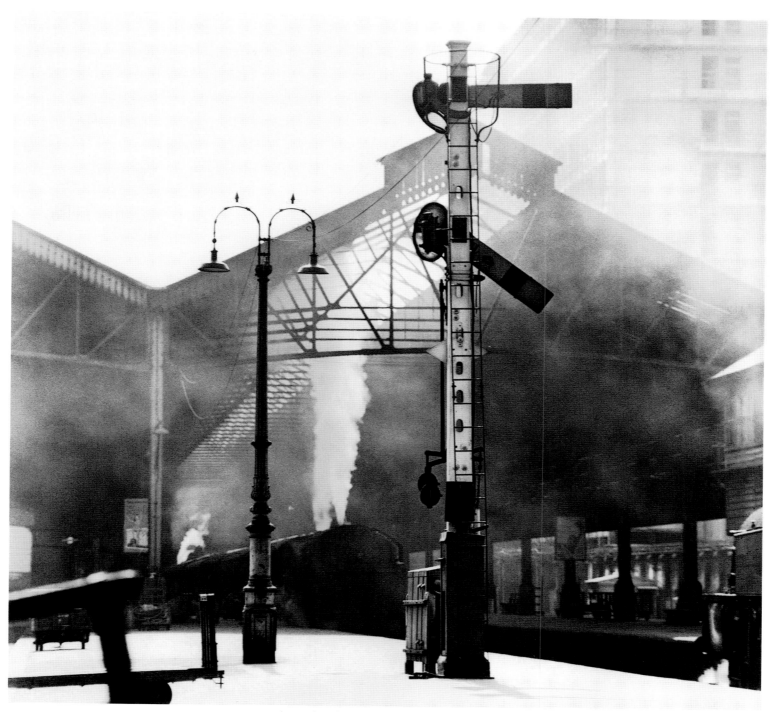

Location for advertising shoot, 1959

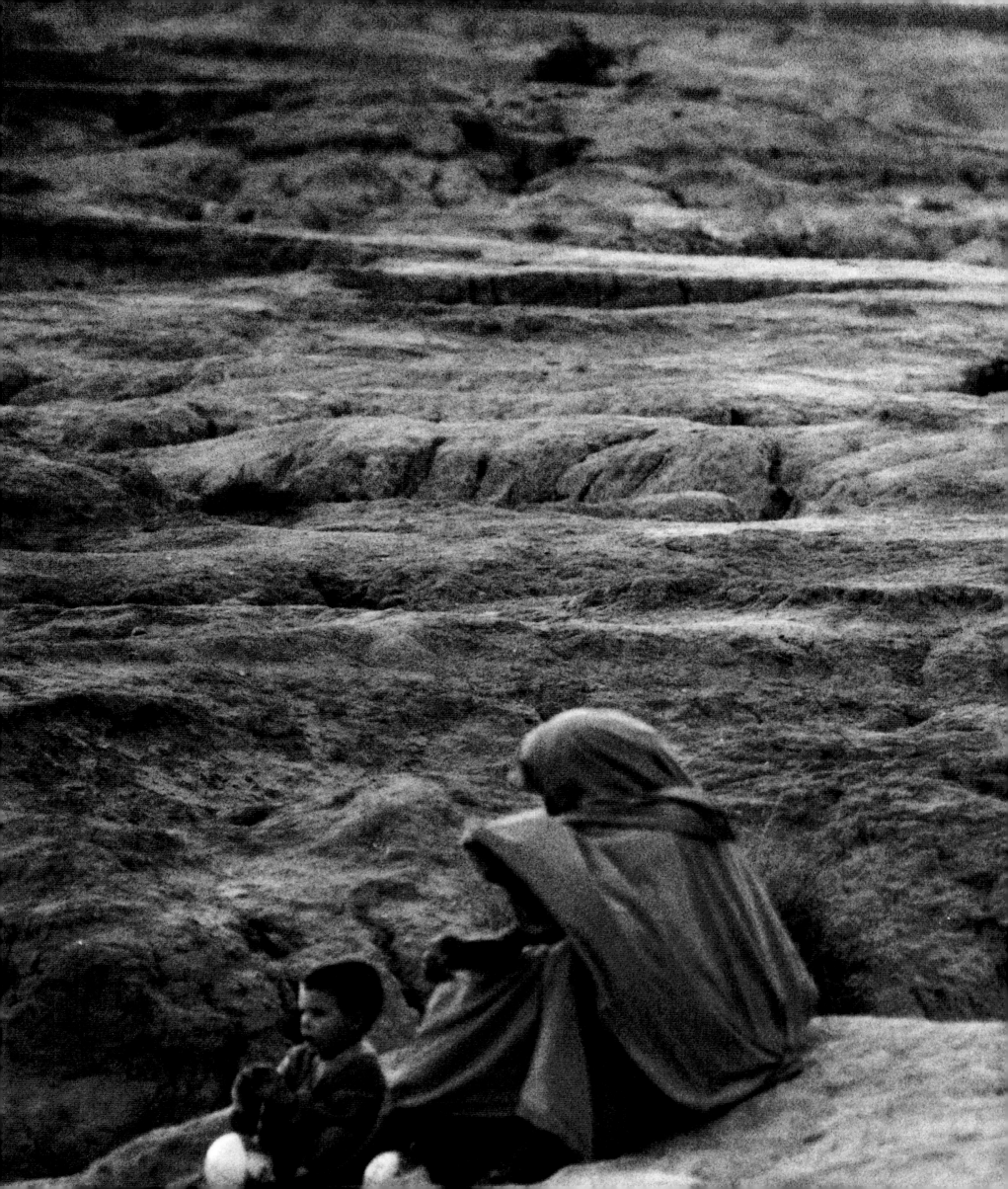

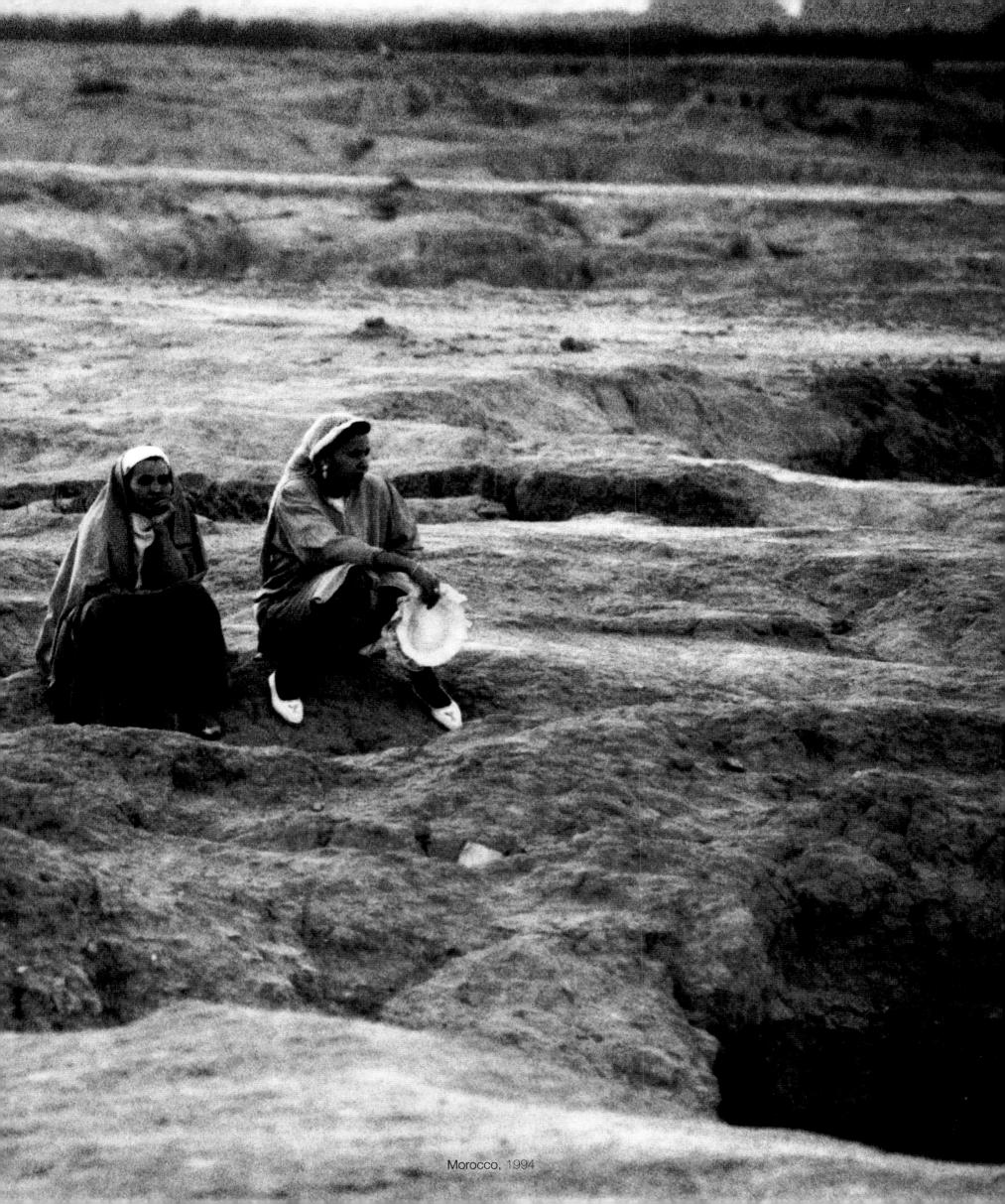

Morocco, 1994

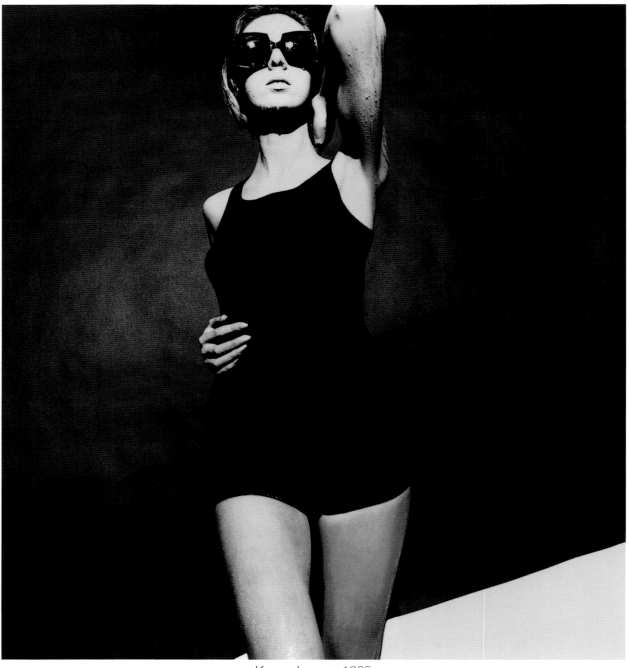
Karen Jensen, 1965

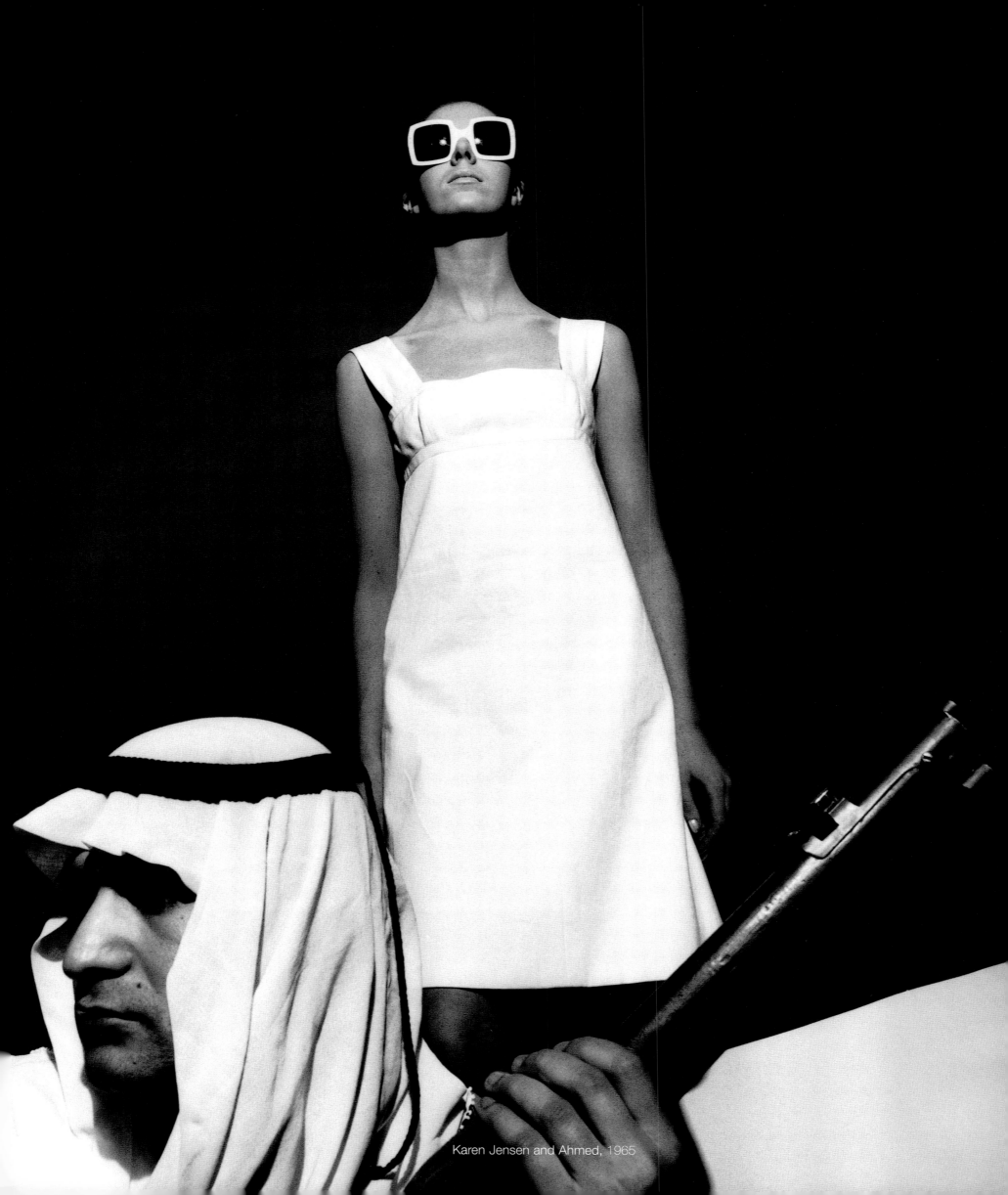

Karen Jensen and Ahmed, 1965

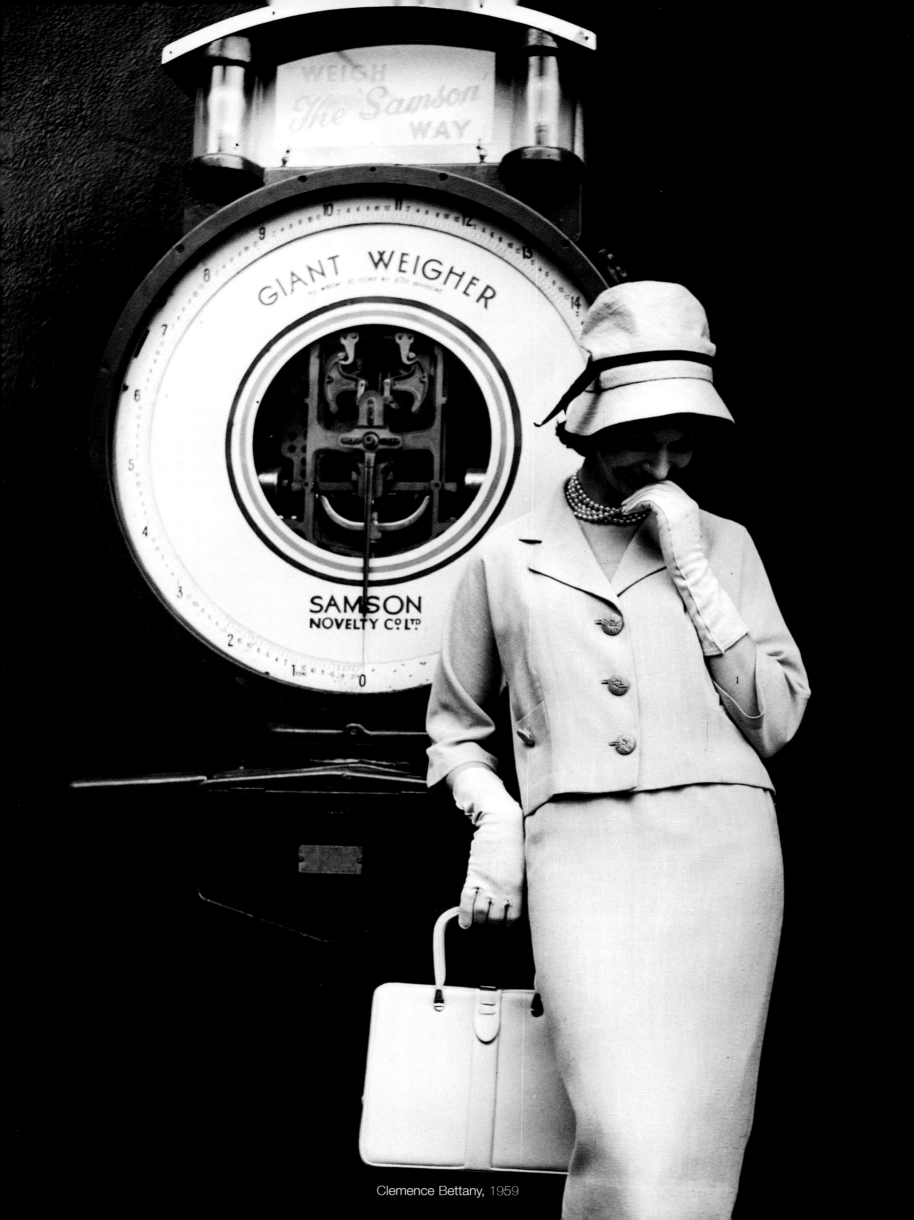

GIANT WEIGHER

WEIGH
The Samson
WAY

SAMSON
NOVELTY C° L™

Clemence Bettany, 1959

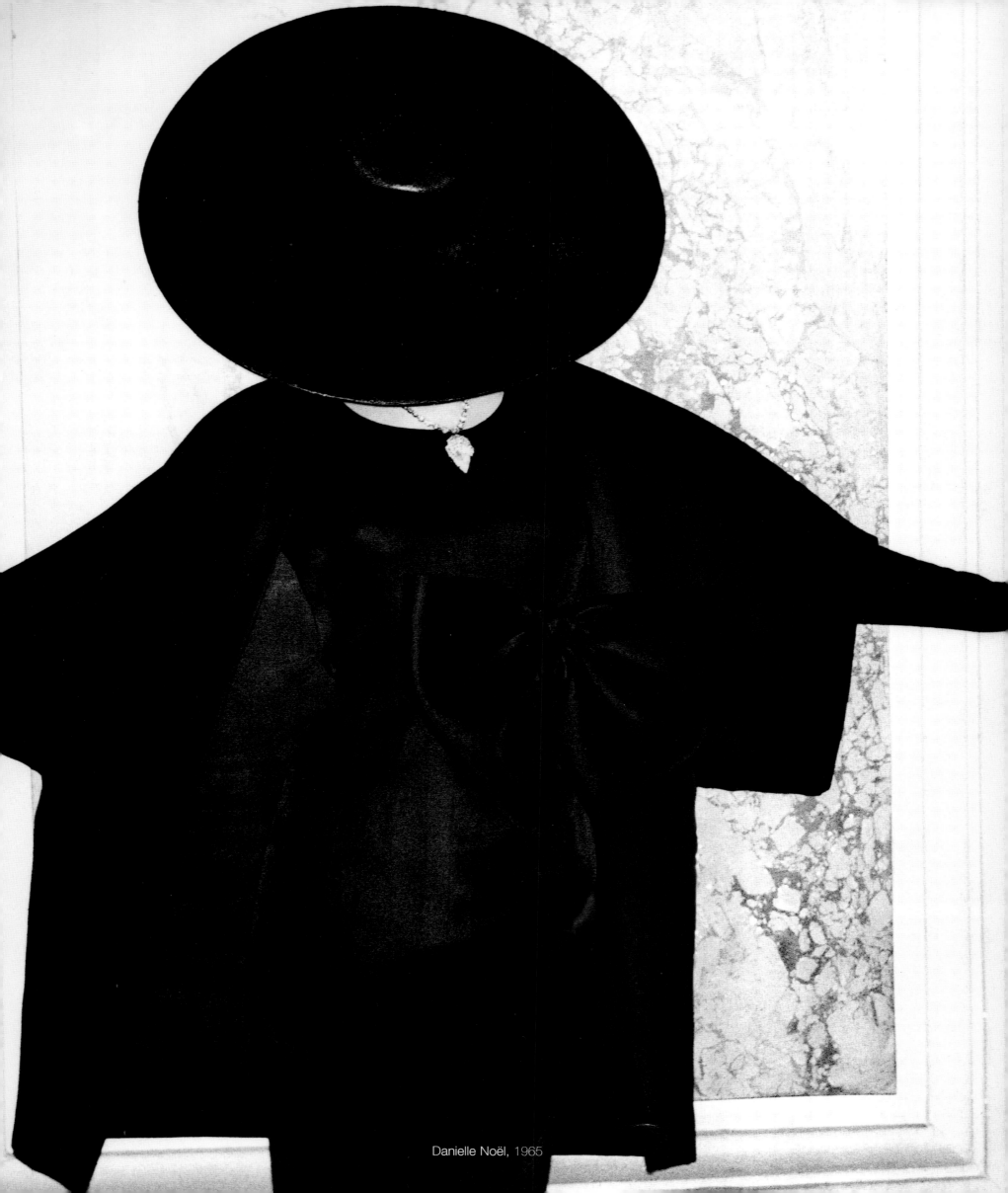

Danielle Noël, 1965

Tessa Butler, 1964

Miss Allan, *1959*

Eastbourne, 1996

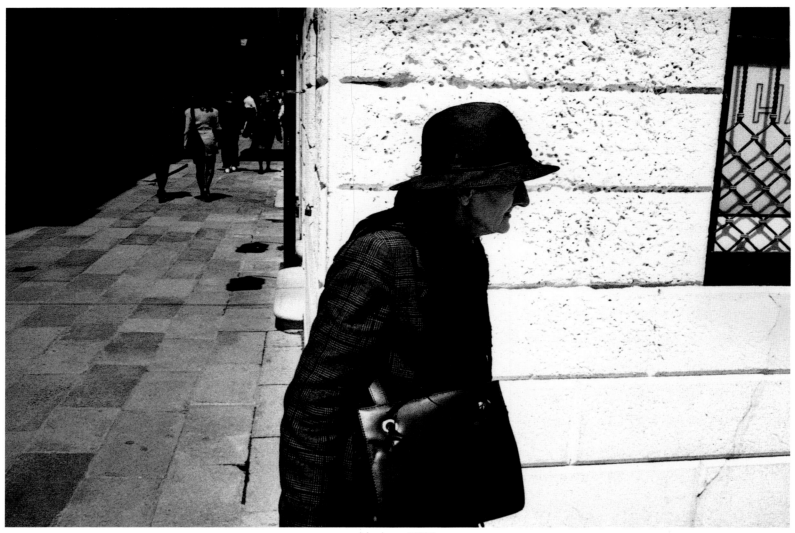

Venice. 1996

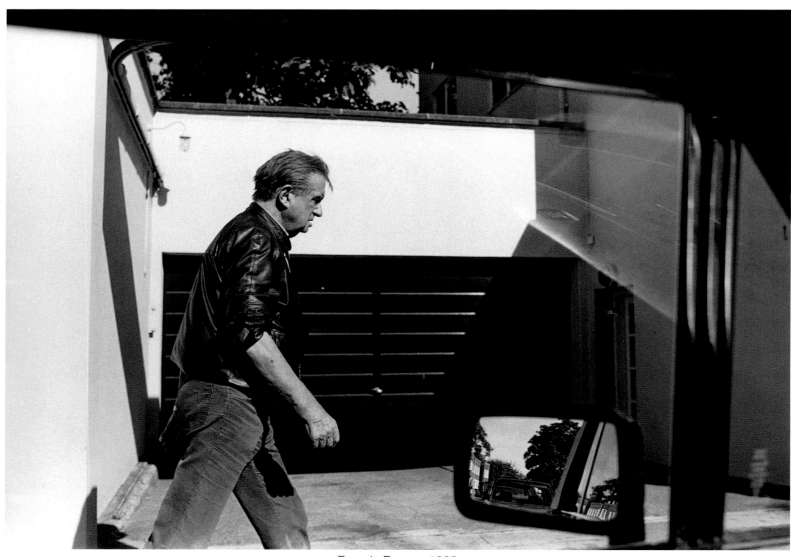

Francis Bacon, 1990

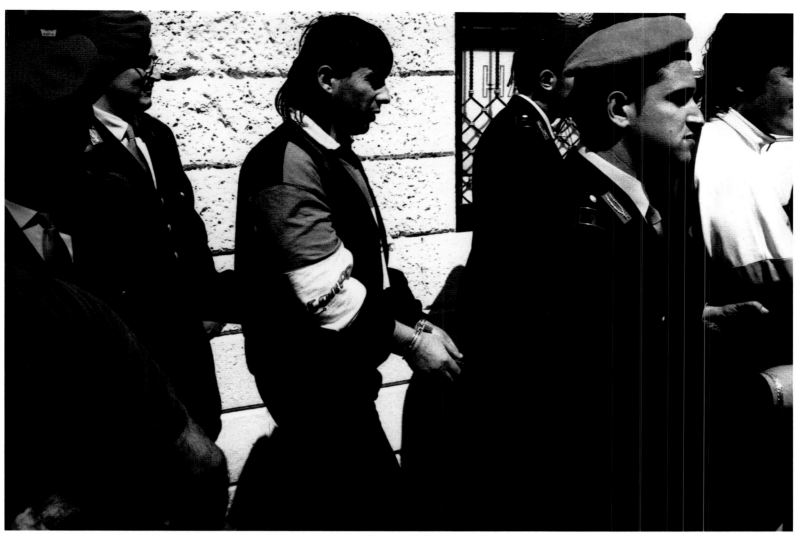

Venice. 1996

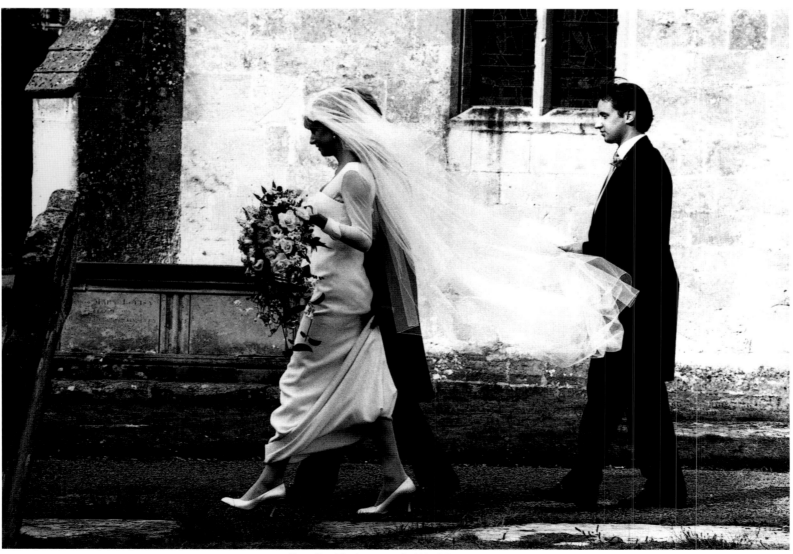

Camilla Christensen's Wedding, 1995

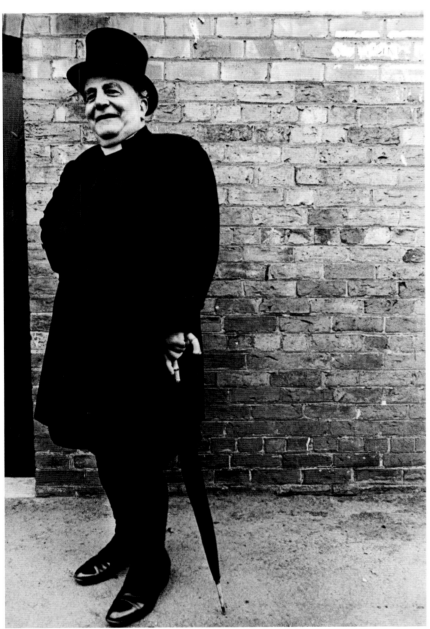

Dick Temple's wedding, 1964

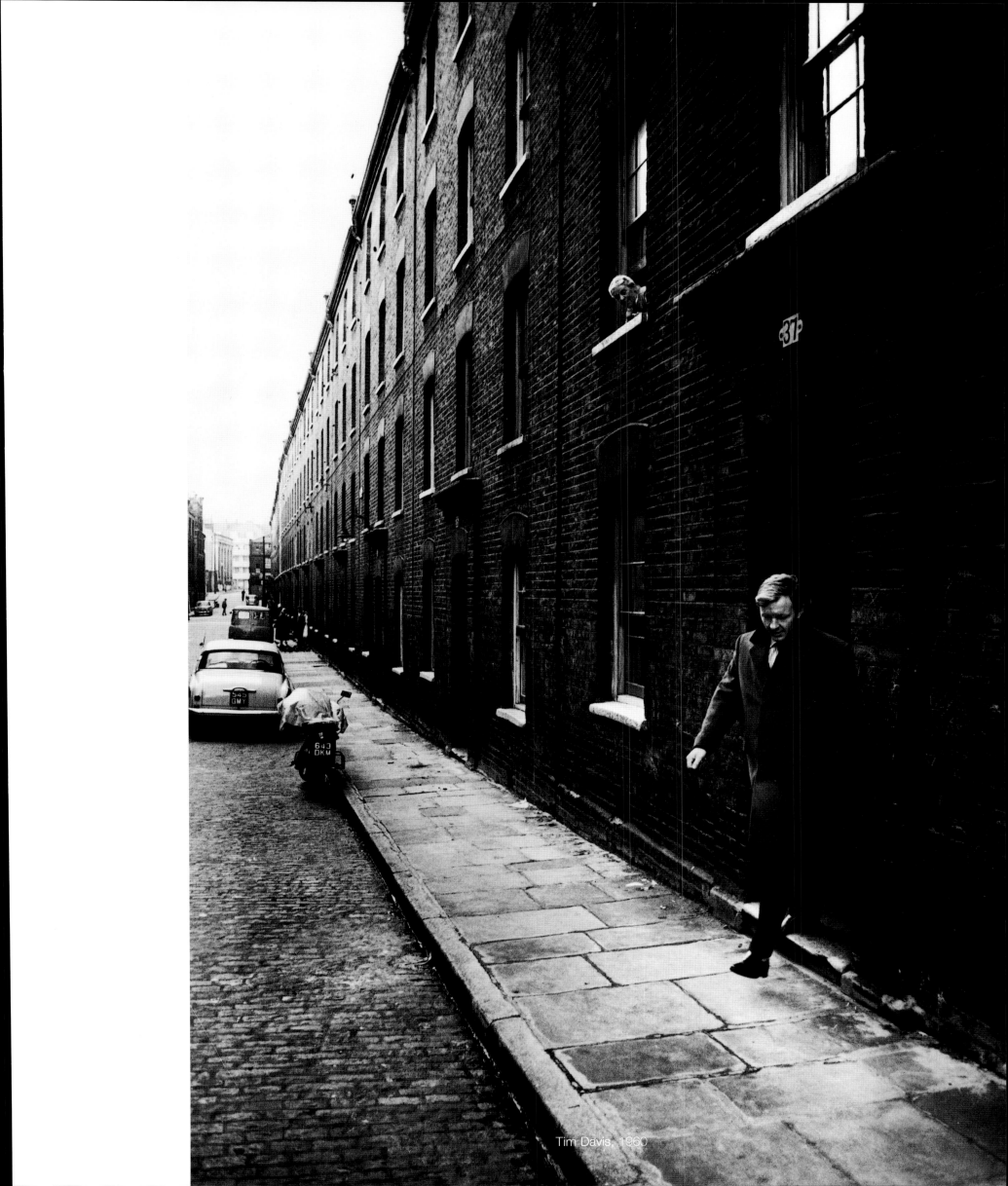

Tim Davis, 1960

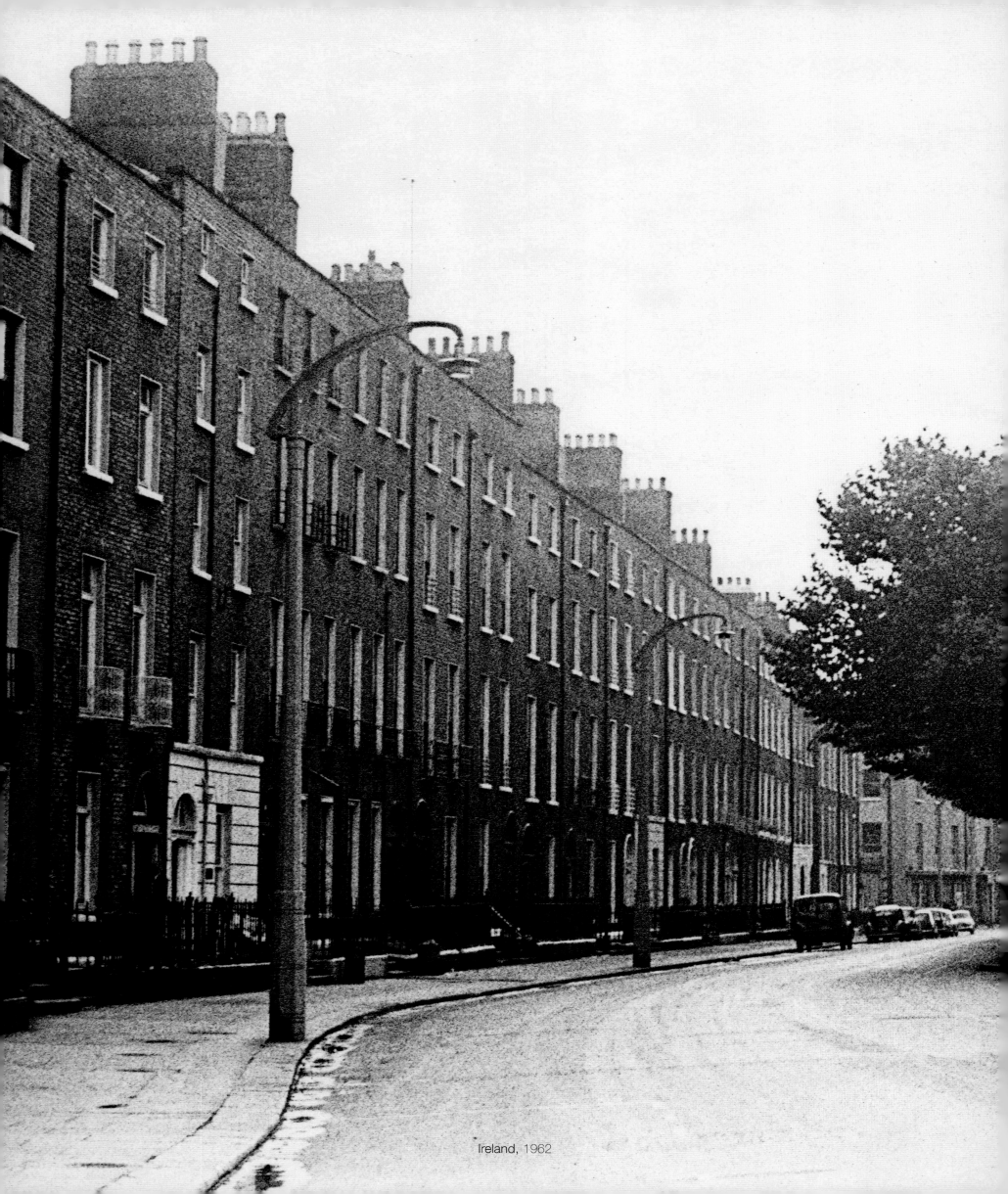

Ireland, 1962

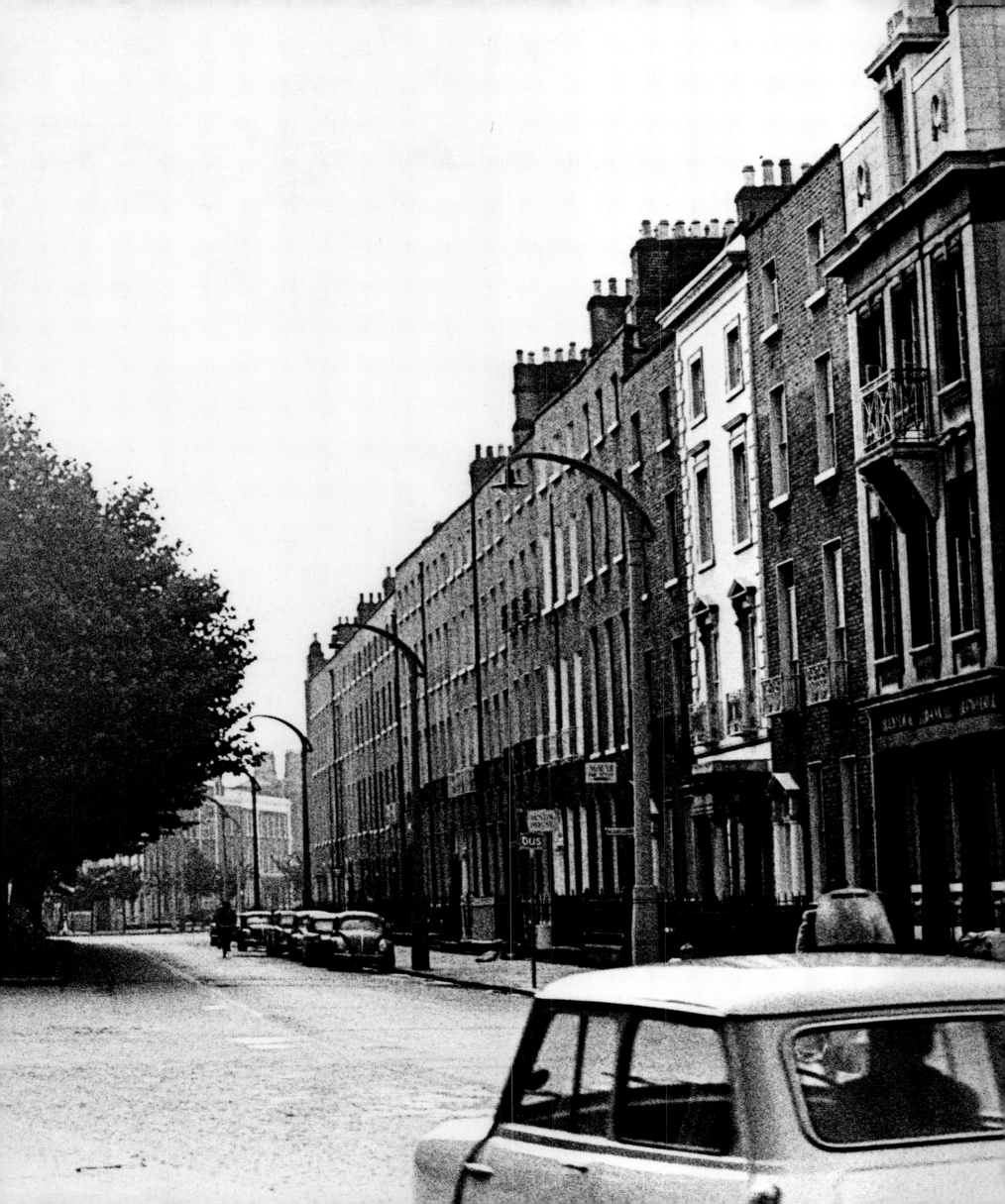

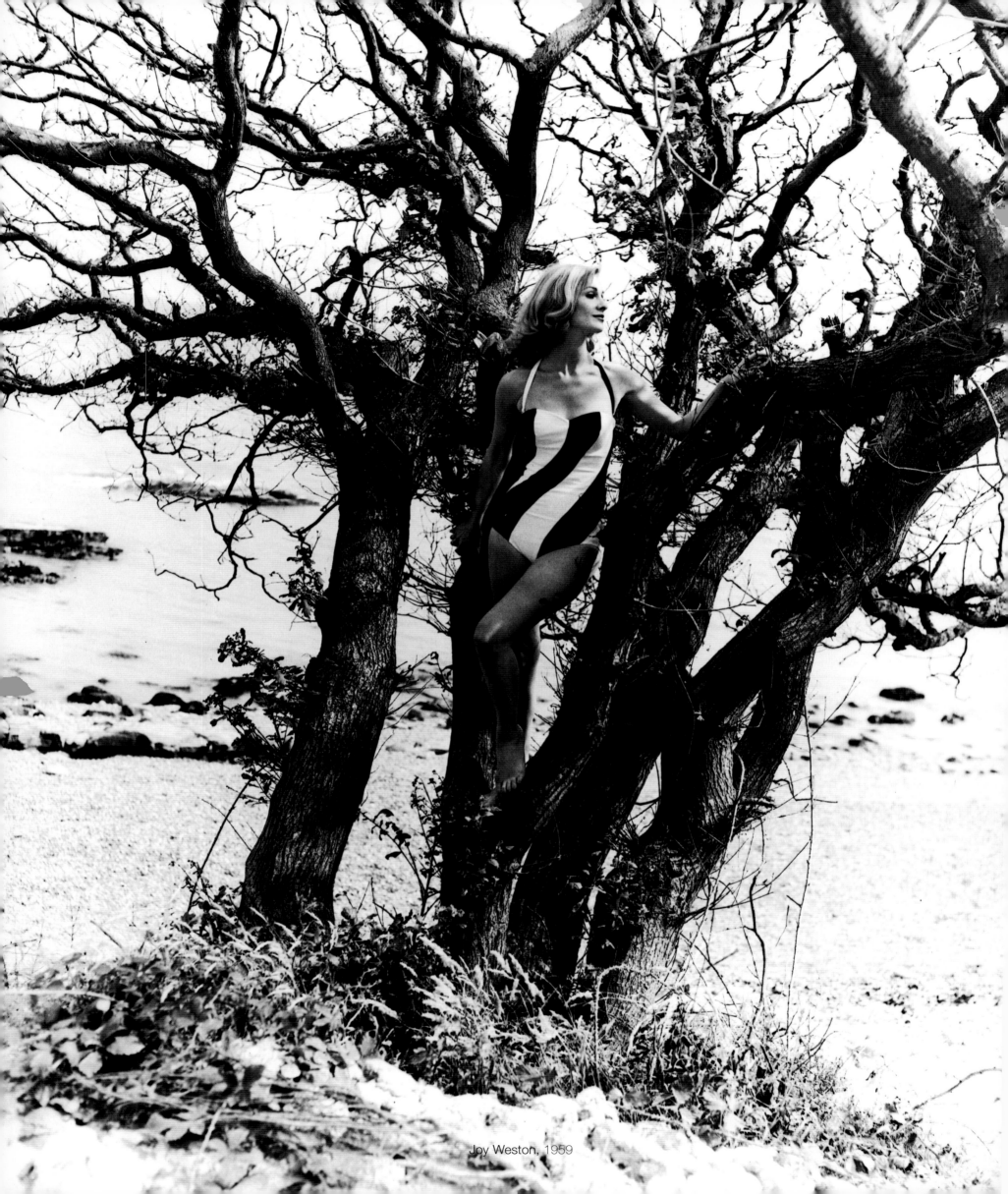

Joy Weston, 1959

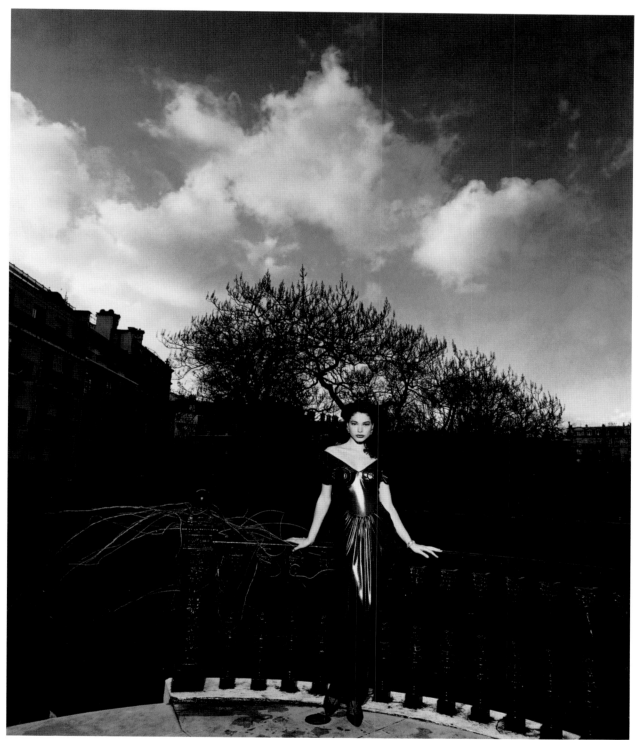

Fashion for *Harper's Bazaar*, 1988

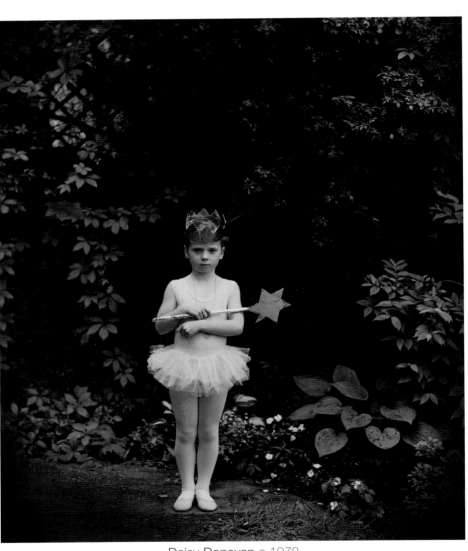

Daisy Donovan c.1978

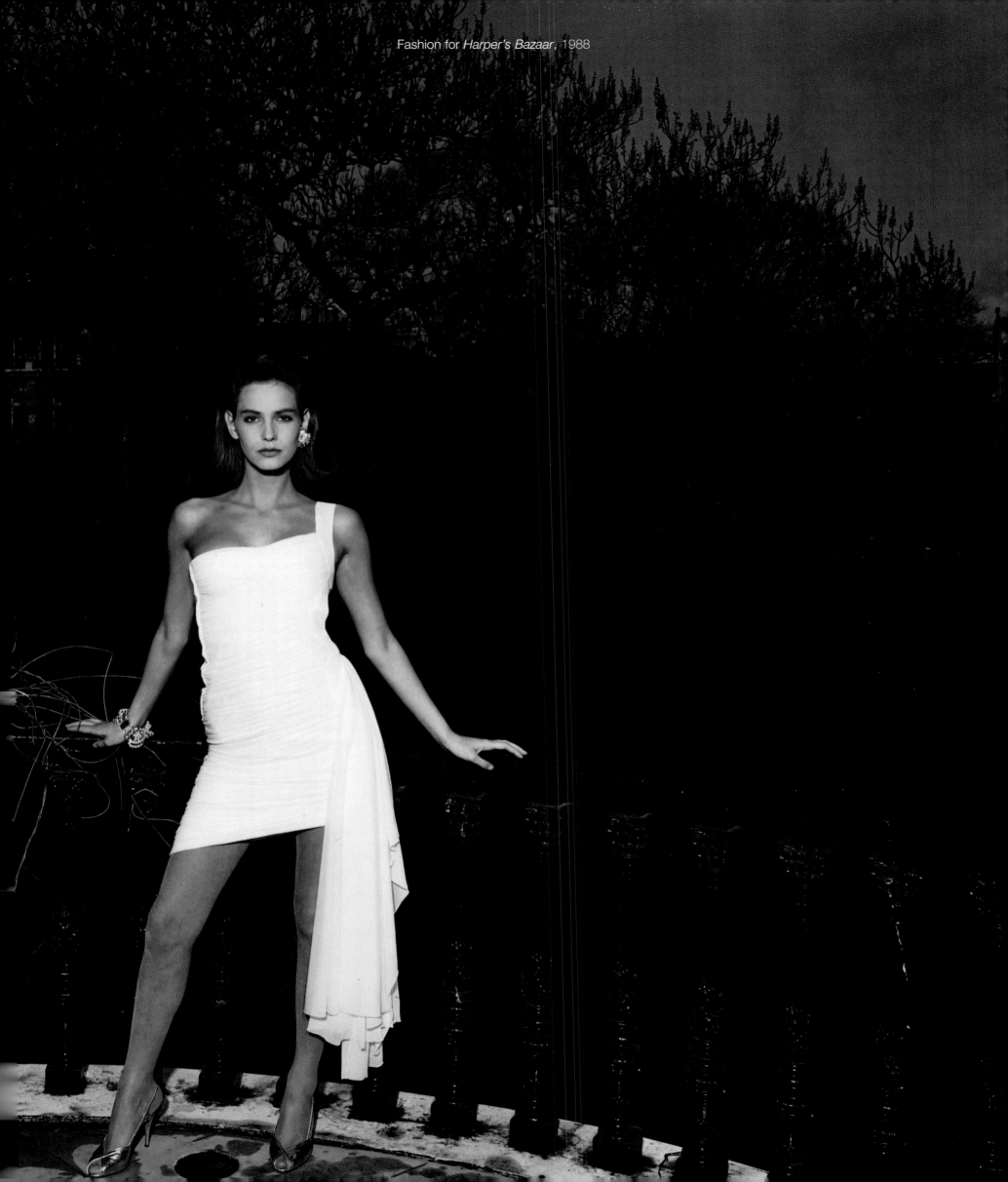

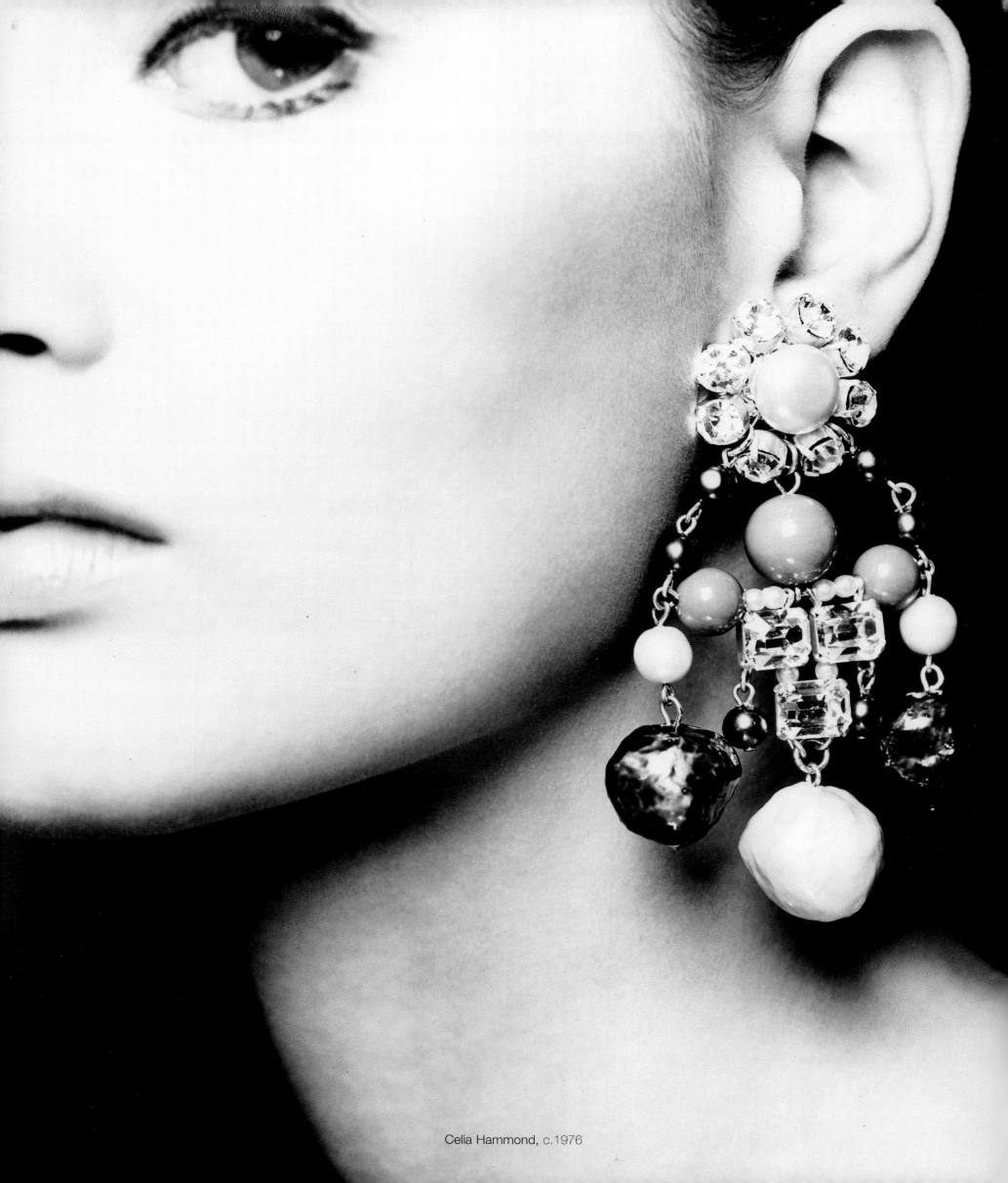

Celia Hammond, c.1976

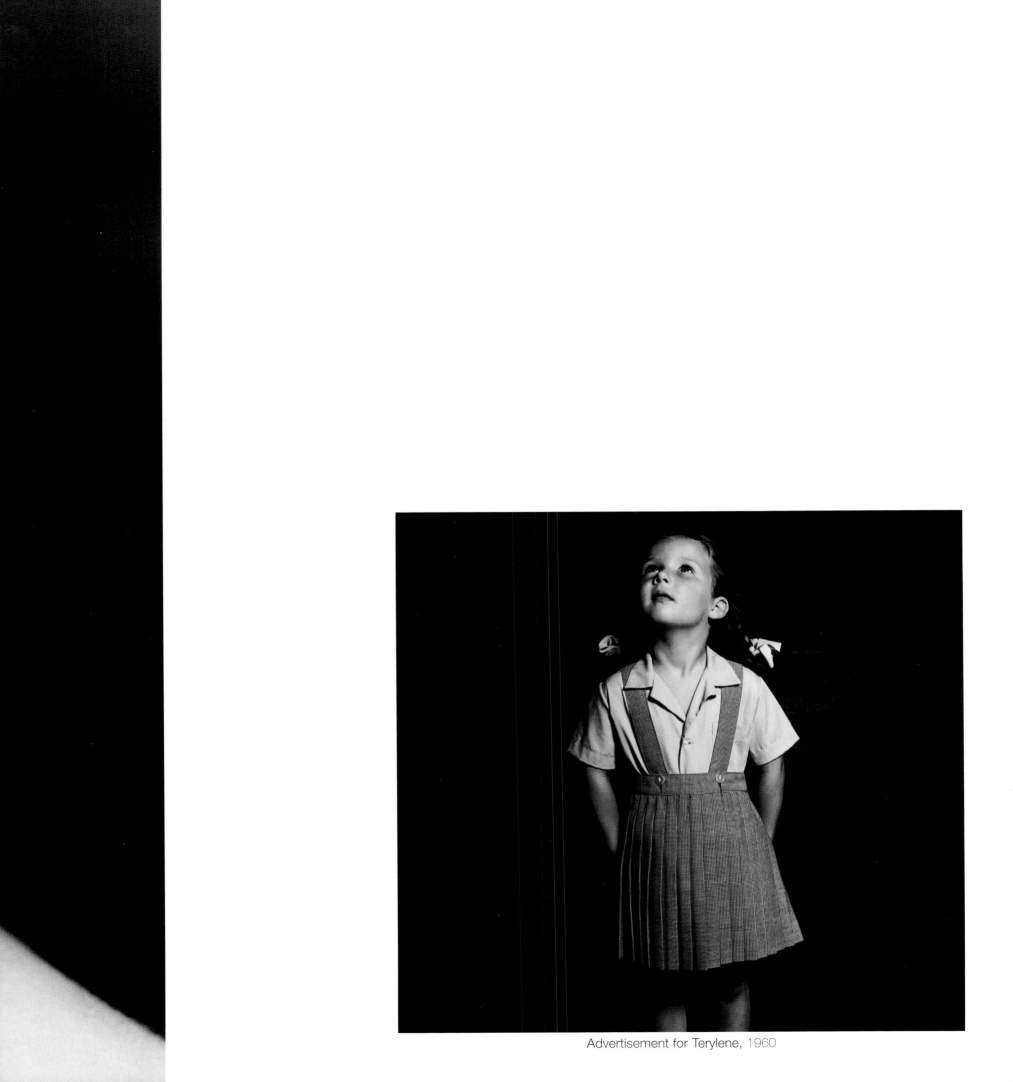

Advertisement for Terylene, 1960

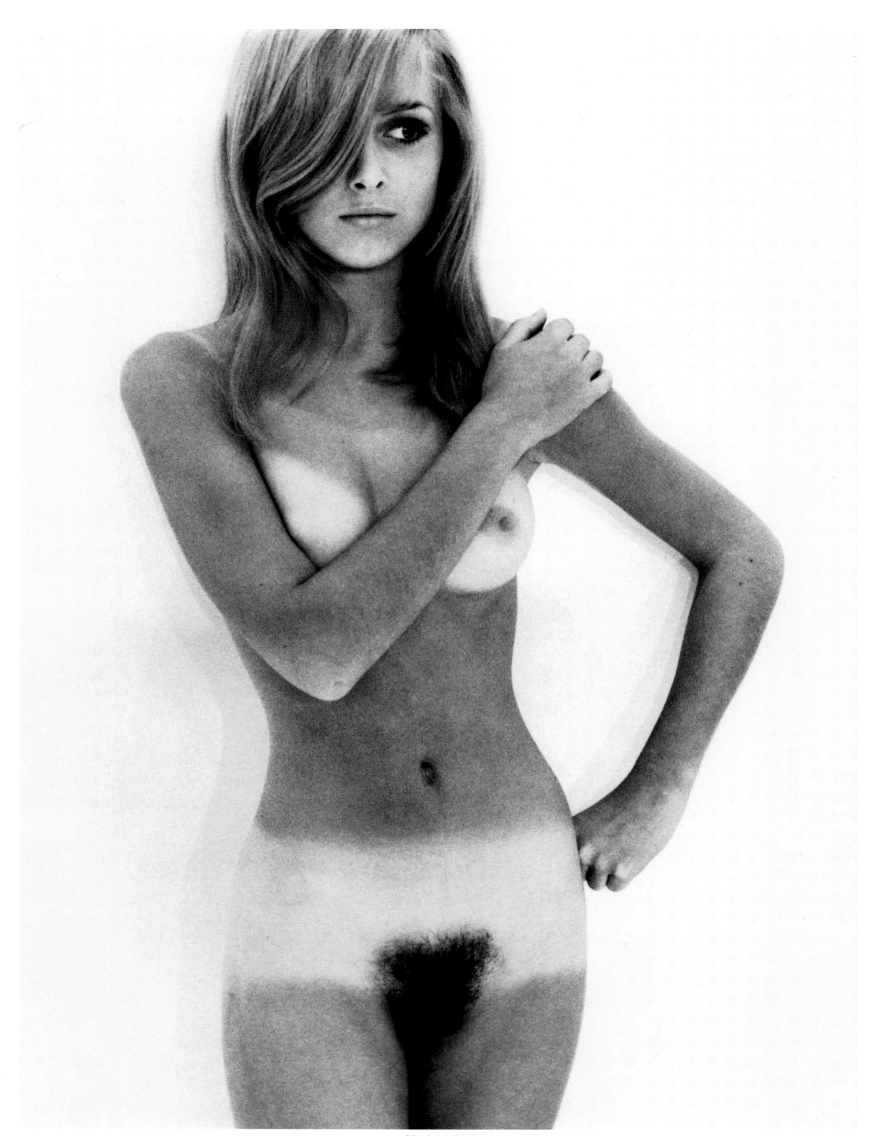

Nude, 1967

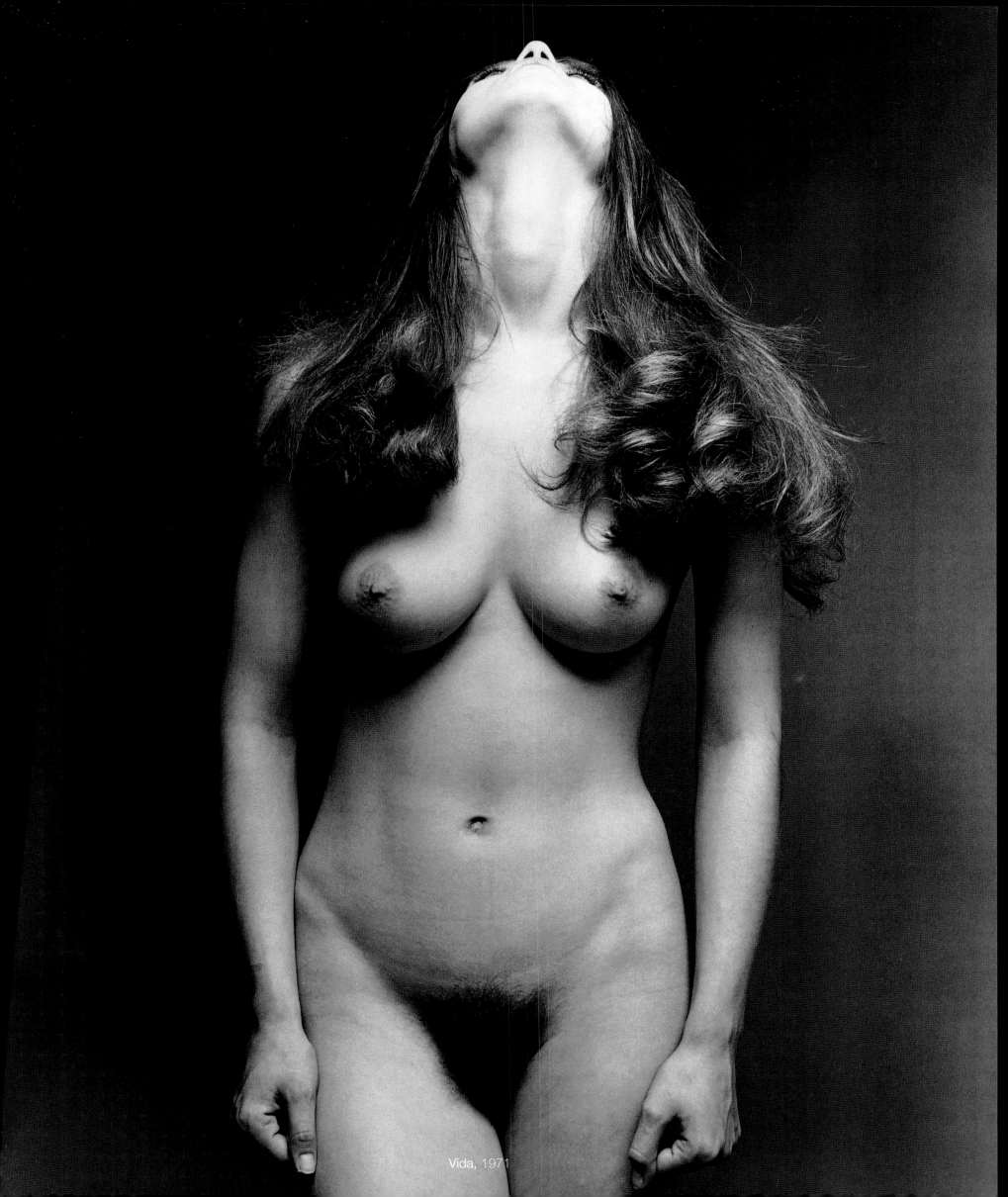

Vida, 1971

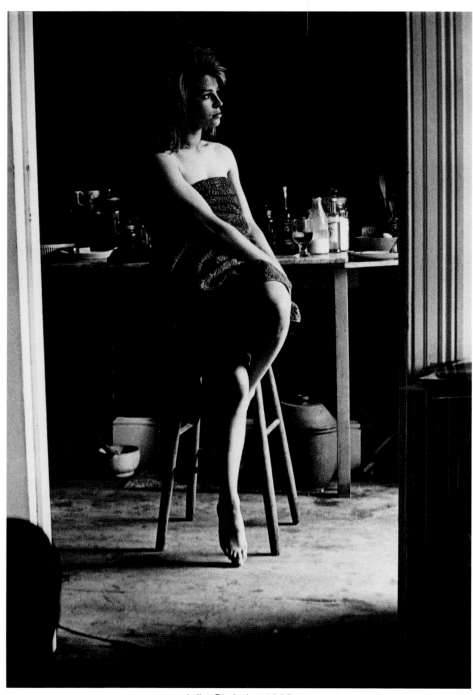

Julie Christie, 1962

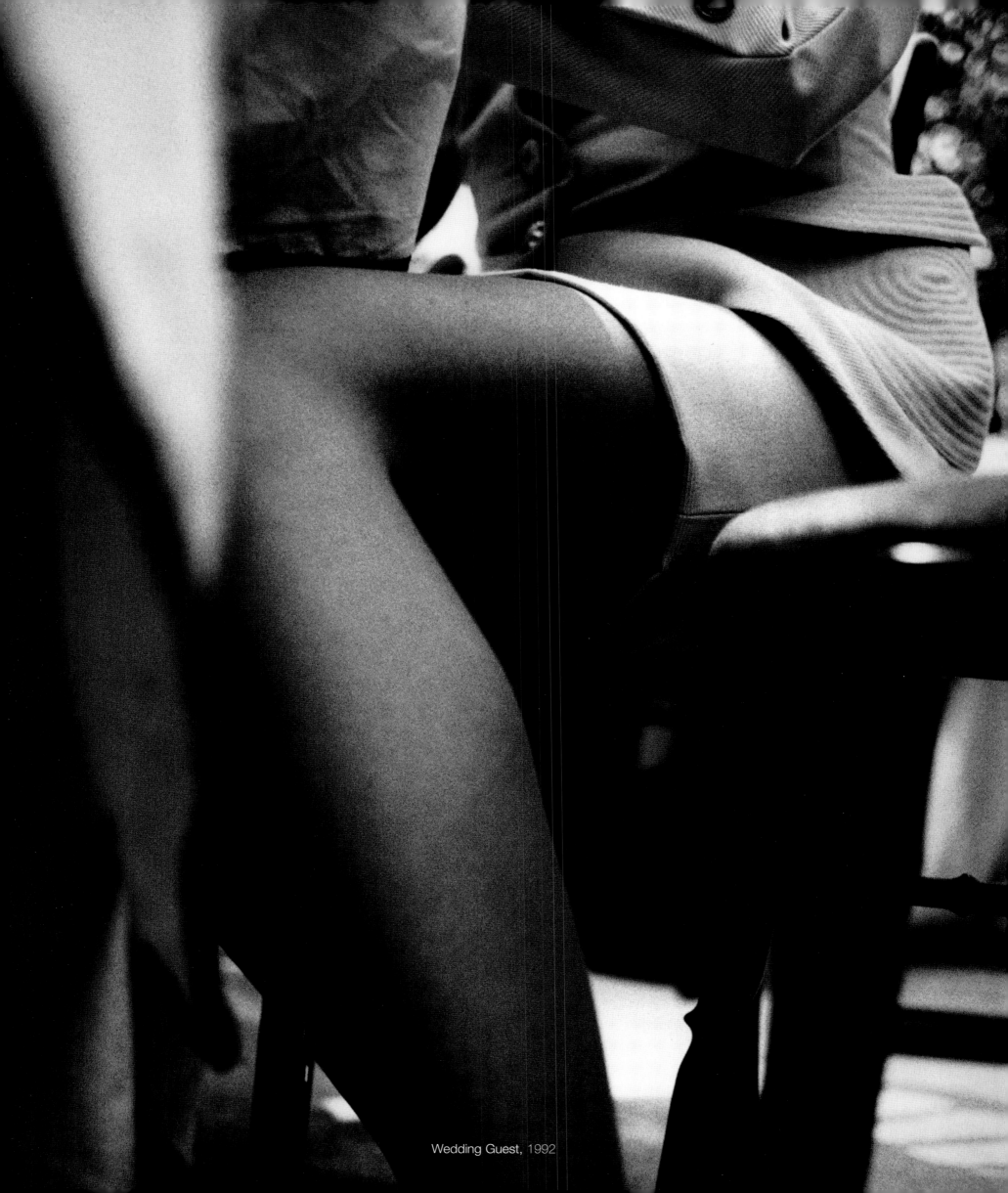

Wedding Guest, 1992

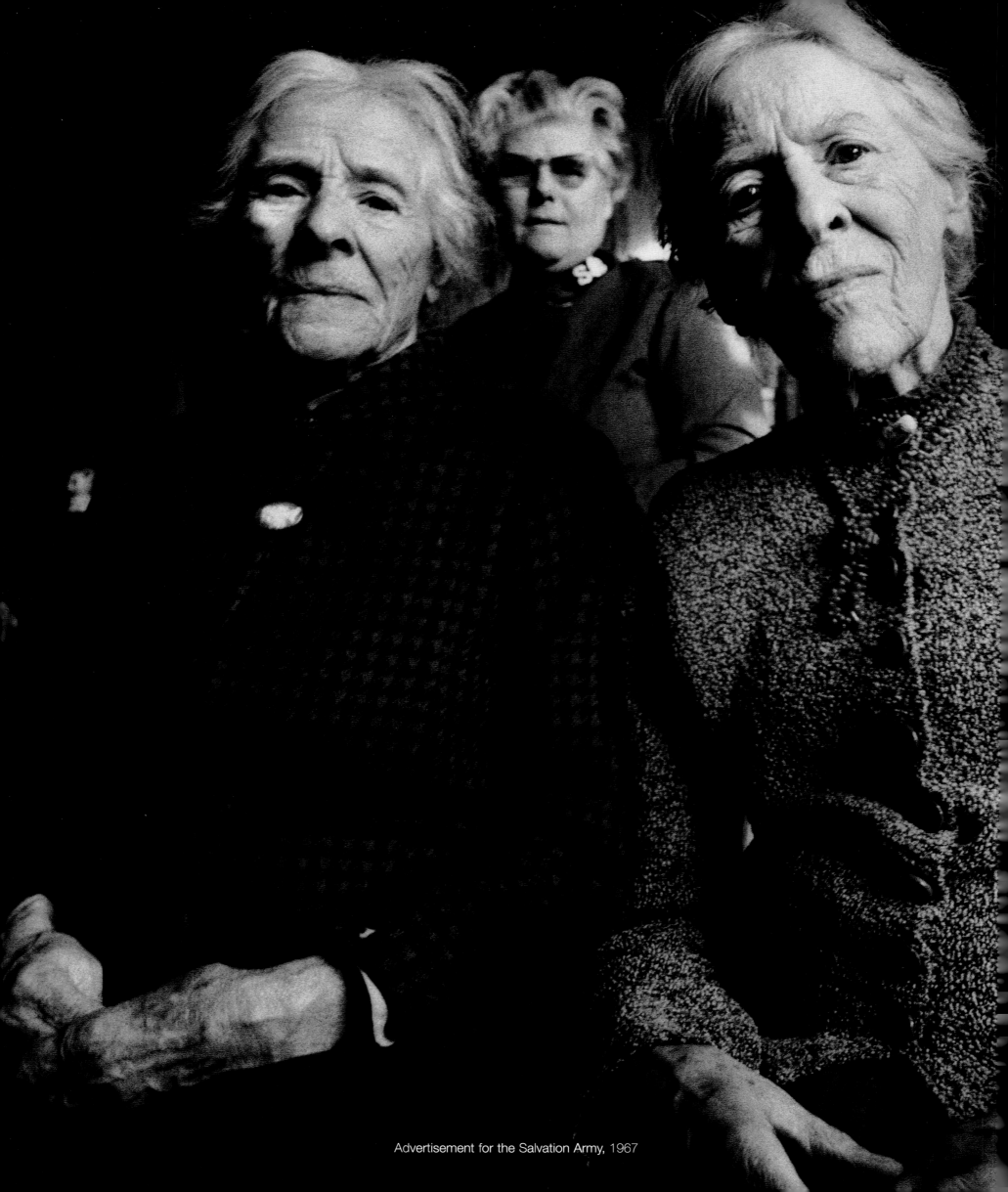

Advertisement for the Salvation Army, 1967

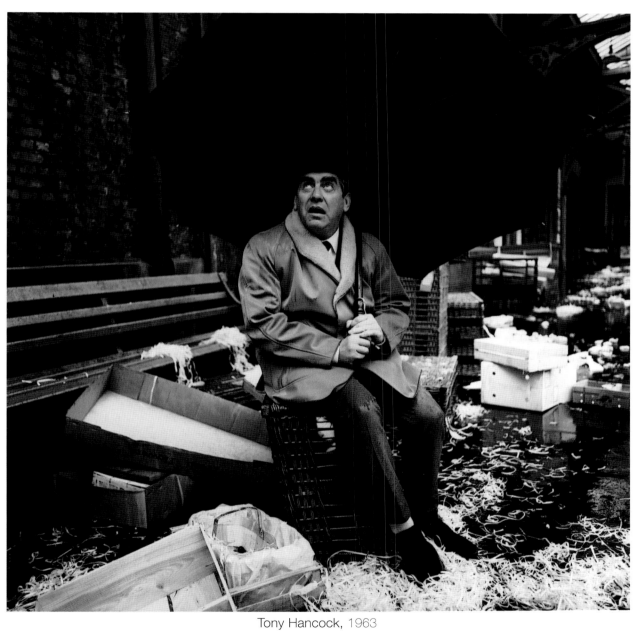

Tony Hancock, 1963

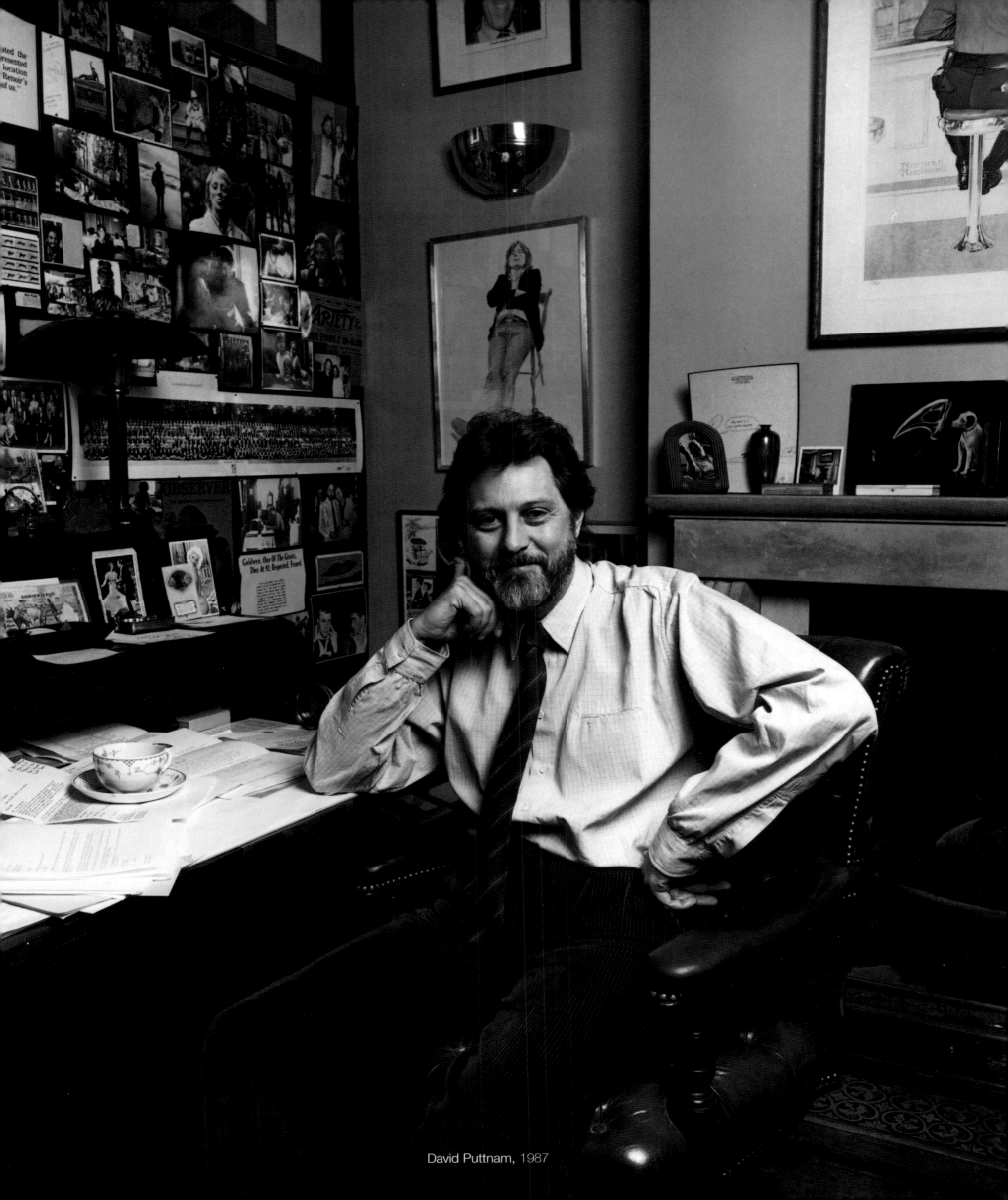

David Puttnam, 1987

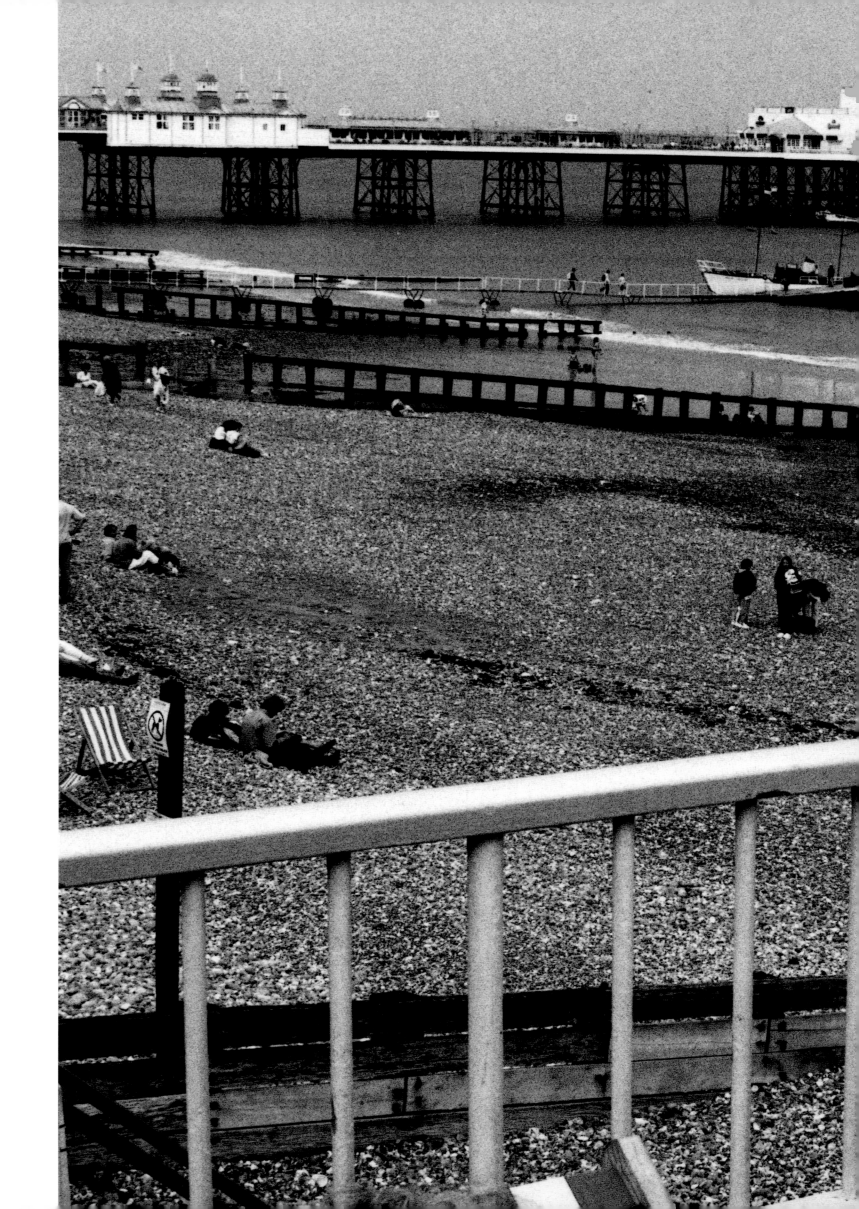

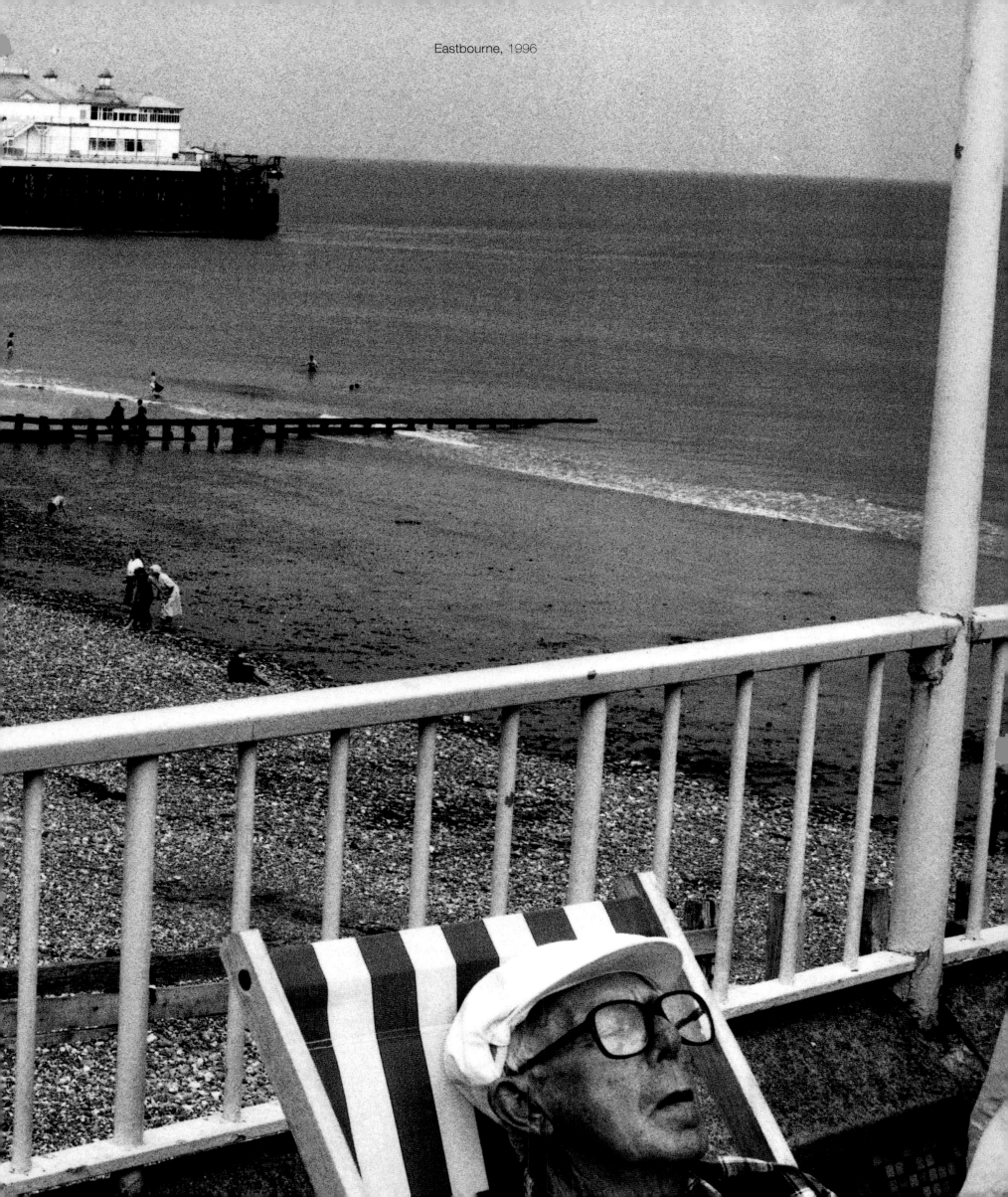

Eastbourne, 1996

Advertisement for the Salvation Army, 1967

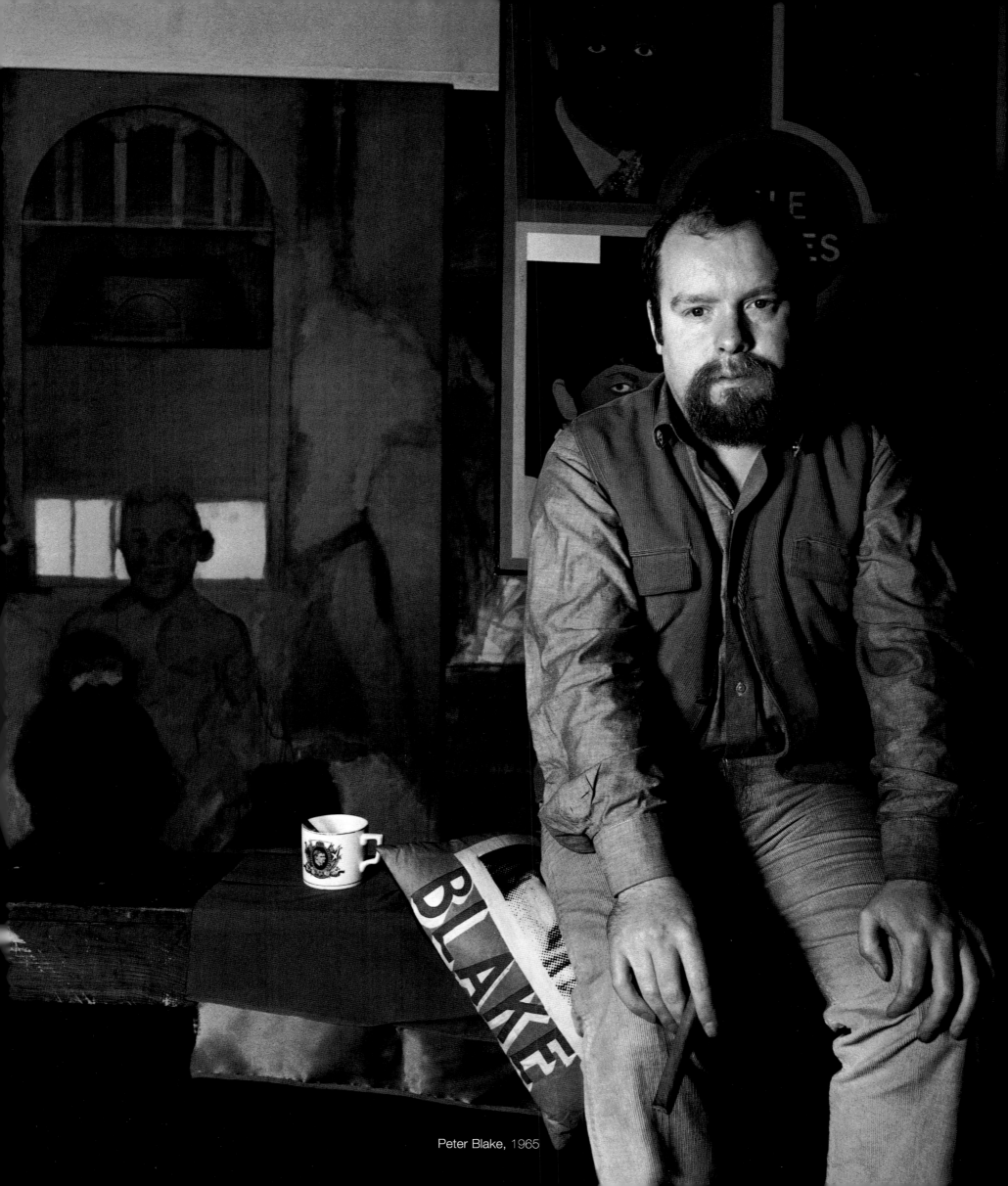
Peter Blake, 1965

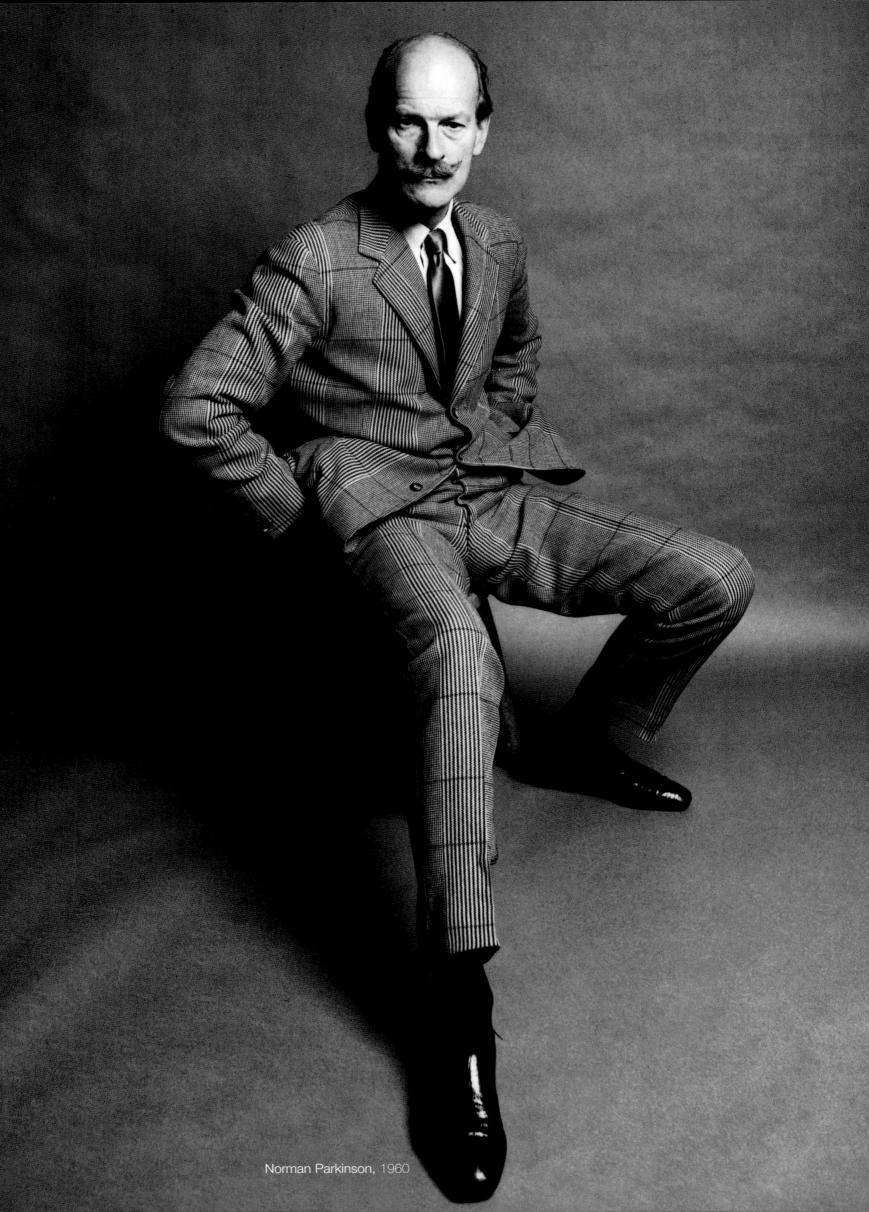
Norman Parkinson, 1960

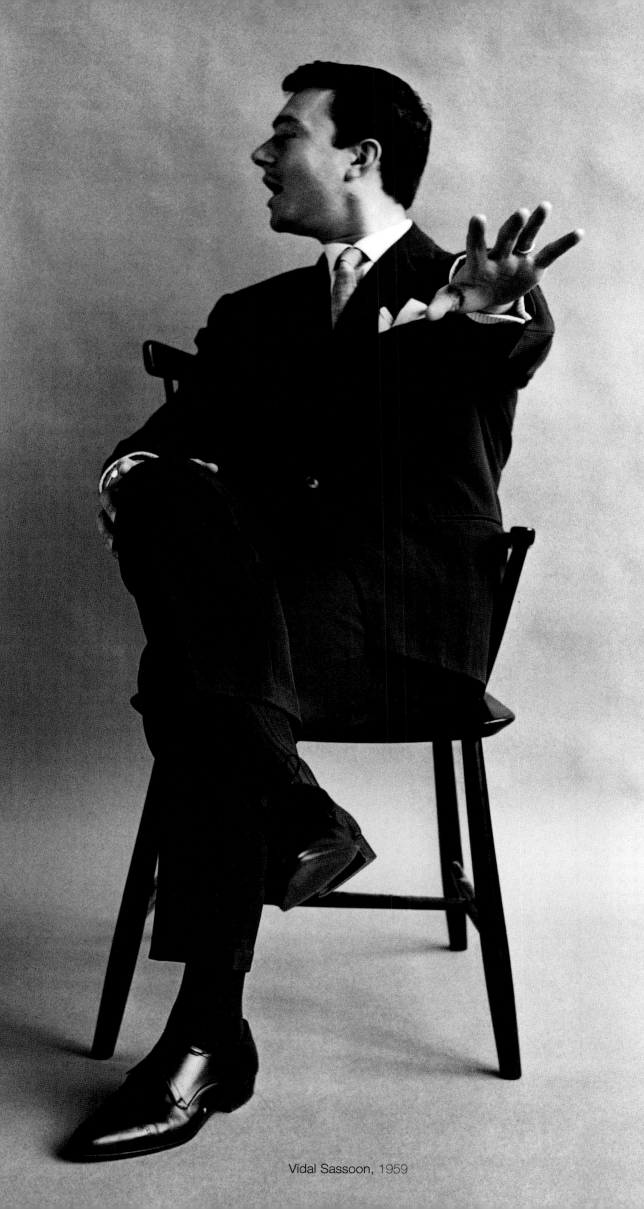

Vidal Sassoon, 1959

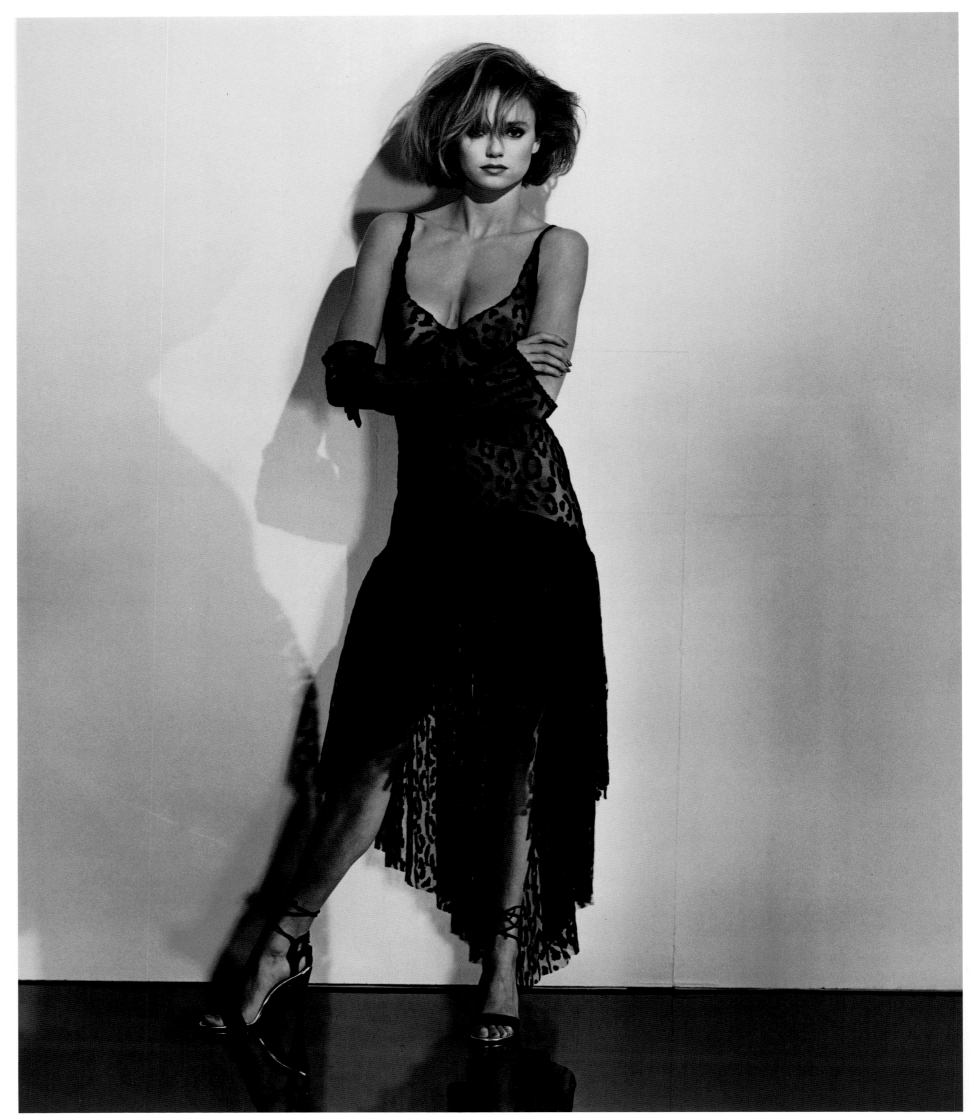

Vanessa Angel, 1984

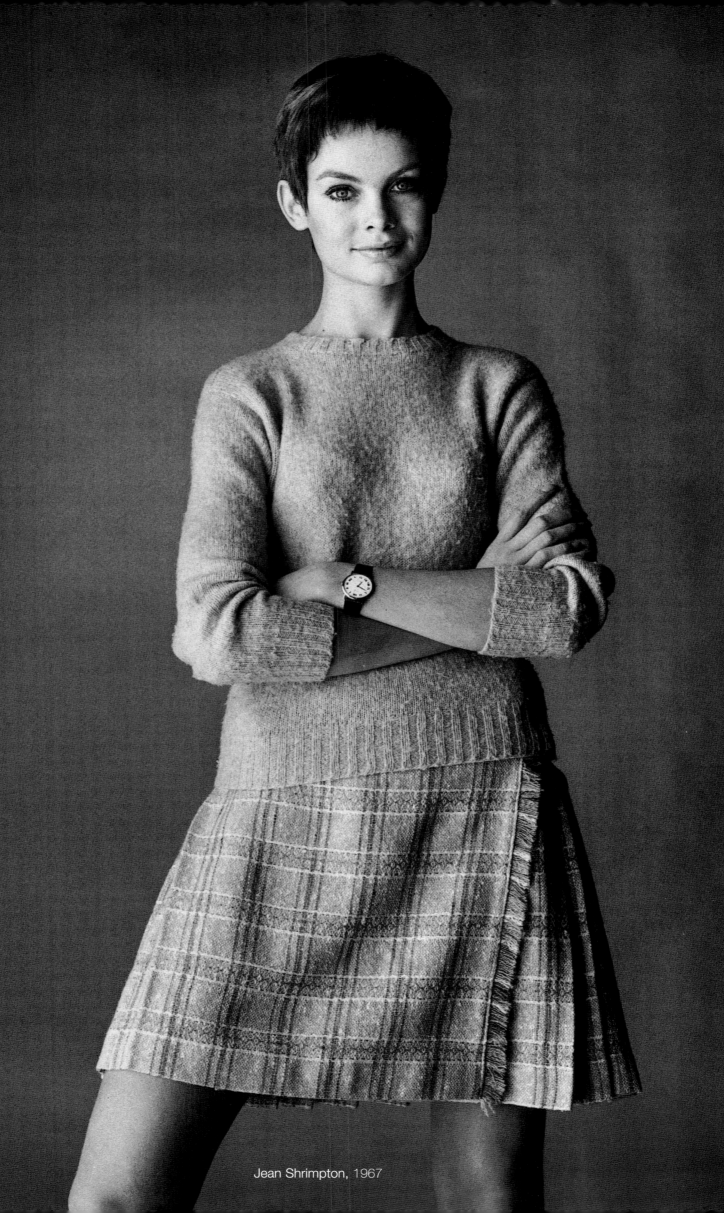

Jean Shrimpton, 1967

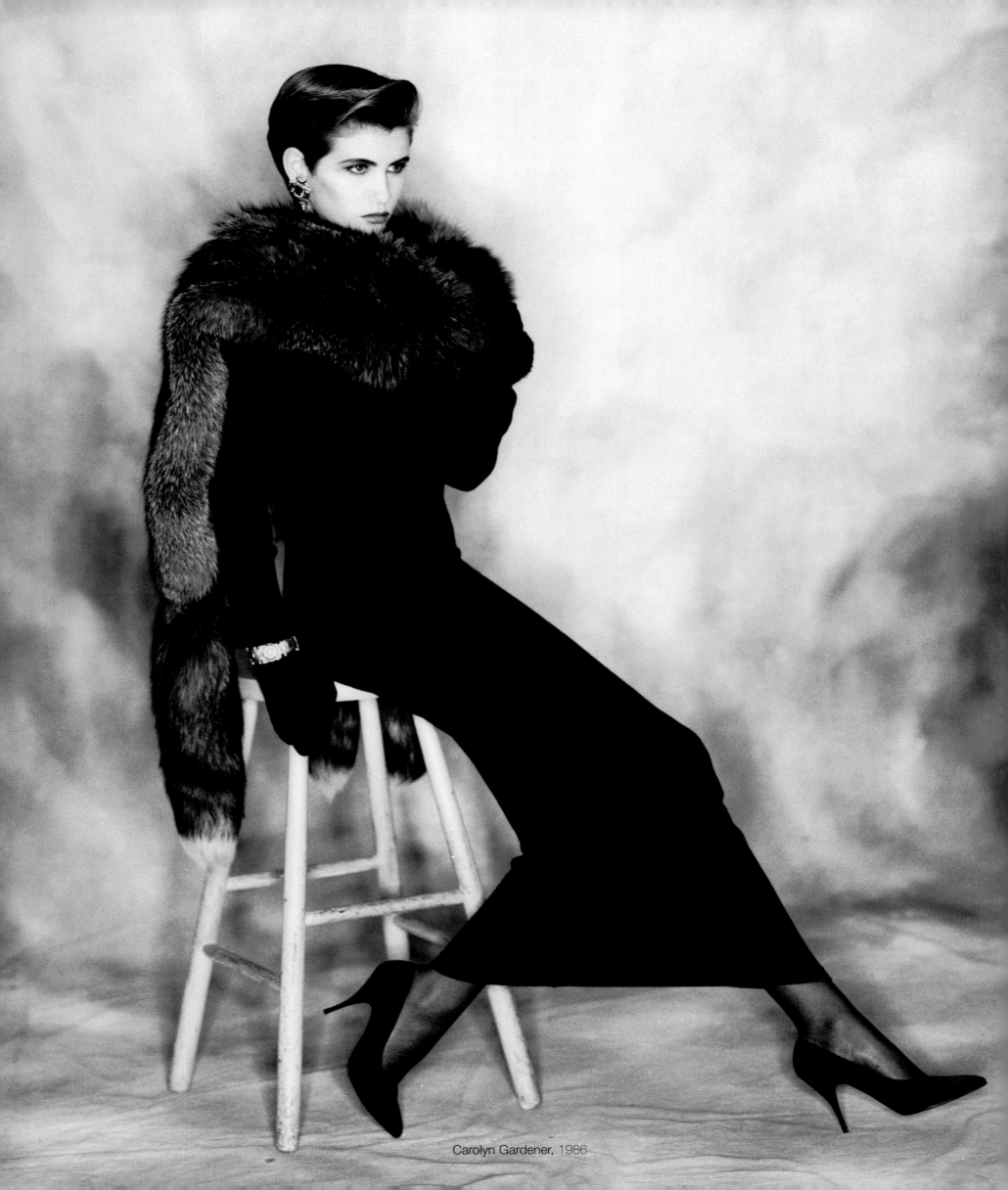

Carolyn Gardener, 1986

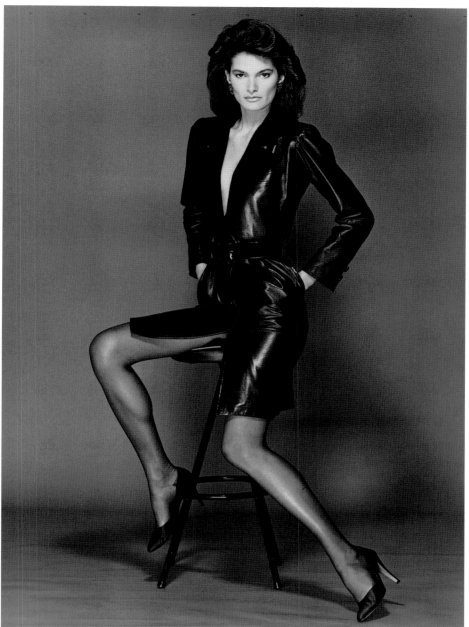

Lynn Costler, 1983

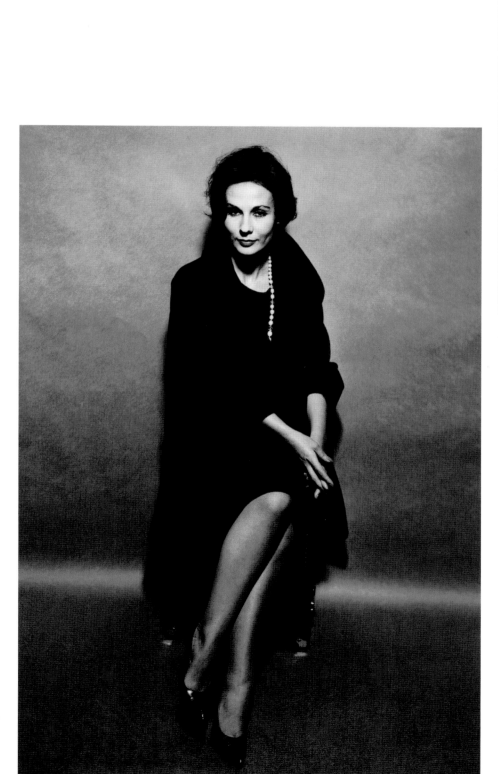

Anne Anderson, 1960

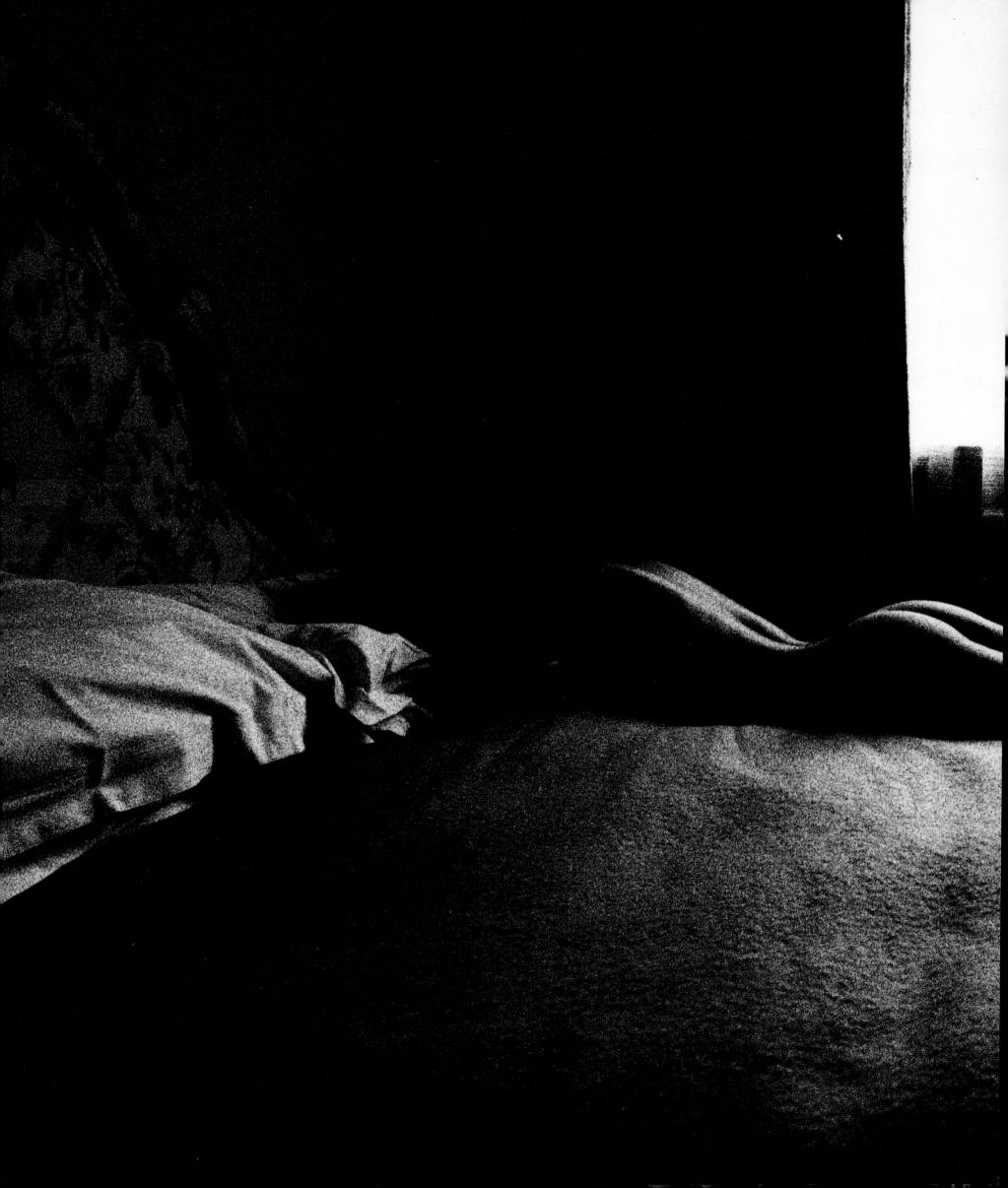

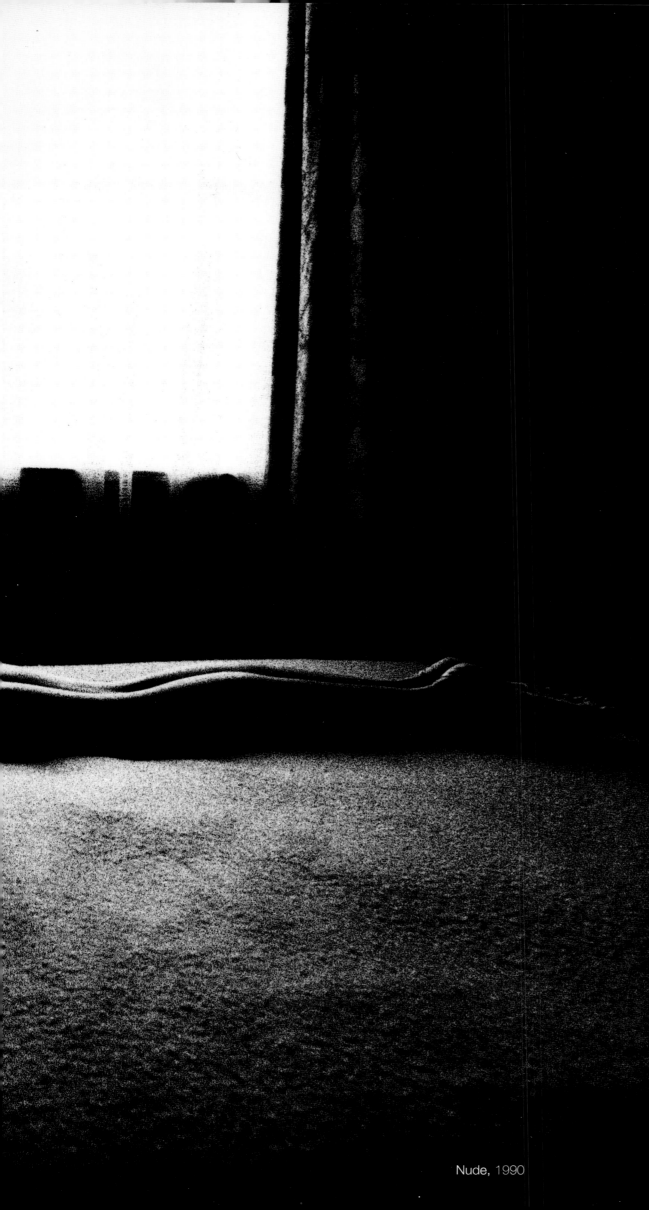

Nude, 1990

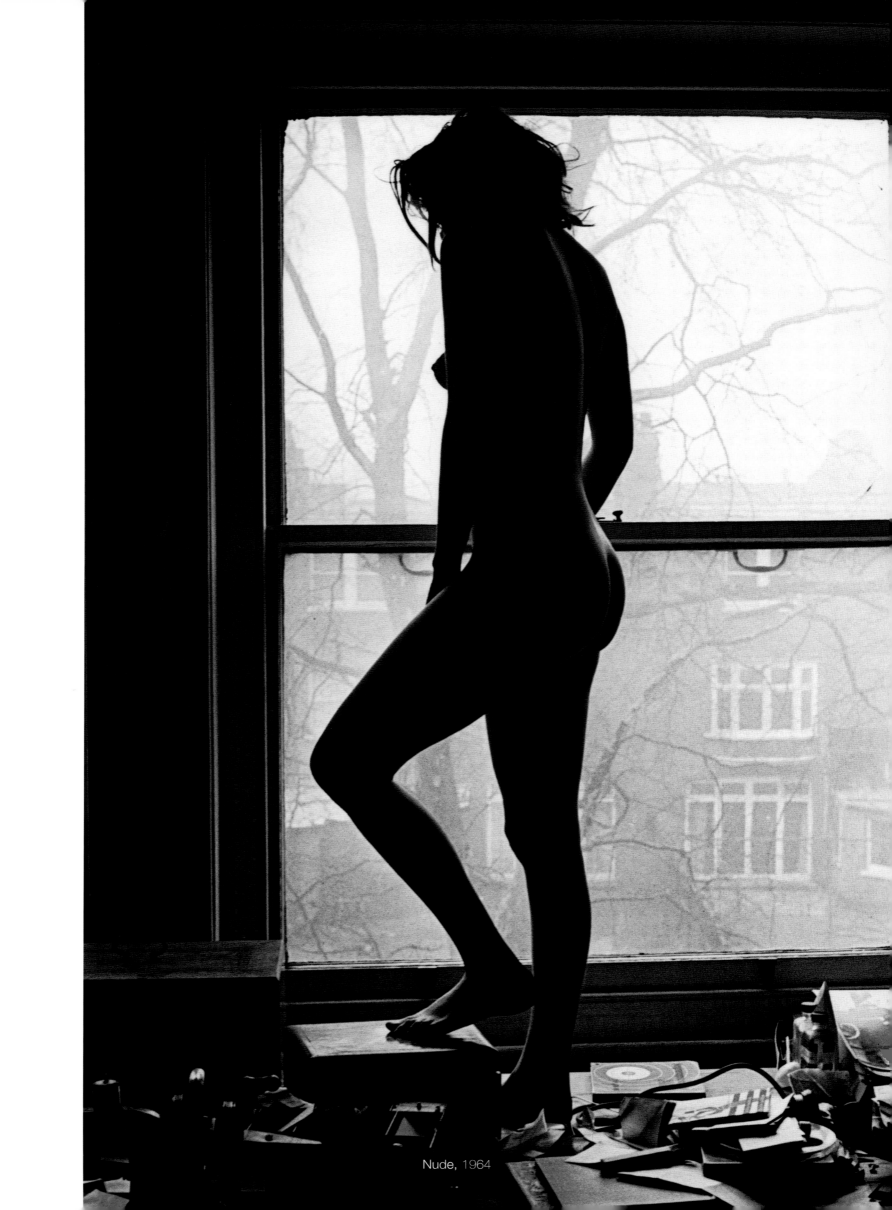

Nude, 1964

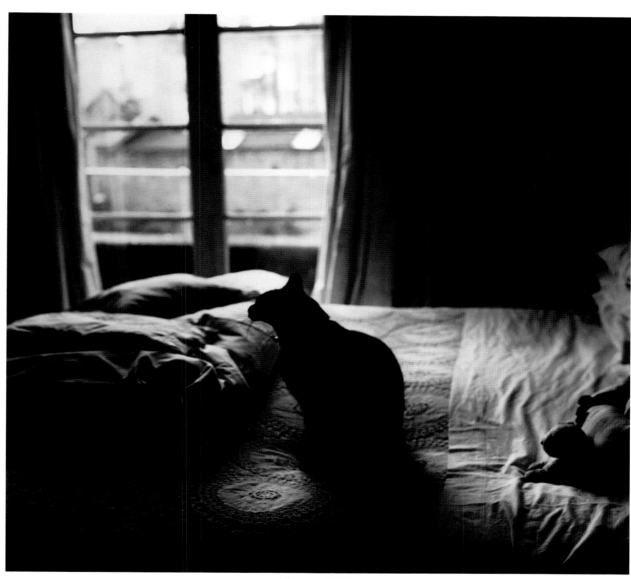

Moses, 1988

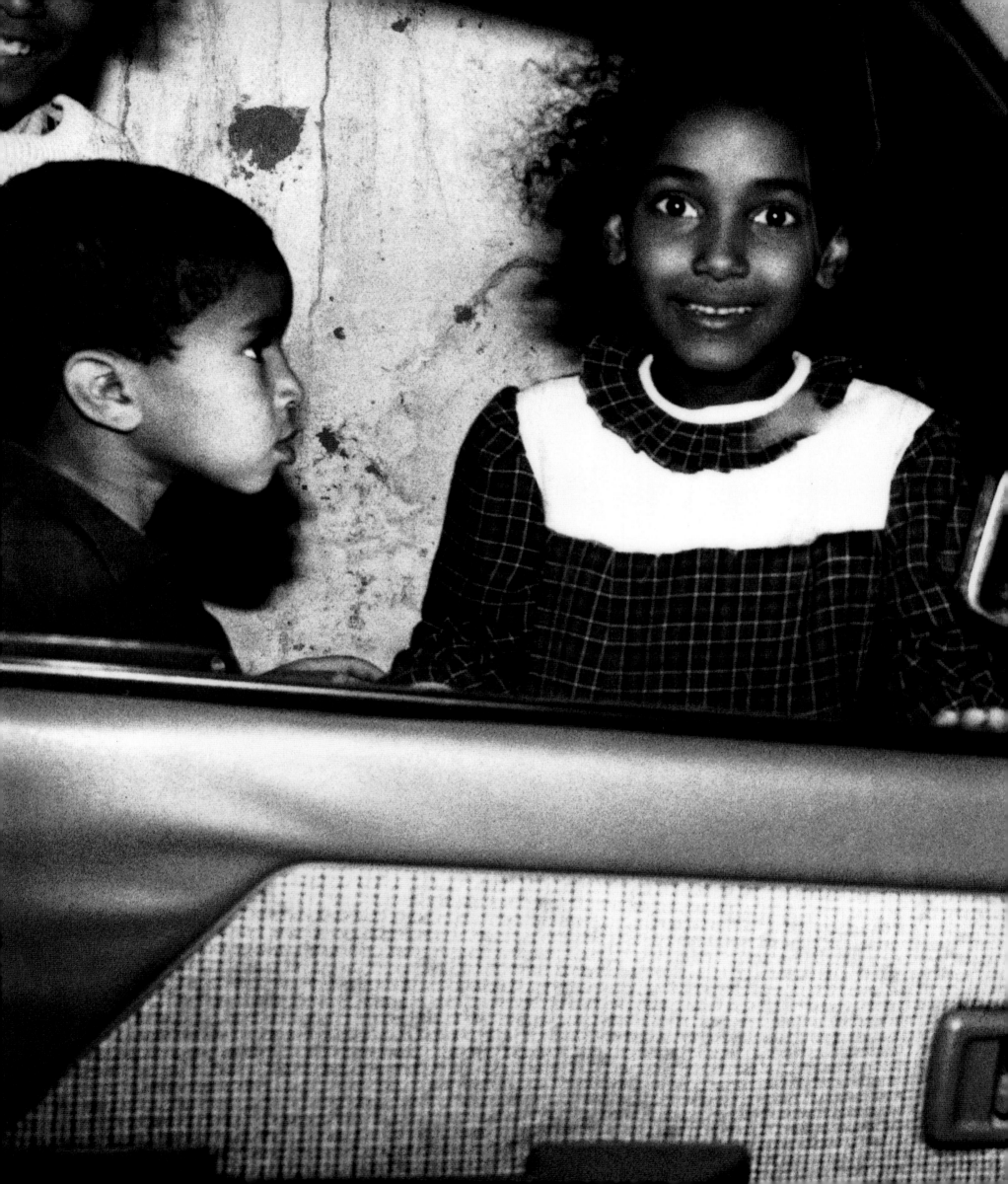

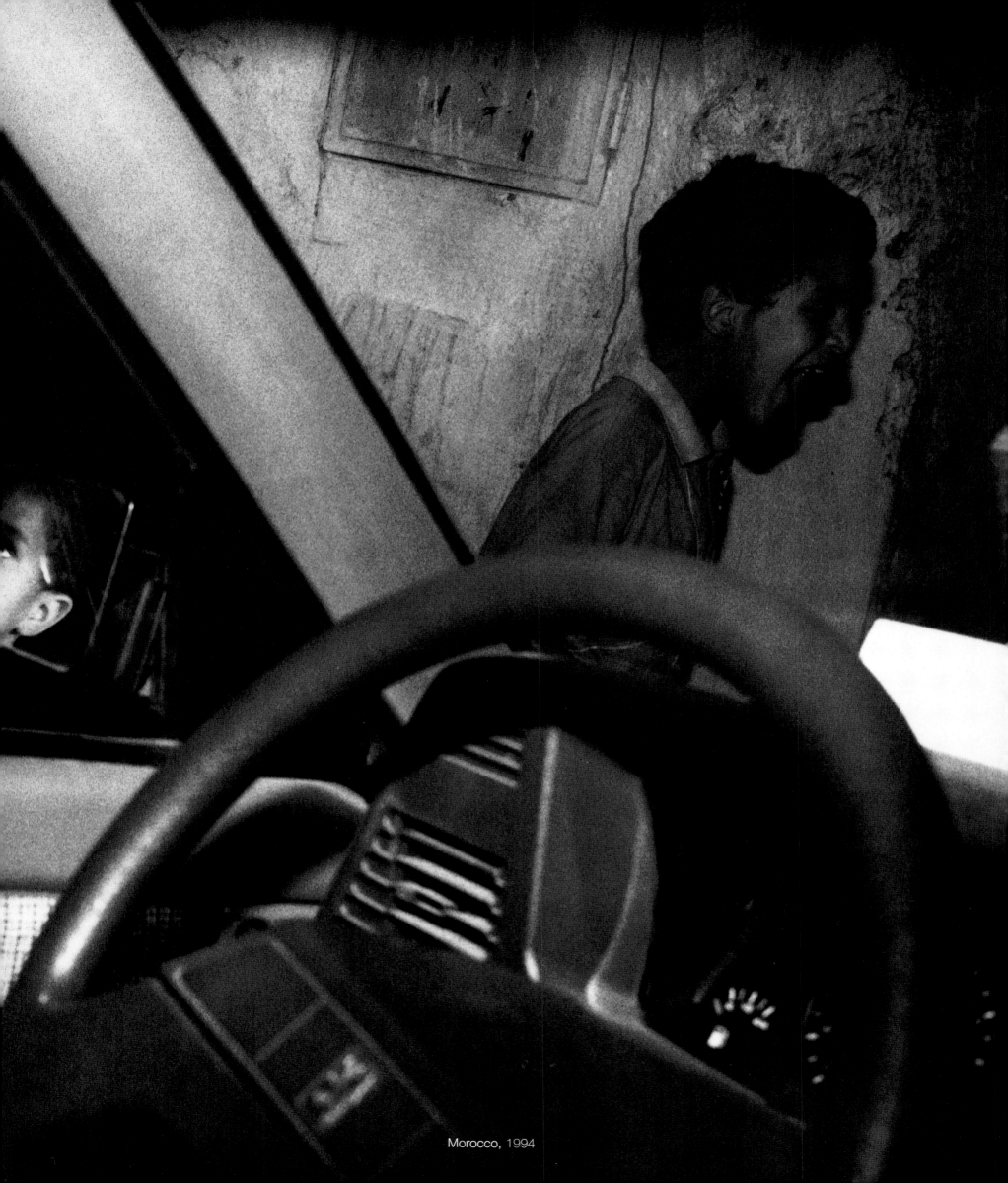

Morocco, 1994

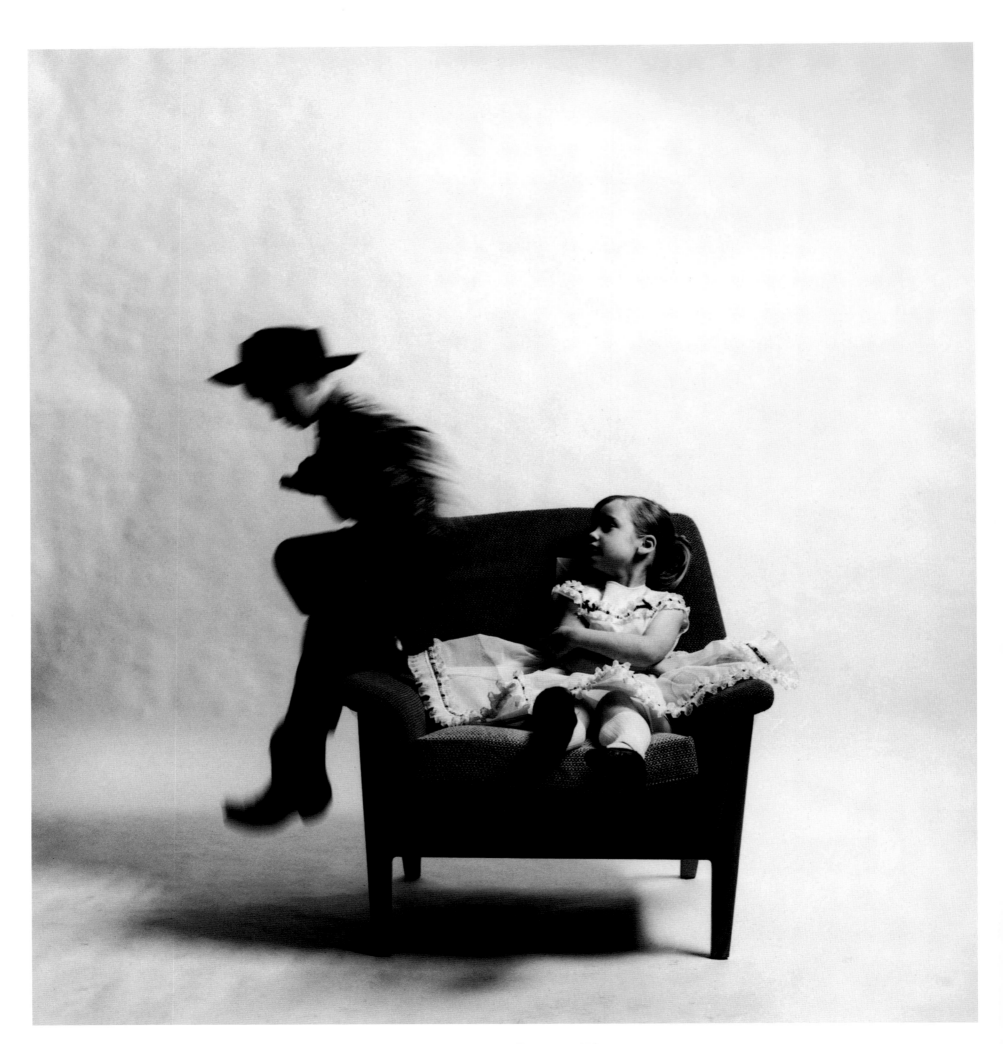

Advertisement for Doracor, 1960

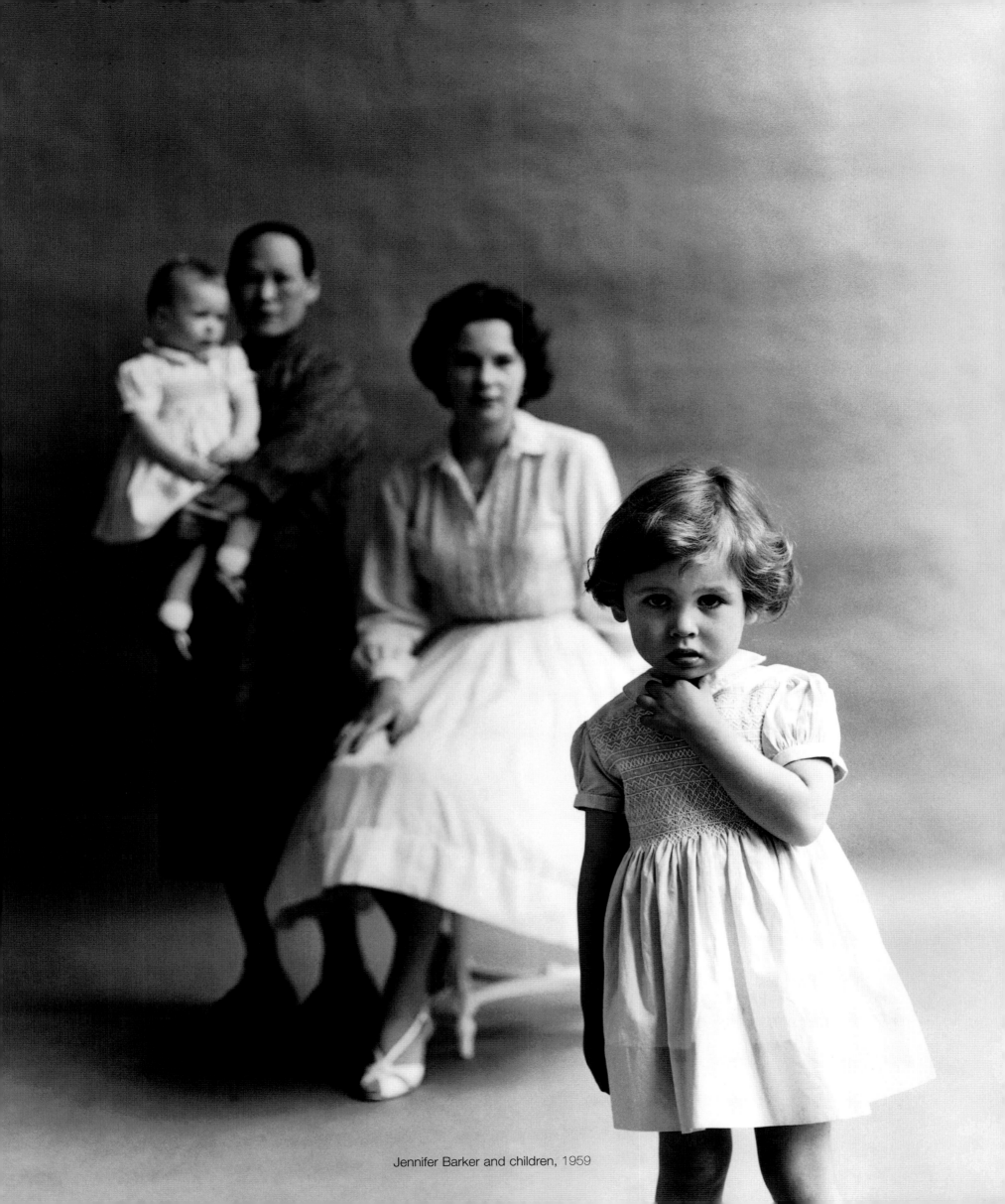

Jennifer Barker and children, 1959

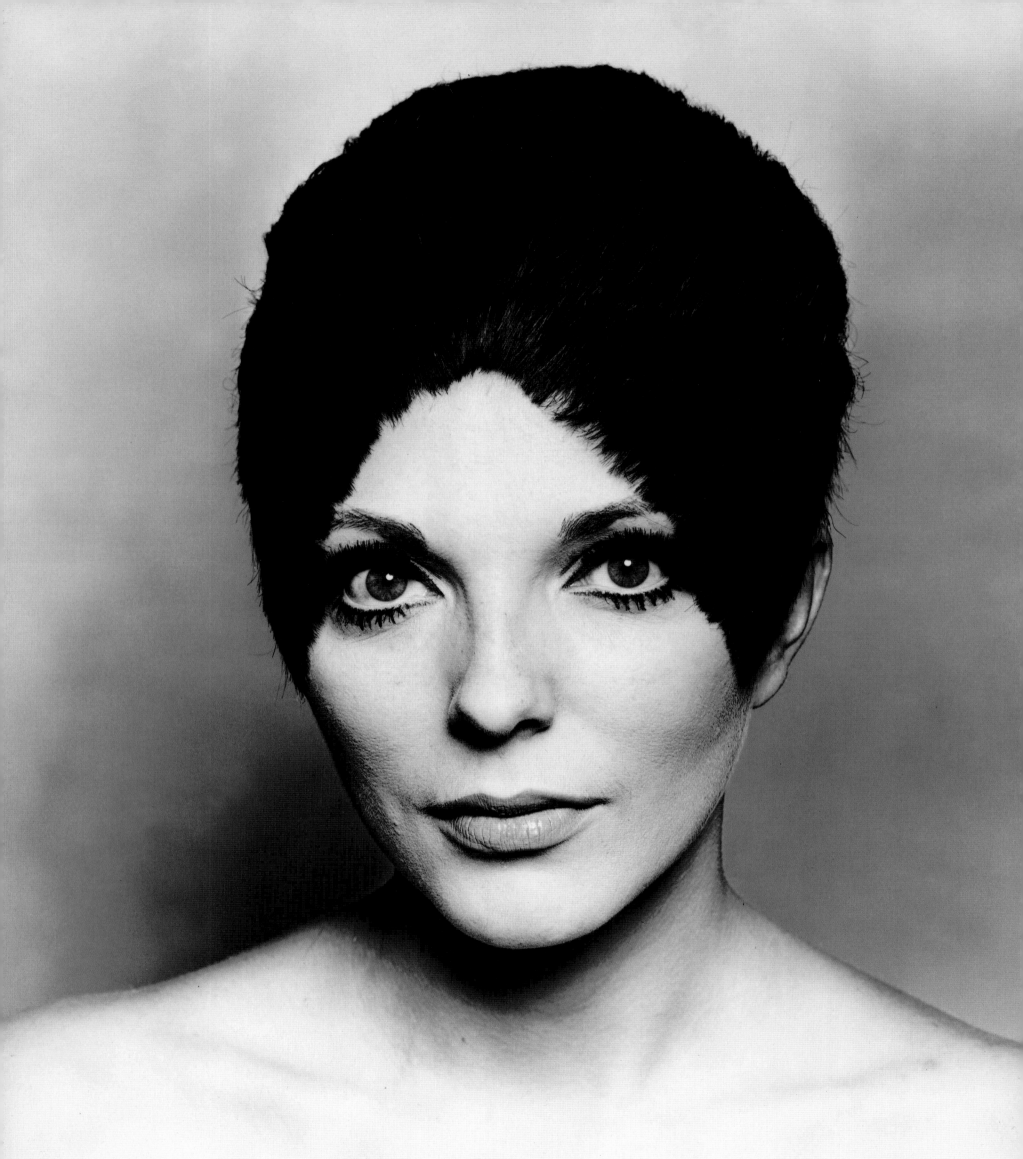

Joan Collins, 1966

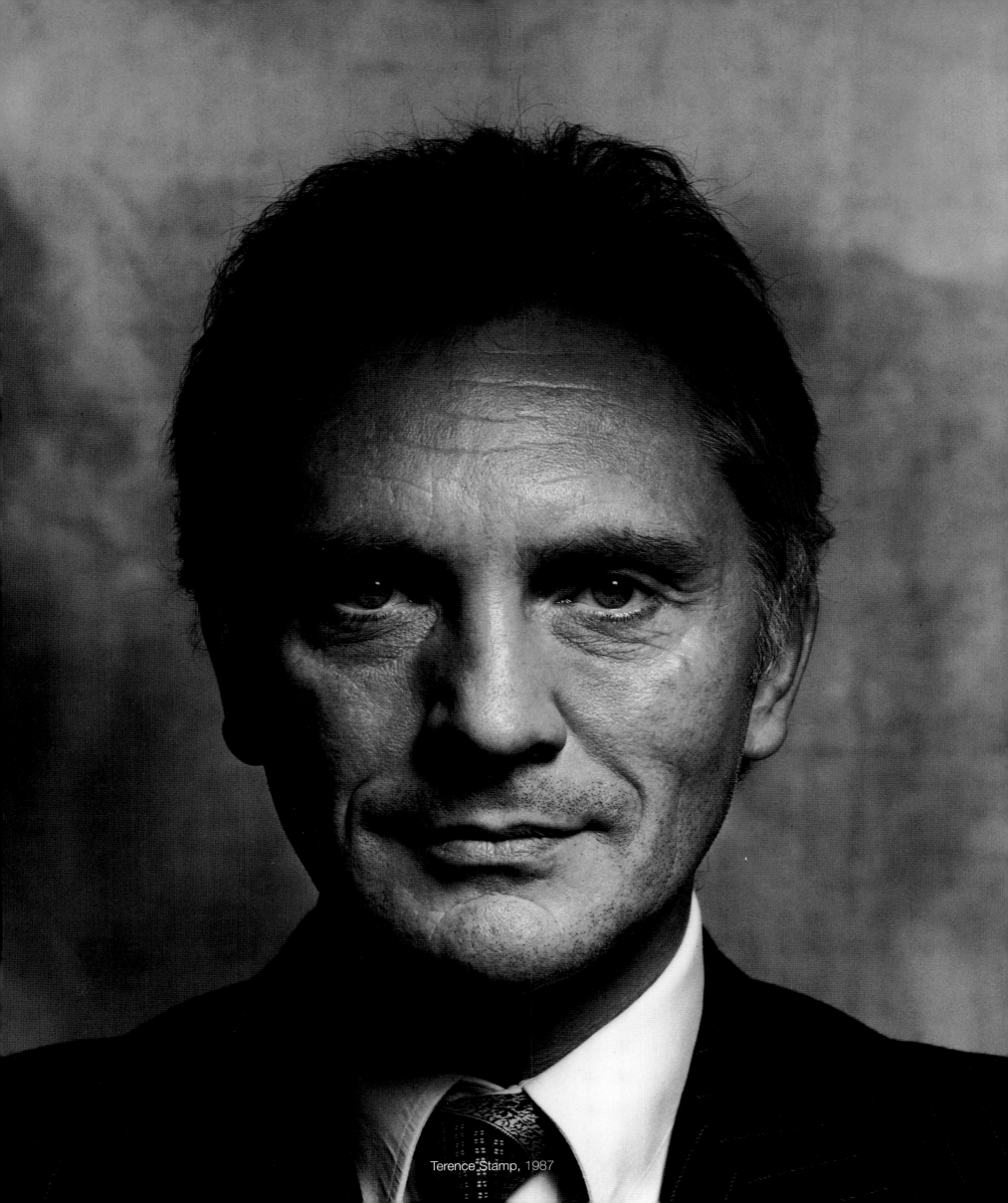
Terence Stamp, 1987

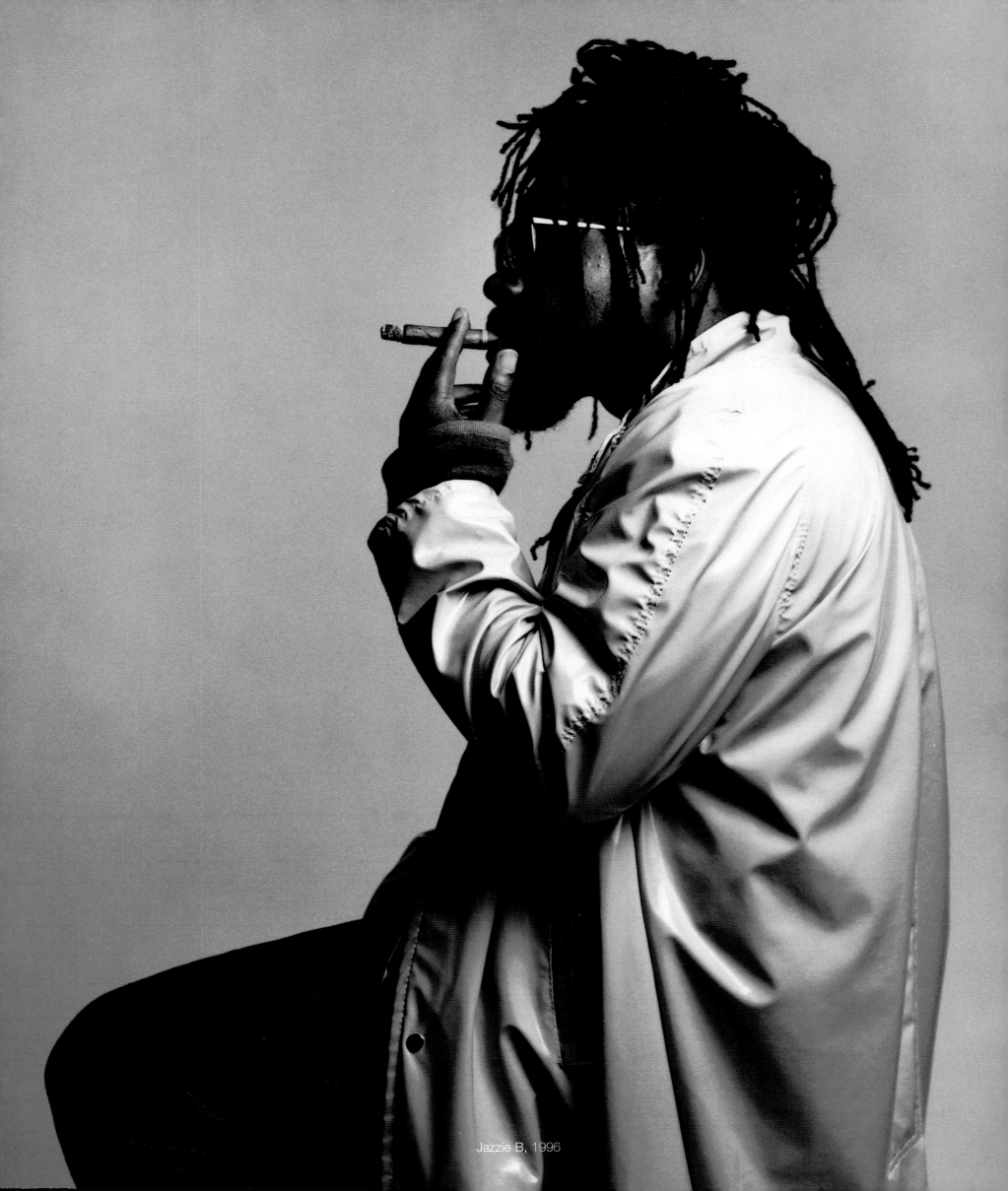

Jazzie B, 1996

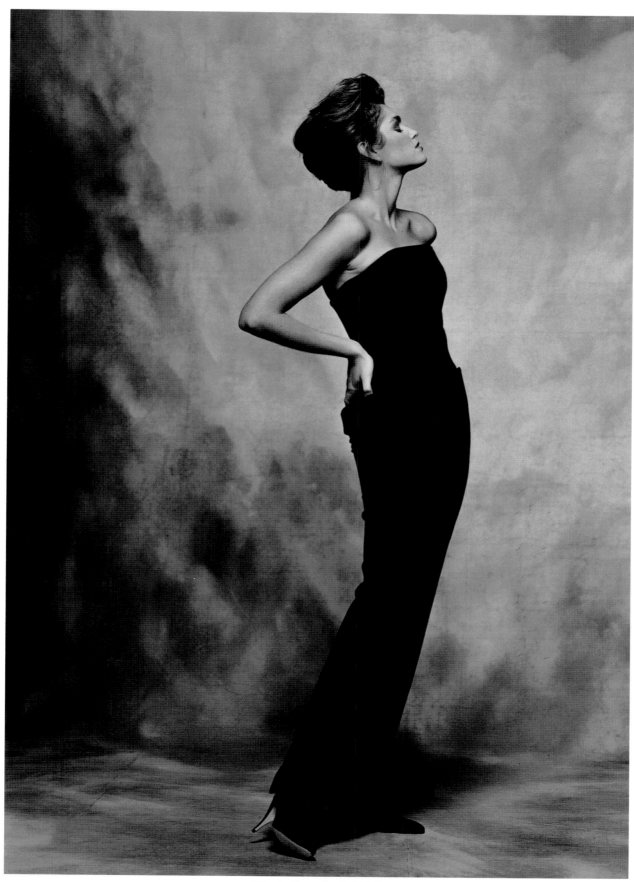

Cindy Crawford, 1988

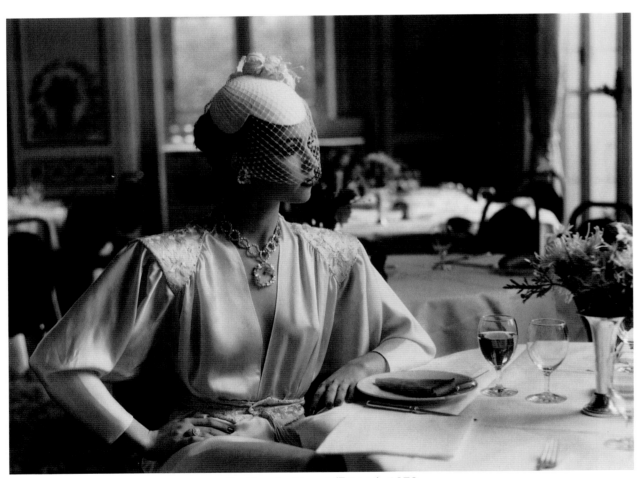

Fashion for *Vogue* (France), 1979

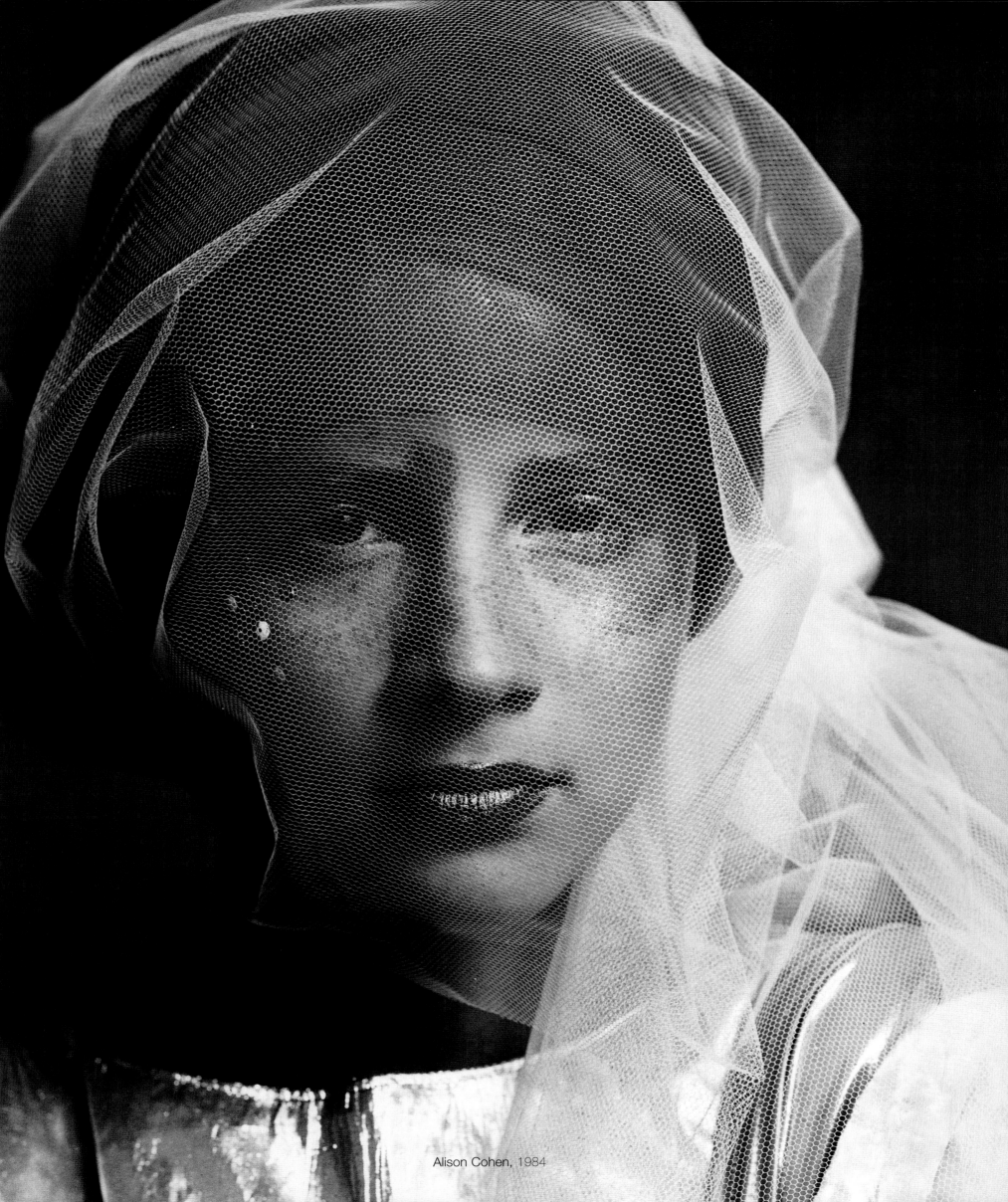
Alison Cohen, 1984

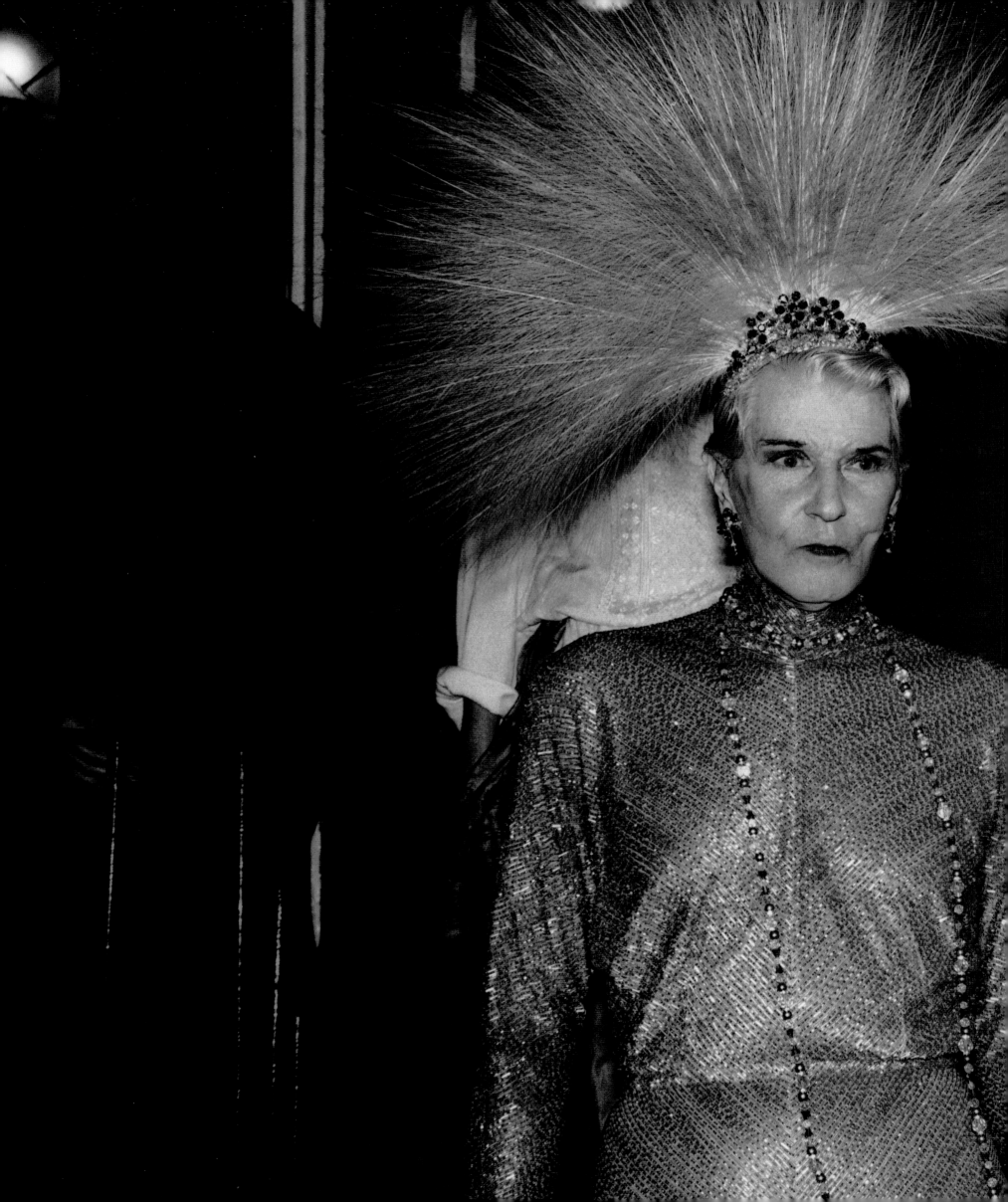

Bunny Roger, 1981

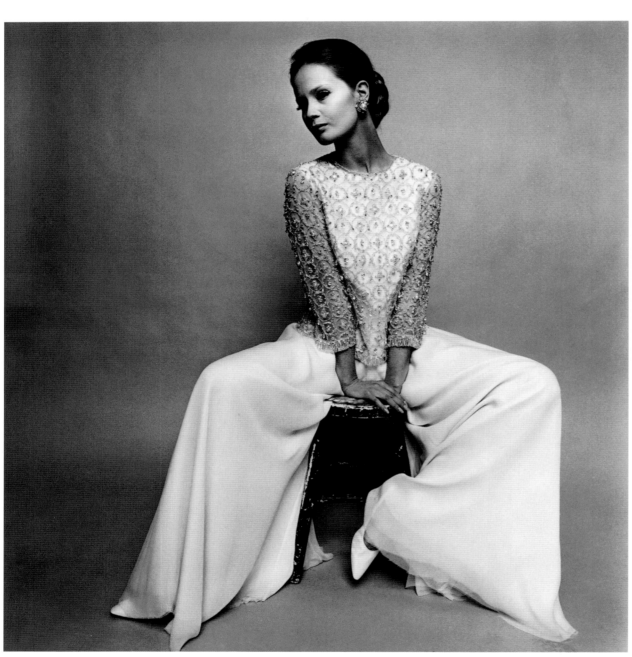

Celia Hammond, 1964

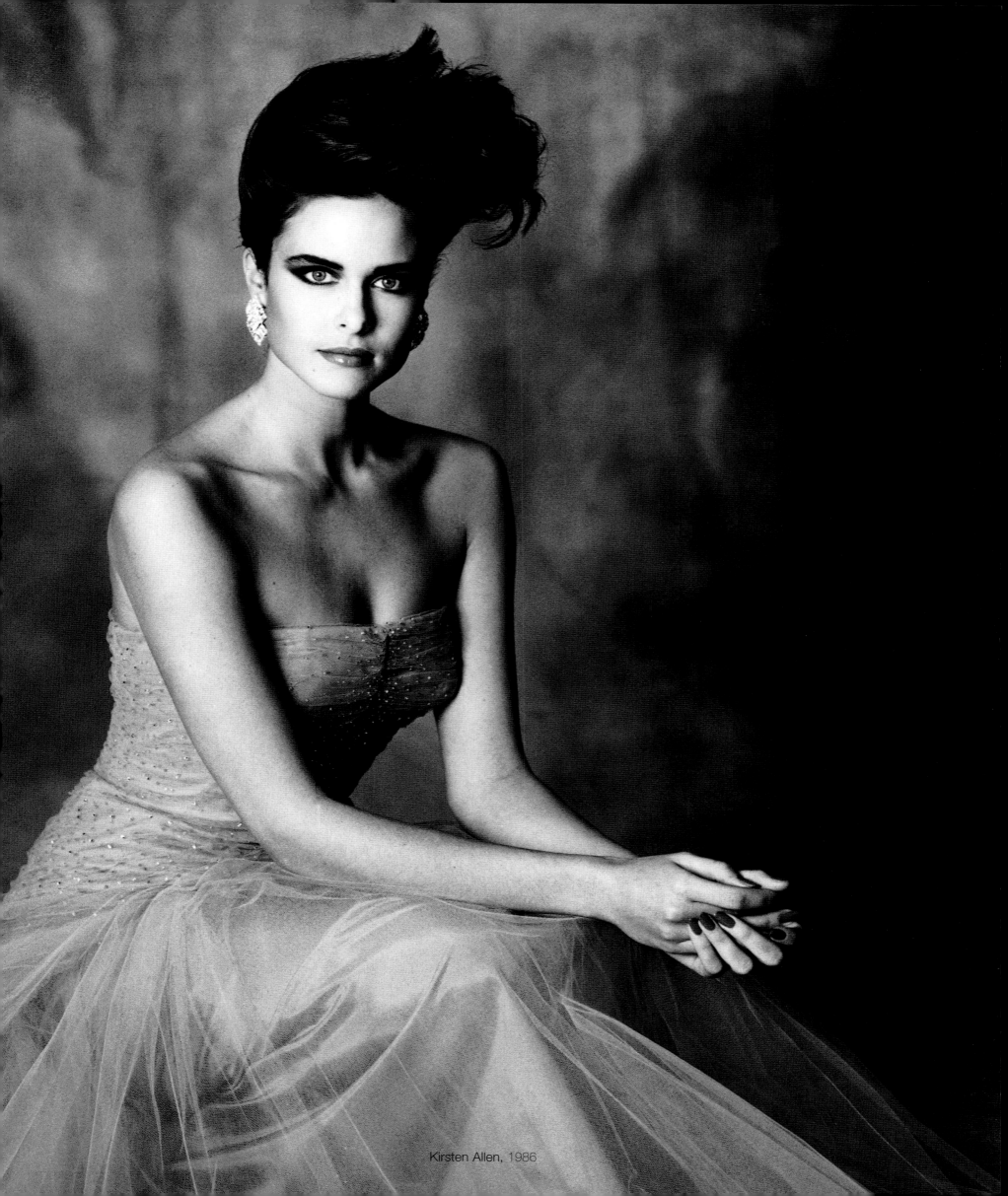

Kirsten Allen, 1986

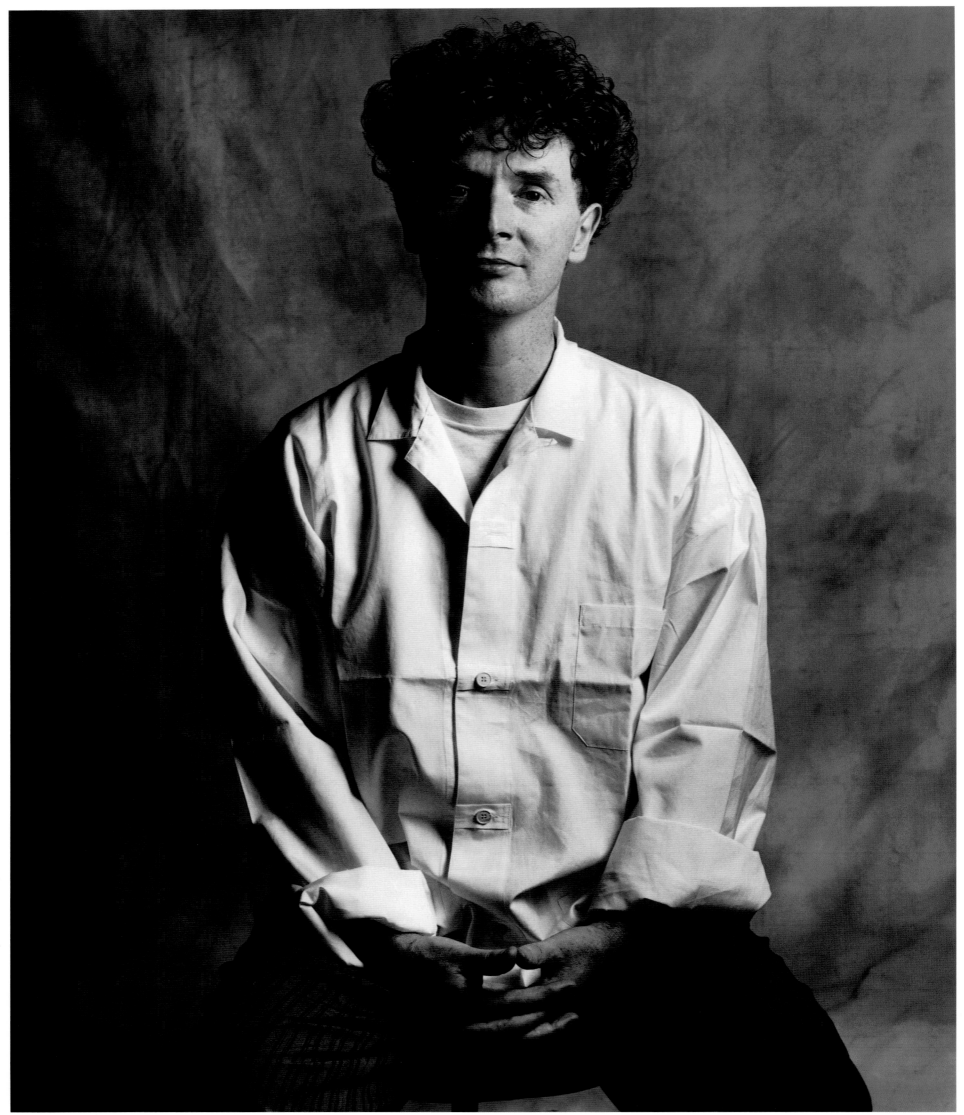

Malcolm McLaren, 1984

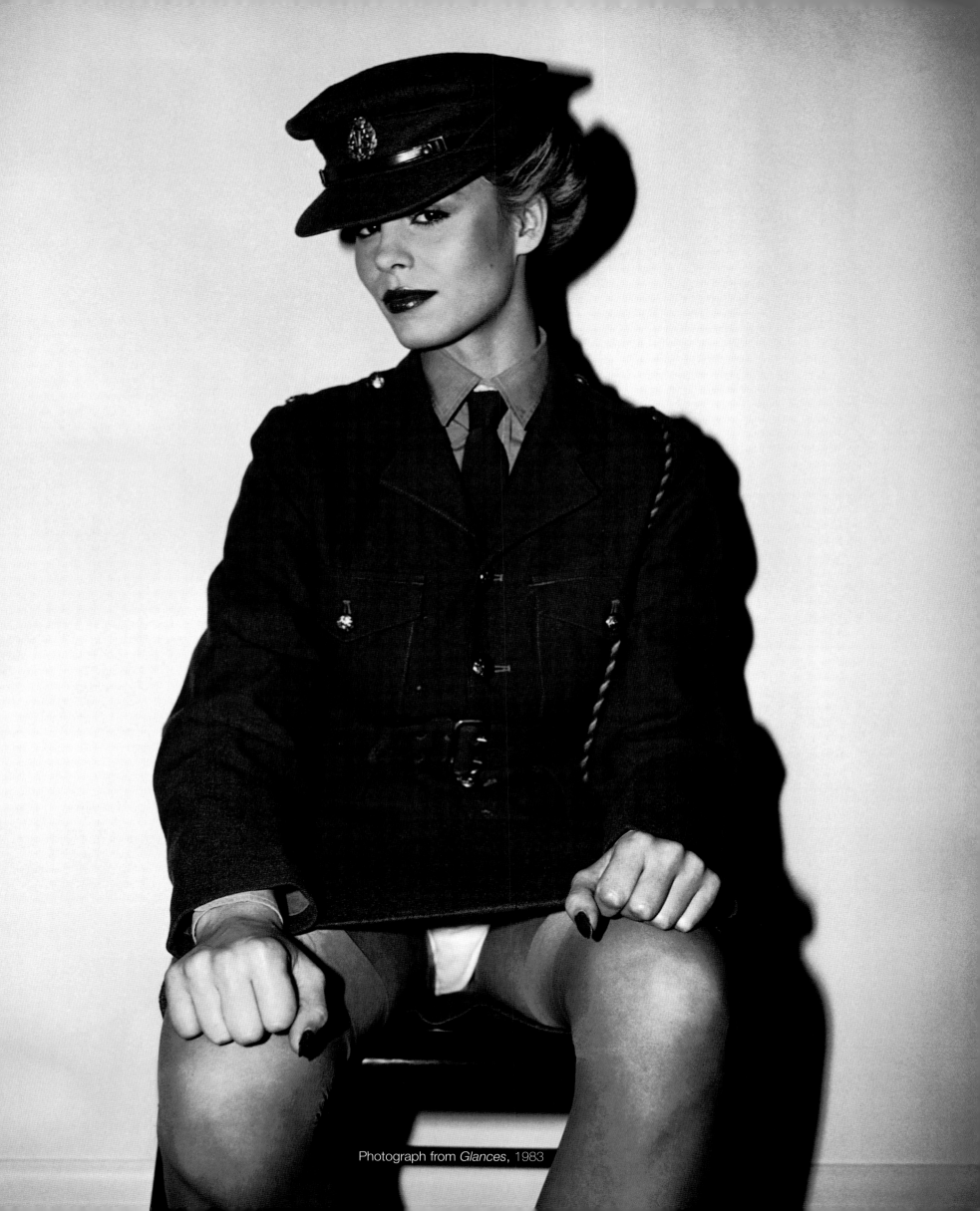

Photograph from *Glances*, 1983

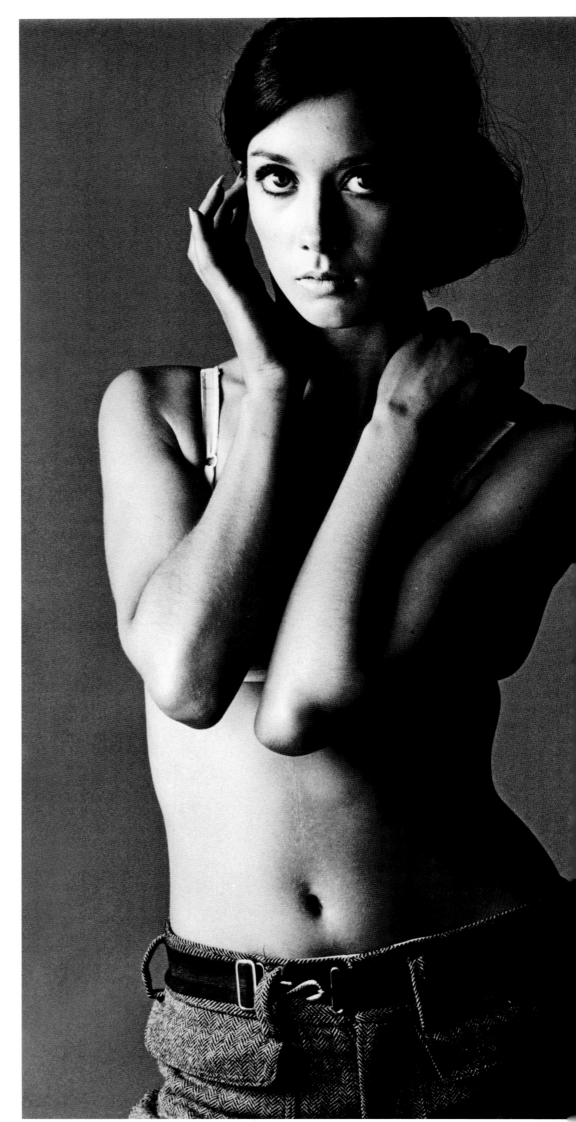

Moyra Swan, 1966

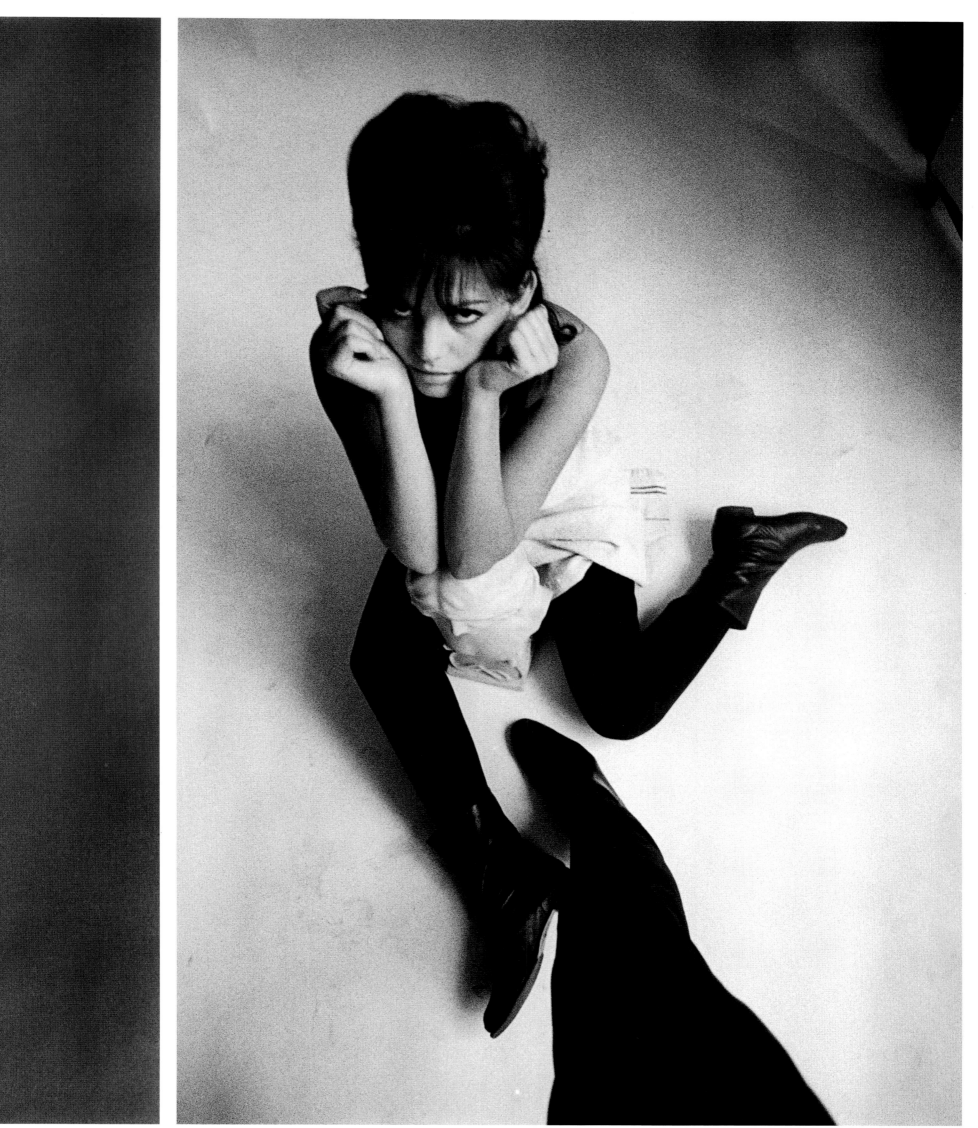

Claudia Cardinale, 1962

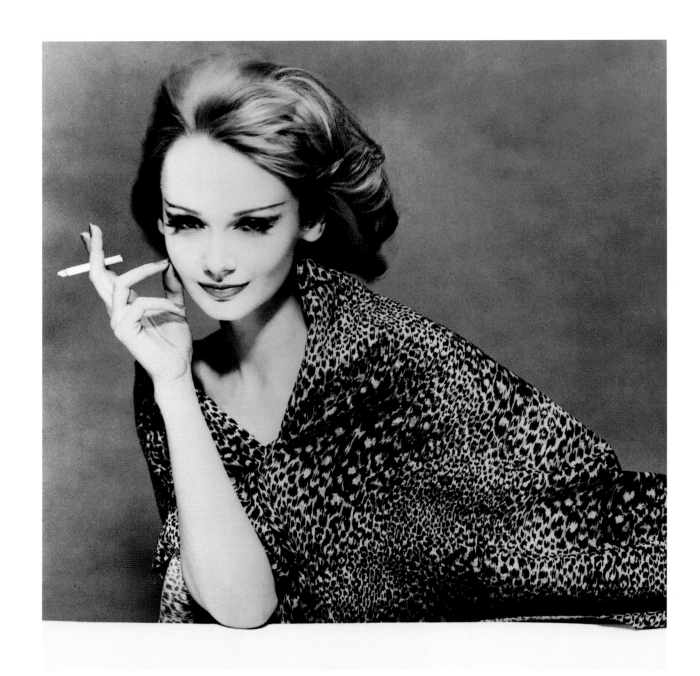

Linda Cuneo, 1961

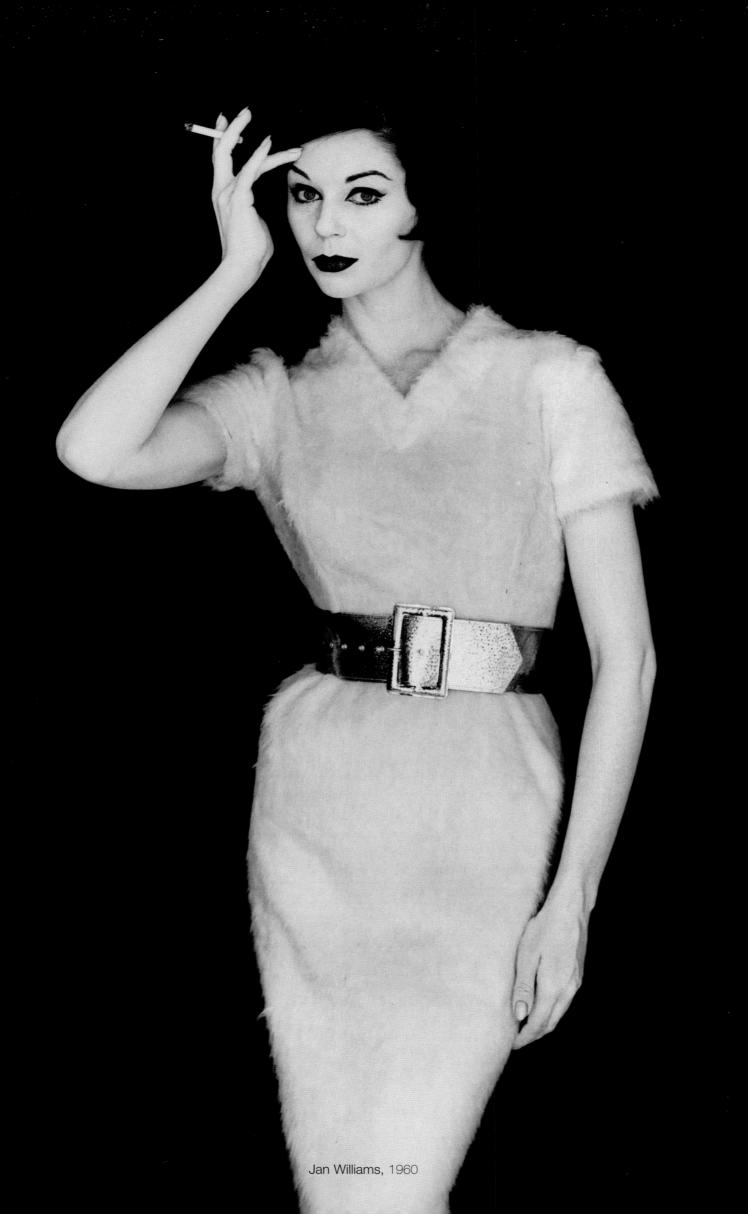

Jan Williams, 1960

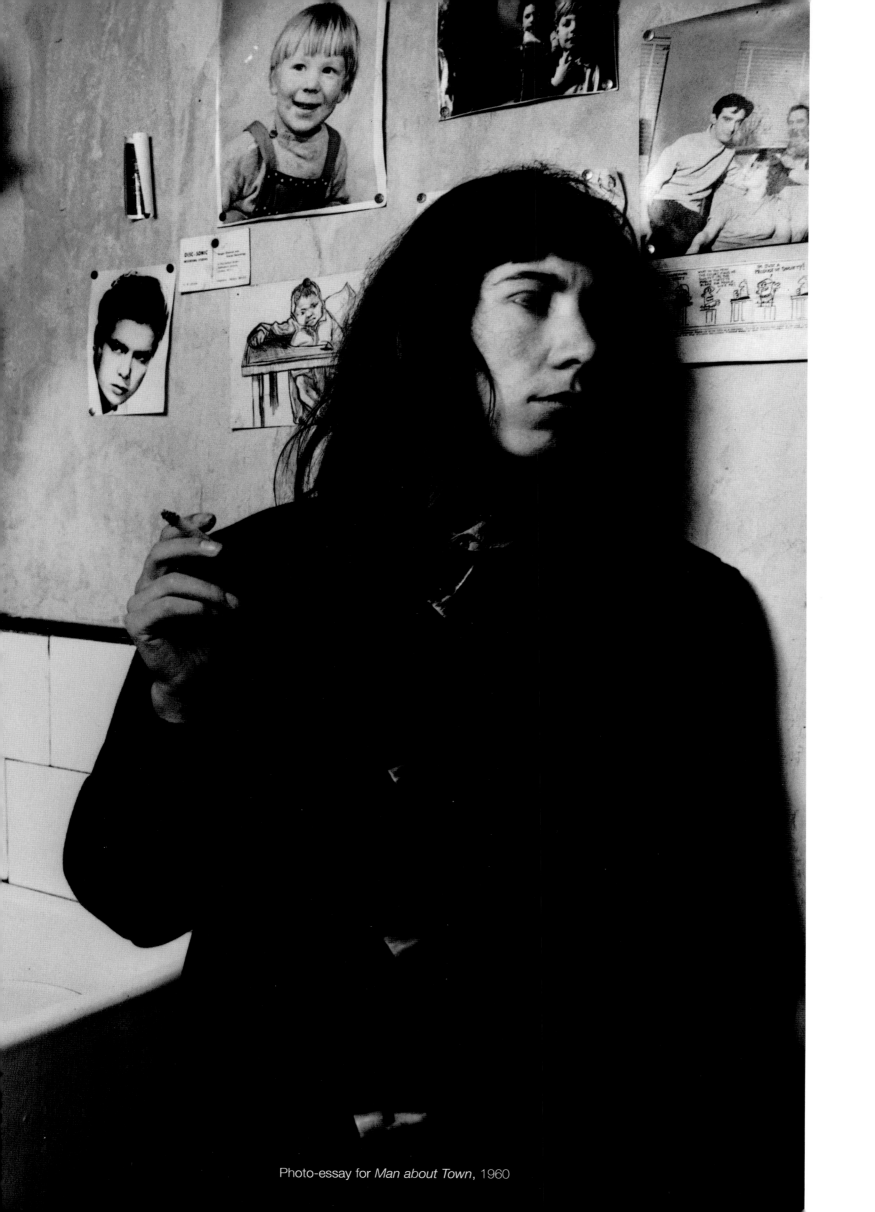
Photo-essay for *Man about Town*, 1960

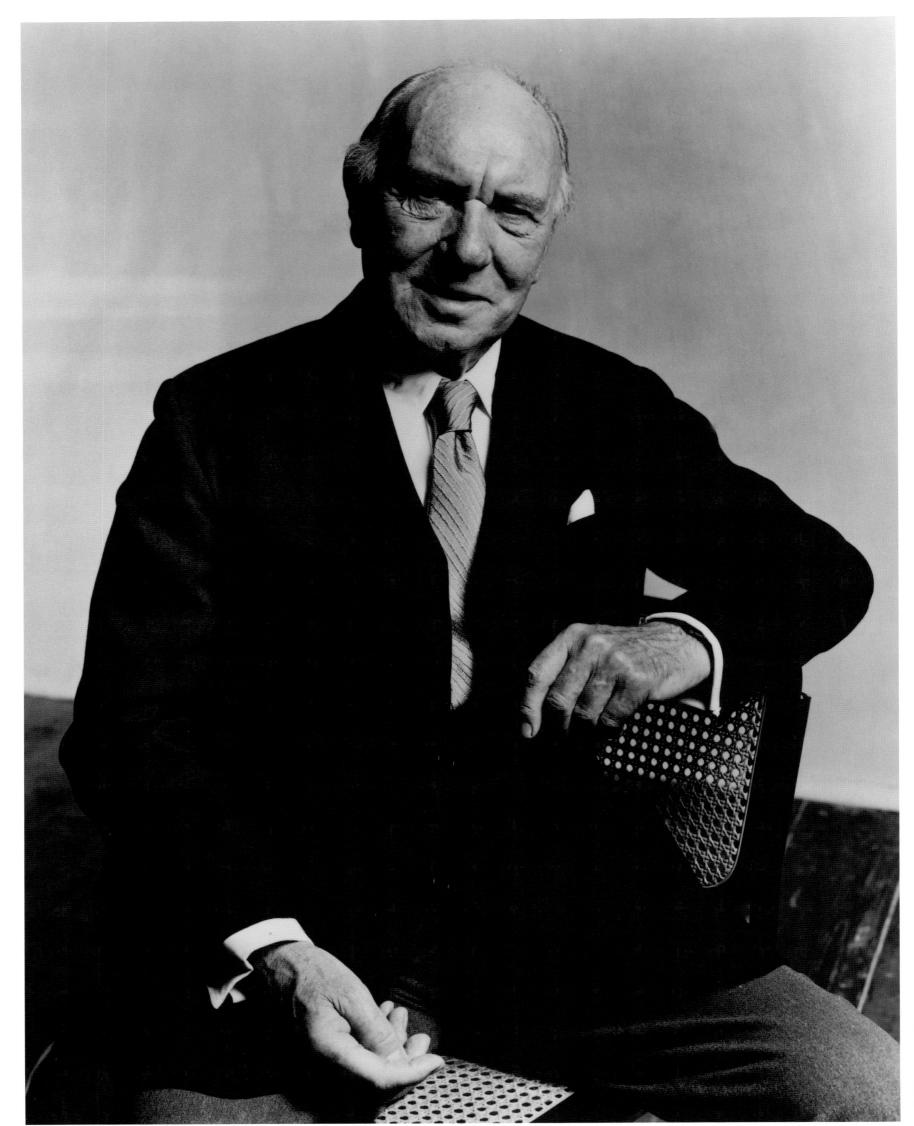

Sir Ralph Richardson, 1980

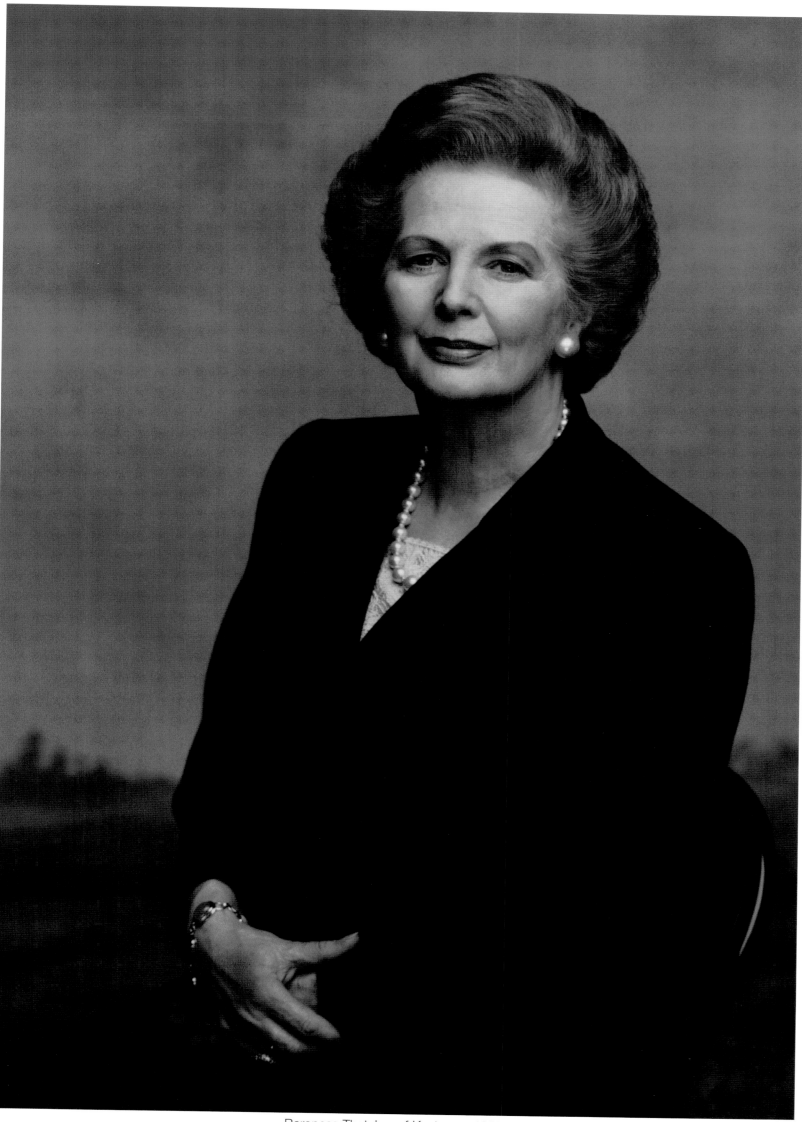

Baroness Thatcher of Kesteven, 1995

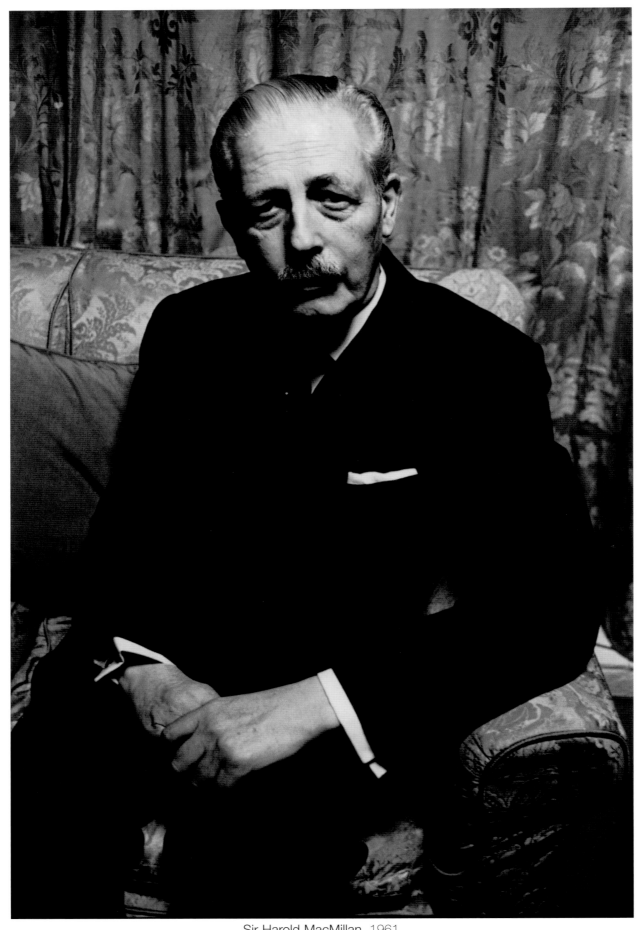

Sir Harold MacMillan, 1961

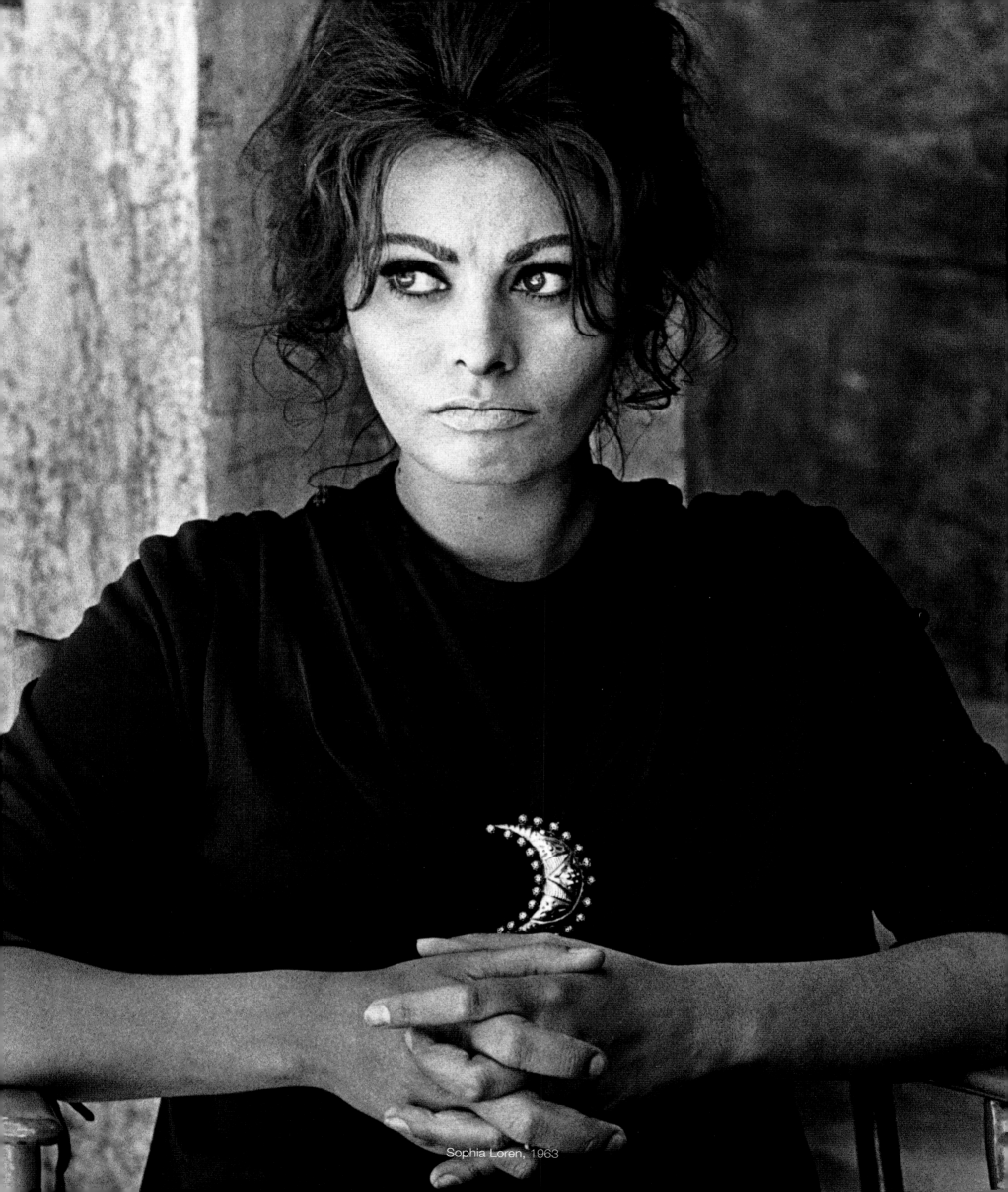

Sophia Loren, 1963

Vicki Ferda, 1987

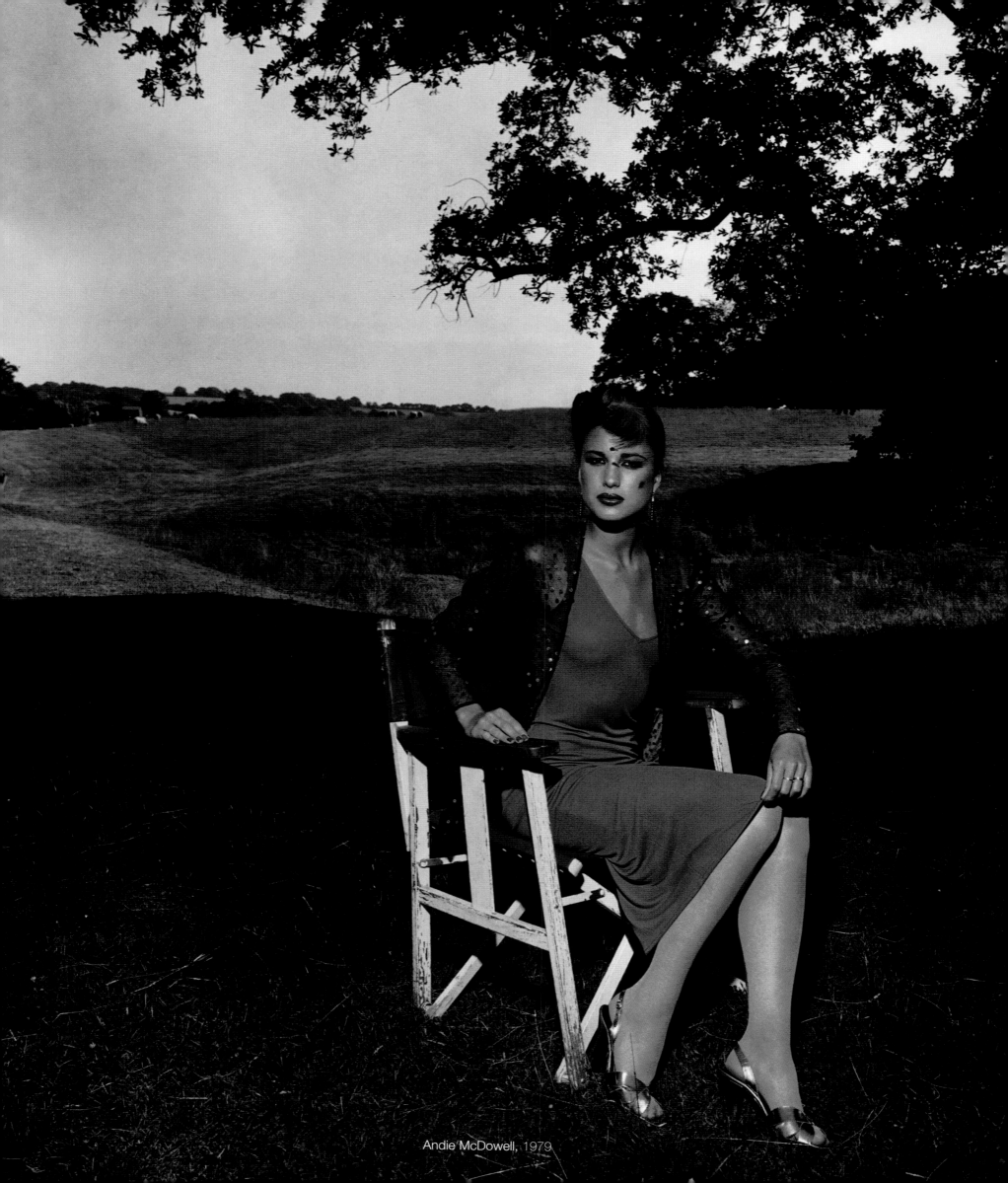

Andie McDowell, 1979

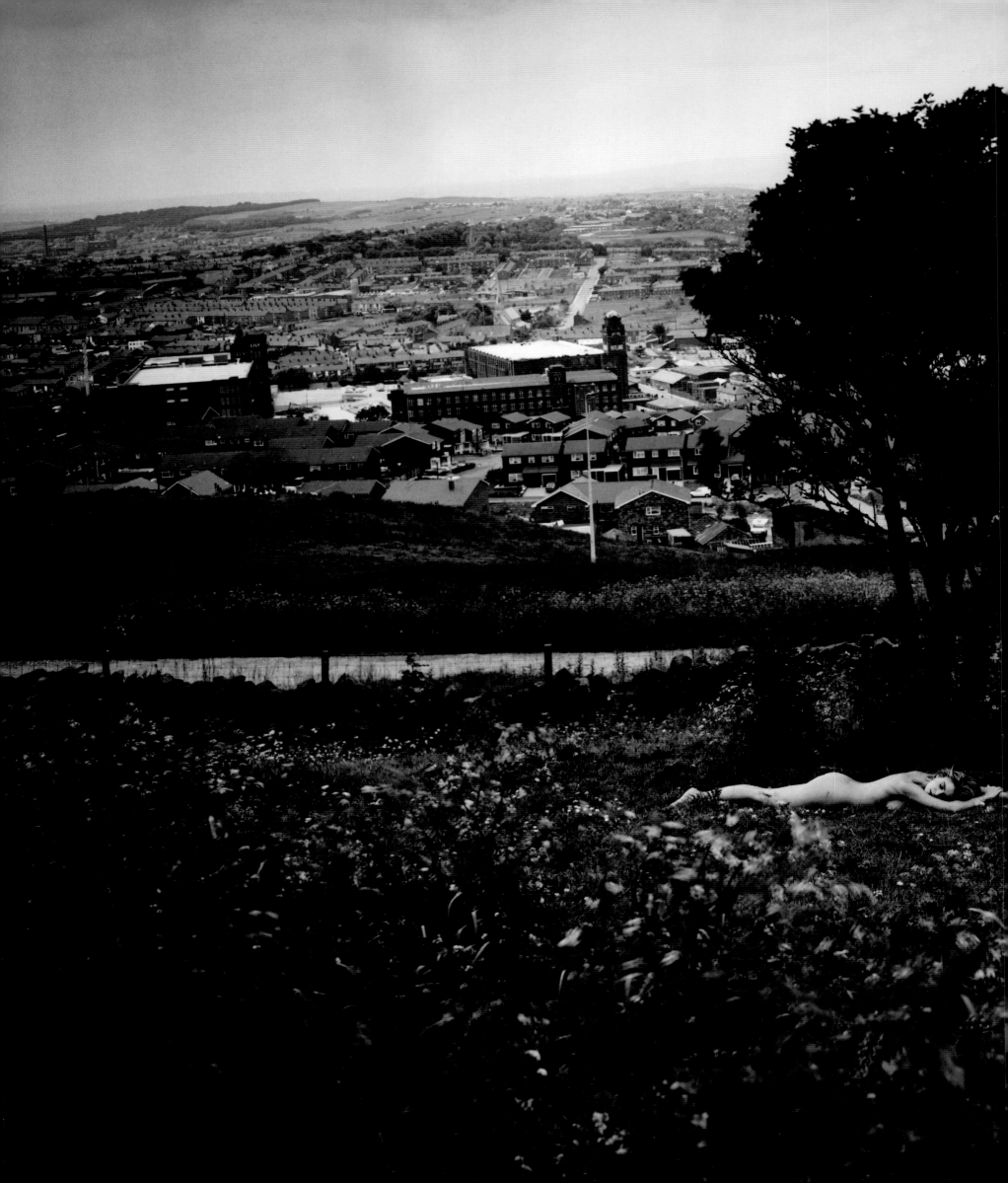

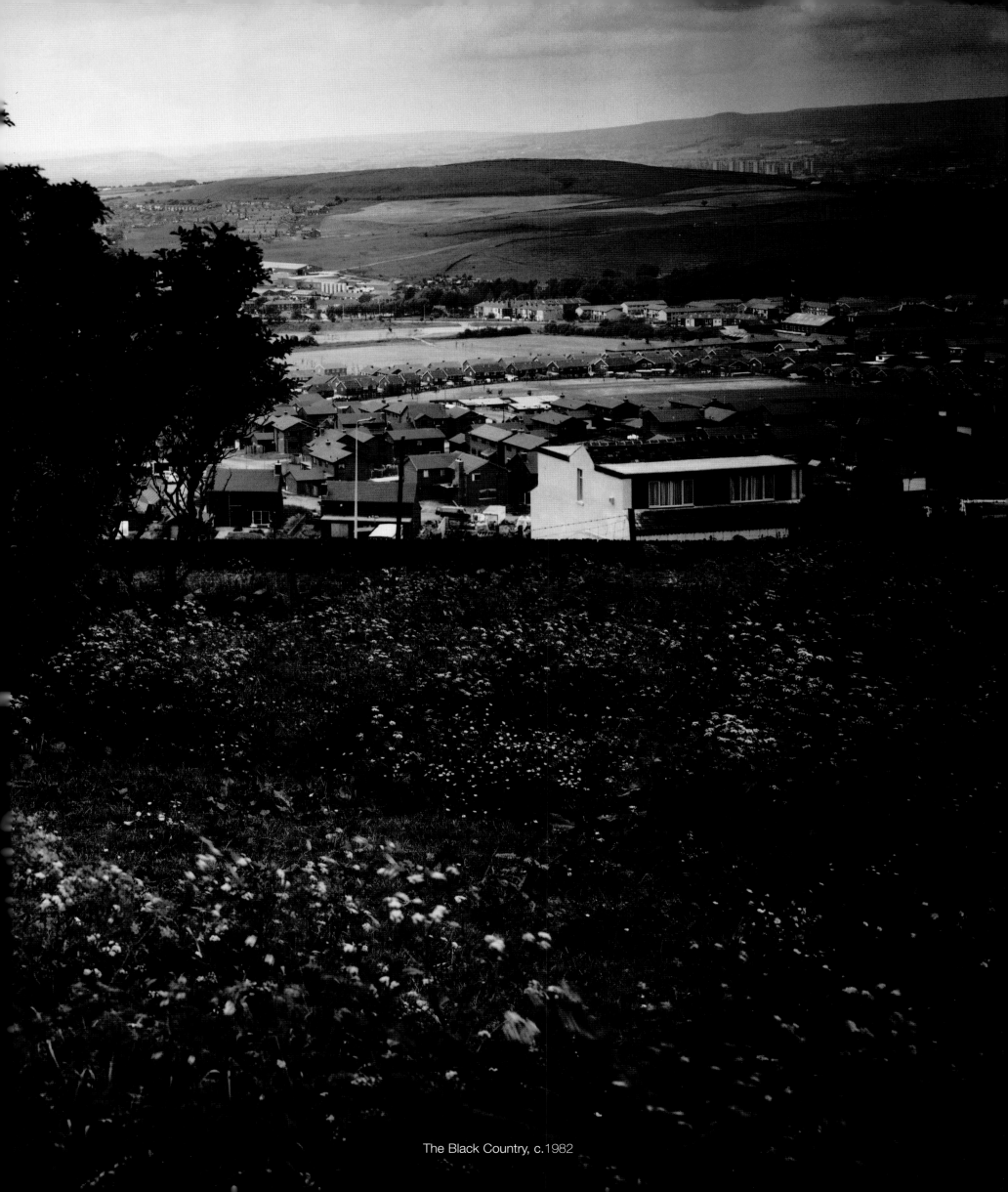

The Black Country, c.1982

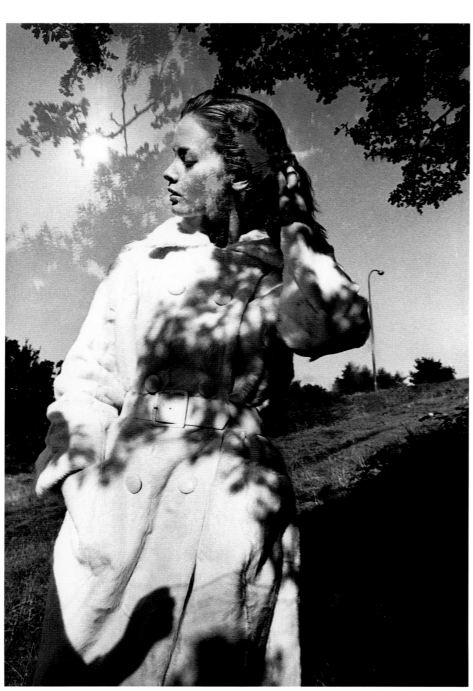

Celia Hammond, 1963

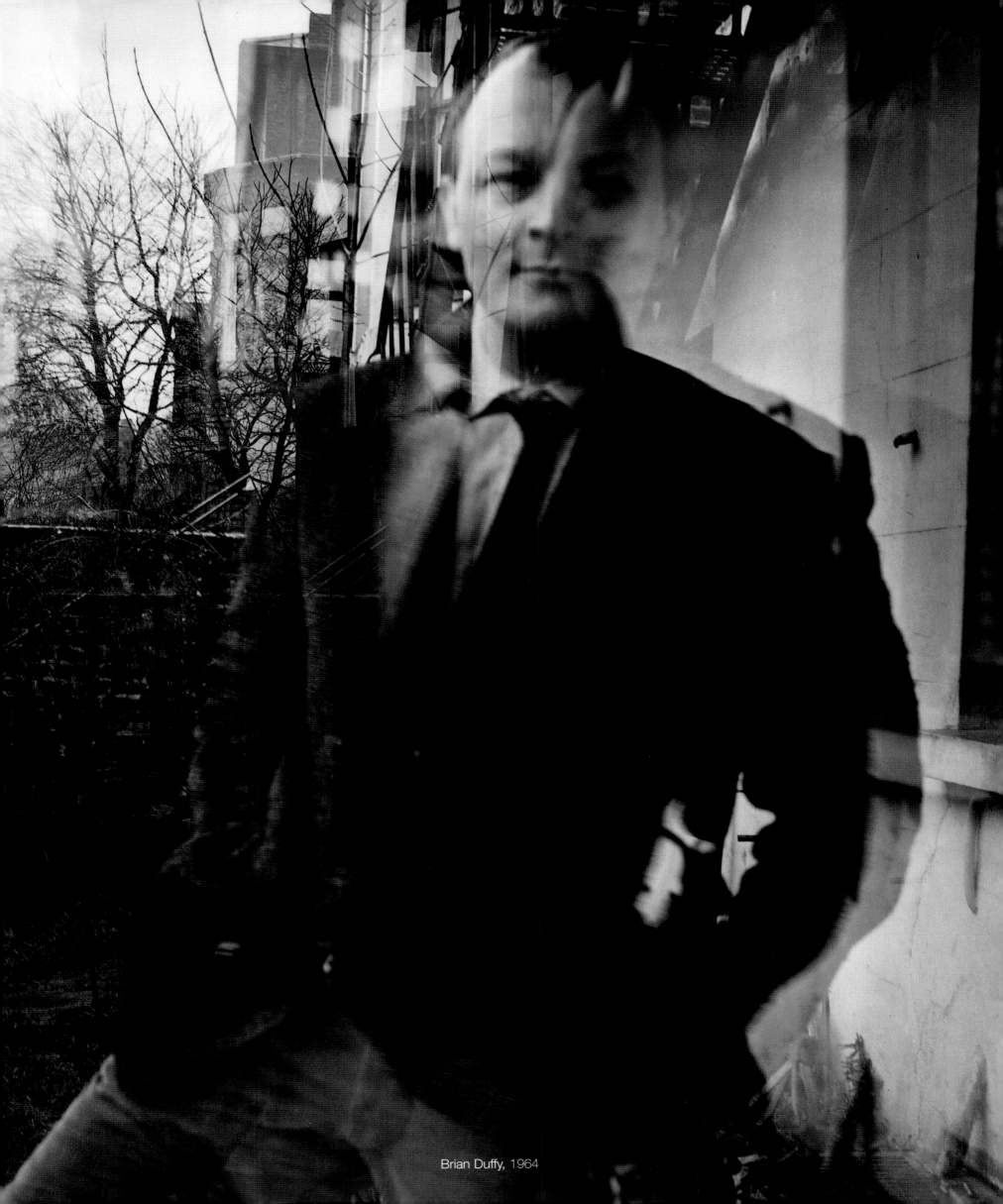

Brian Duffy, 1964

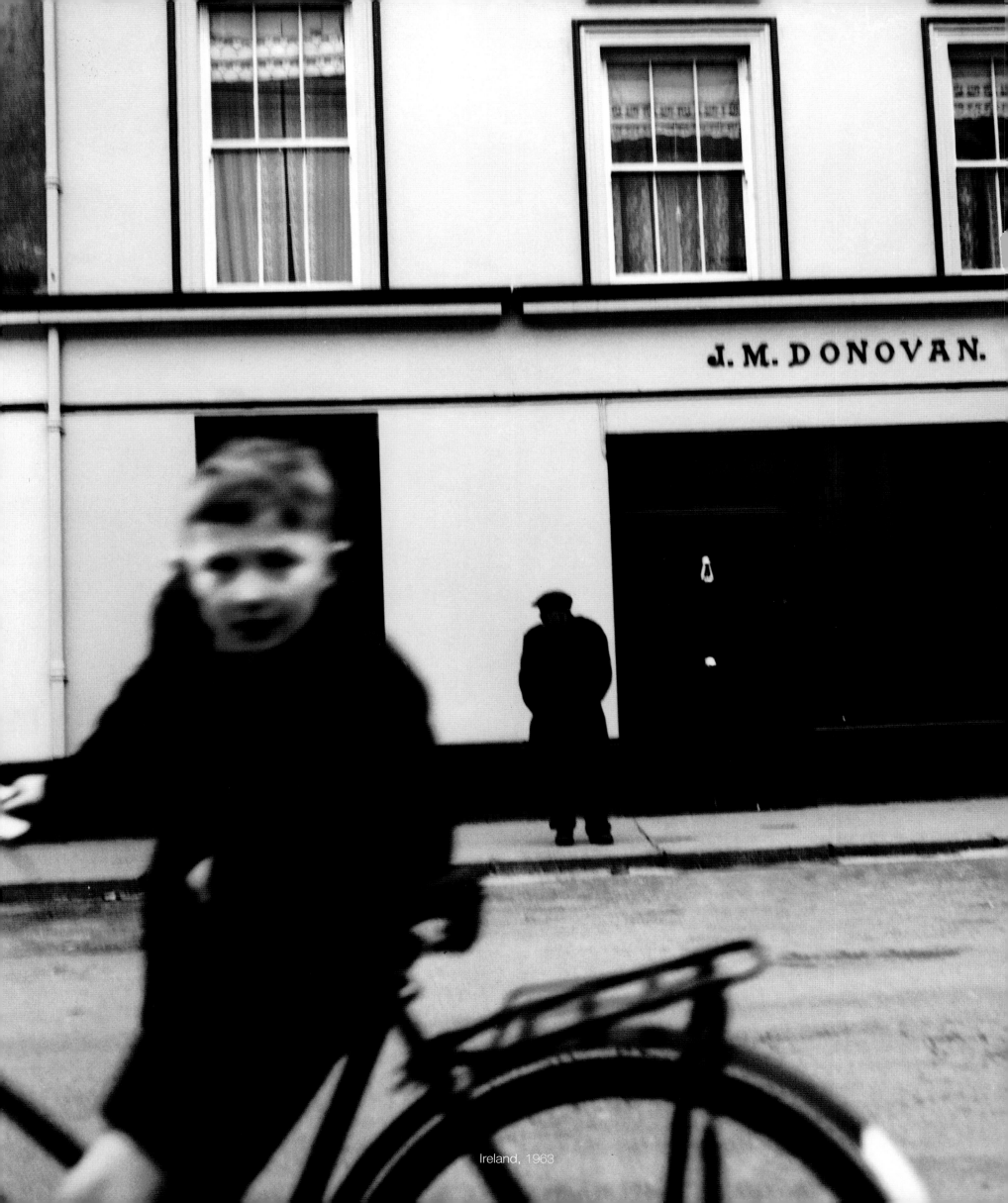
Ireland, 1963

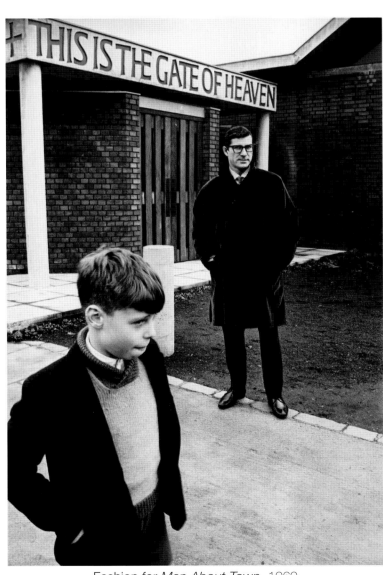

Fashion for *Man About Town*, 1960

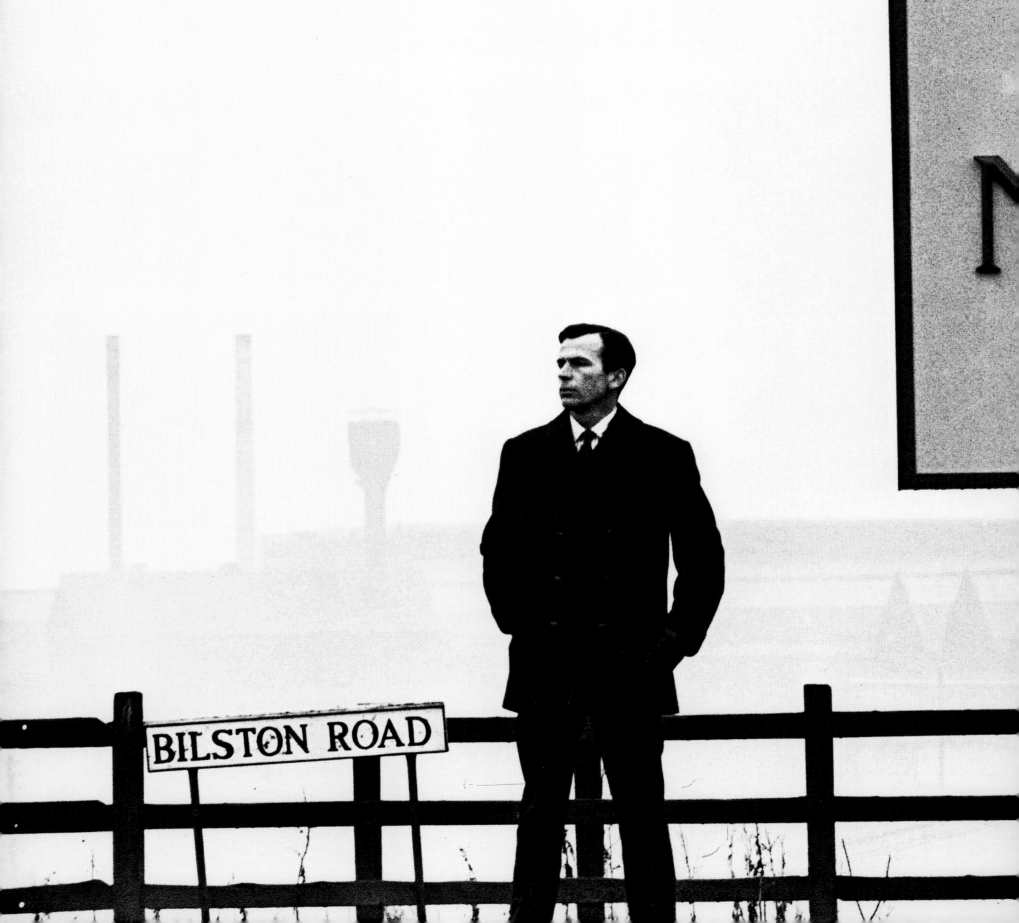

Fashion for *Man About Town*, 1960

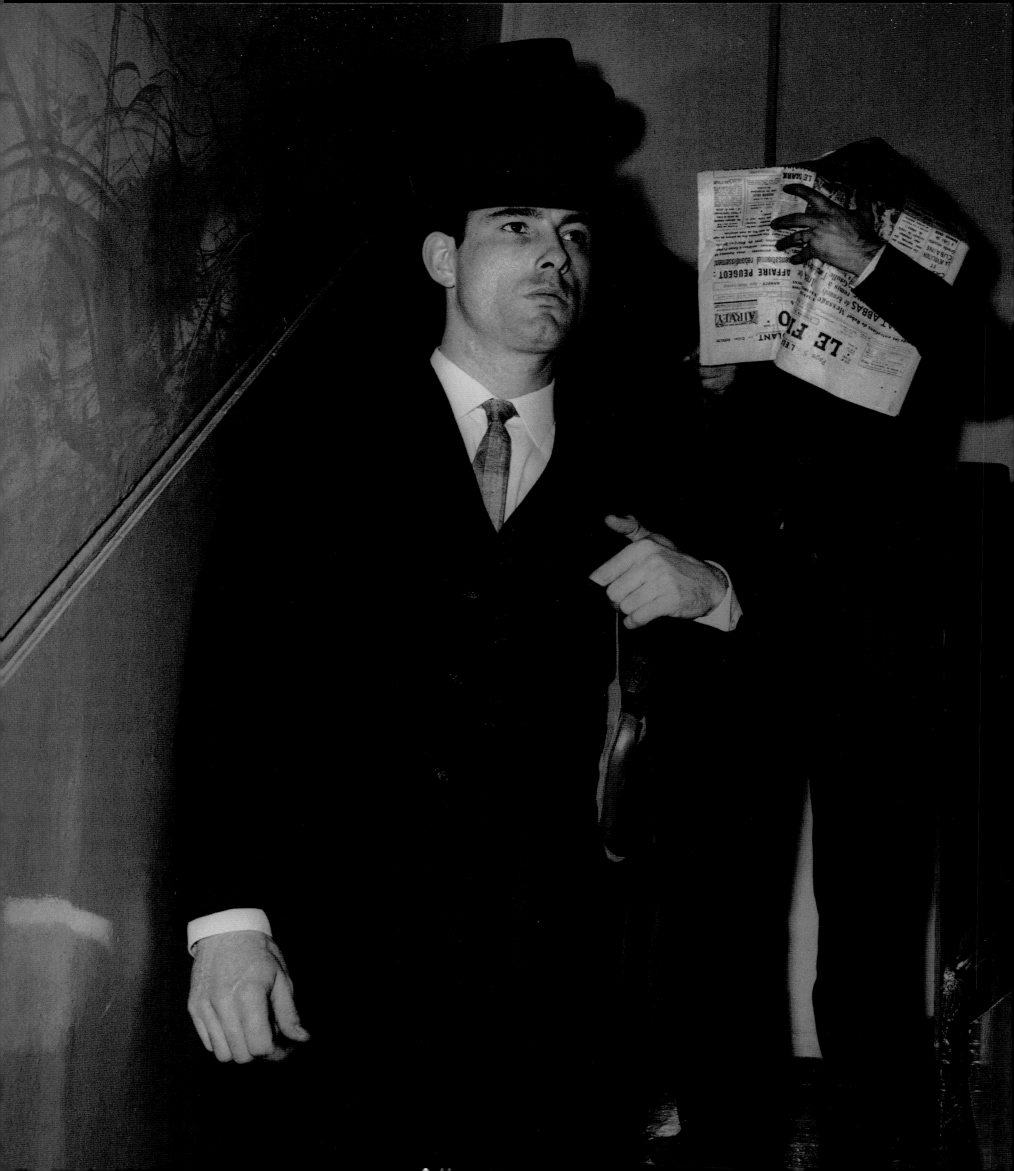

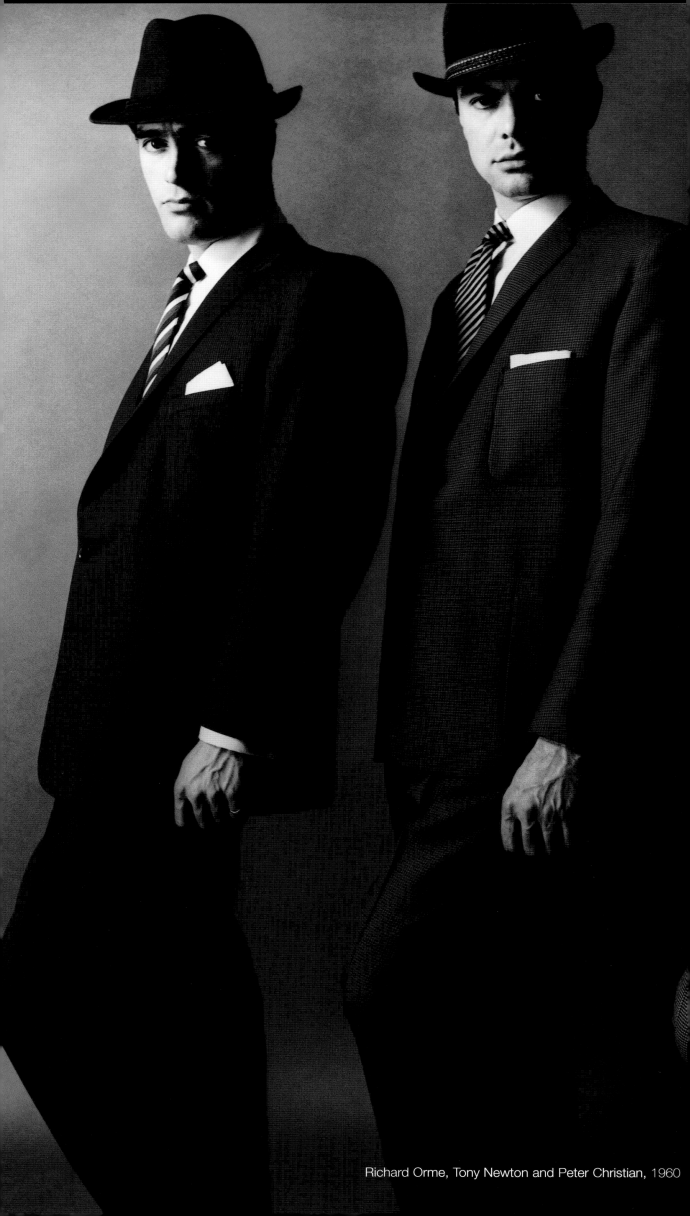

Richard Orme, Tony Newton and Peter Christian, 1960

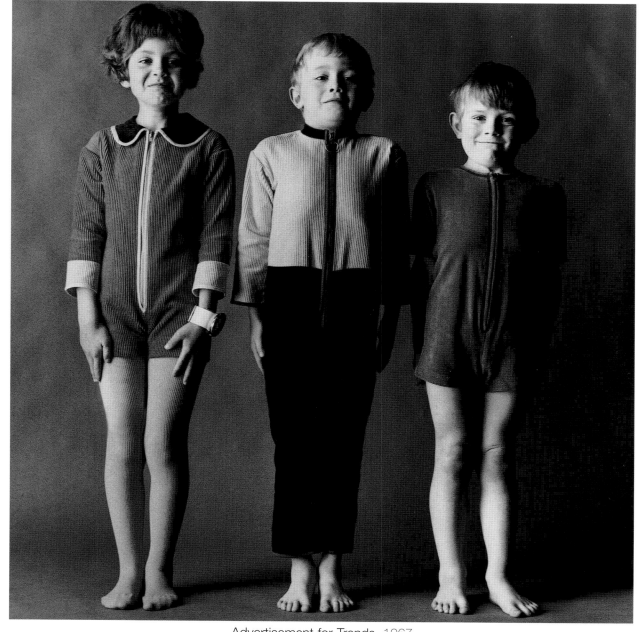

Advertisement for Trends, 1967

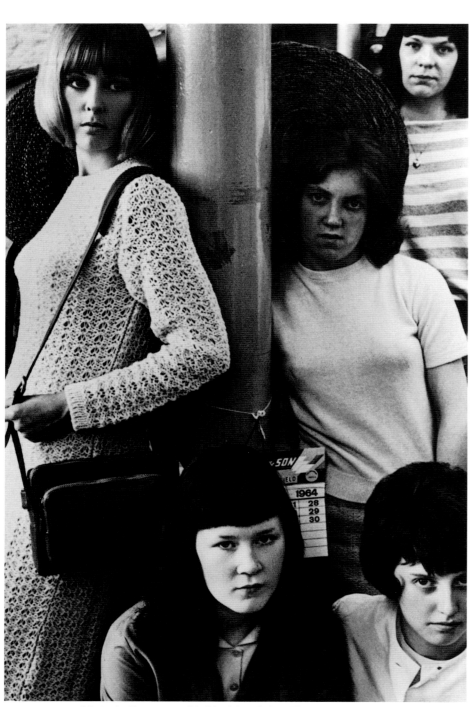

Victoria Stevens with Huddersfield Mill workers, 1964

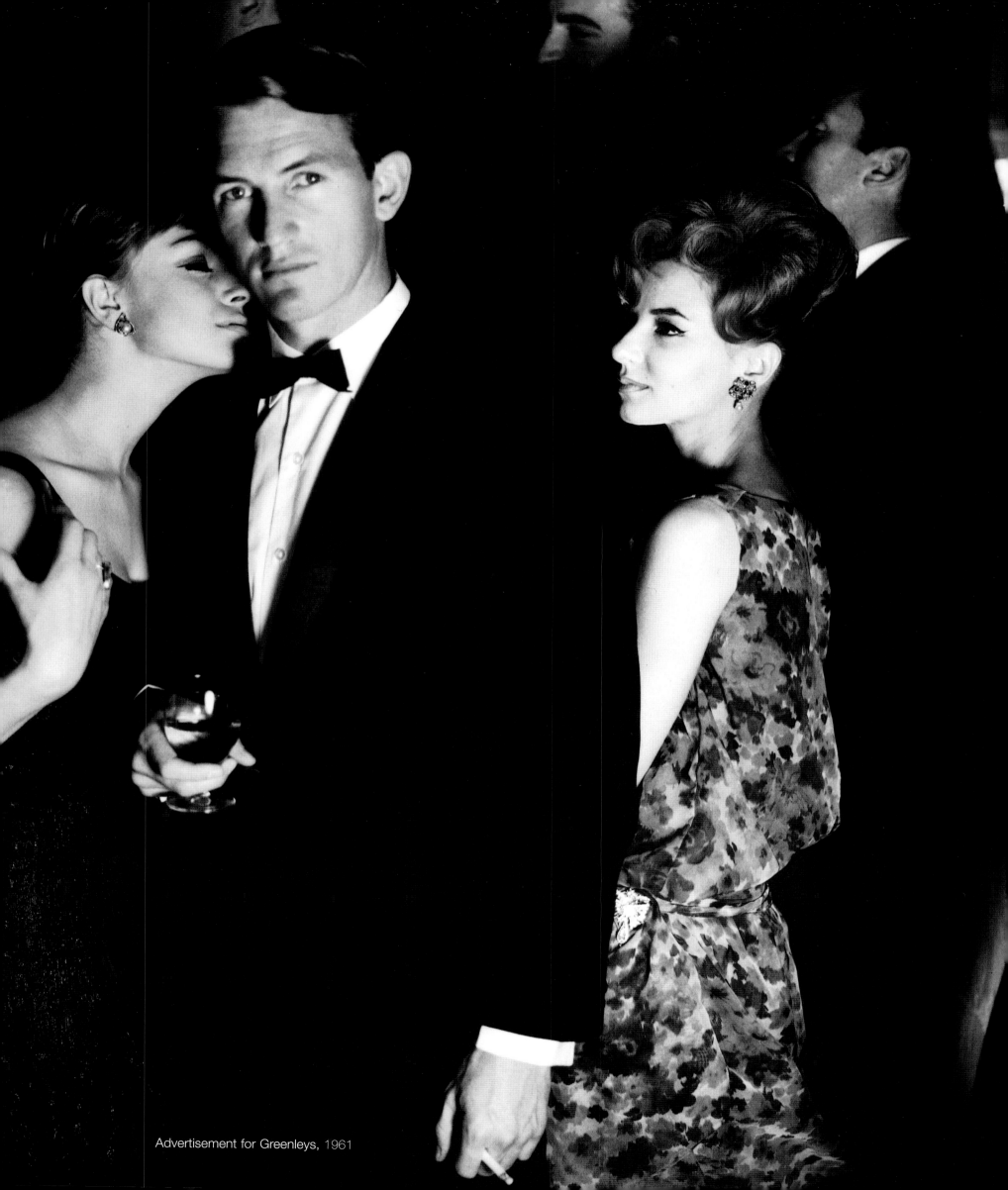

Advertisement for Greenleys, 1961

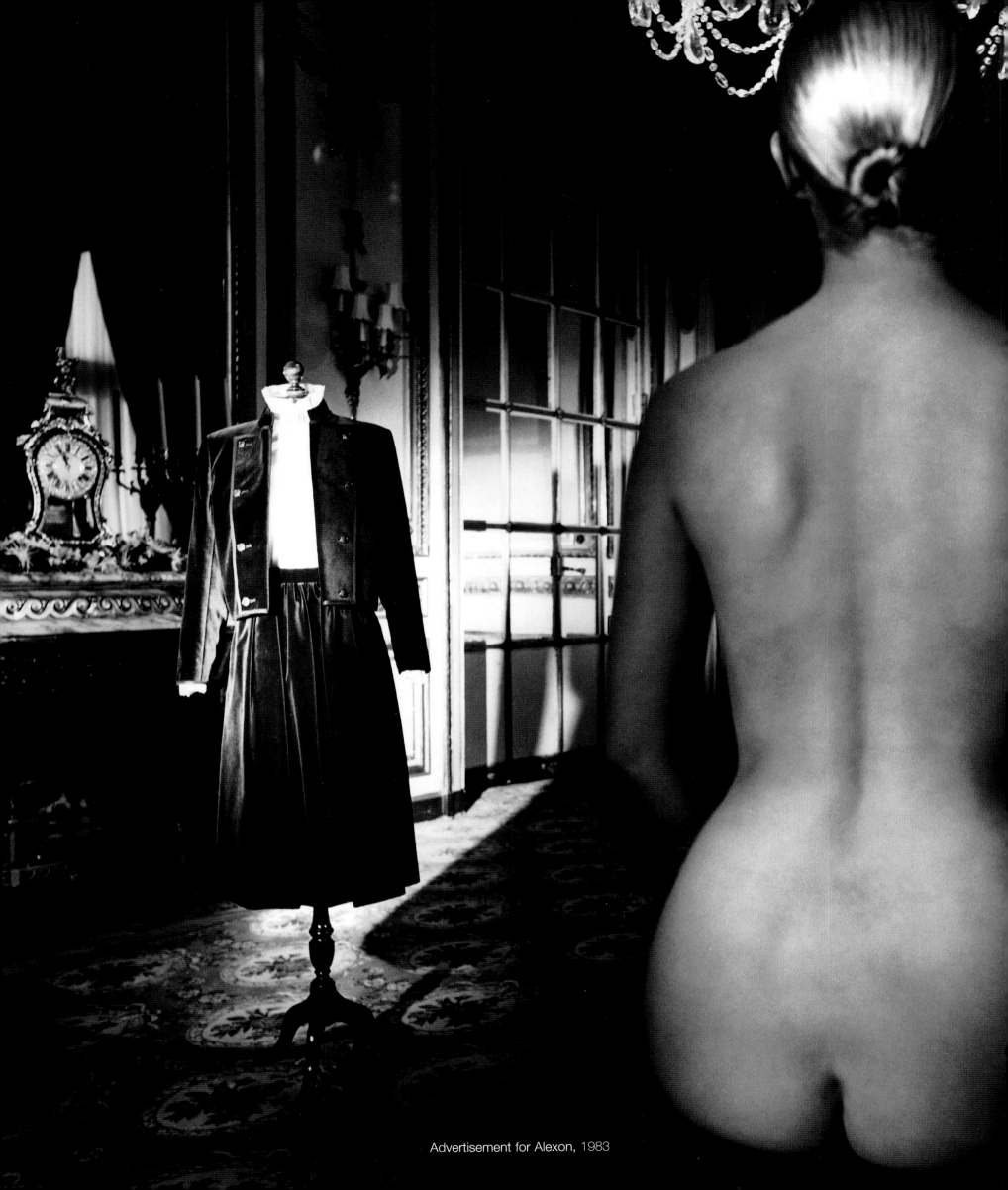

Advertisement for Alexon, 1983

Dress by Jasper Conran, 1994

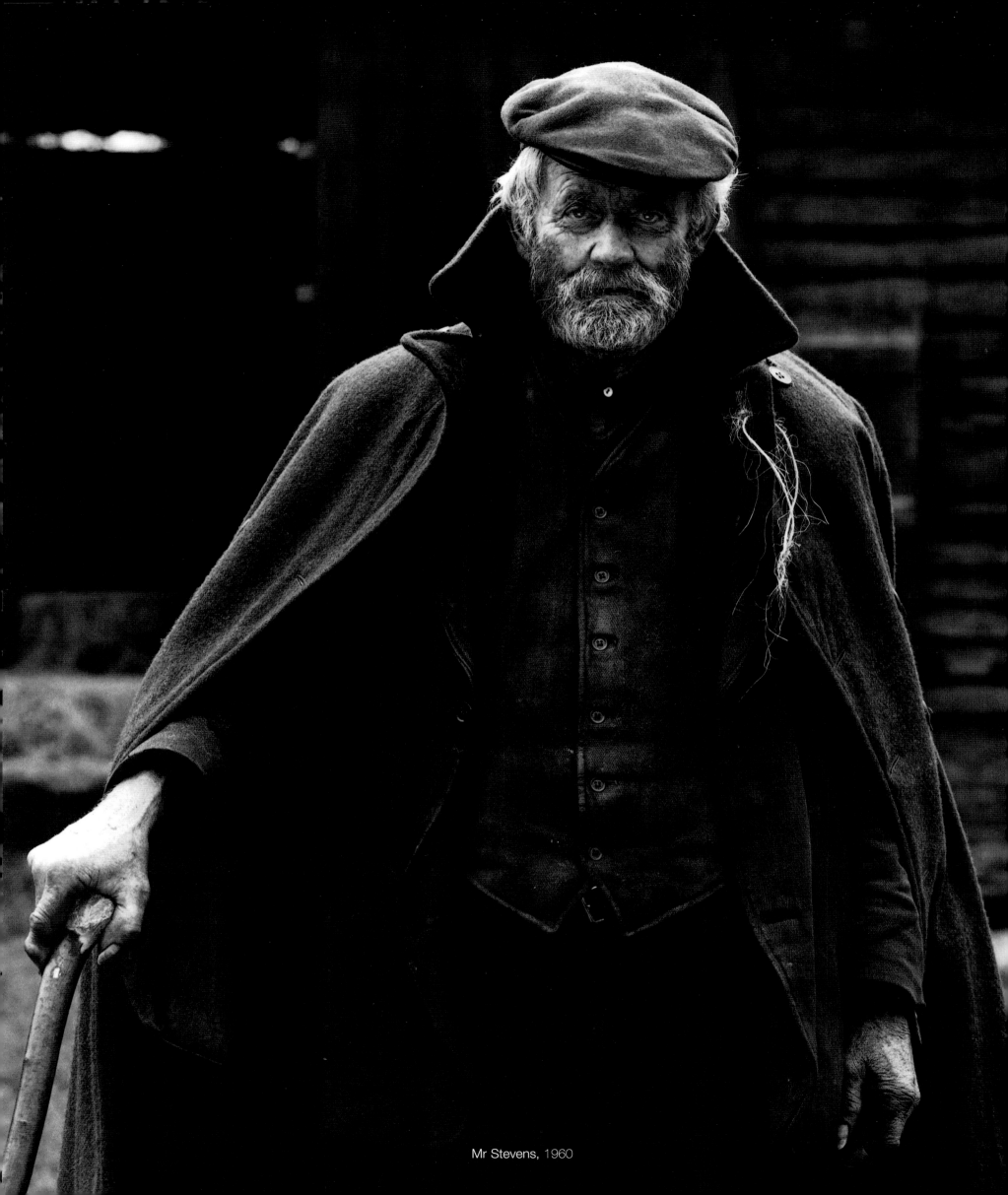

Mr Stevens, 1960

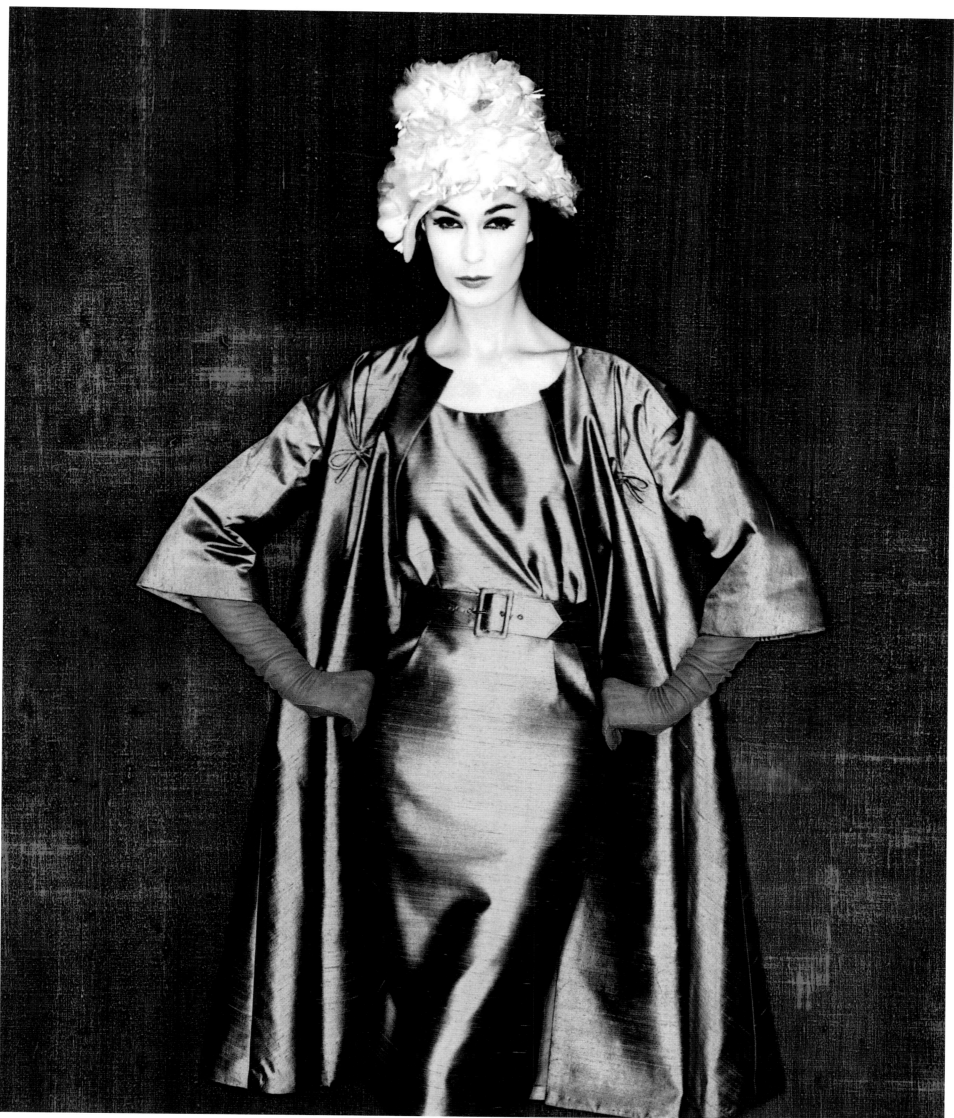

Maggie Benn, 1961

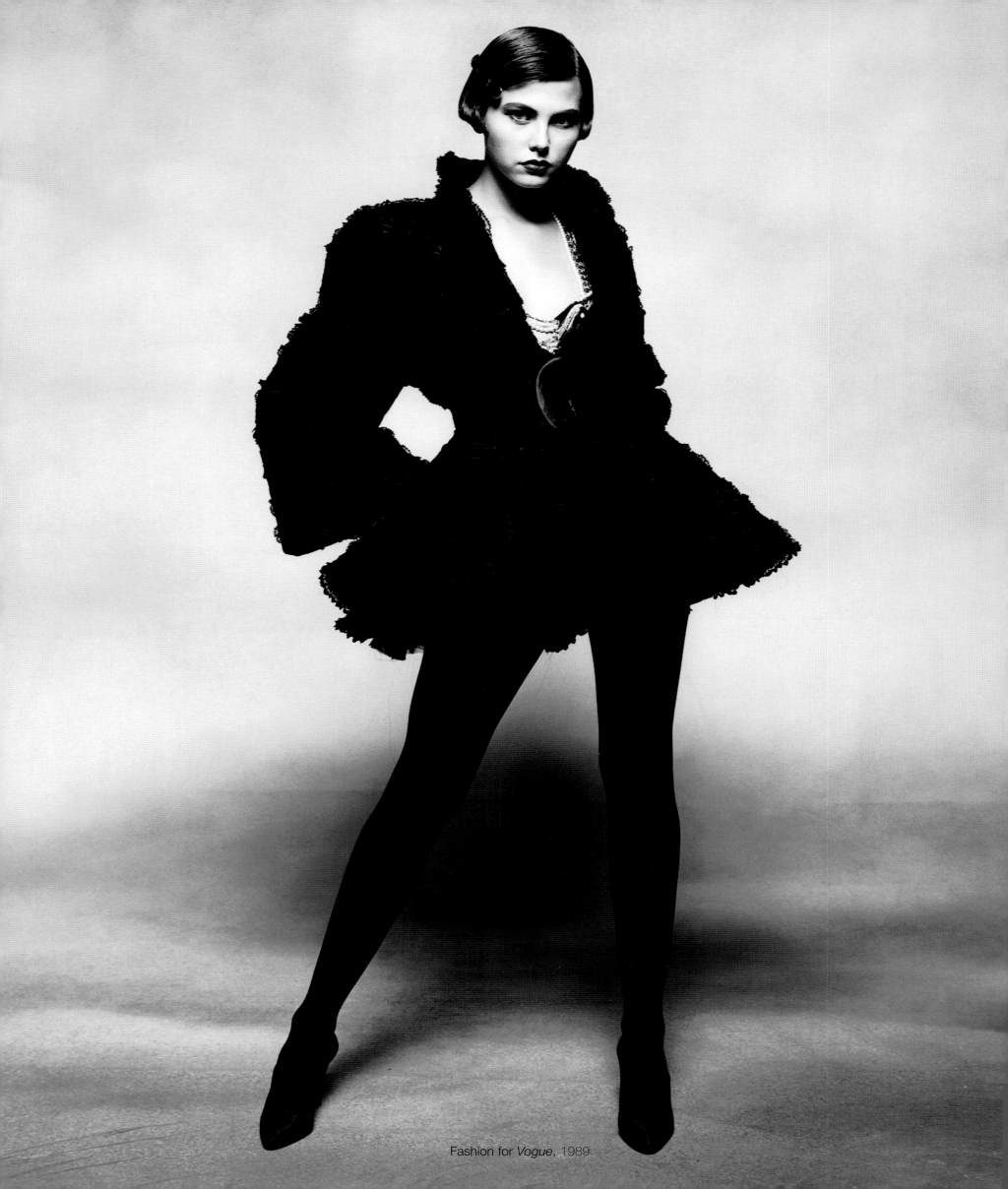

Fashion for *Vogue*, 1989

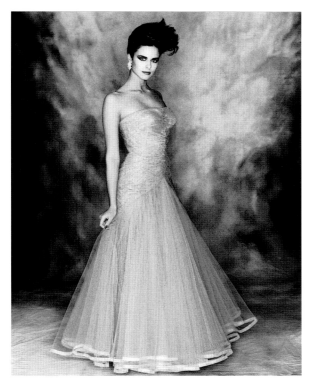

Kirsten Allen, 1986

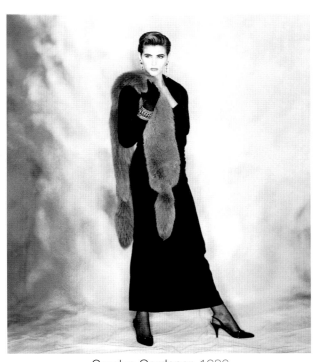

Carolyn Gardener, 1986

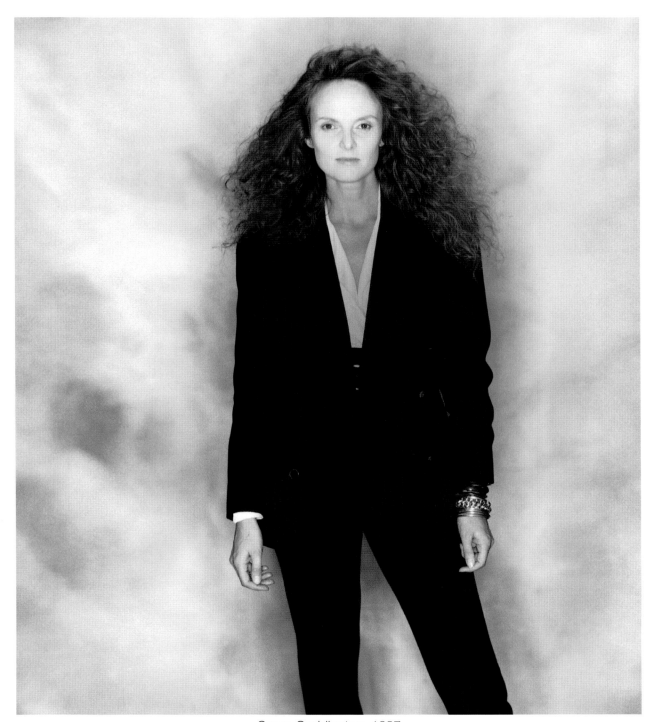

Grace Coddington, 1987

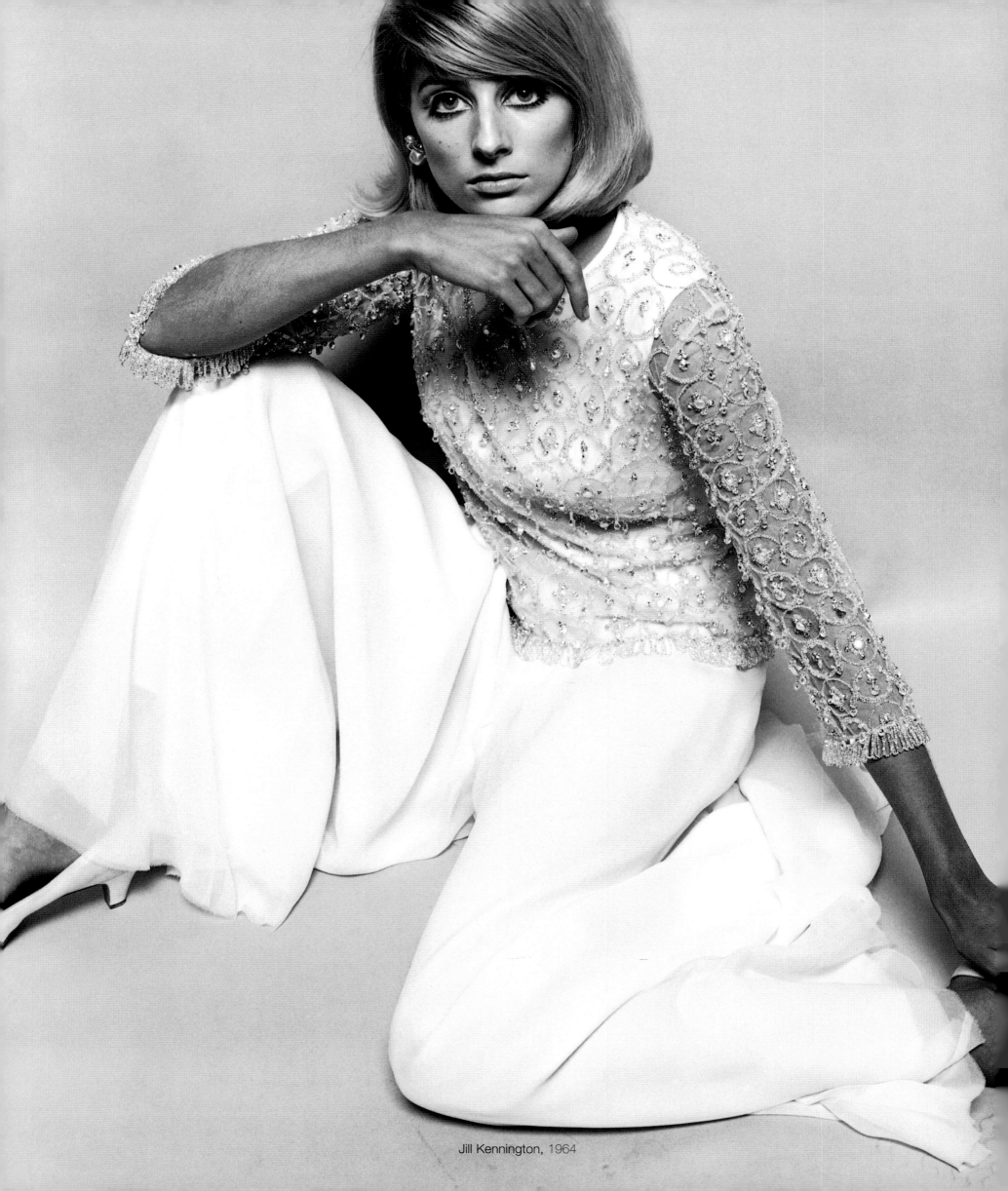

Jill Kennington, 1964

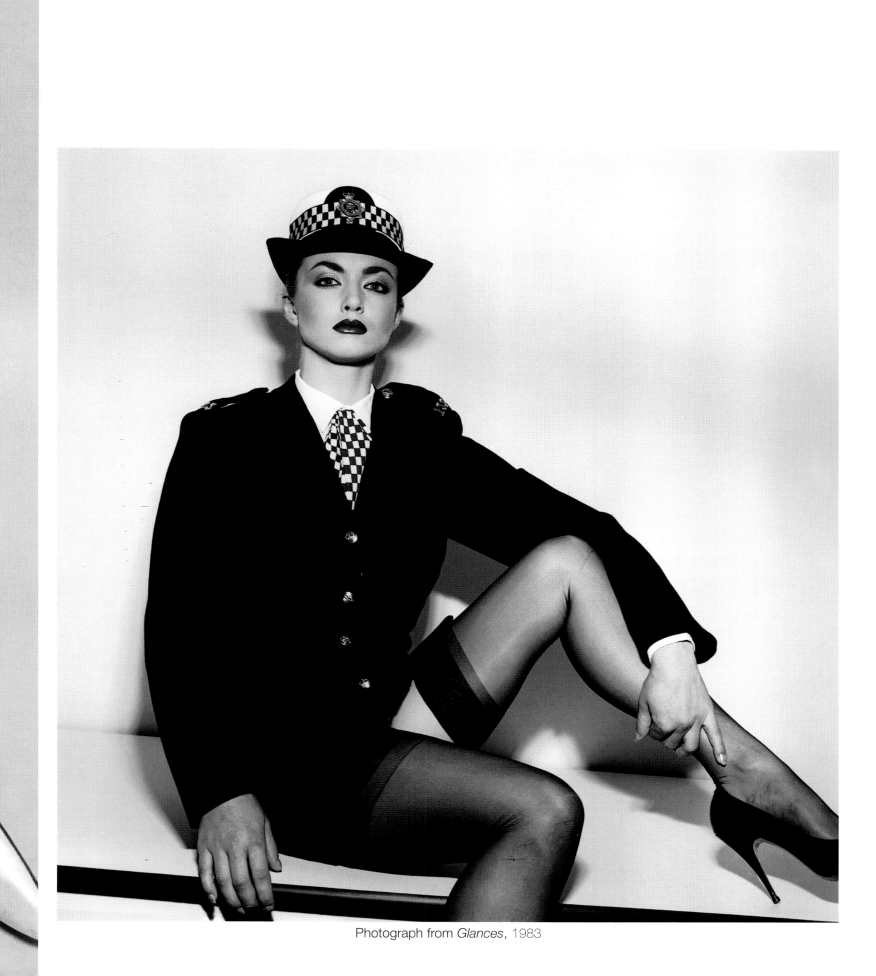

Photograph from *Glances*, 1983

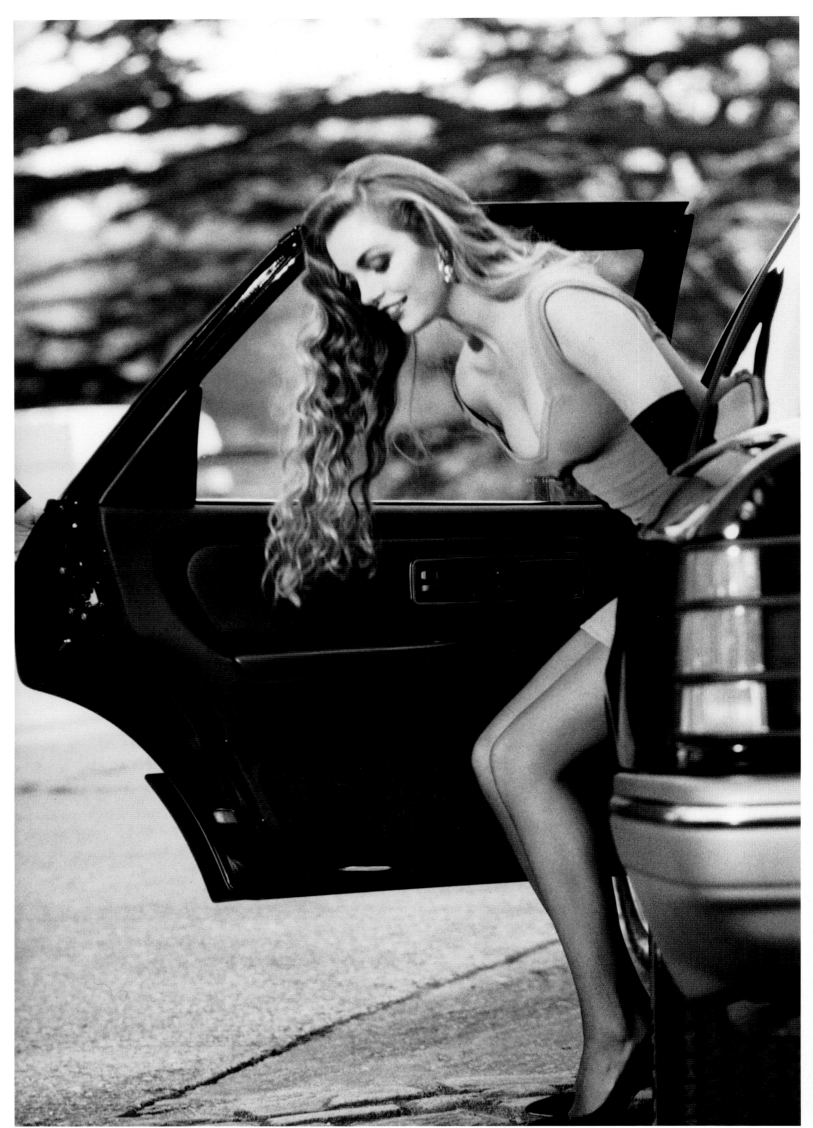

Nadia, 1989

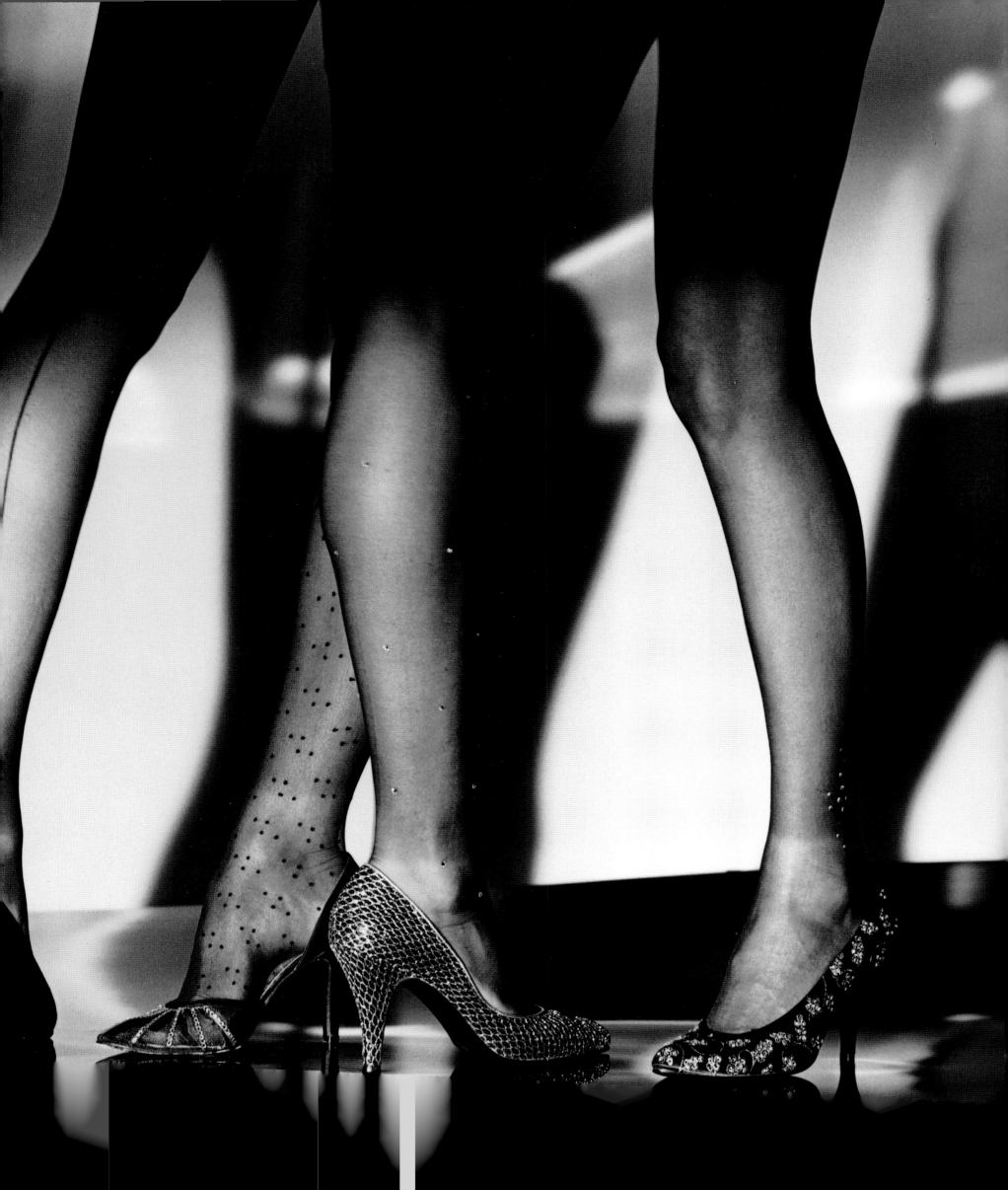

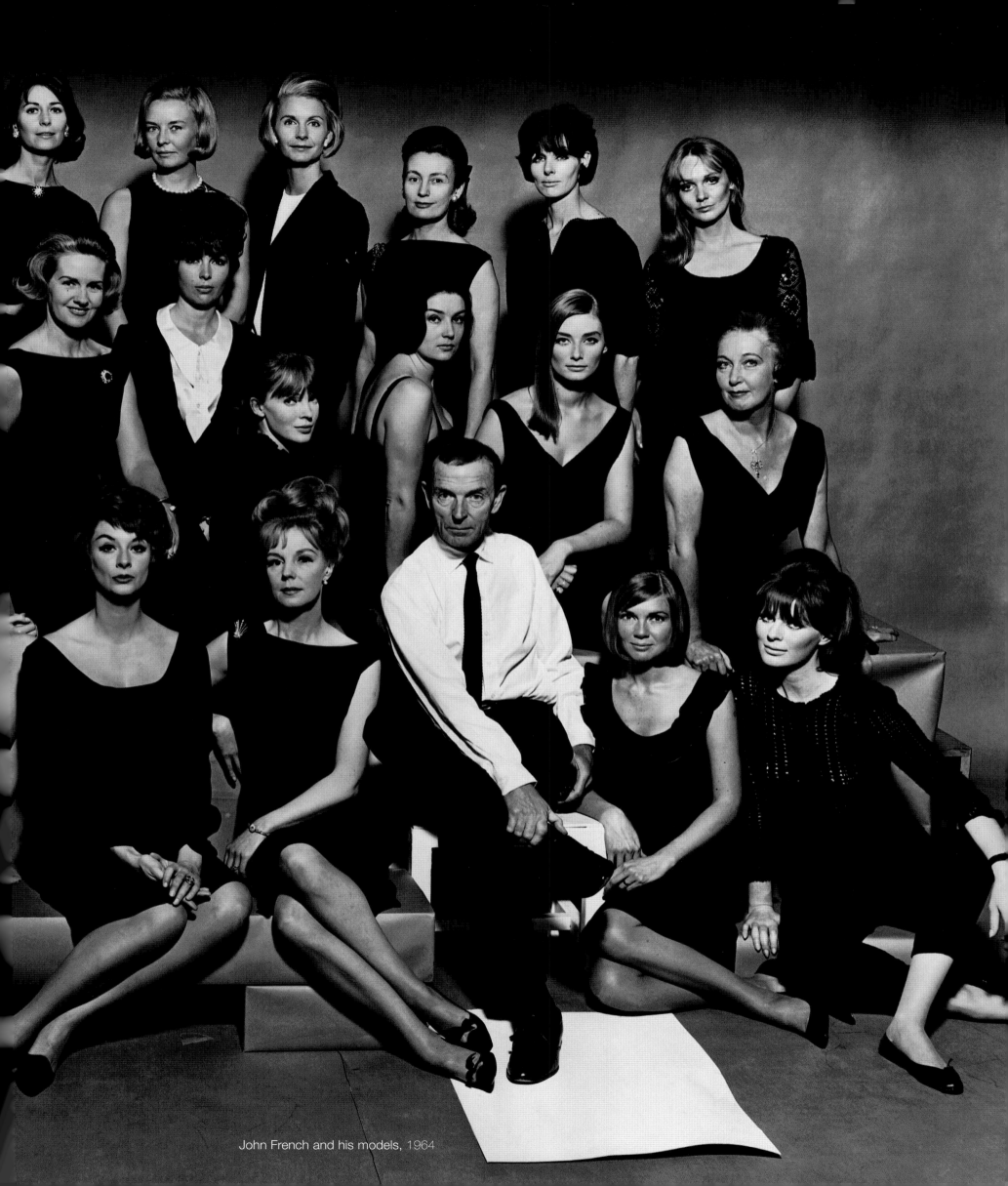

John French and his models, 1964

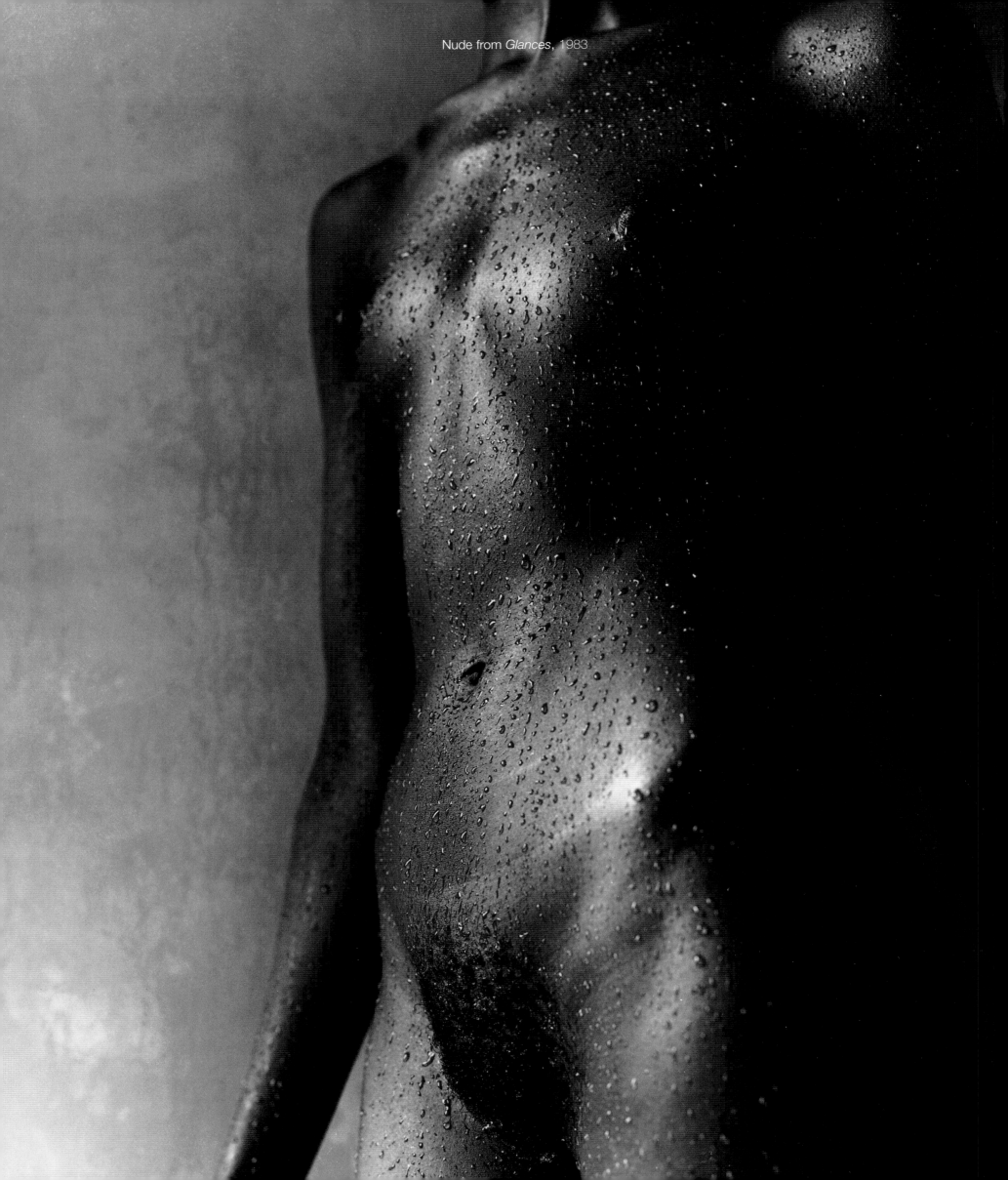

Nude from *Glances*, 1983

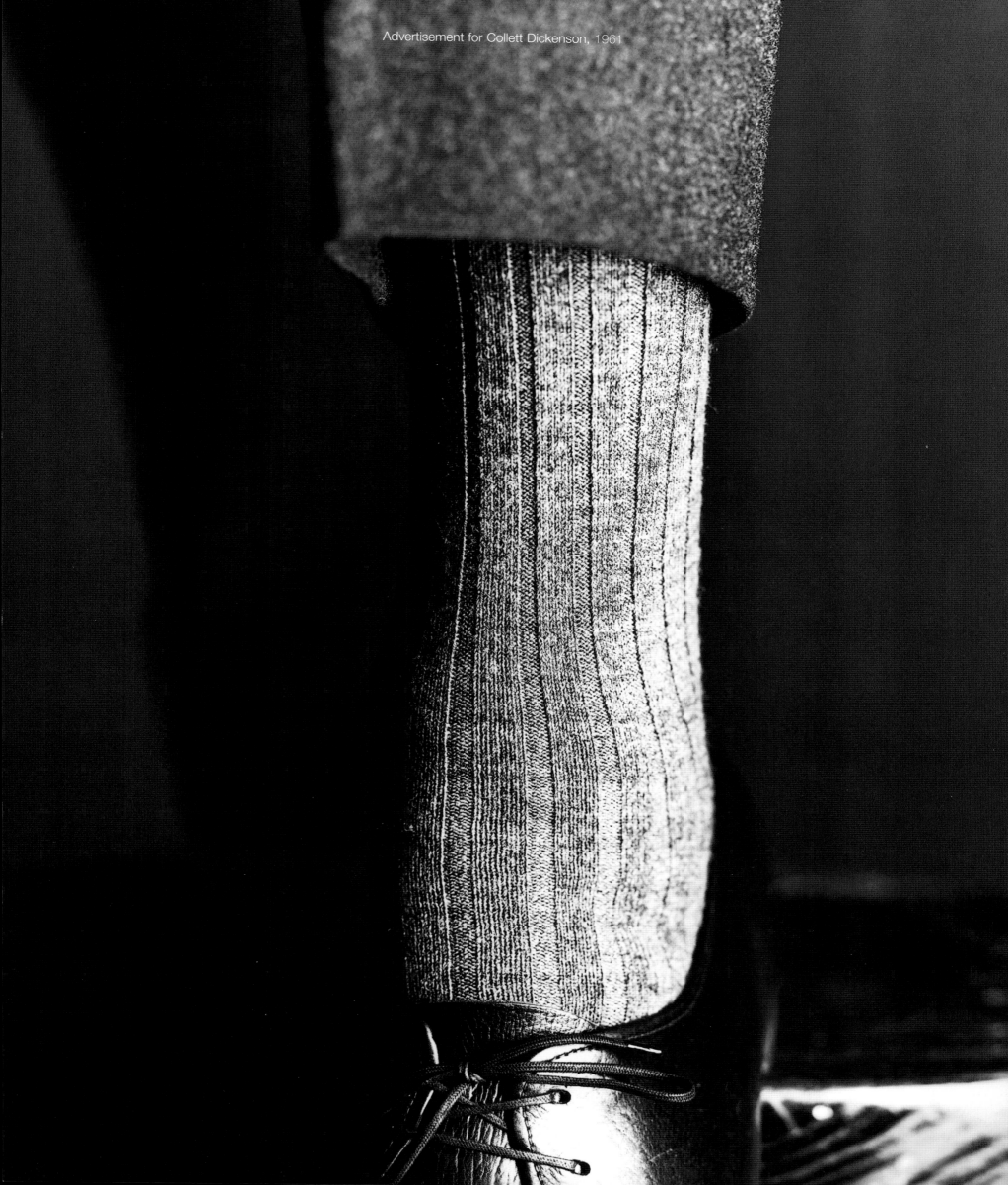

Advertisement for Collett Dickenson, 1961

Celia Hammond, 1961

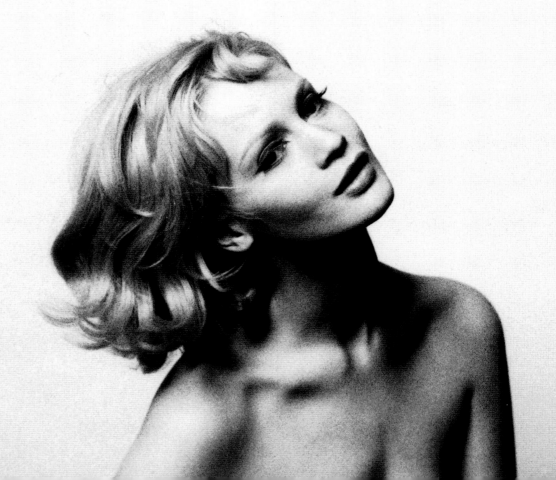

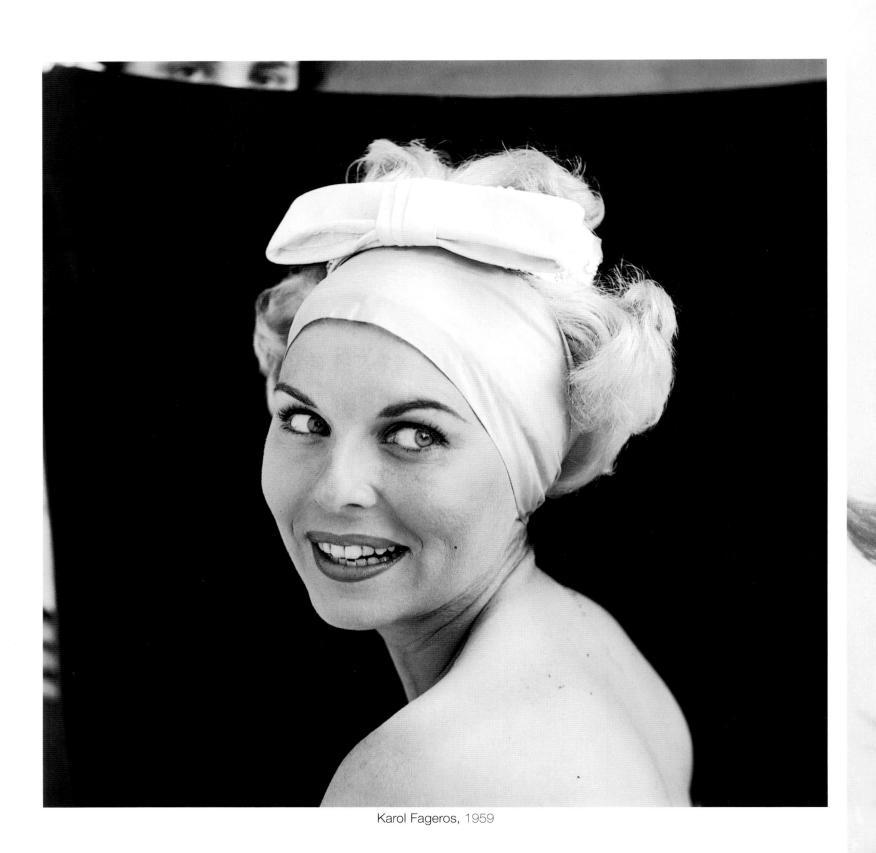

Karol Fageros, 1959

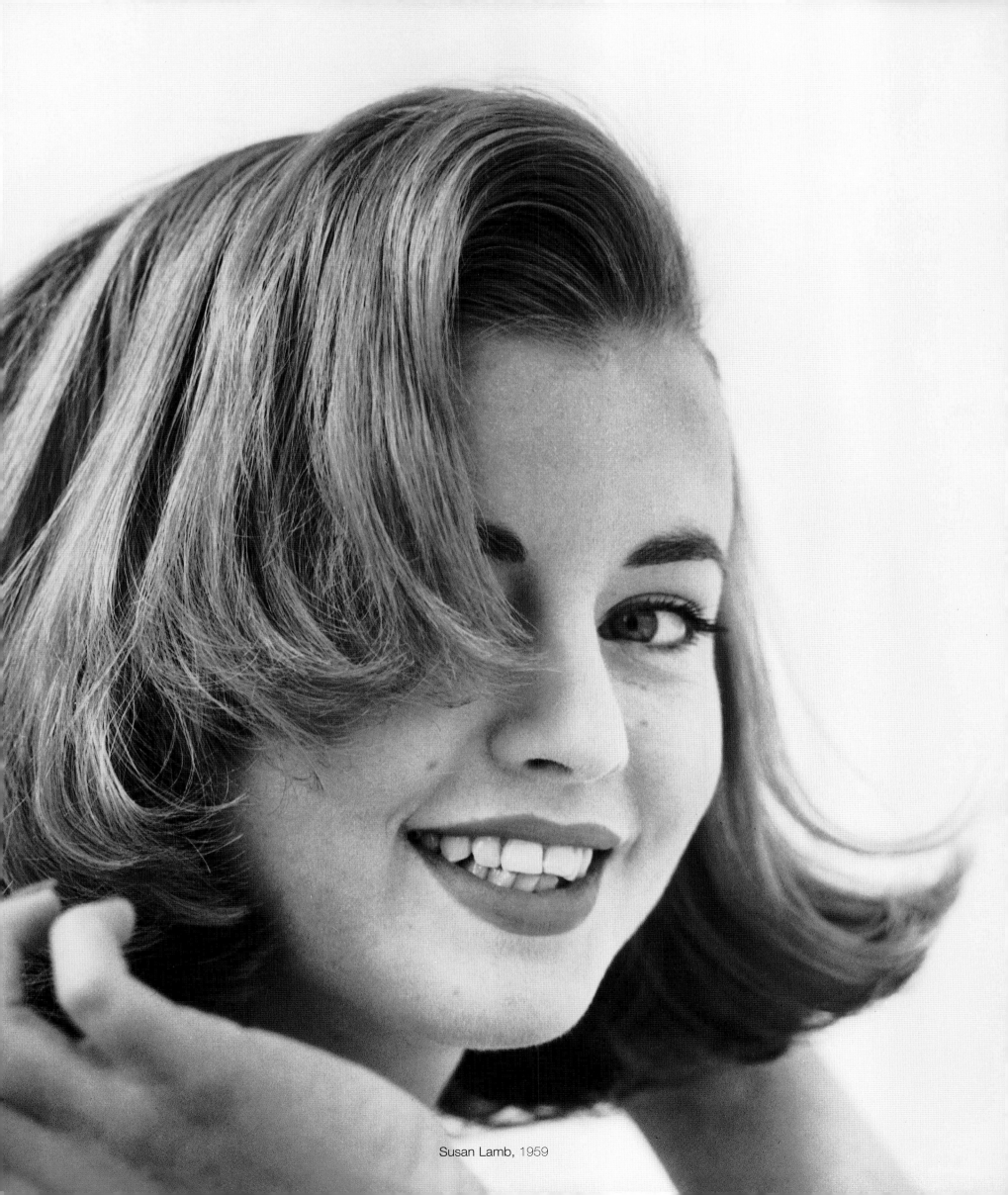

Susan Lamb, 1959

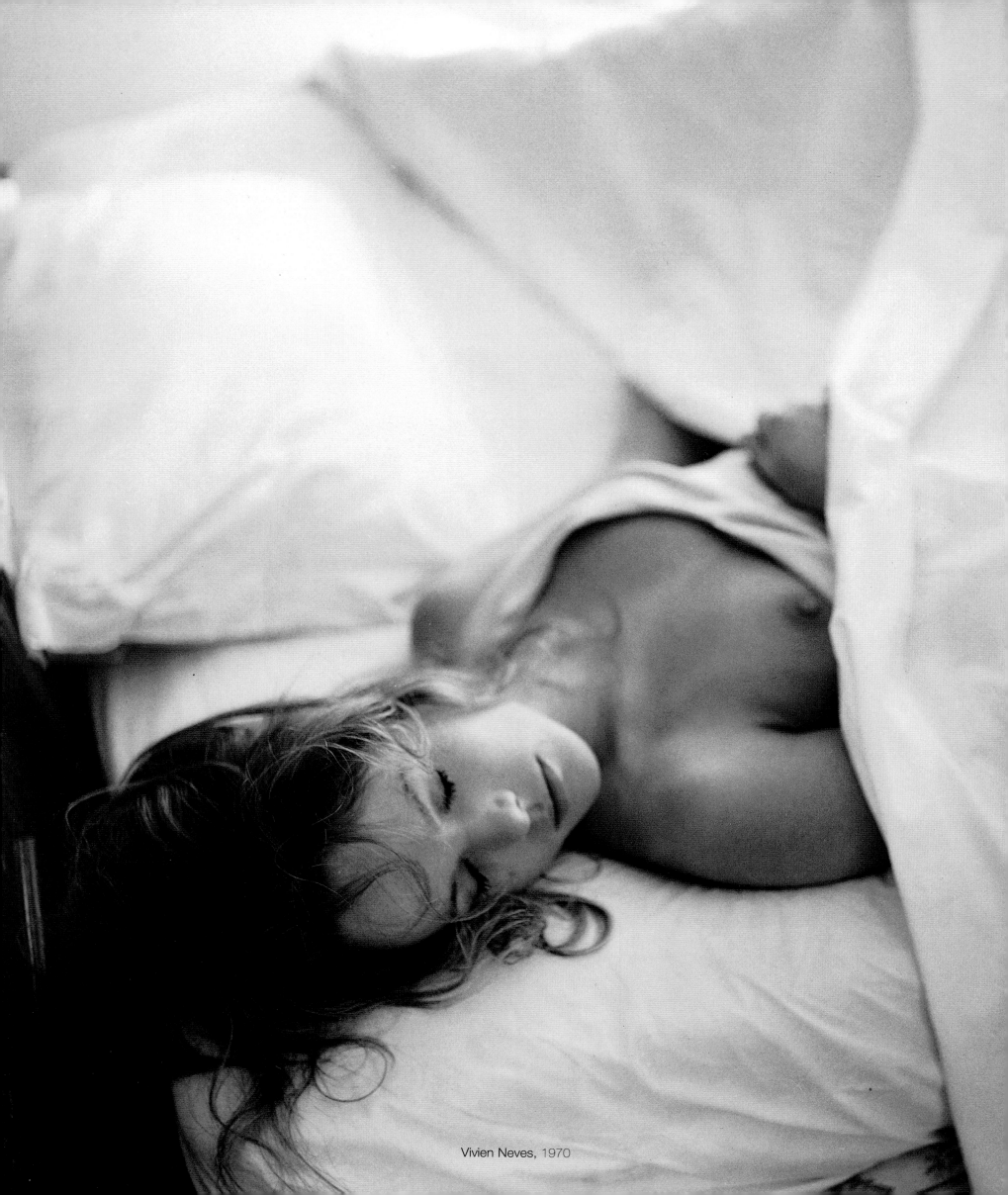

Vivien Neves, 1970

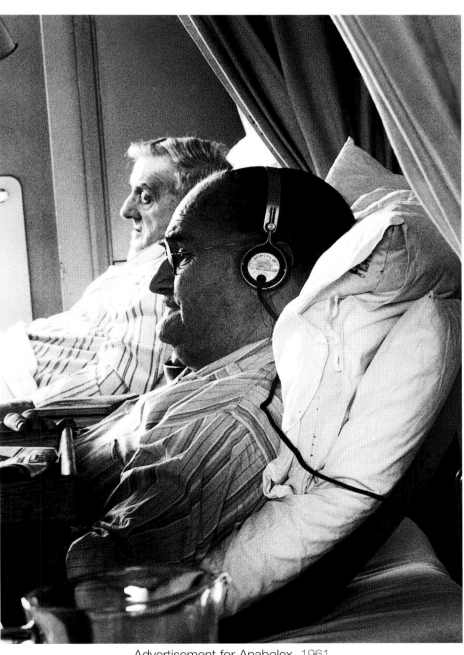

Advertisement for Anabolex, 1961

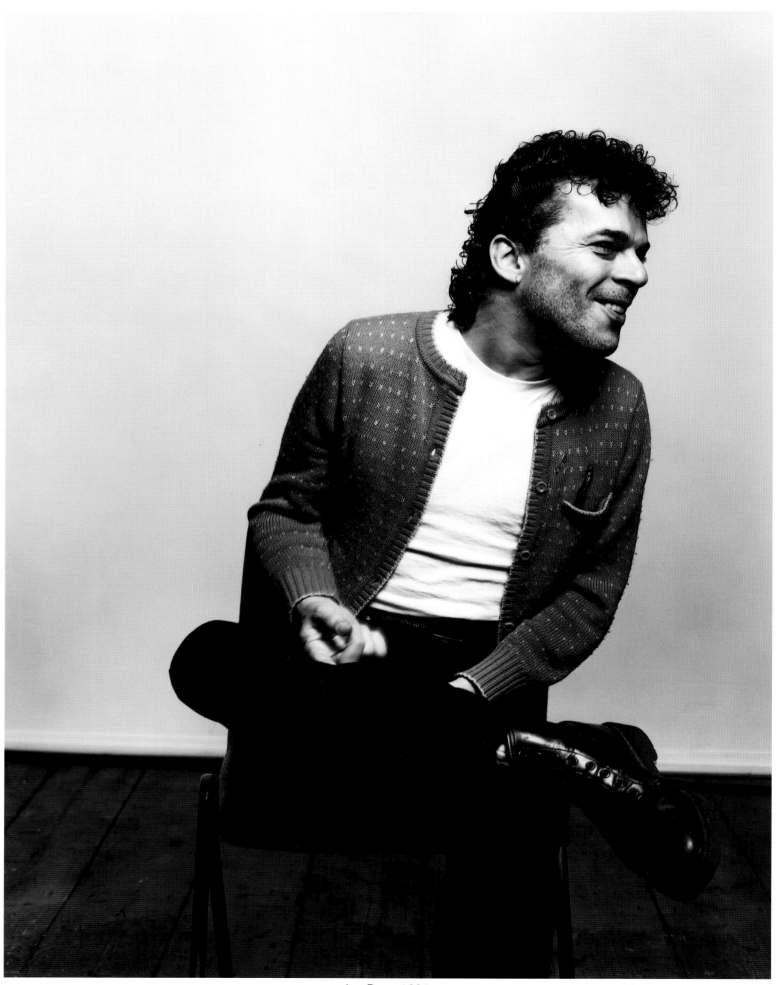

Ian Dury, 1981

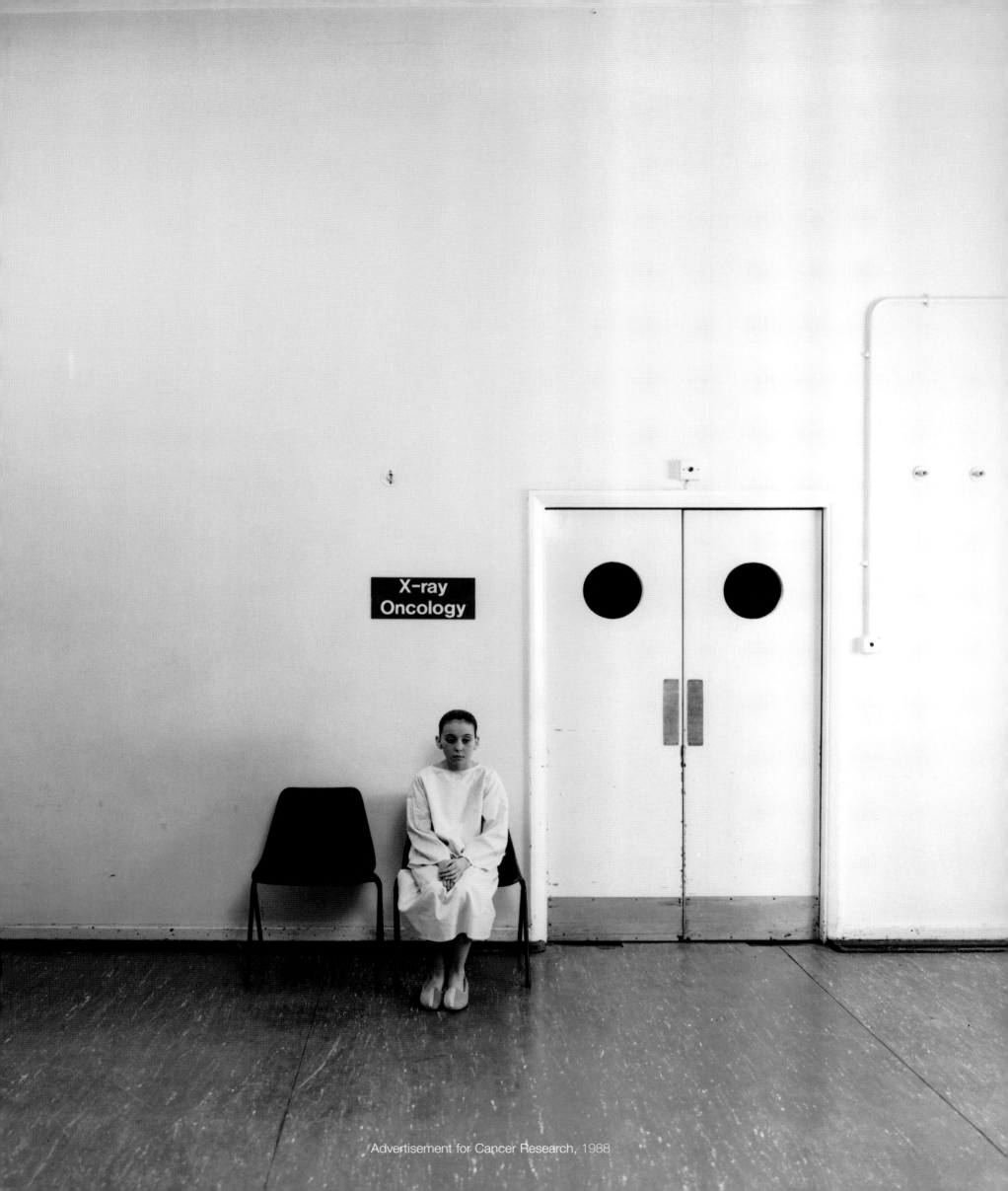

Advertisement for Cancer Research, 1988

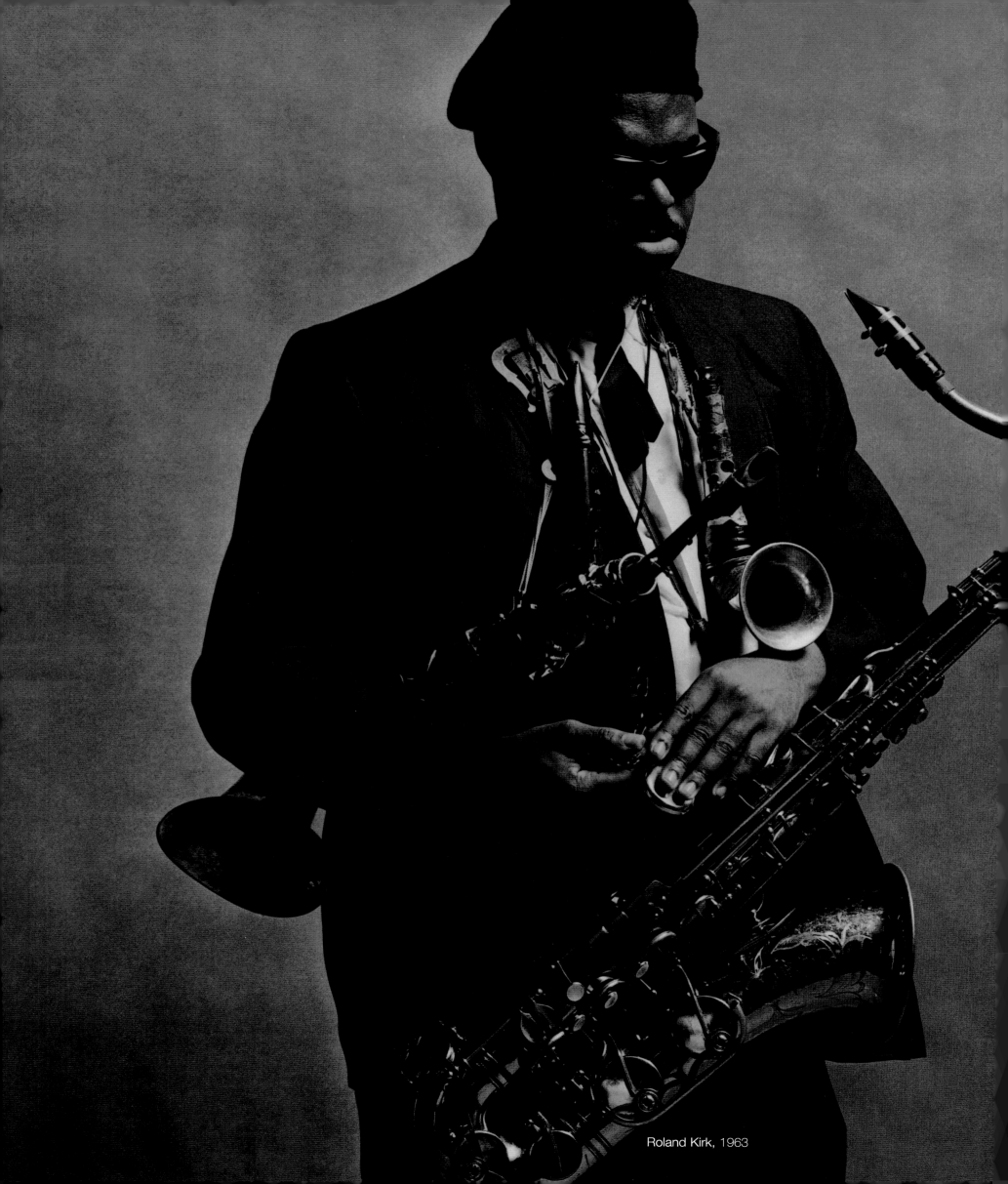

Roland Kirk, 1963

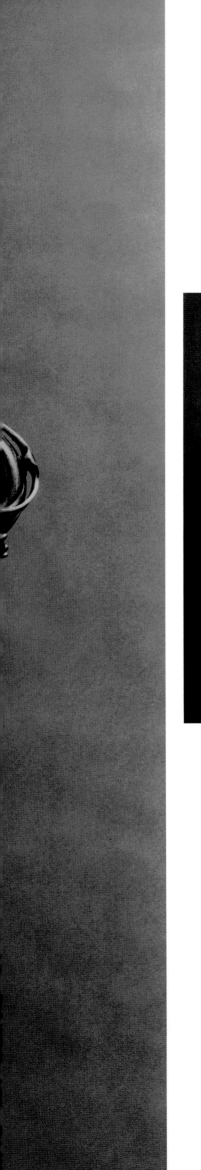

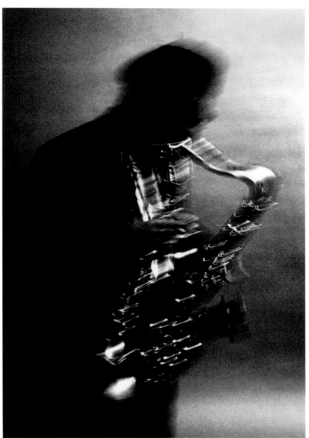

Roland Kirk, 1963

Courtney Pine, 1996

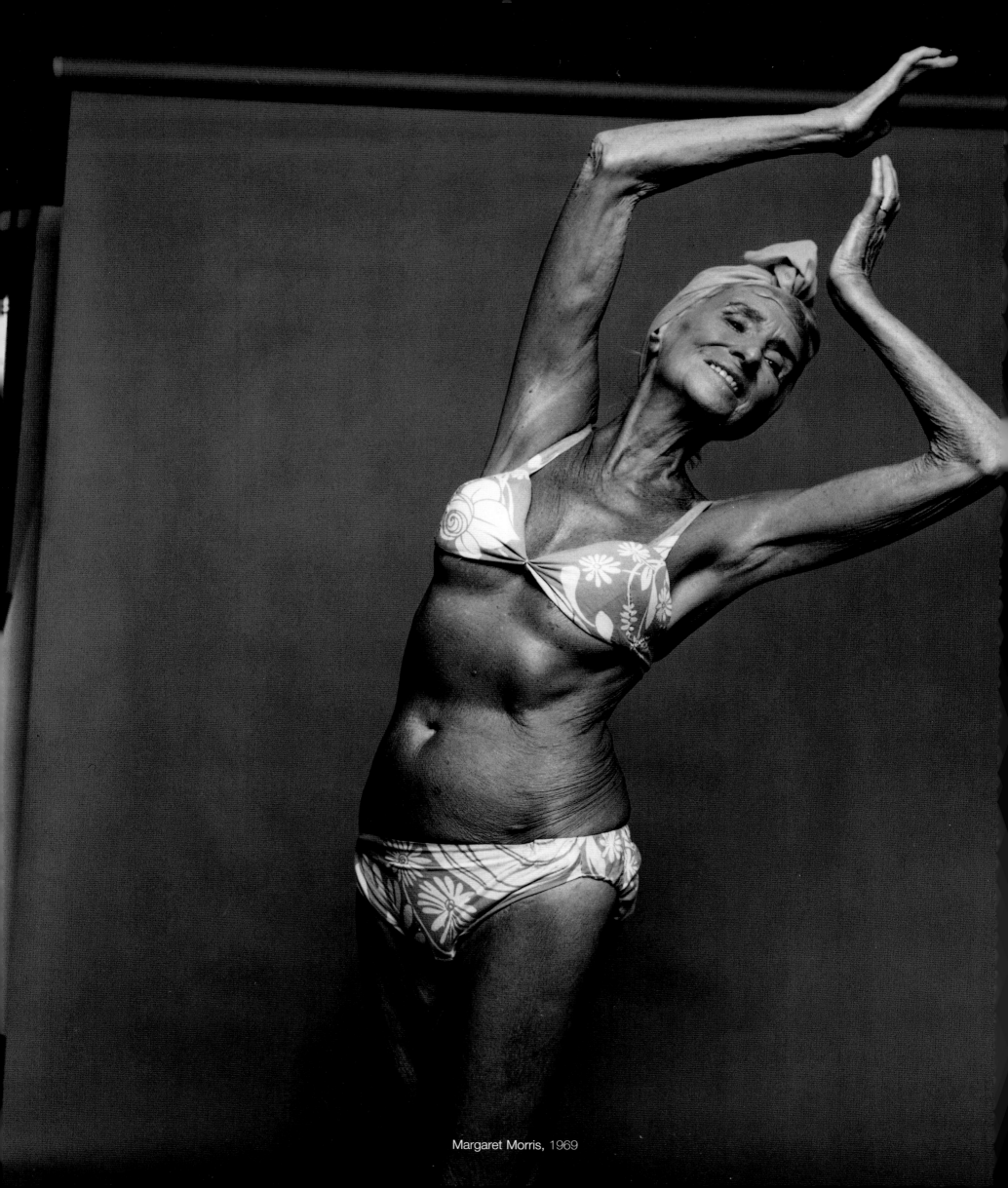

Margaret Morris, 1969

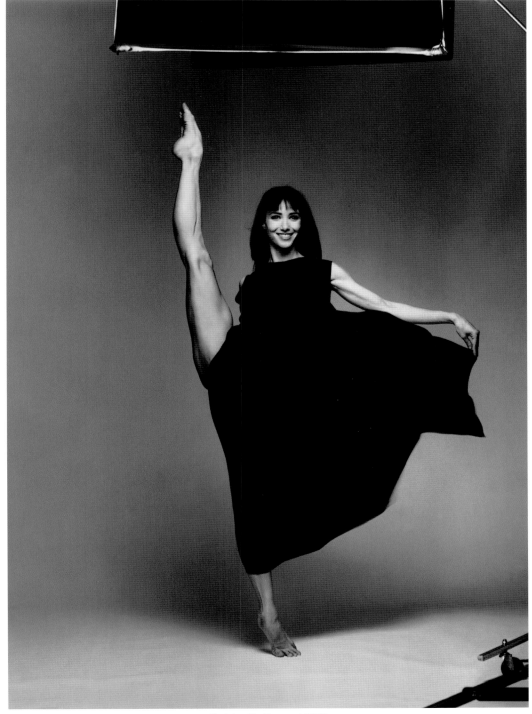

Sylvie Guillem, 1993

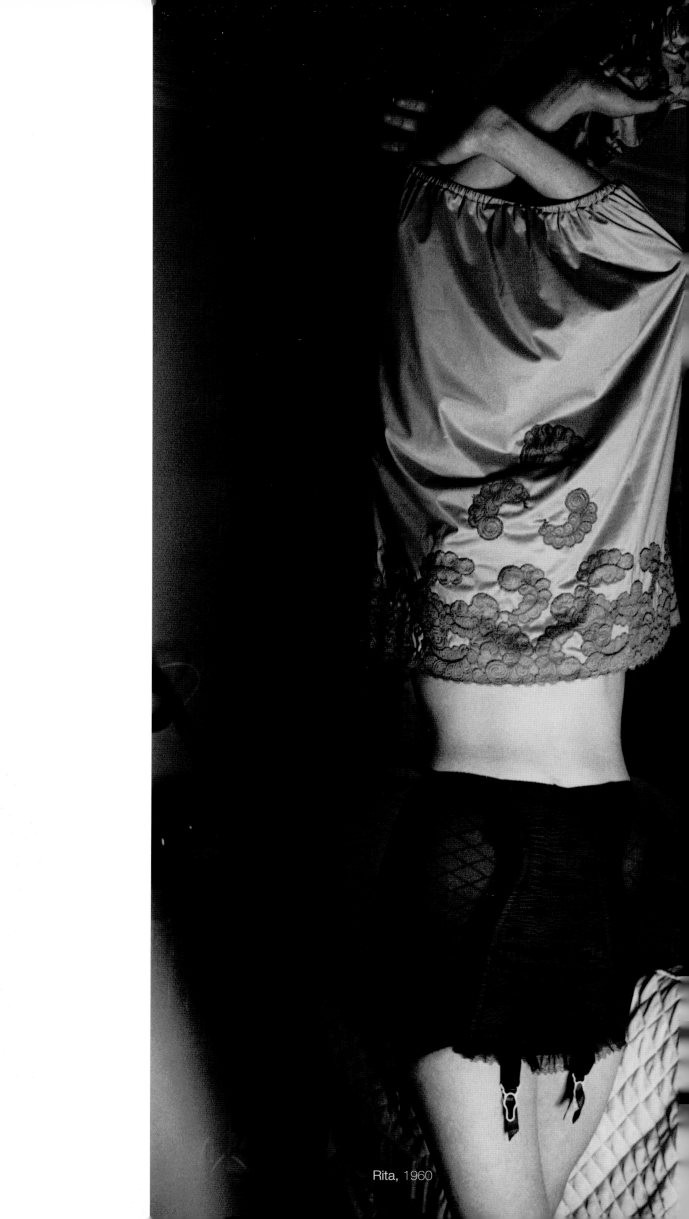

Rita, 1960

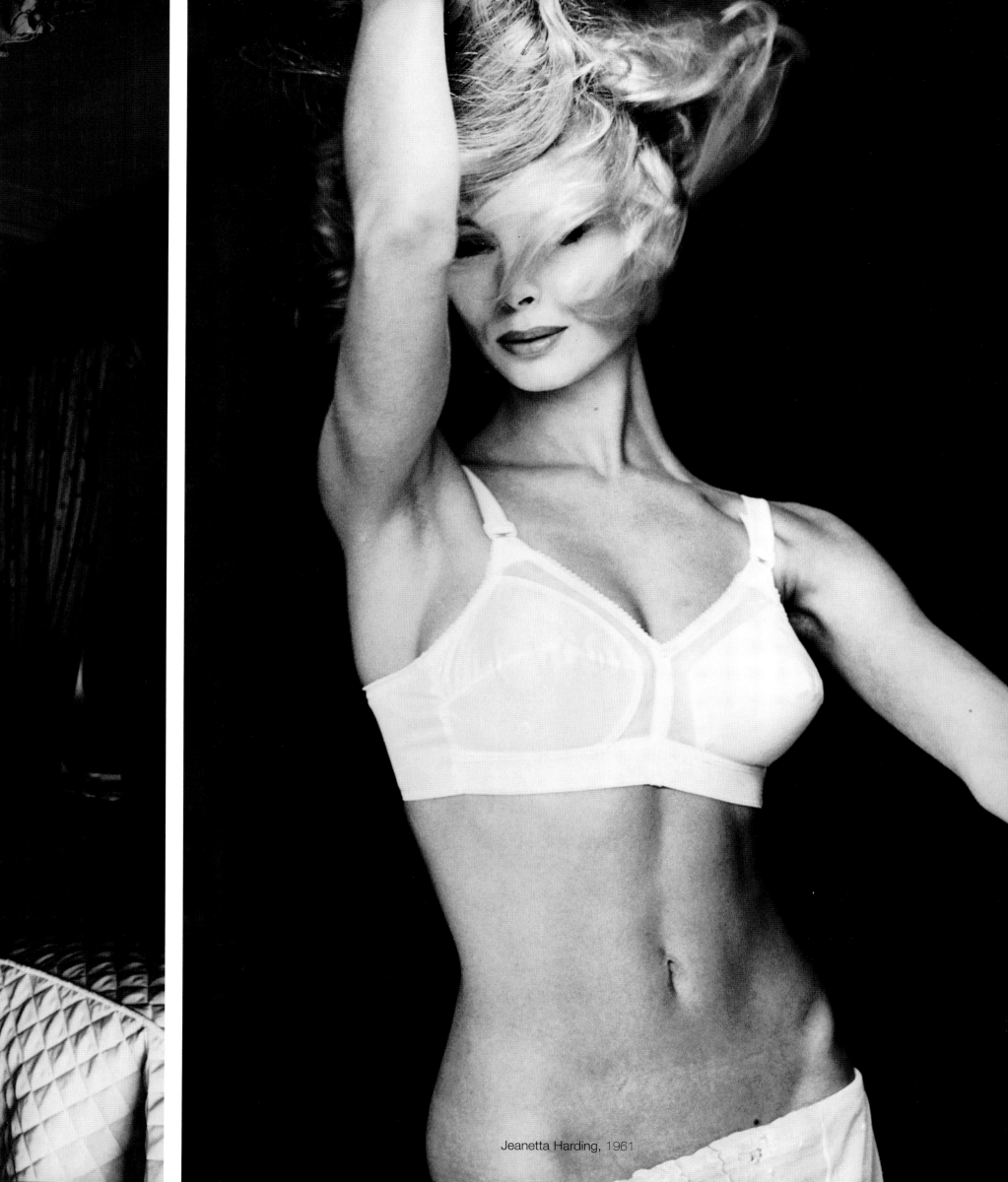

Jeanetta Harding, 1961

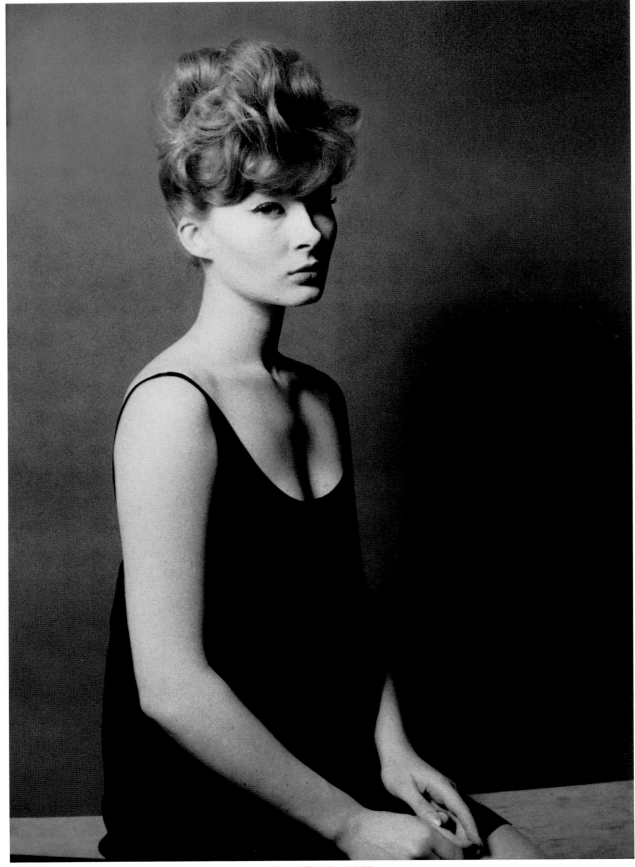

Liese Deniz, *1959*

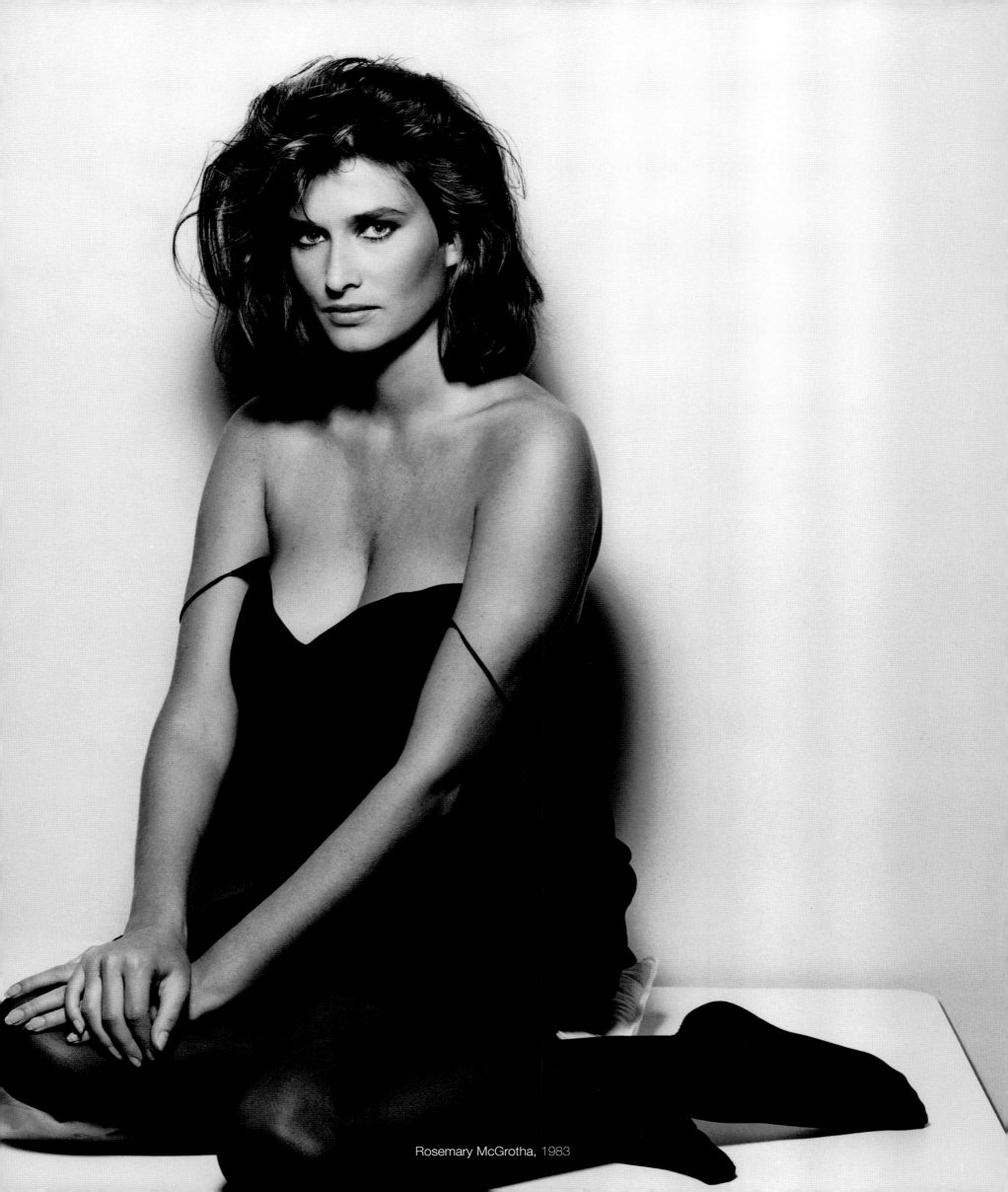
Rosemary McGrotha, 1983

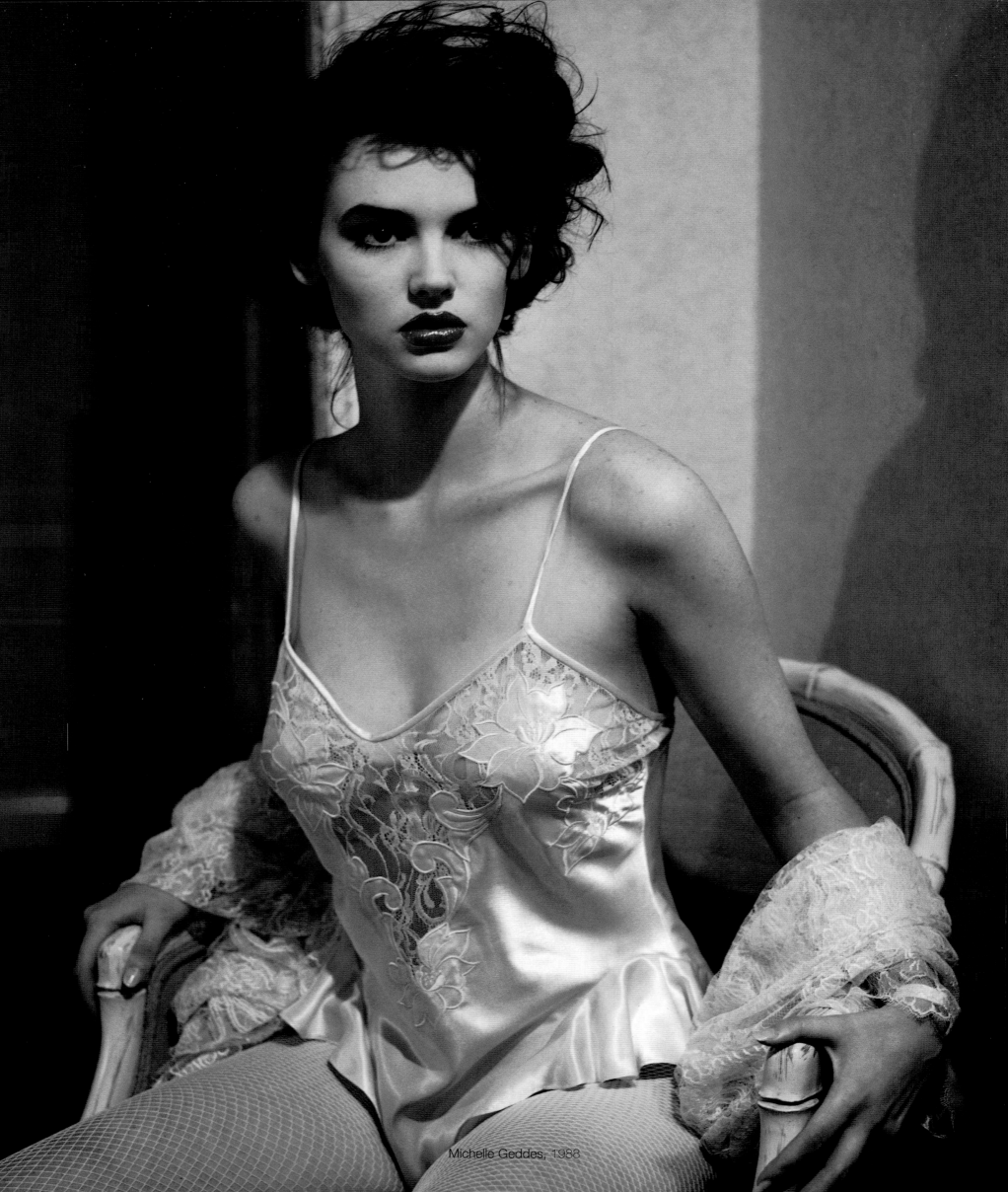

Michelle Geddes, 1988

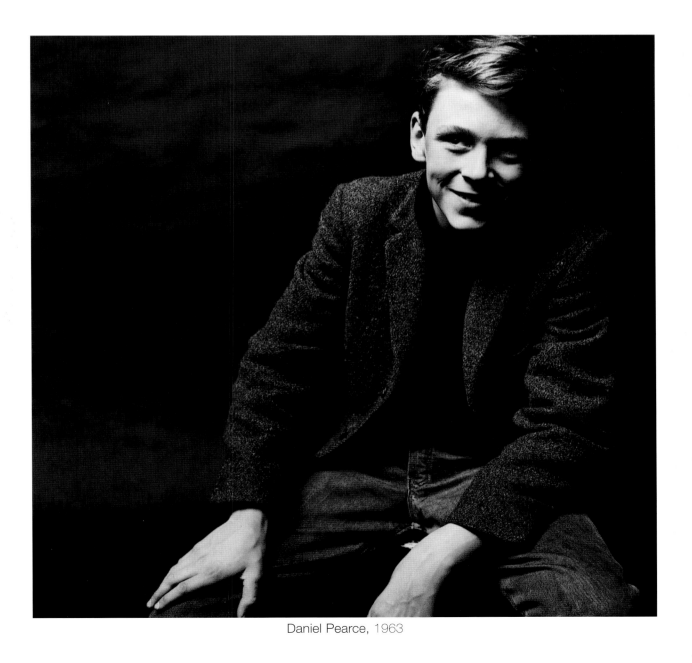

Daniel Pearce, 1963

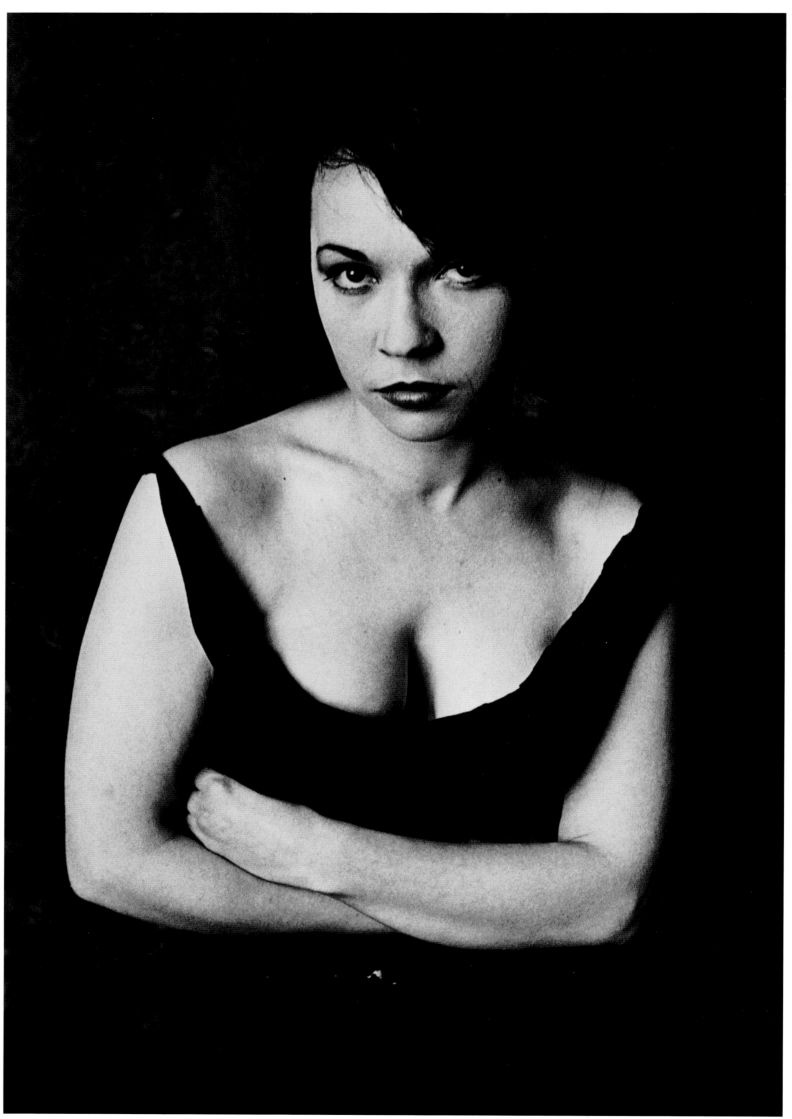

Maria Kazan, 1963

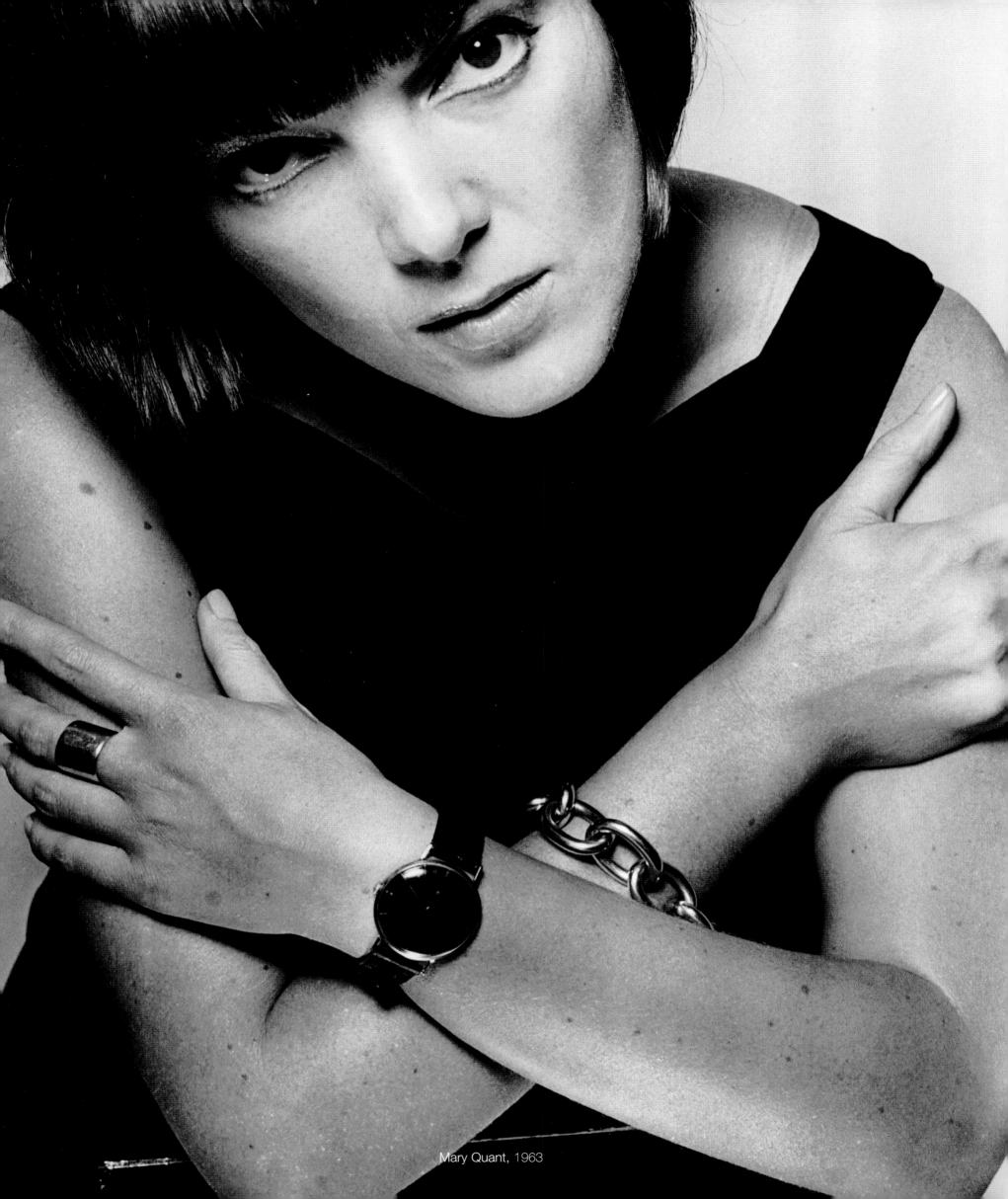
Mary Quant, 1963

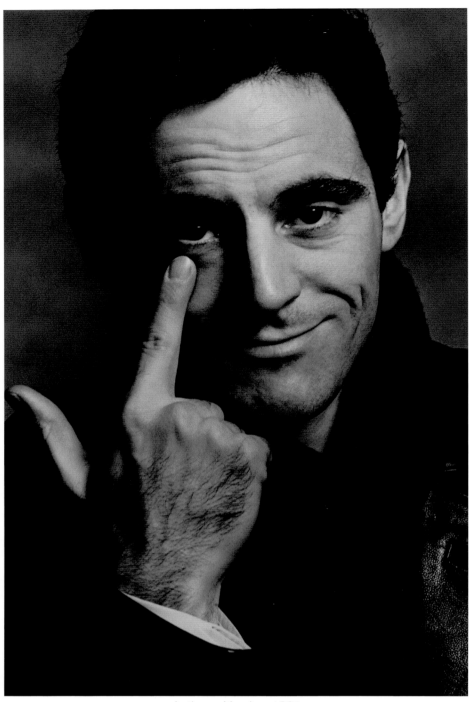

Anthony Newley, 1961

Ruth Abromwitz, 1959

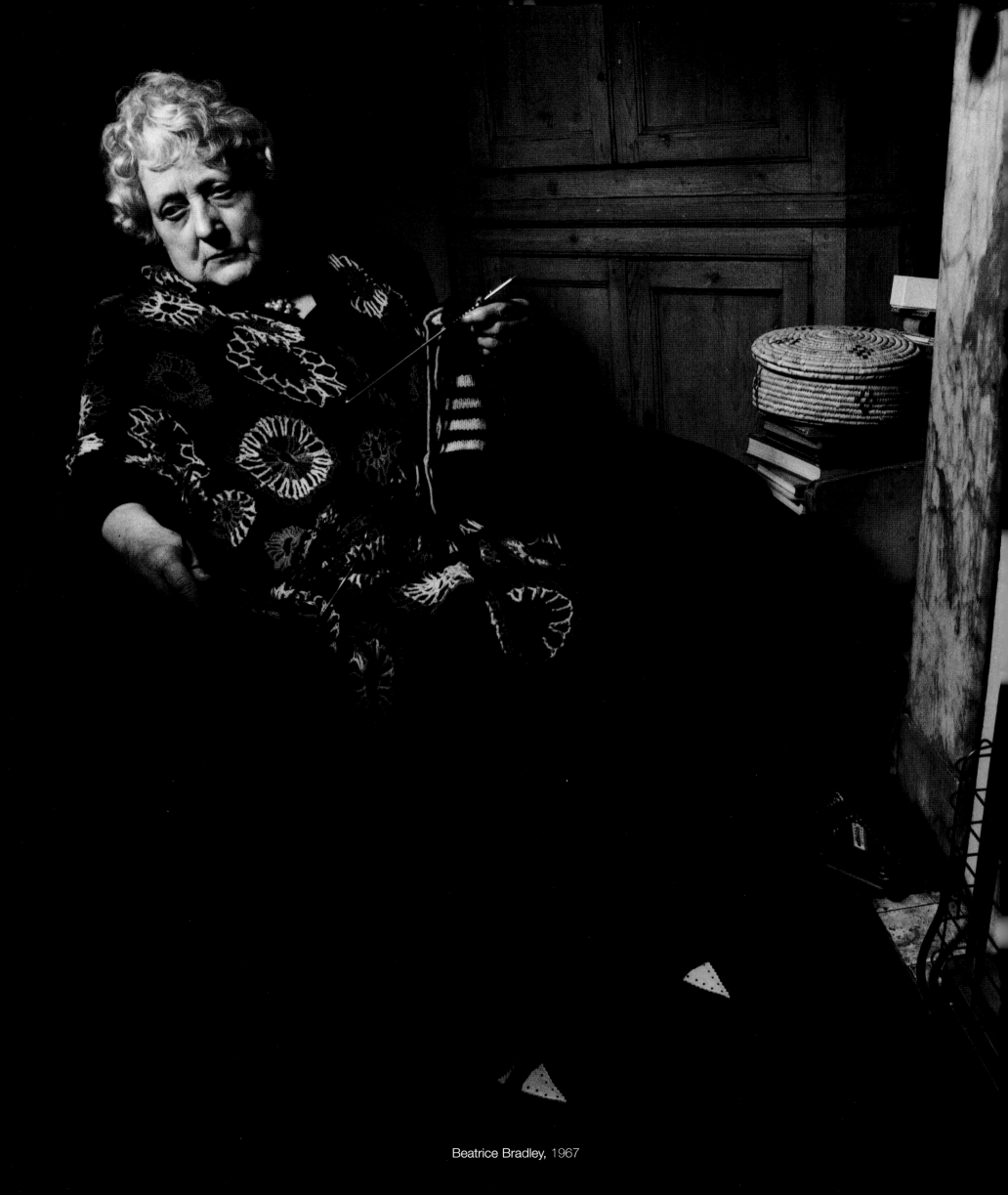

Beatrice Bradley, 1967

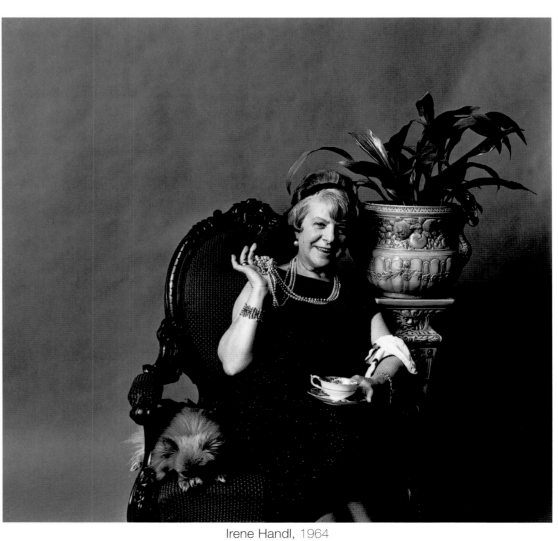

Irene Handl, 1964

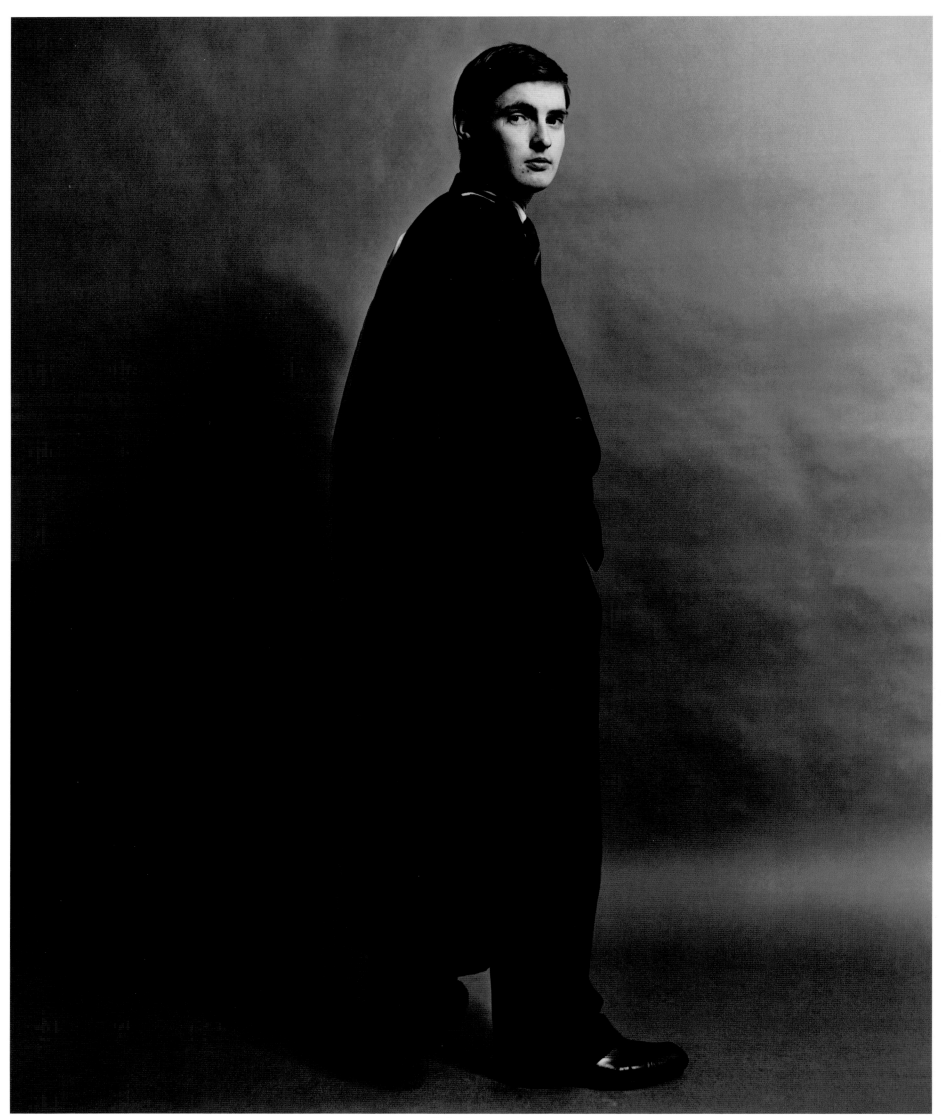
Colin Stuart, 1959

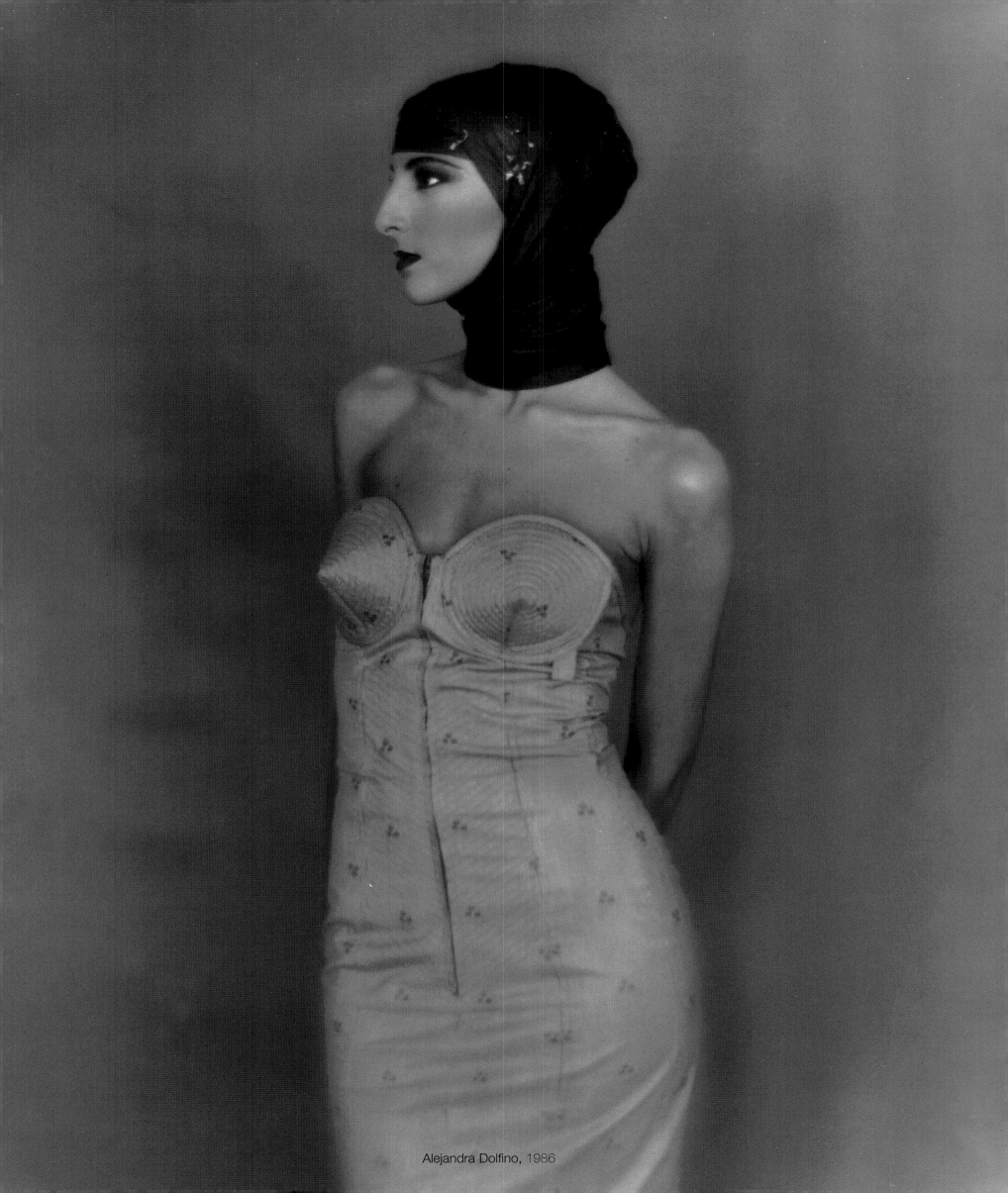

Alejandra Dolfino, 1986

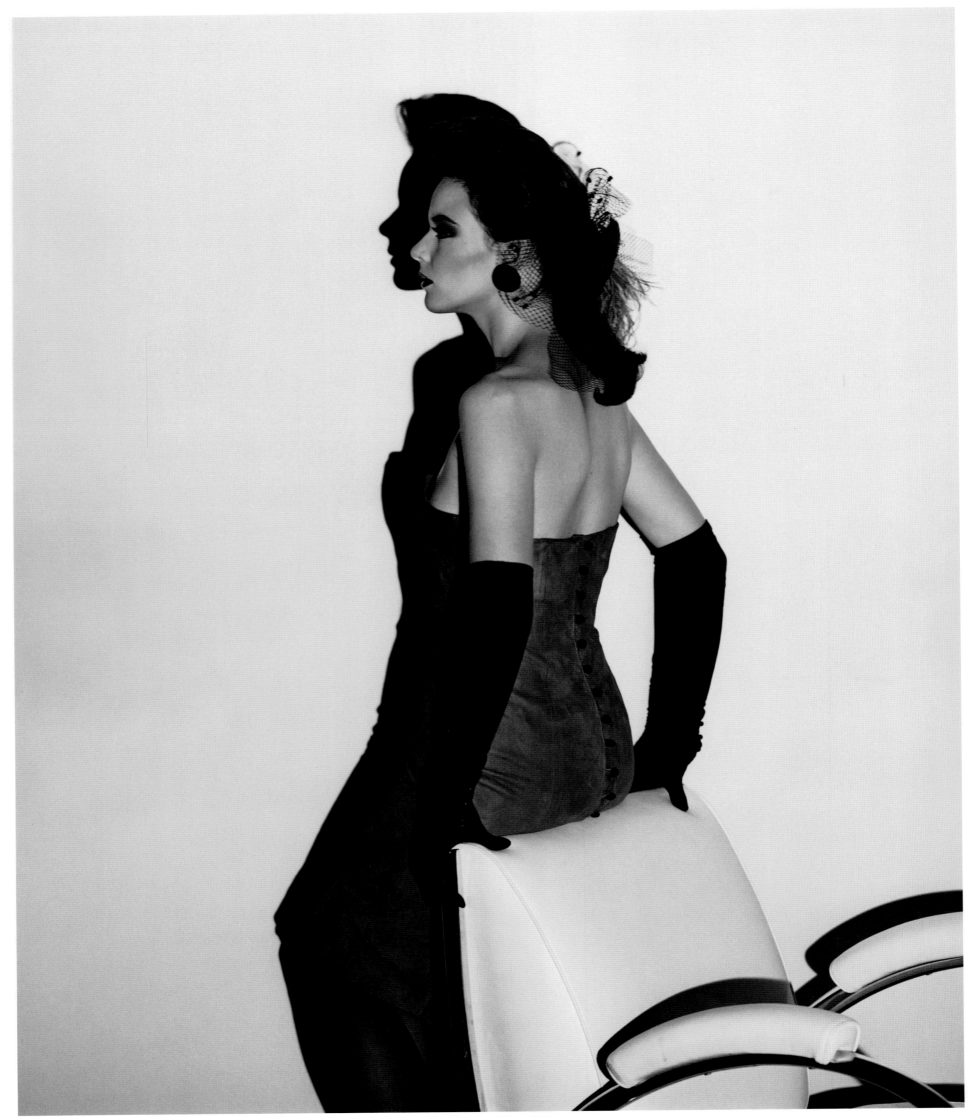

Fashion for *Ritz*, 1984

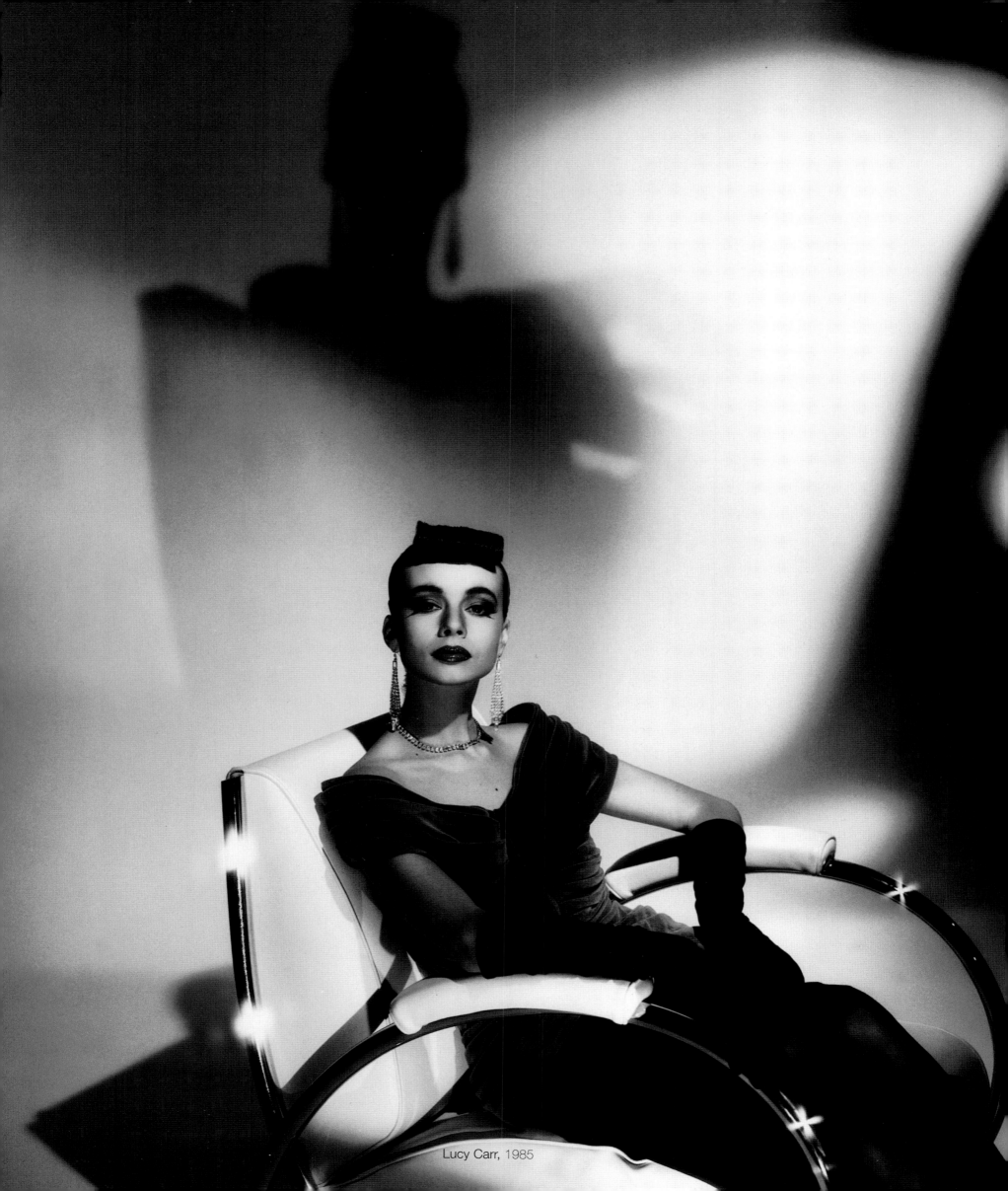

Lucy Carr, 1985

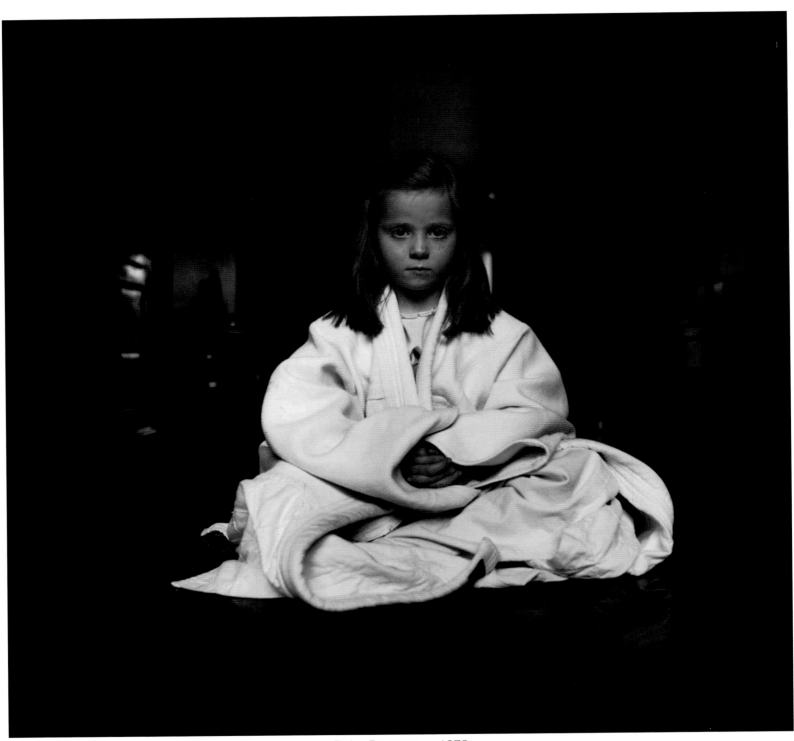

Daisy Donovan, c.1978

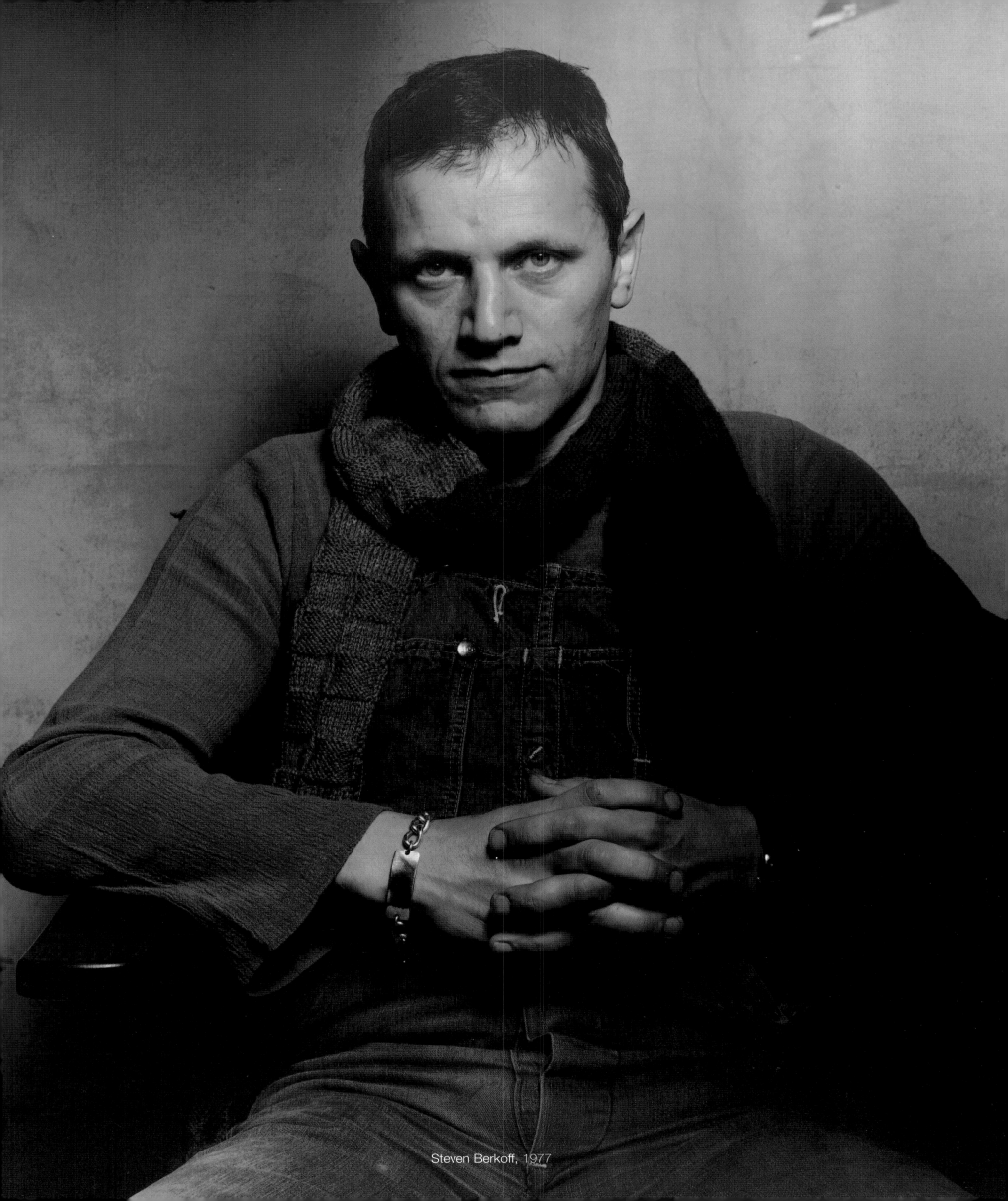

Steven Berkoff, 1977

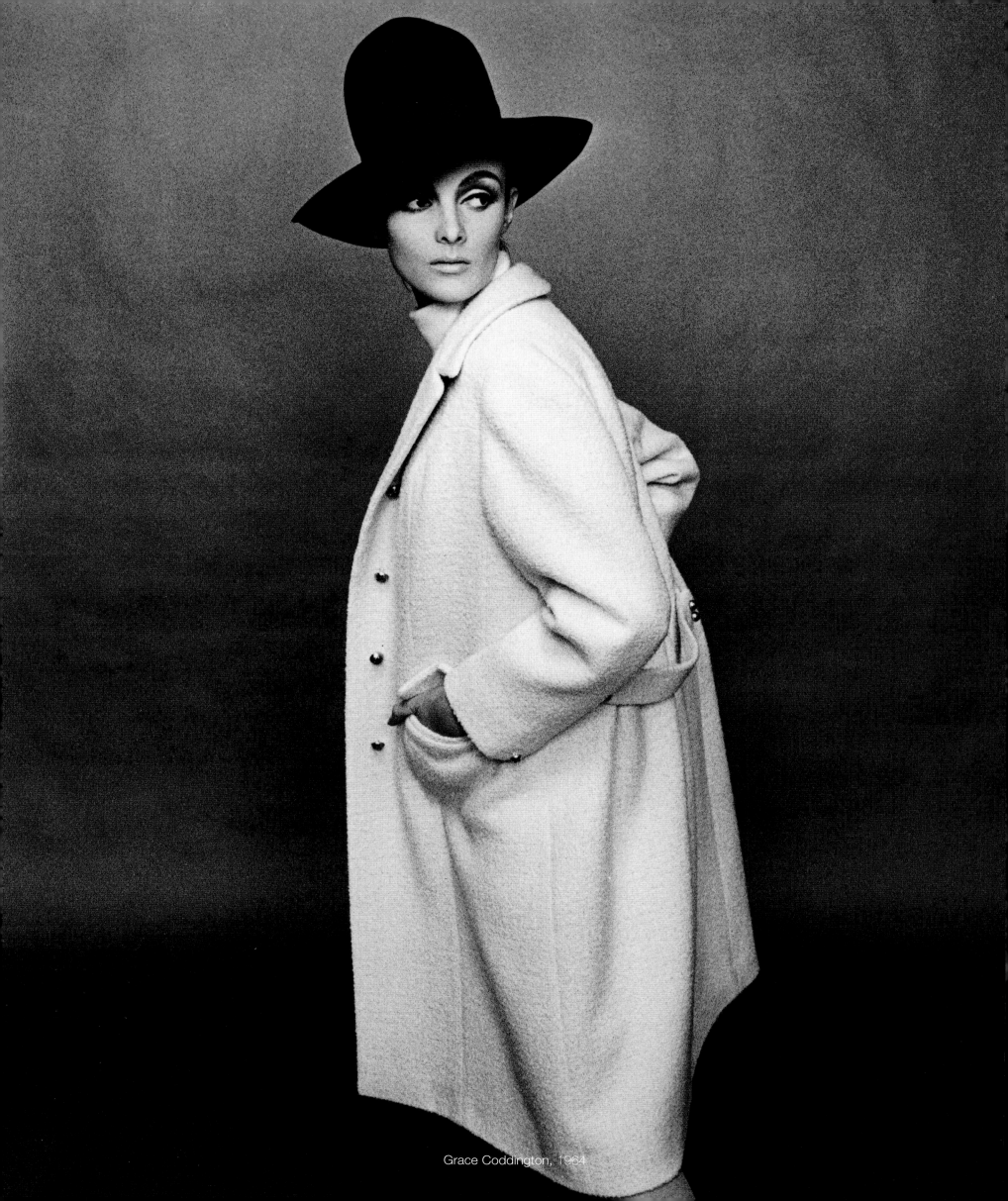

Grace Coddington, 1964

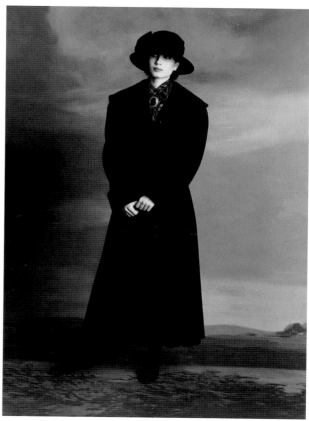

Advertisement for Laura Ashley, 1990

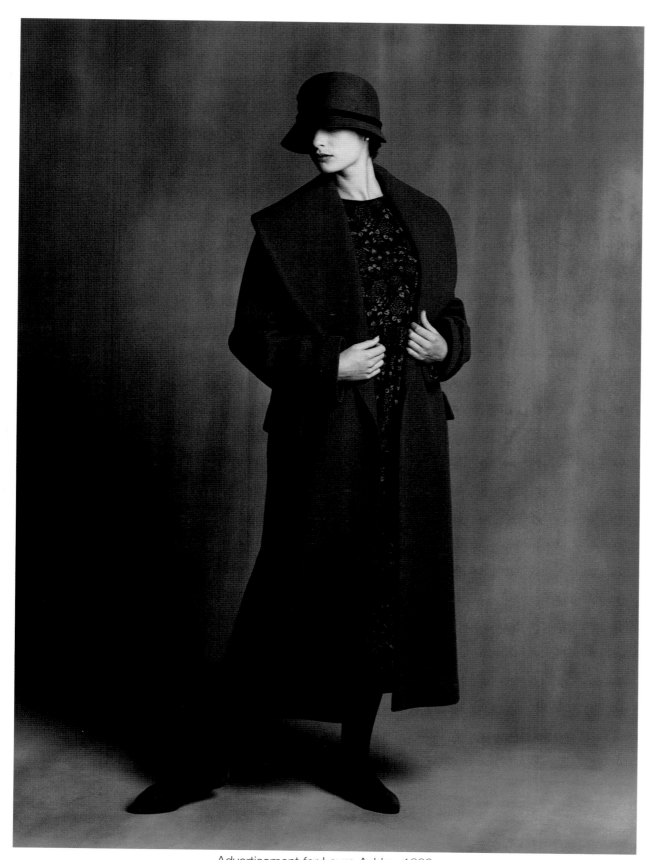

Advertisement for Laura Ashley, 1990

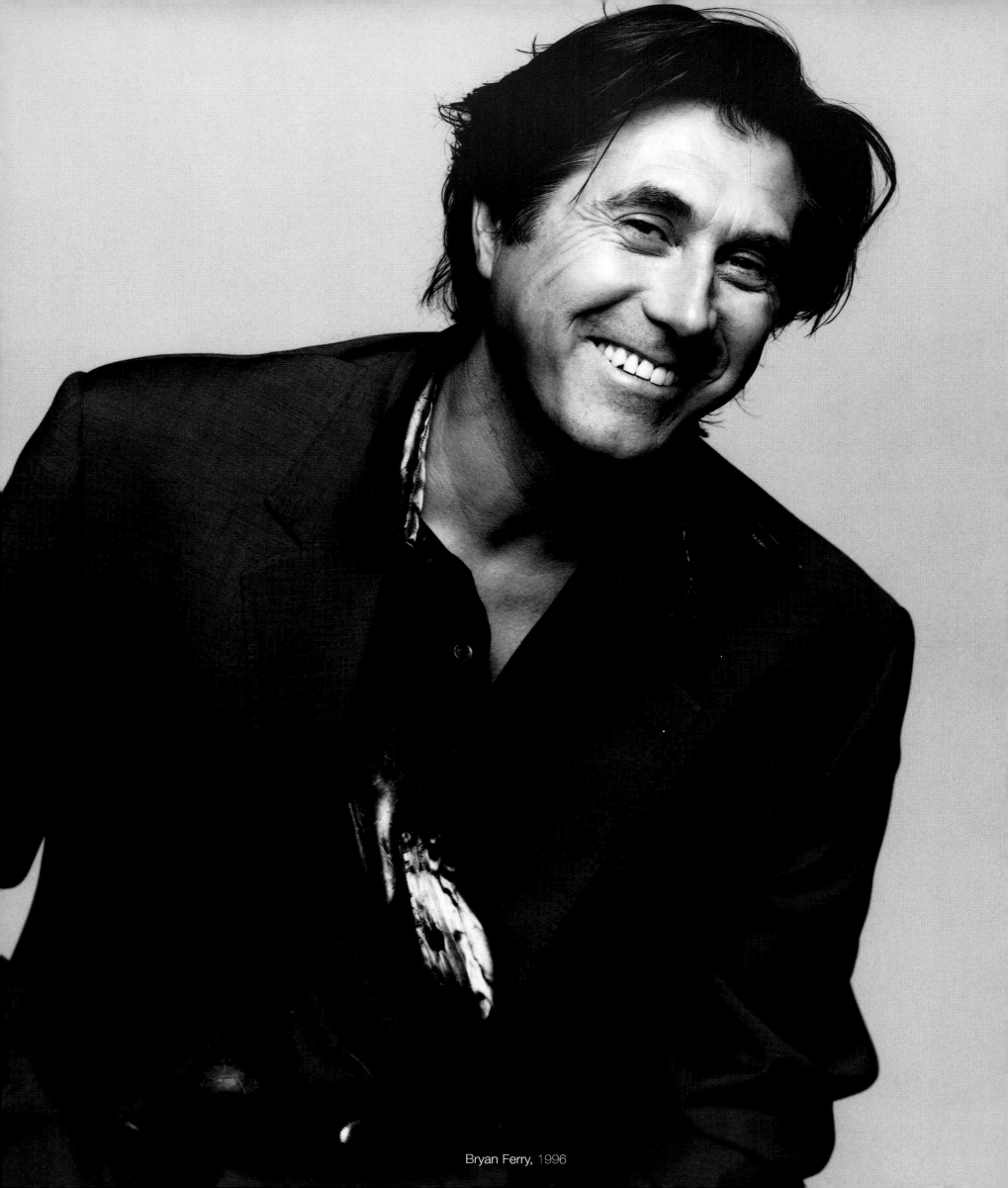

Bryan Ferry, 1996

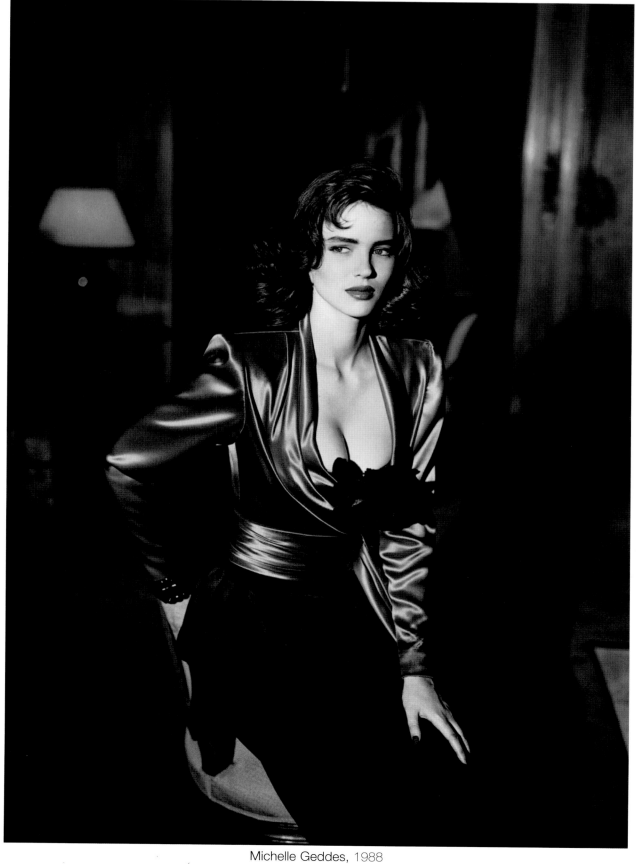

Michelle Geddes, 1988

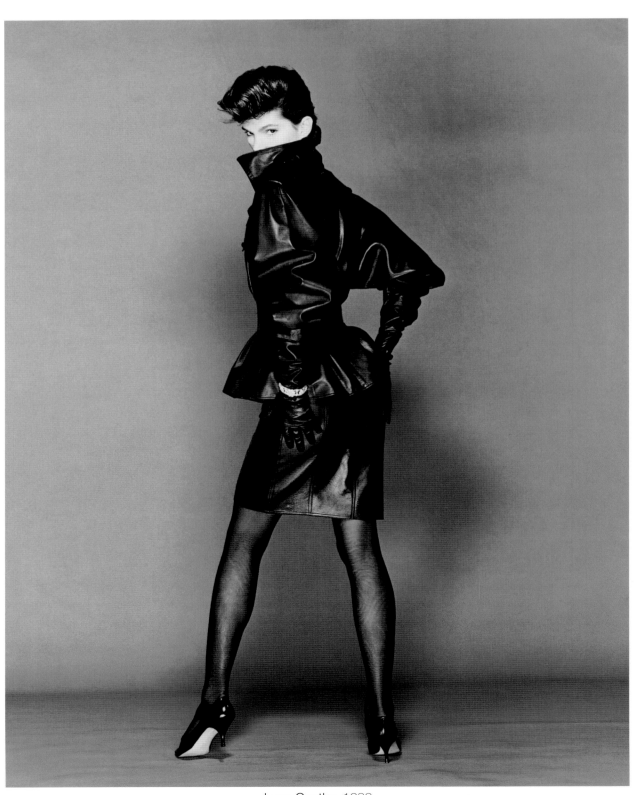

Lynn Costler, 1983

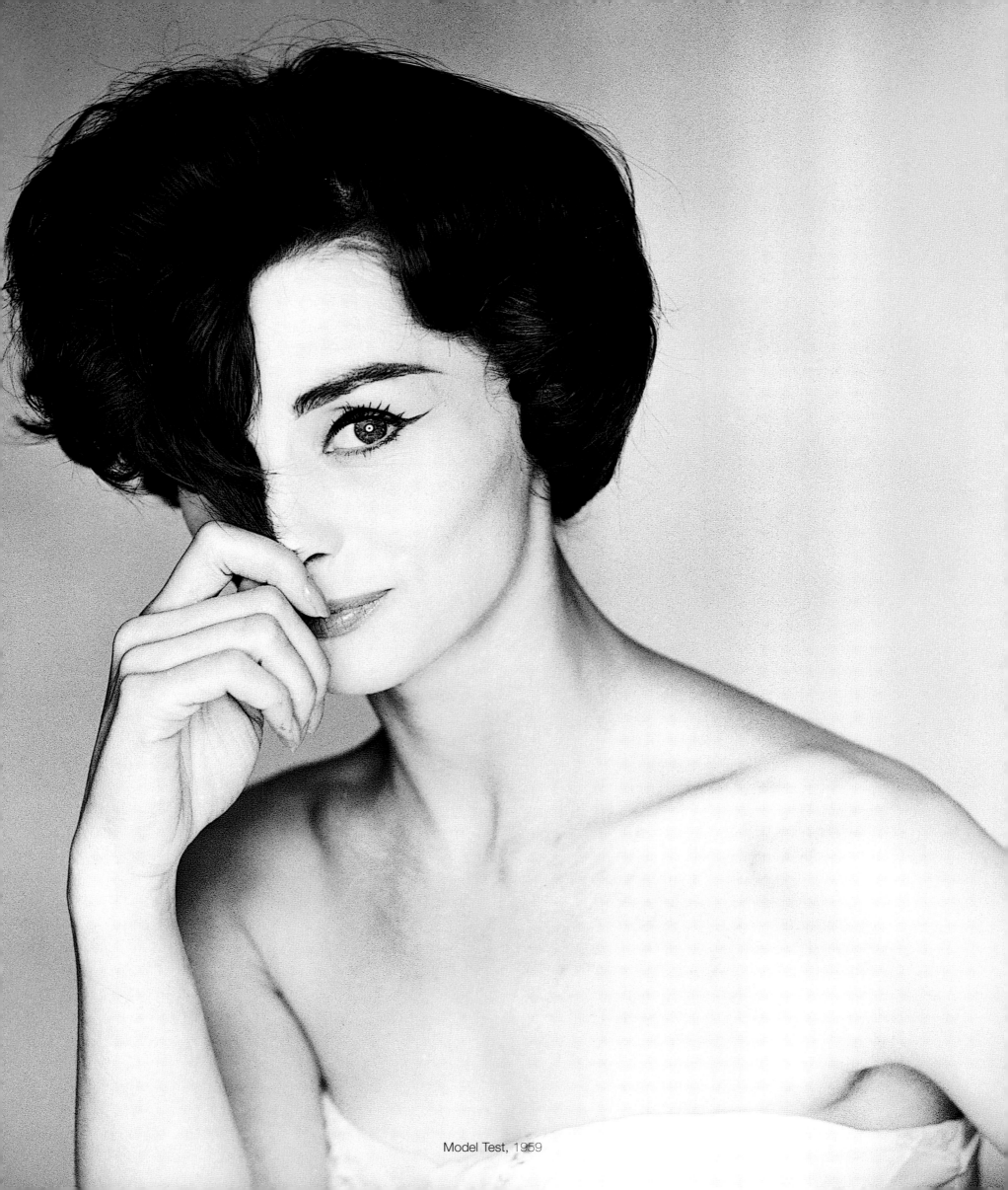

Model Test, 1959

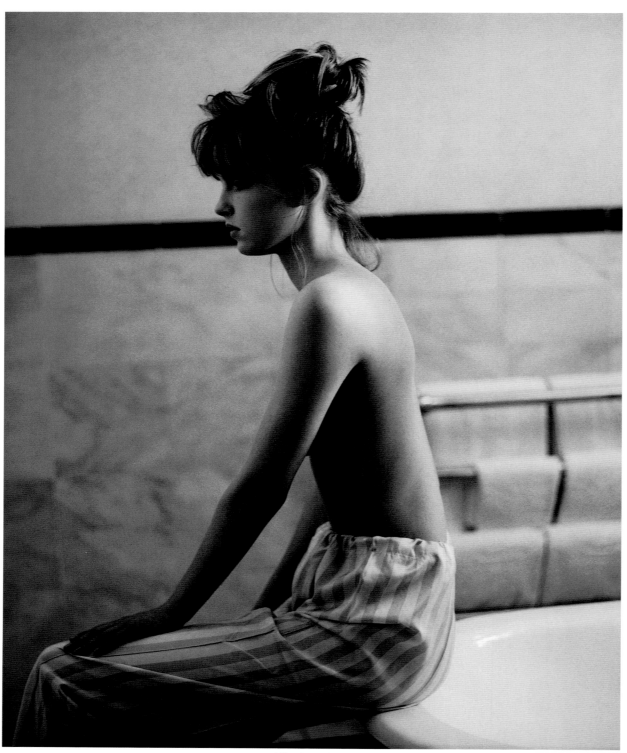

Nicola, 1987

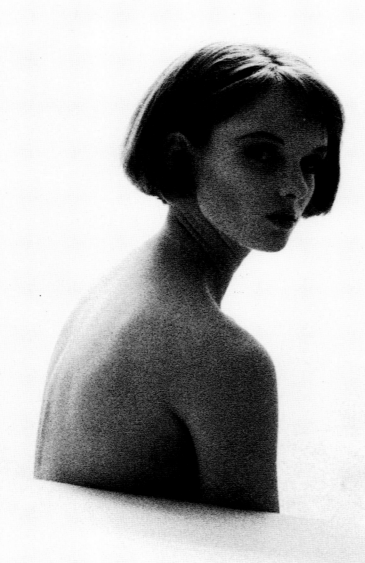

Grace Coddington, 1960

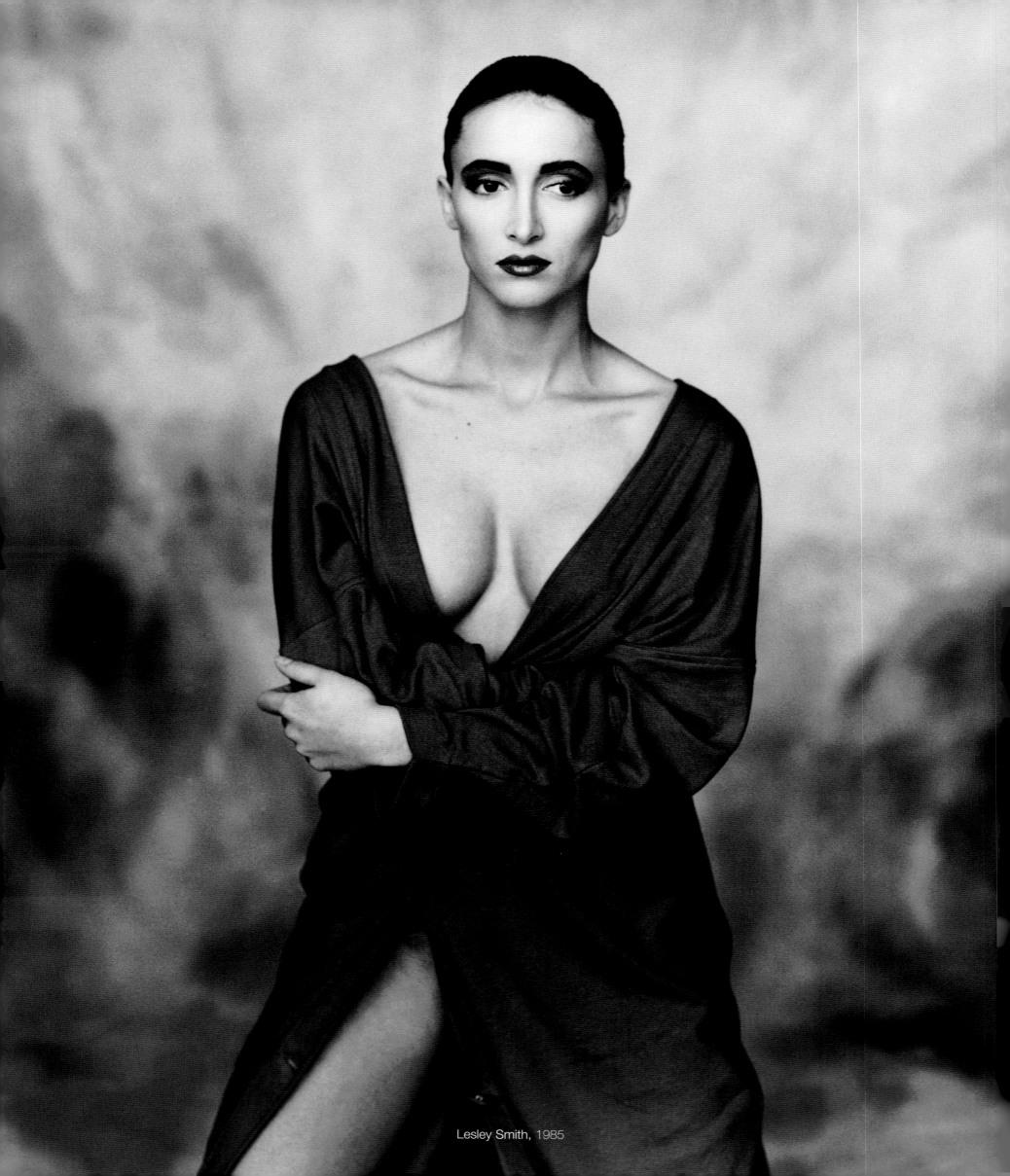

Lesley Smith, 1985

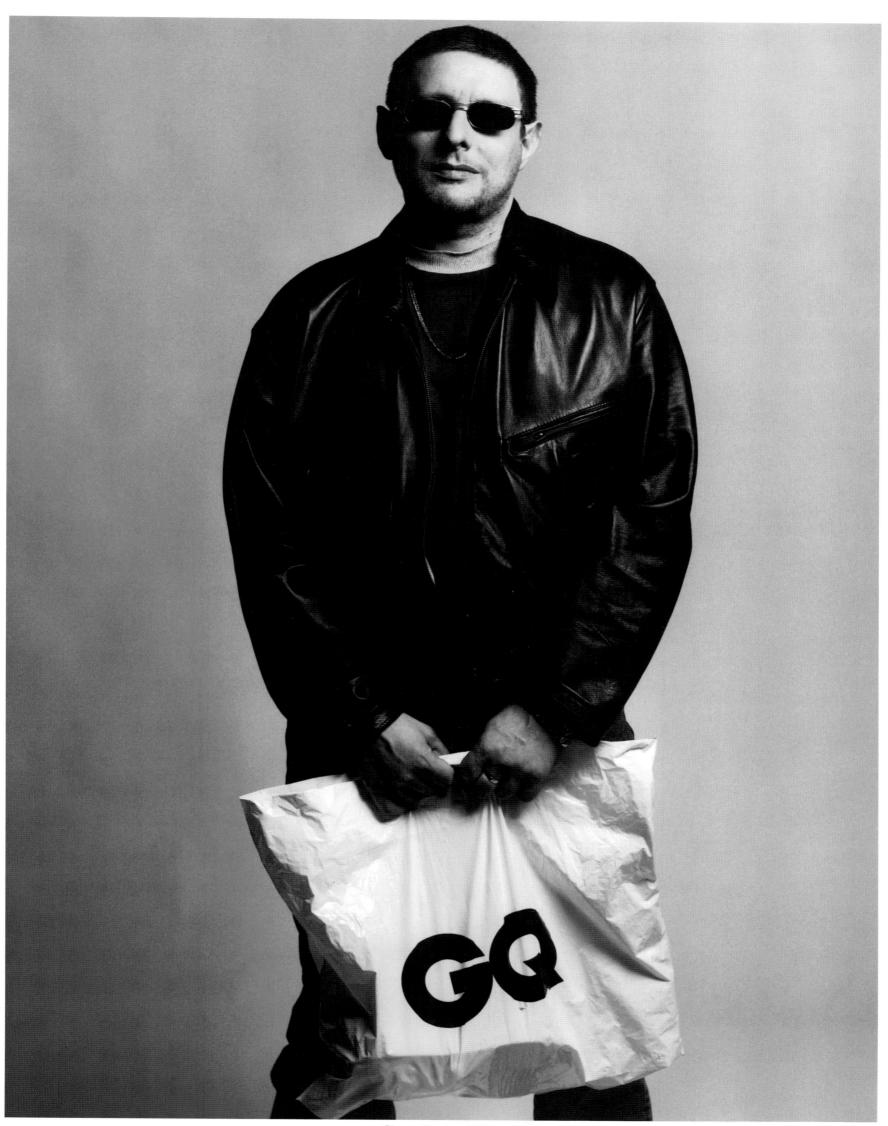

Shaun Ryder, 1996

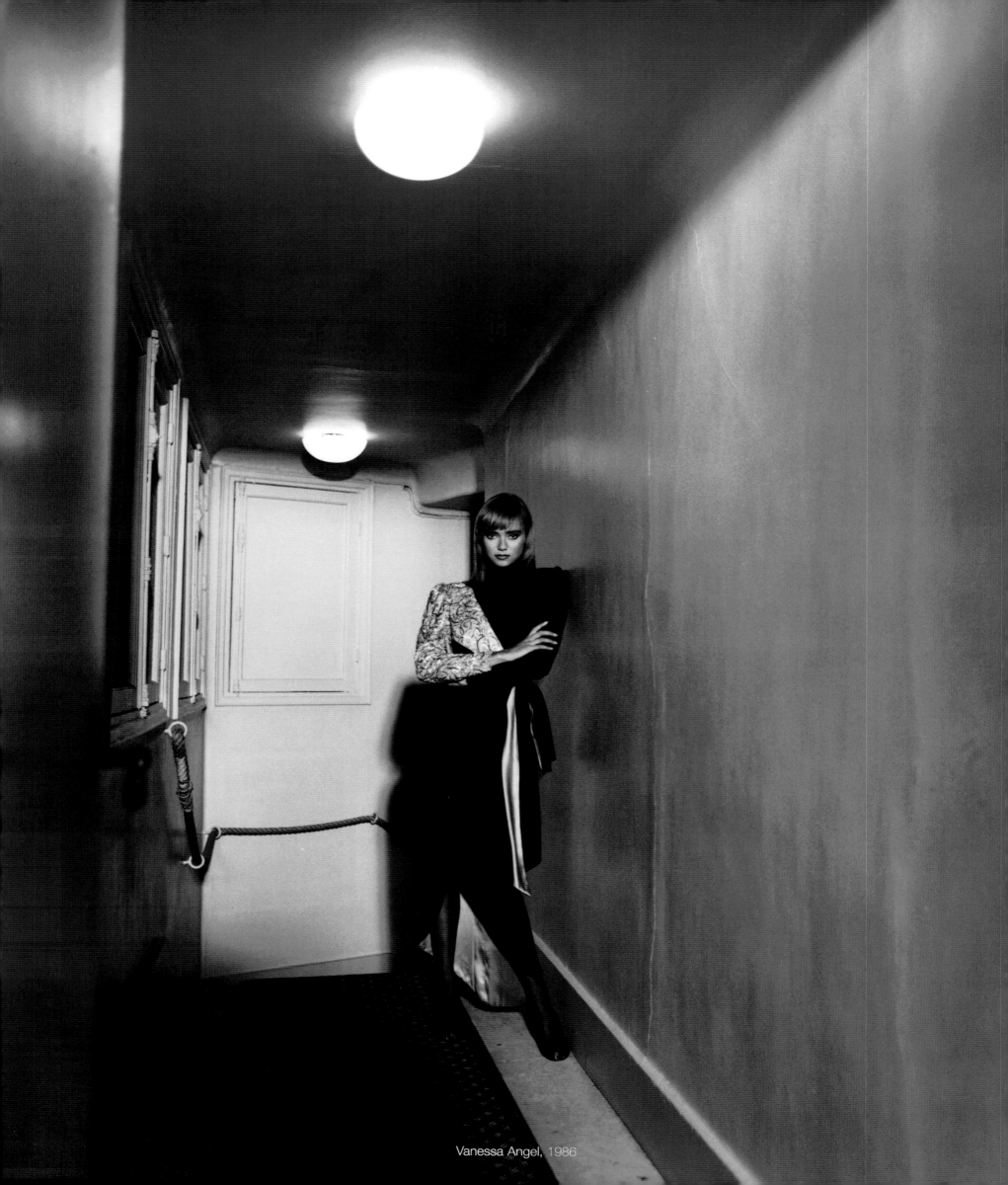

Vanessa Angel, 1986

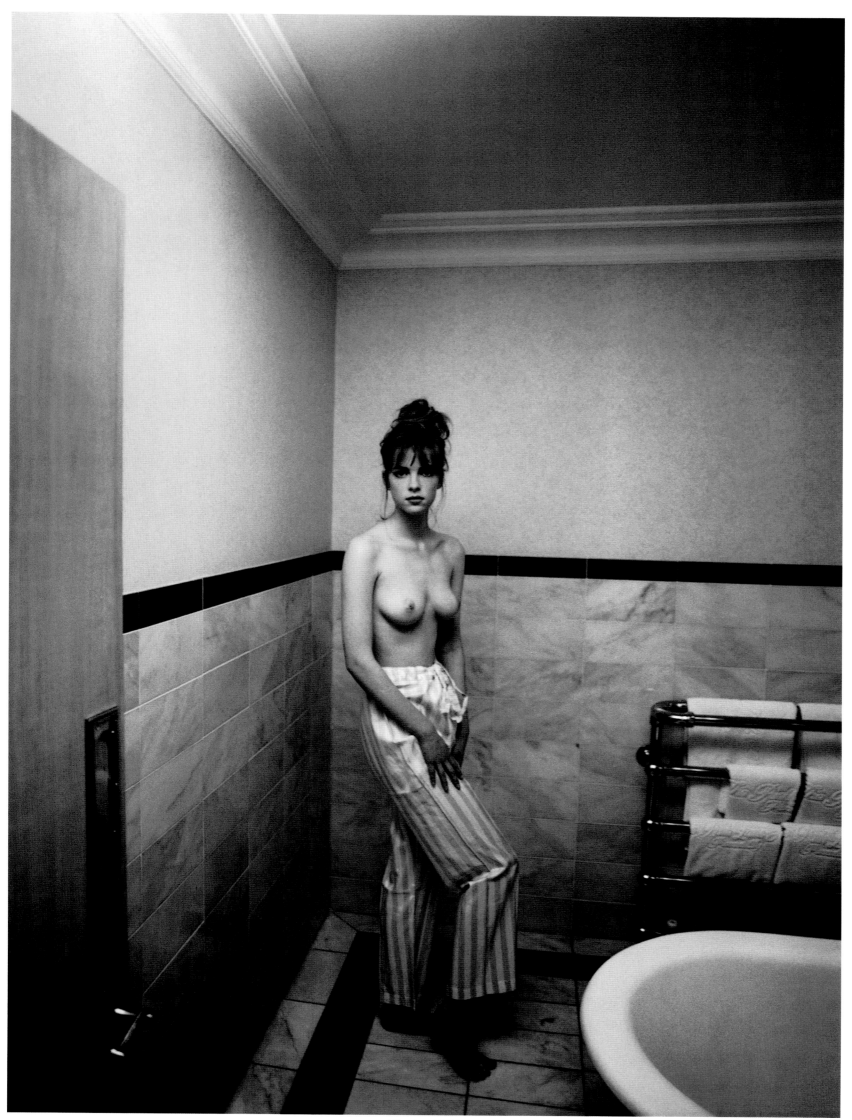

Nicola, 1987

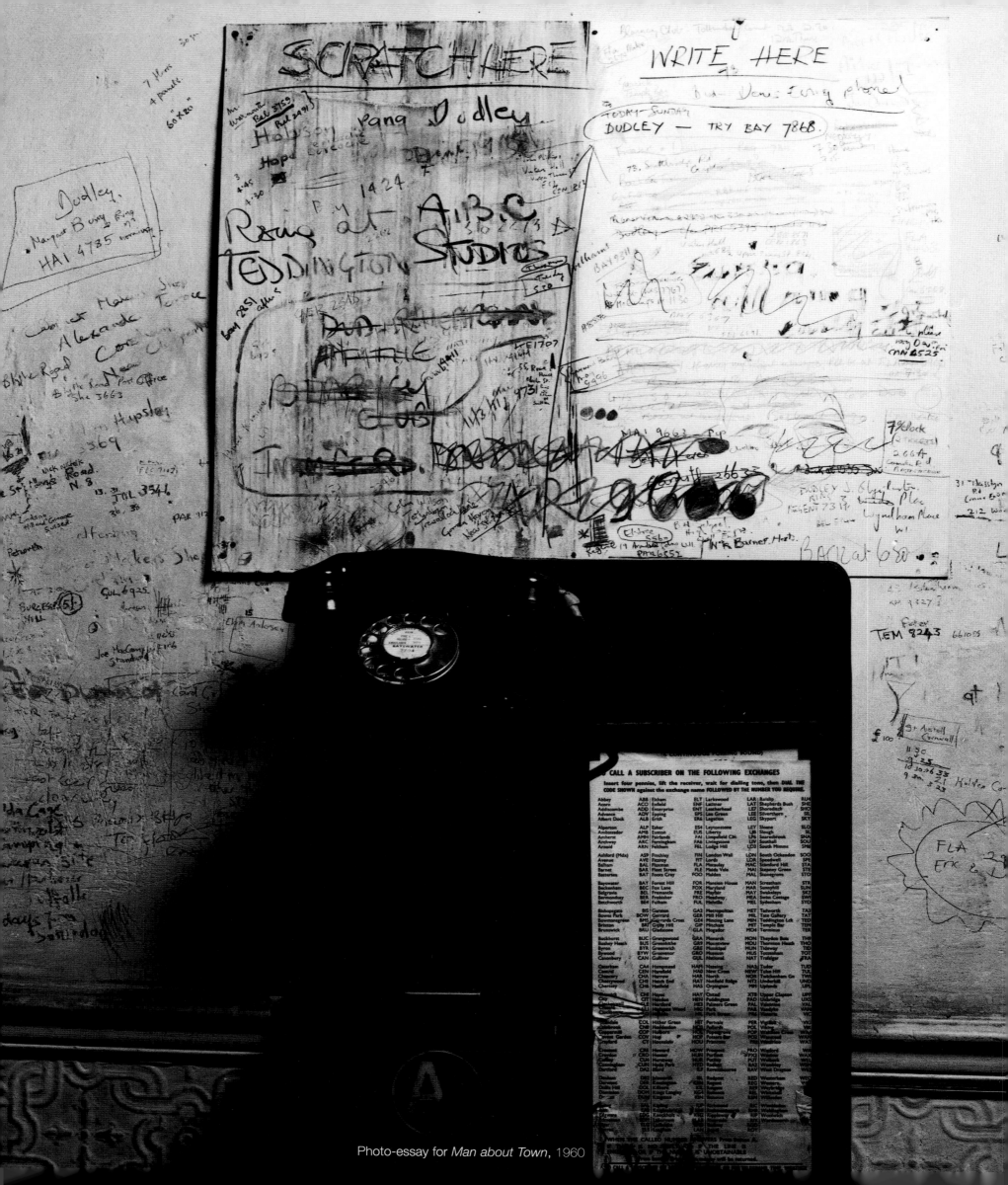

Photo-essay for *Man about Town*, 1960

Photo-essay for *Man about Town*, 1960

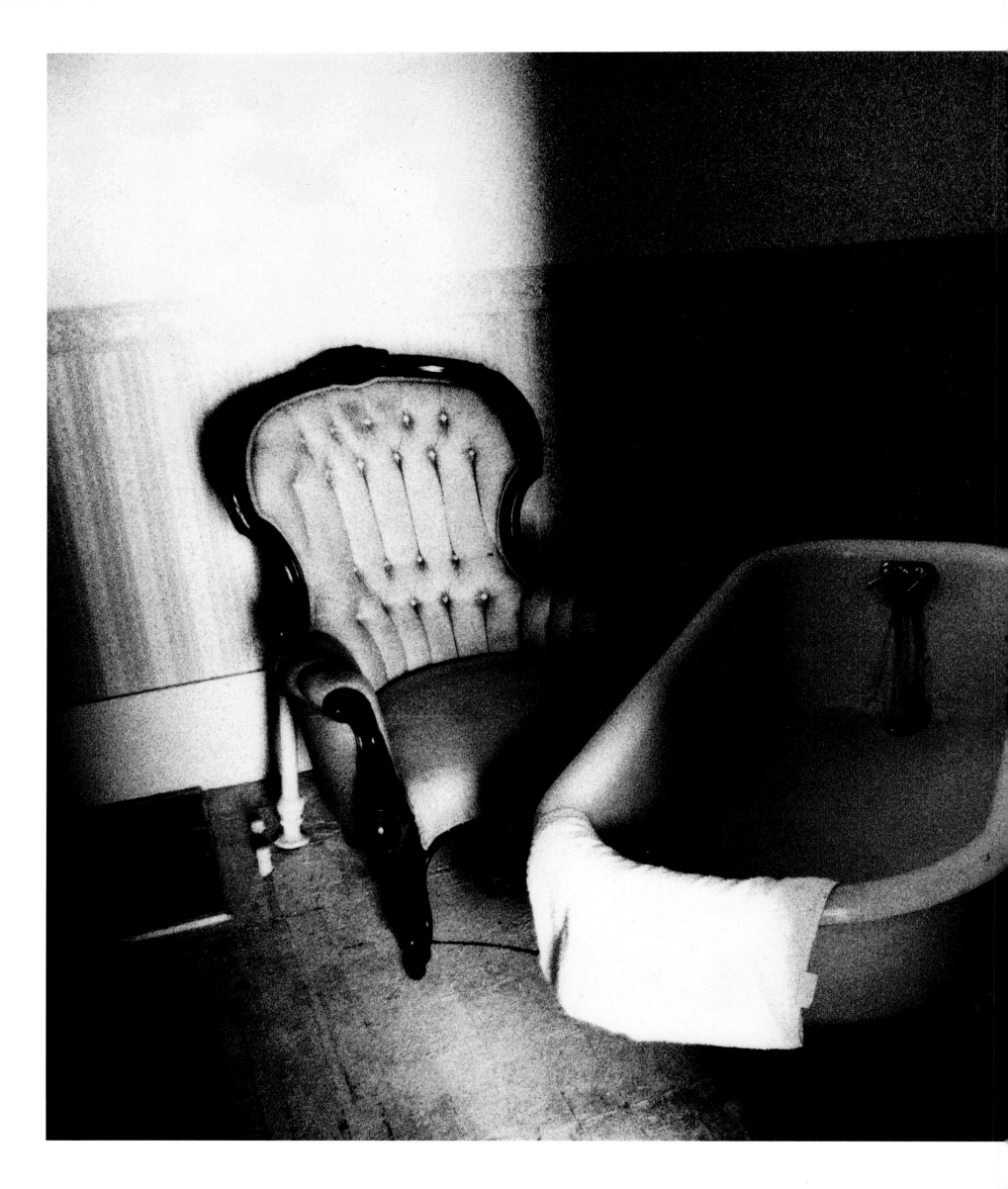

Arizona, 1996

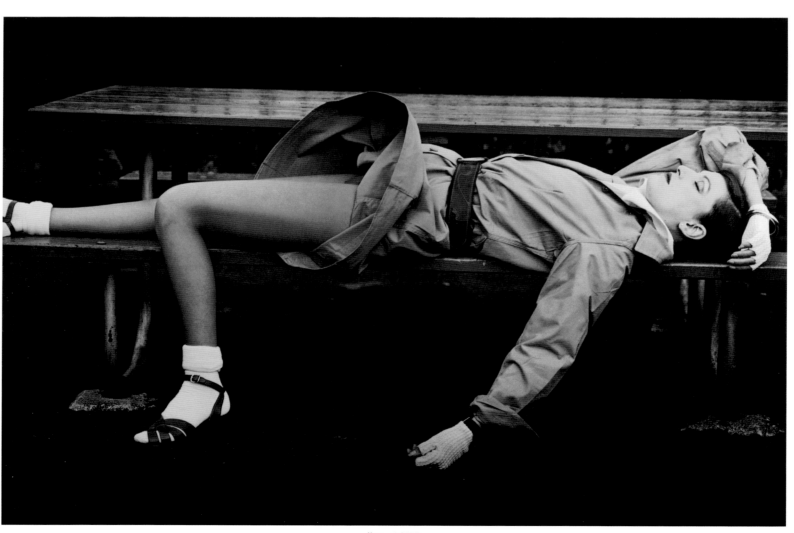

Ika, 1973

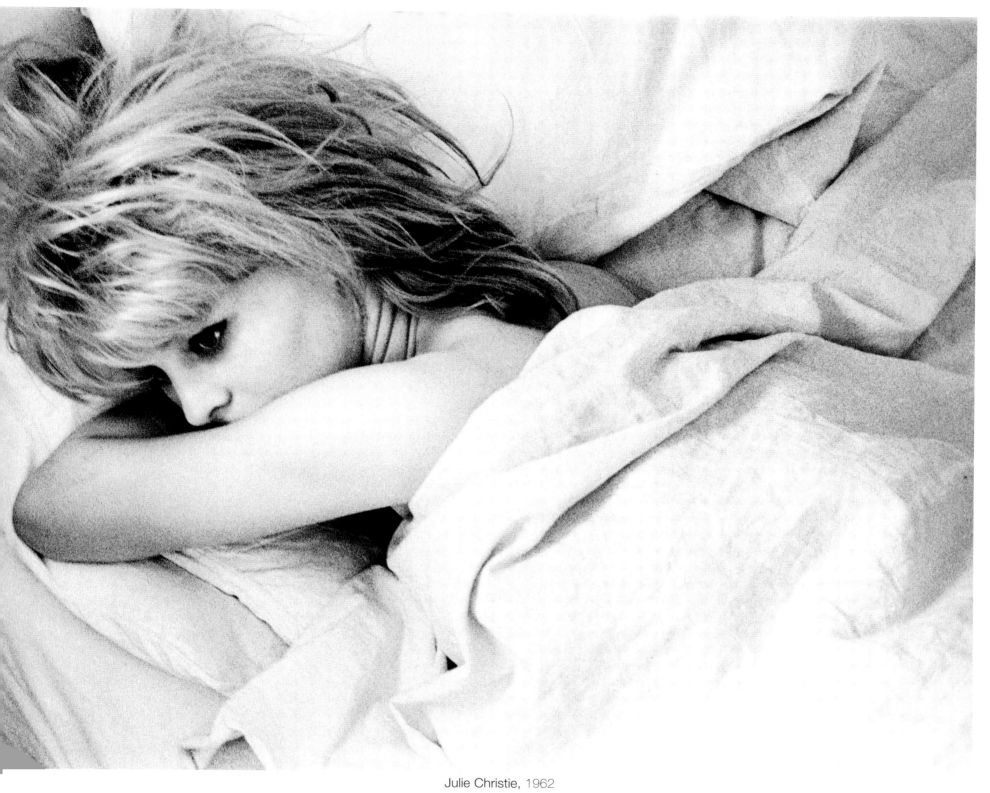

Julie Christie, 1962

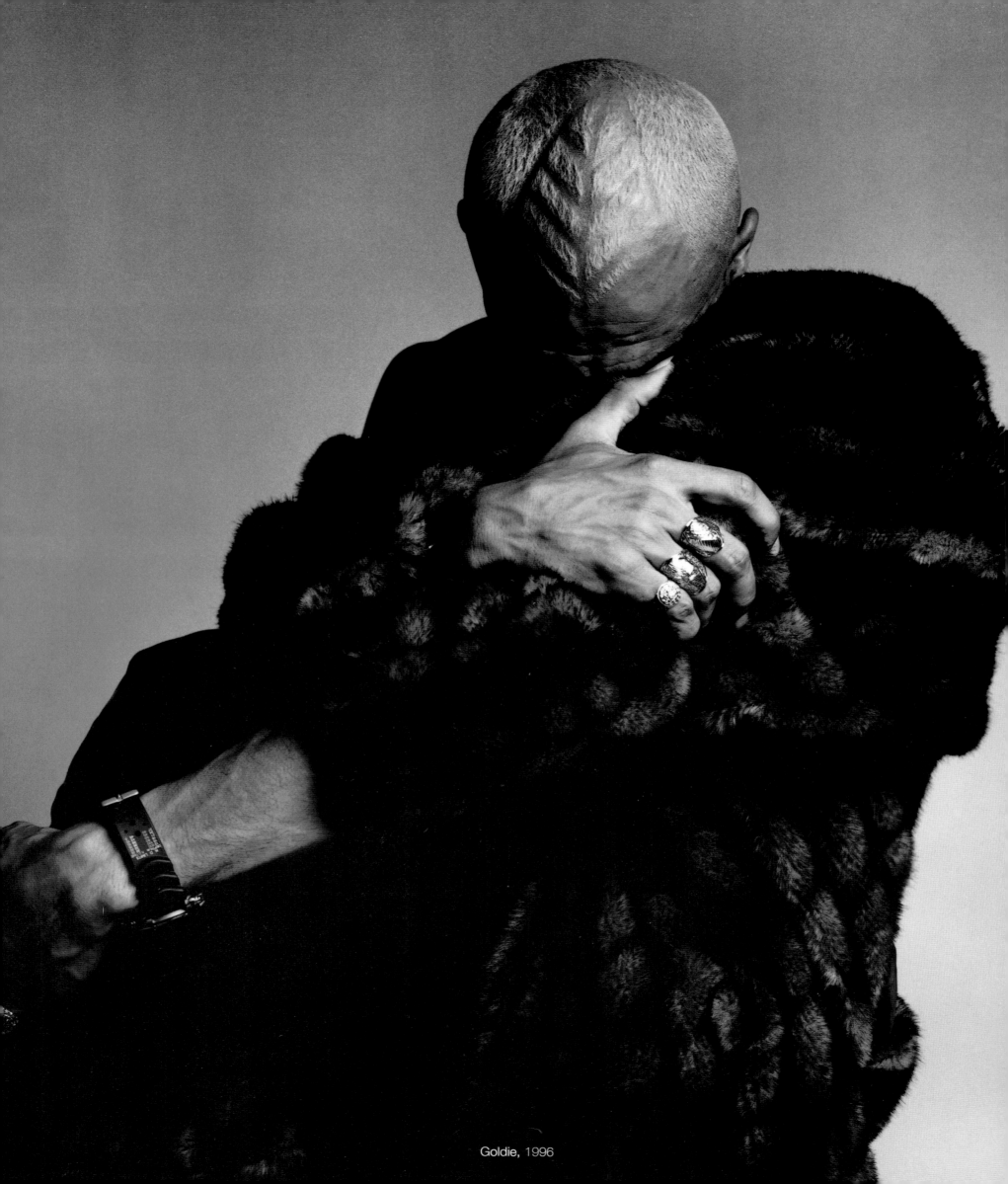

Goldie, 1996

Ambrose Congreve, 1989

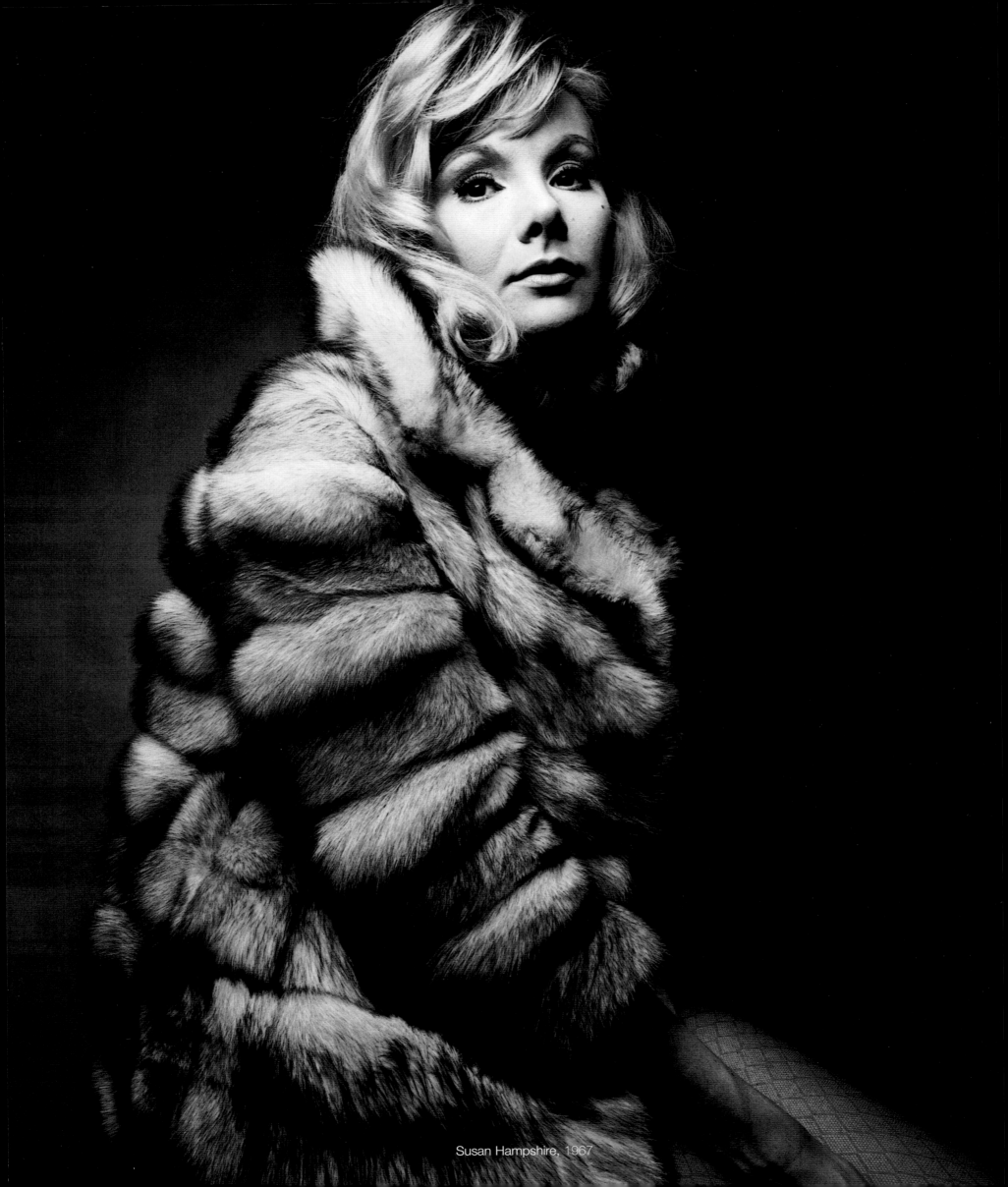
Susan Hampshire, 1967

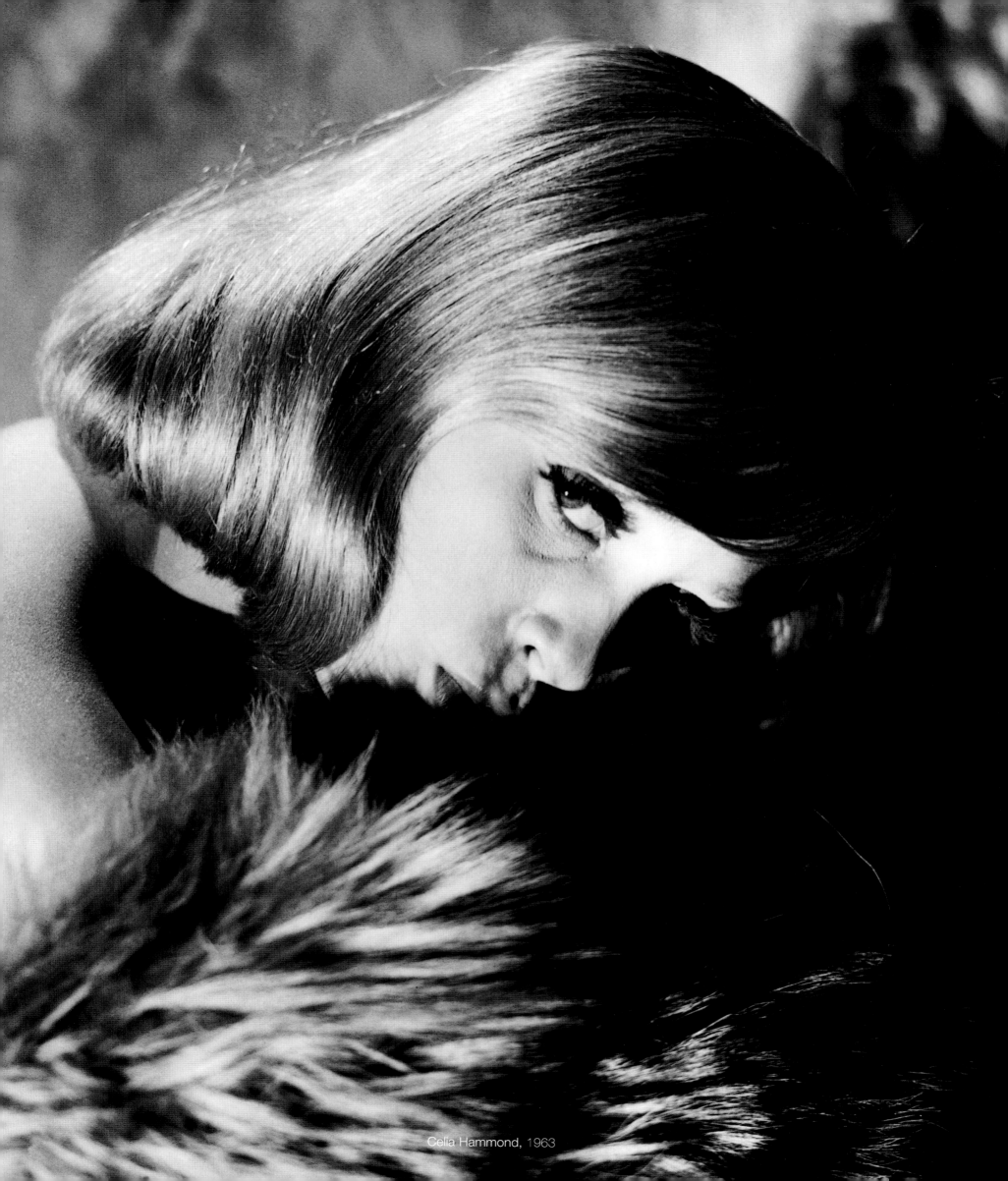

Celia Hammond, 1963

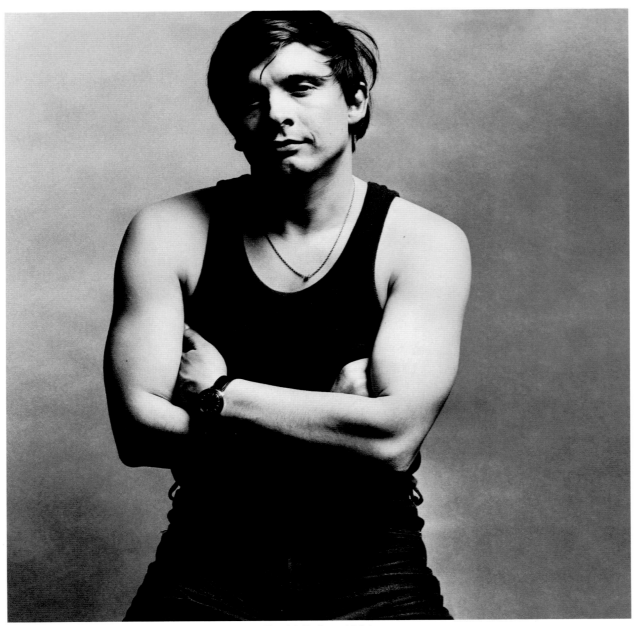

David Bailey, 1964

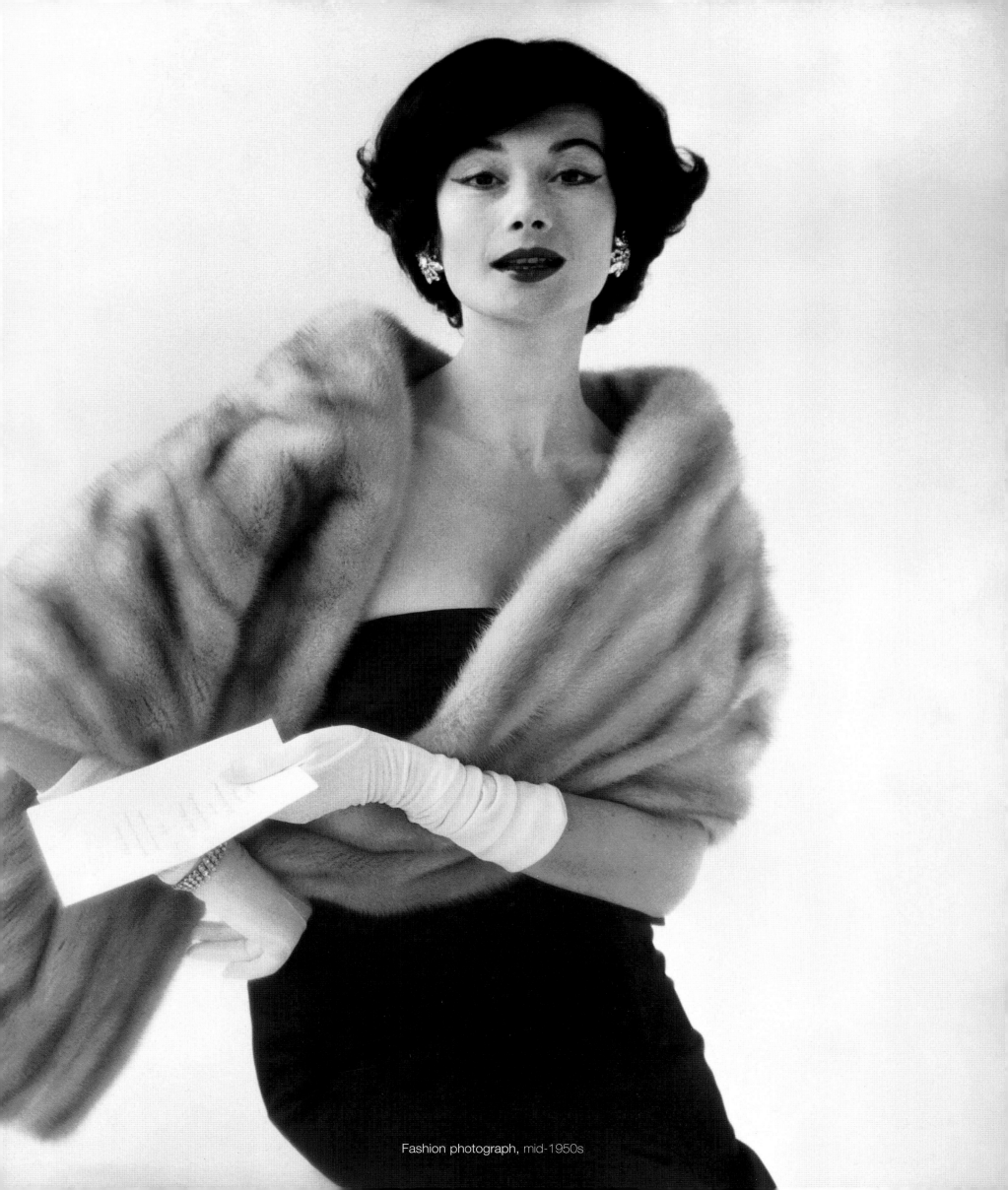

Fashion photograph, mid-1950s

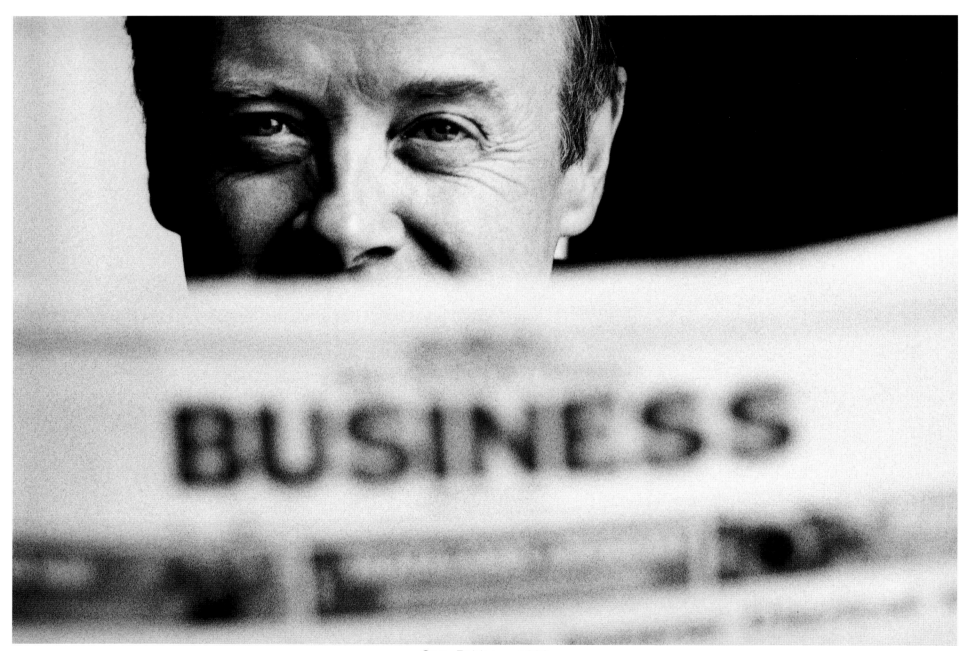

Gerry Robinson, 1996

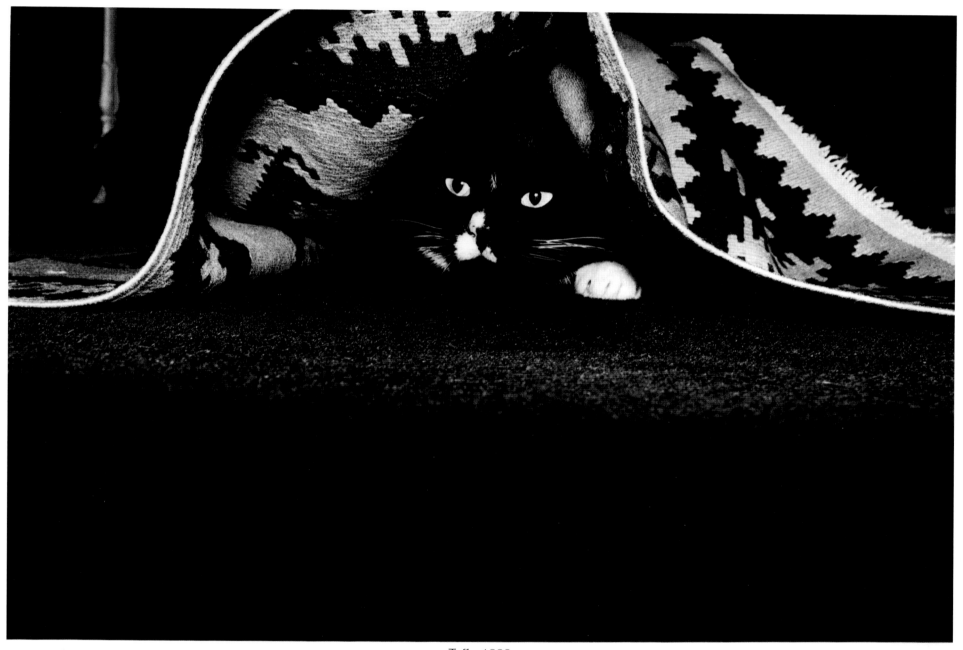

Tuffy, 1993

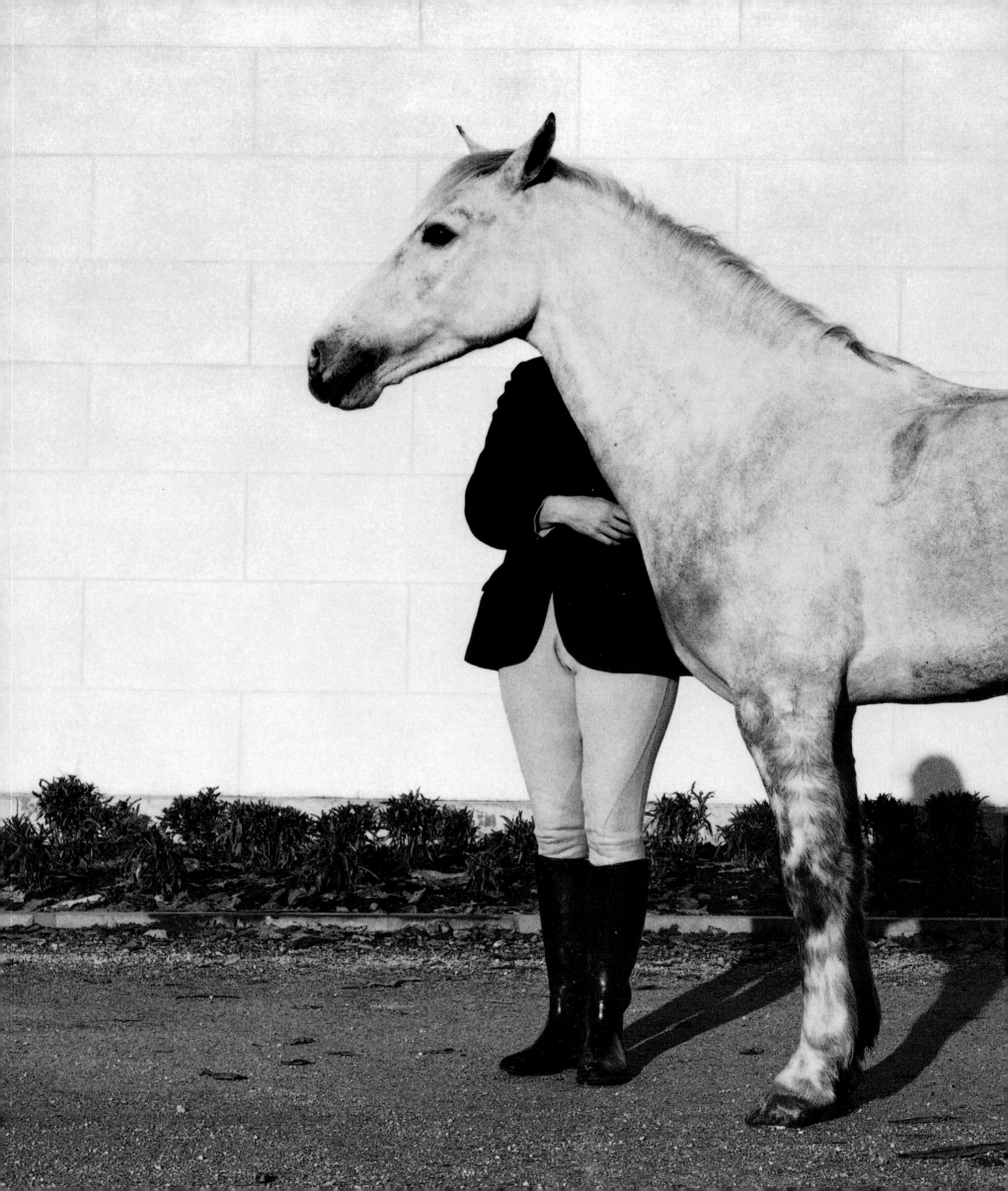

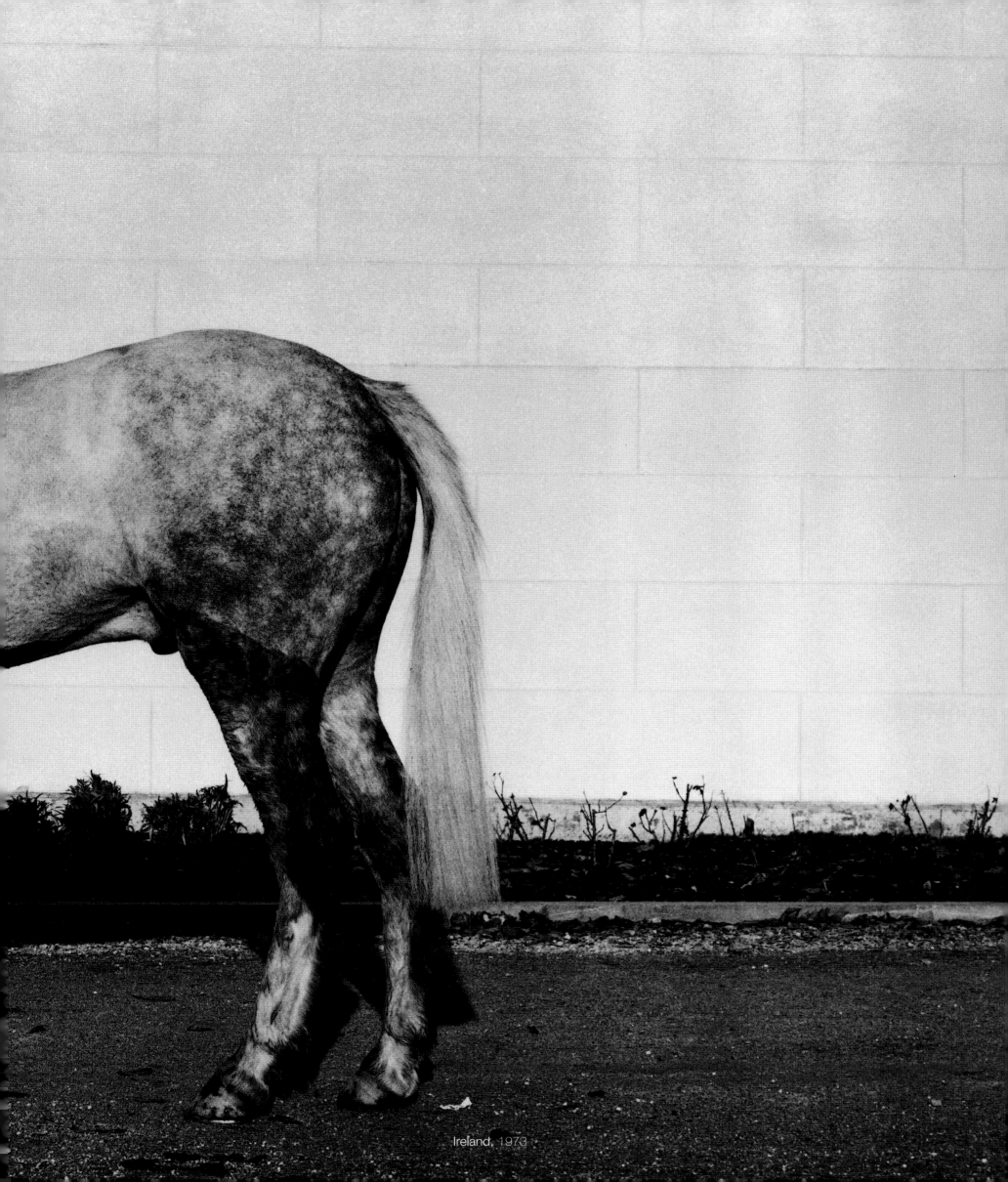
Ireland, 1973

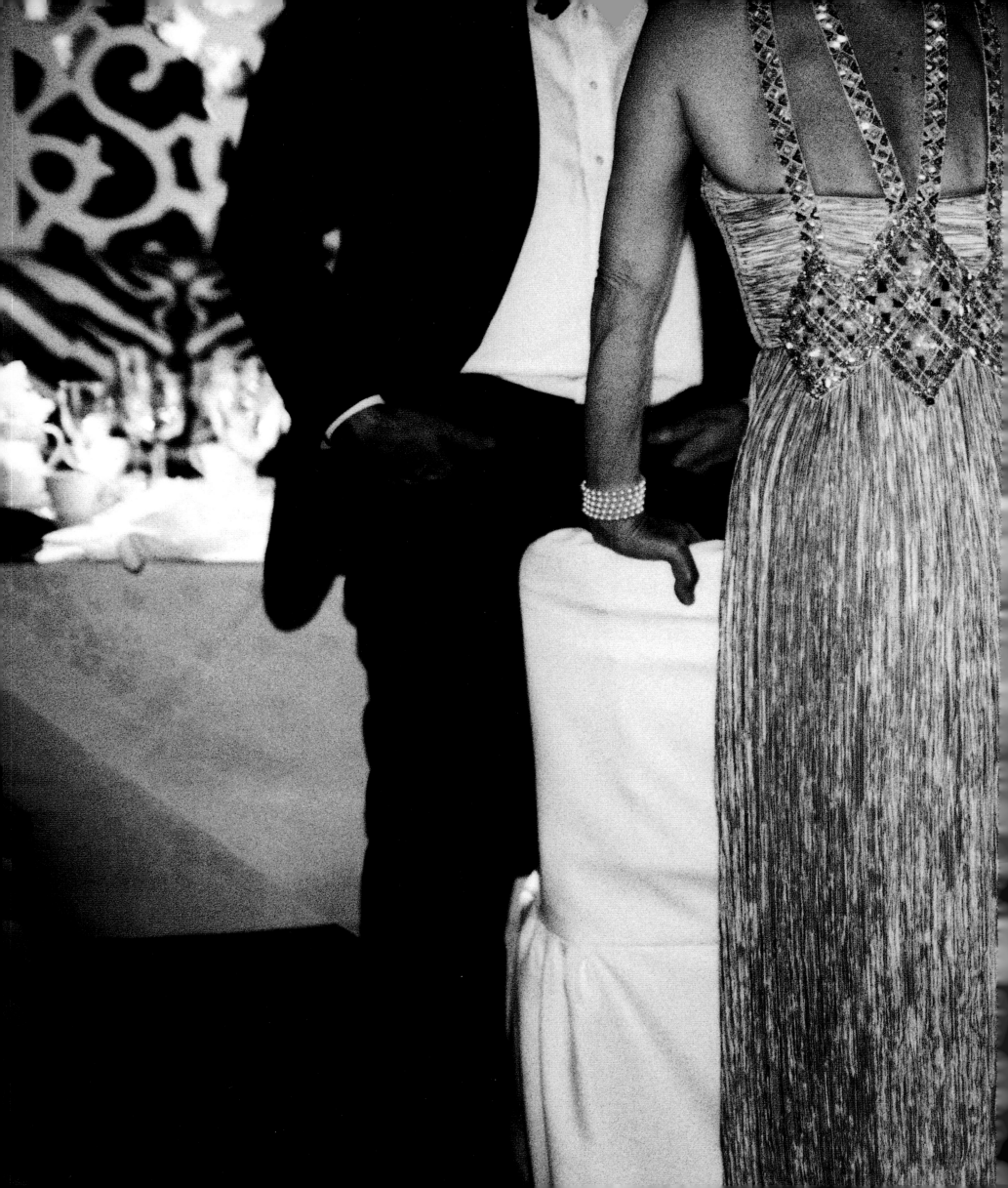

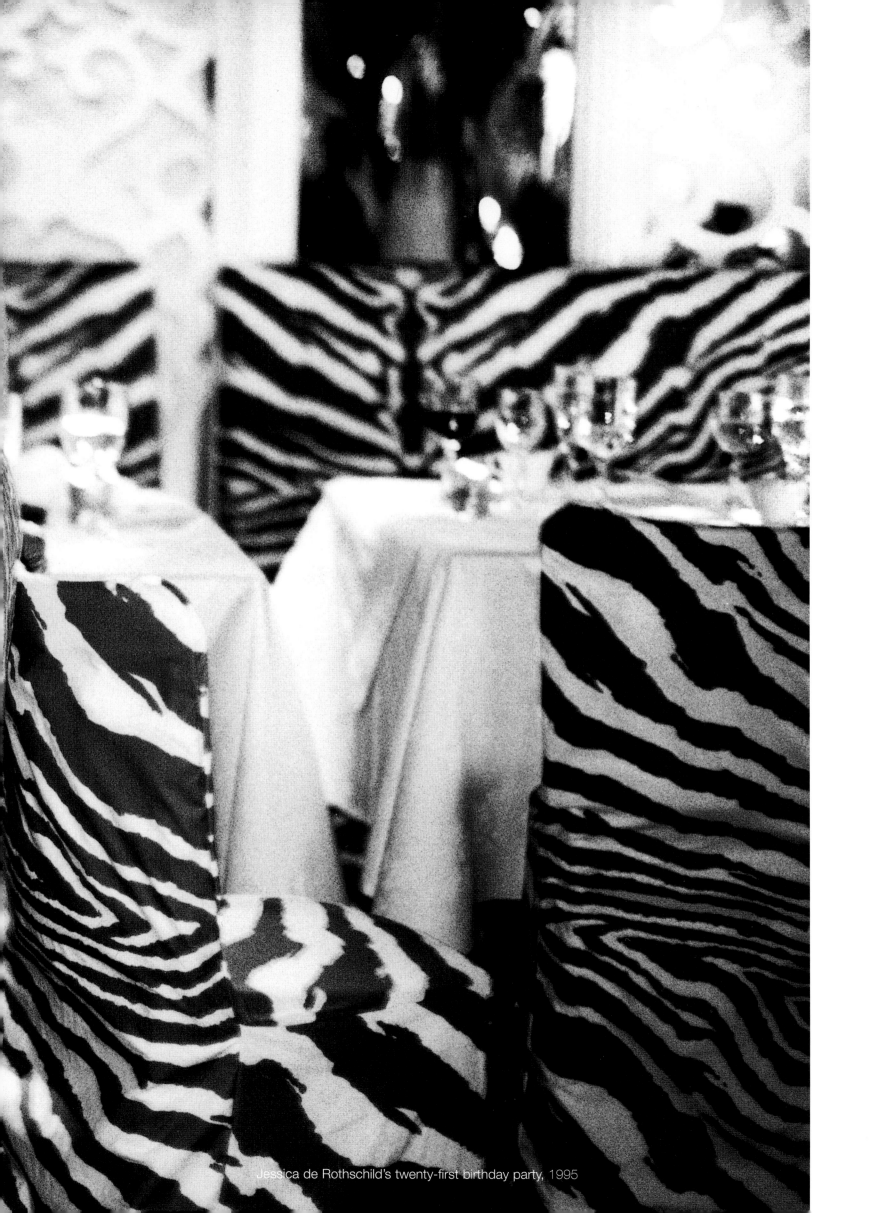

Jessica de Rothschild's twenty-first birthday party, 1995

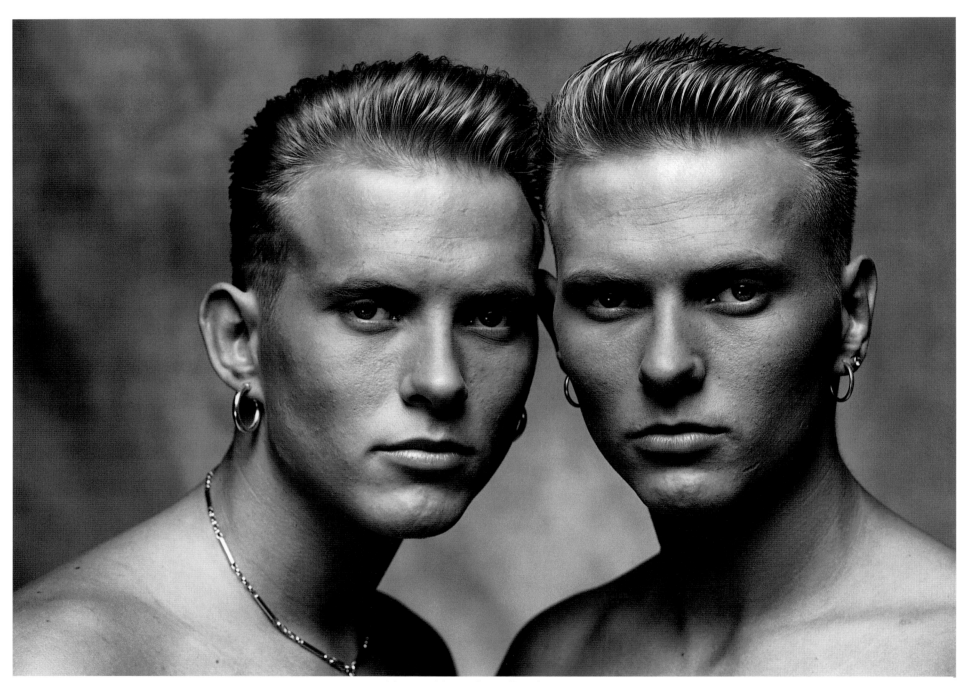

Matt and Luke Goss (Bros), 1989

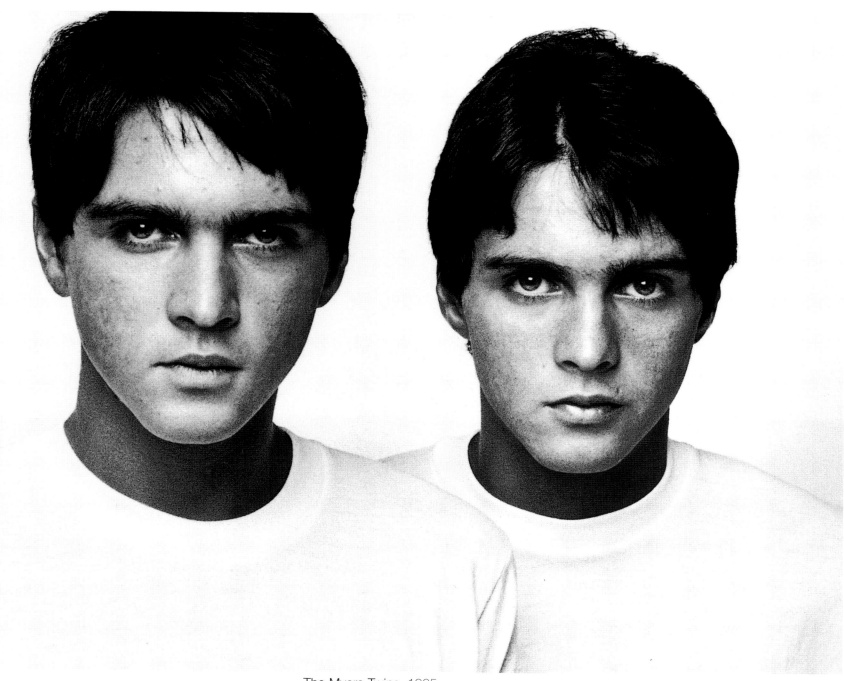

The Myers Twins, 1965

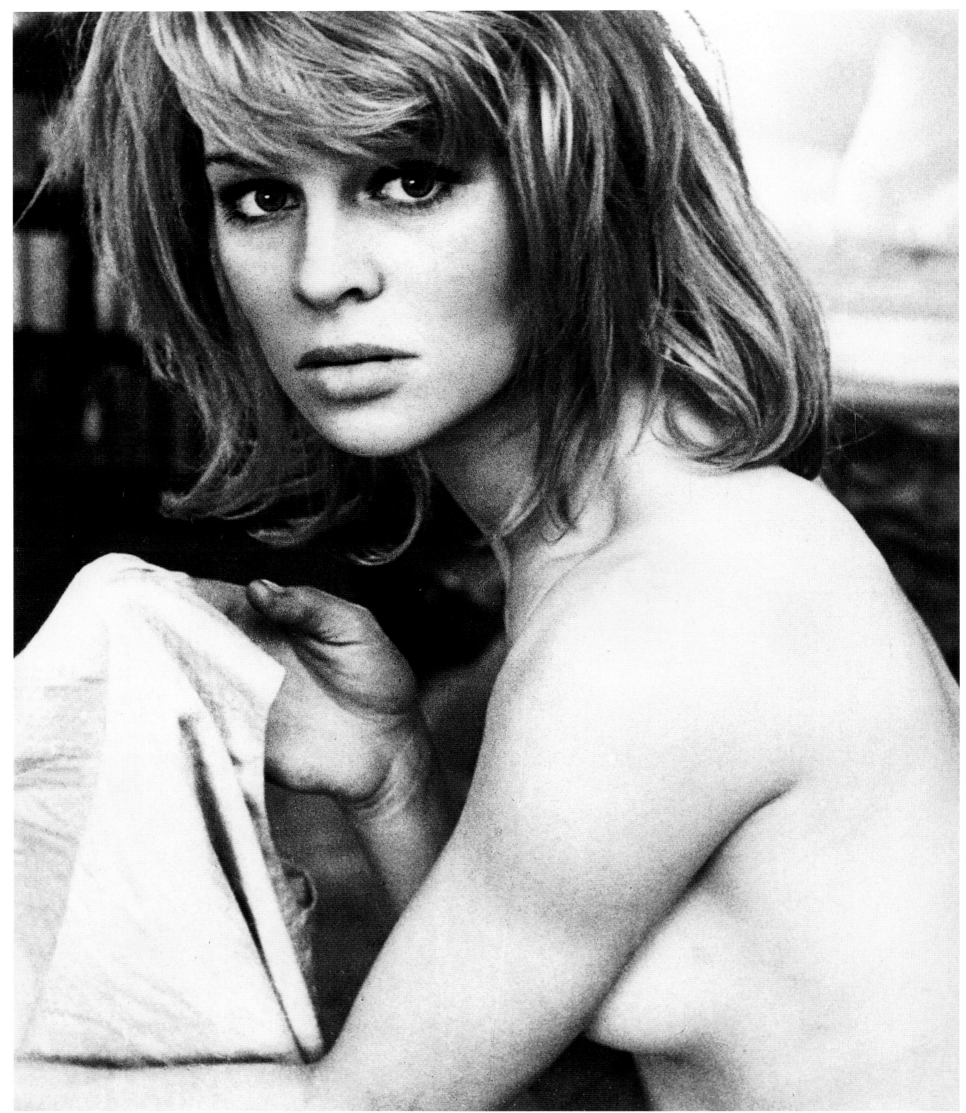

Julie Christie, 1962

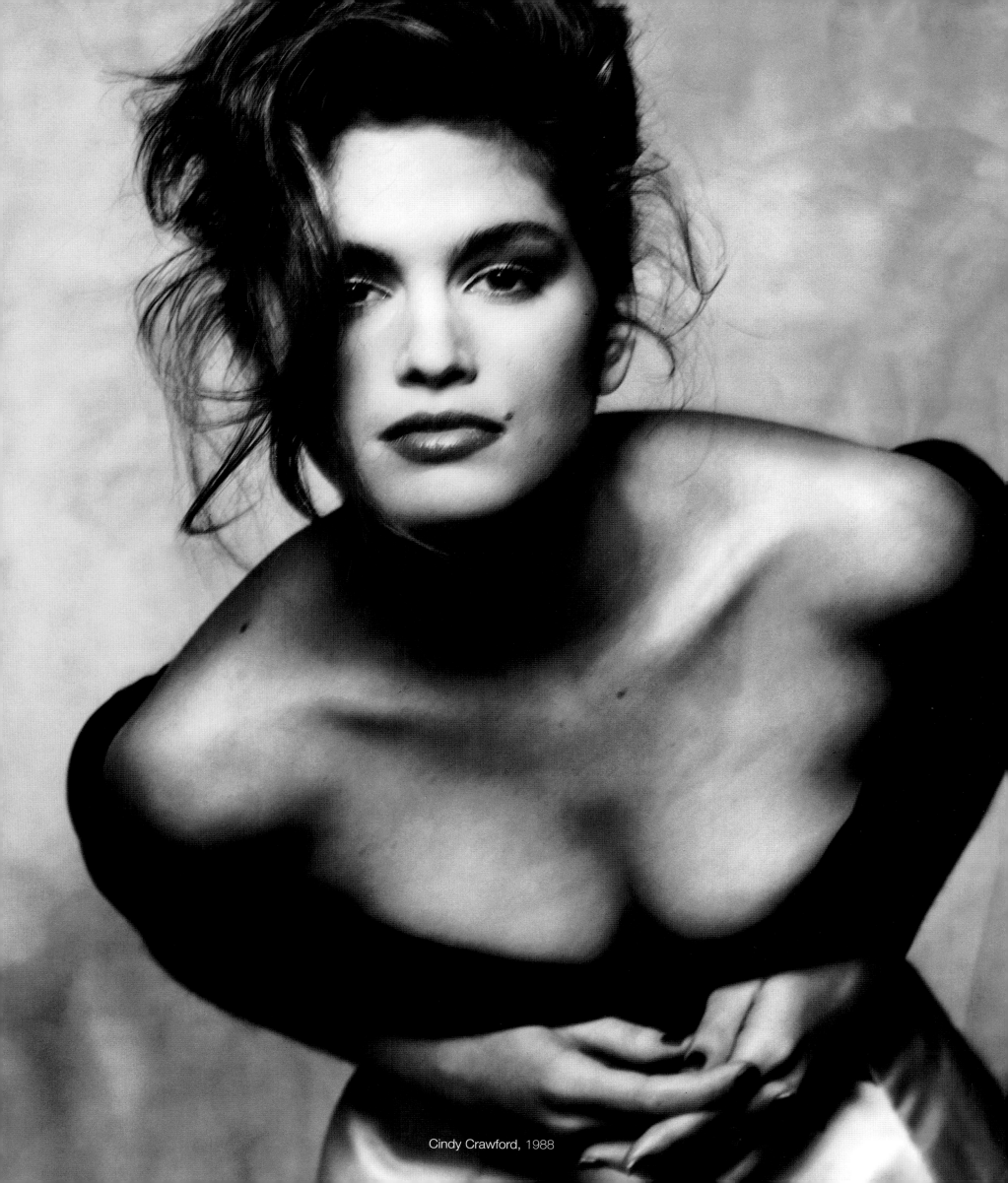
Cindy Crawford, 1988

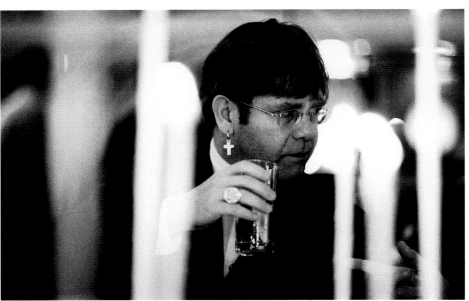

Elton John, 1996

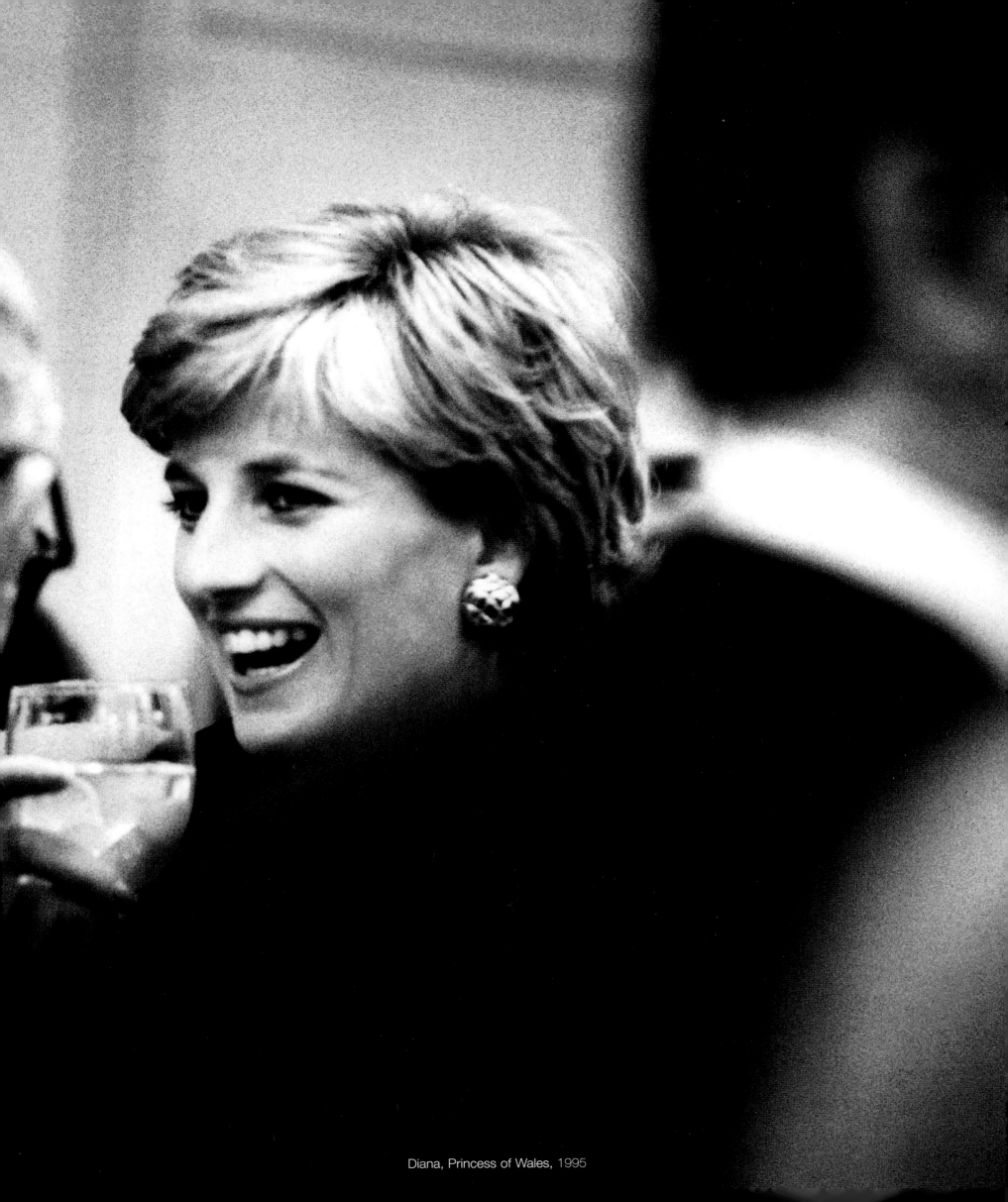

Diana, Princess of Wales, 1995

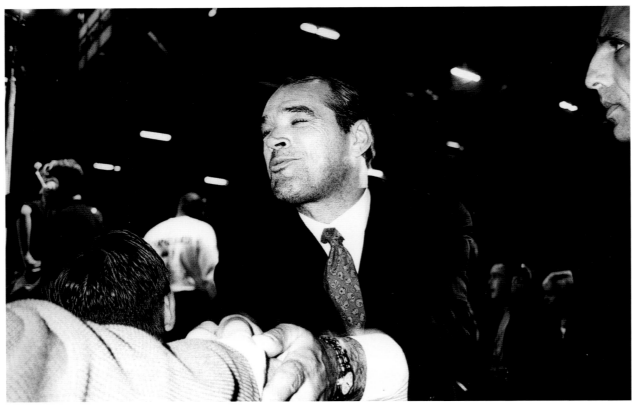

Boxing Match, 1994

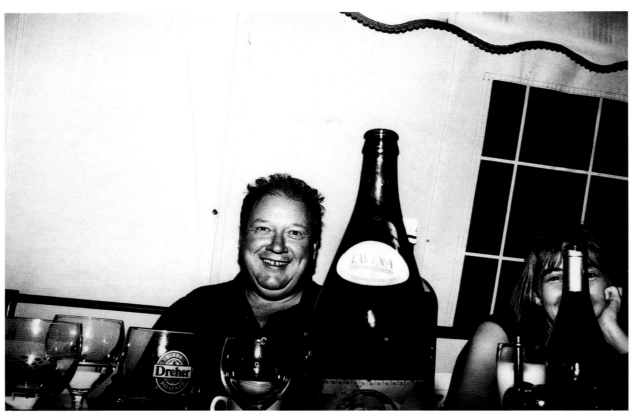

Alistair McAlpine, 1994

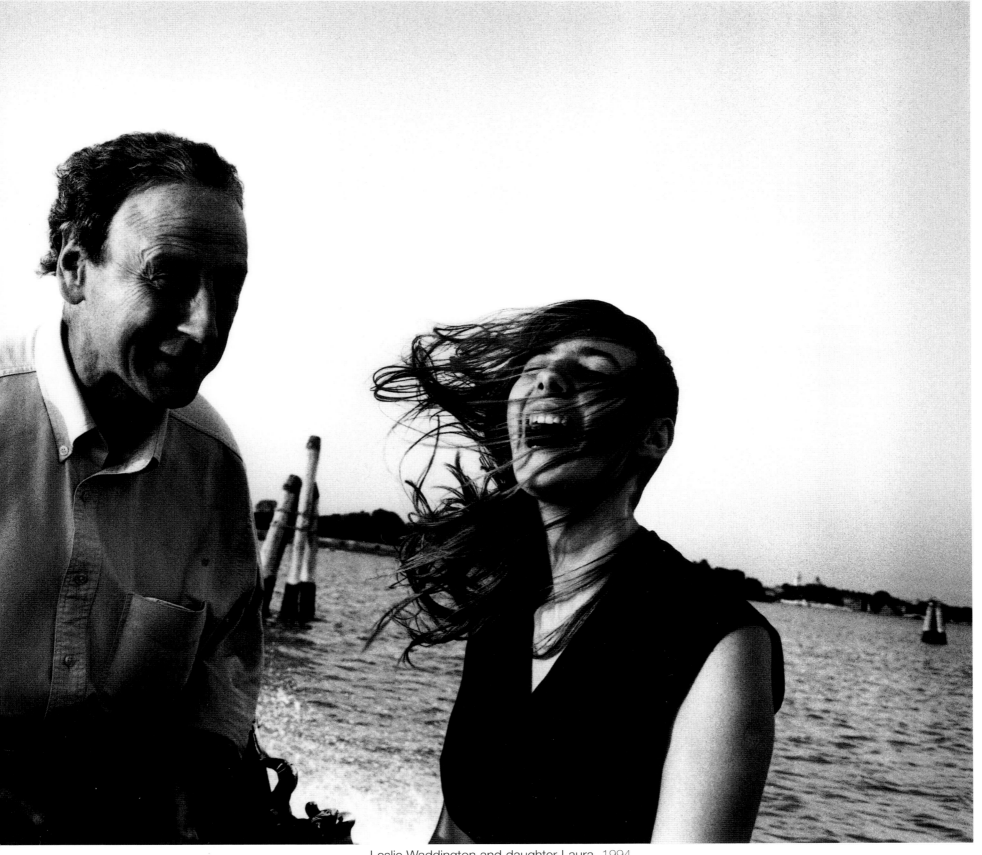

Leslie Waddington and daughter Laura, 1994

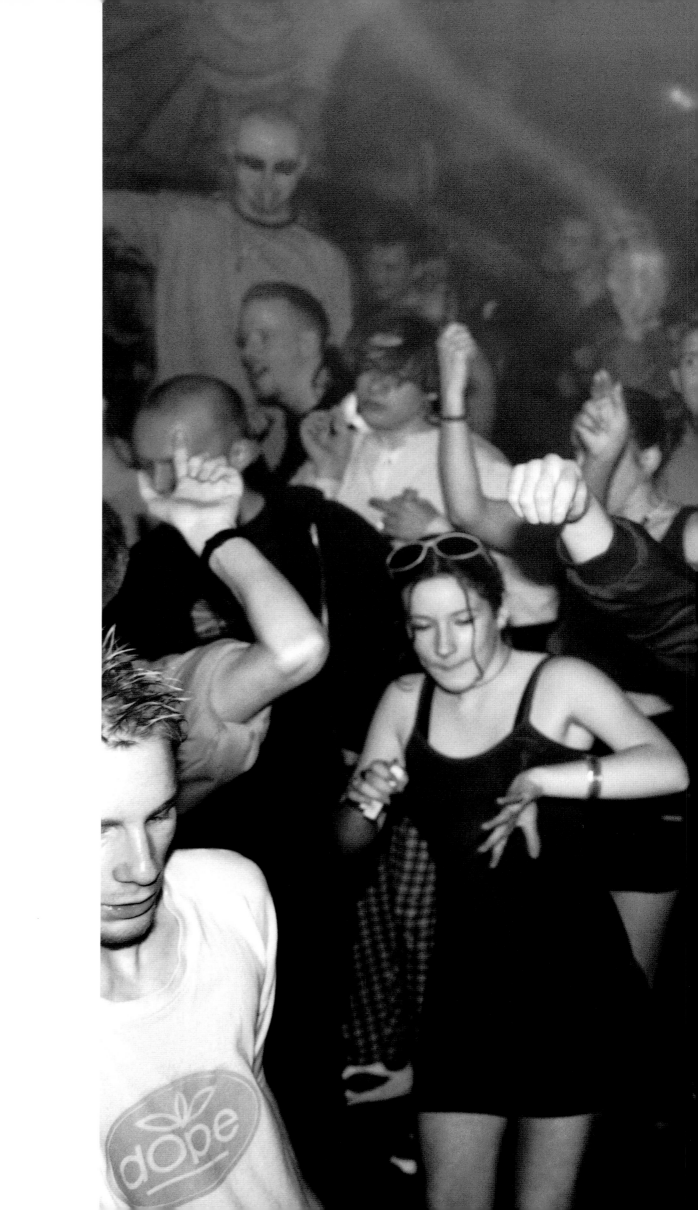

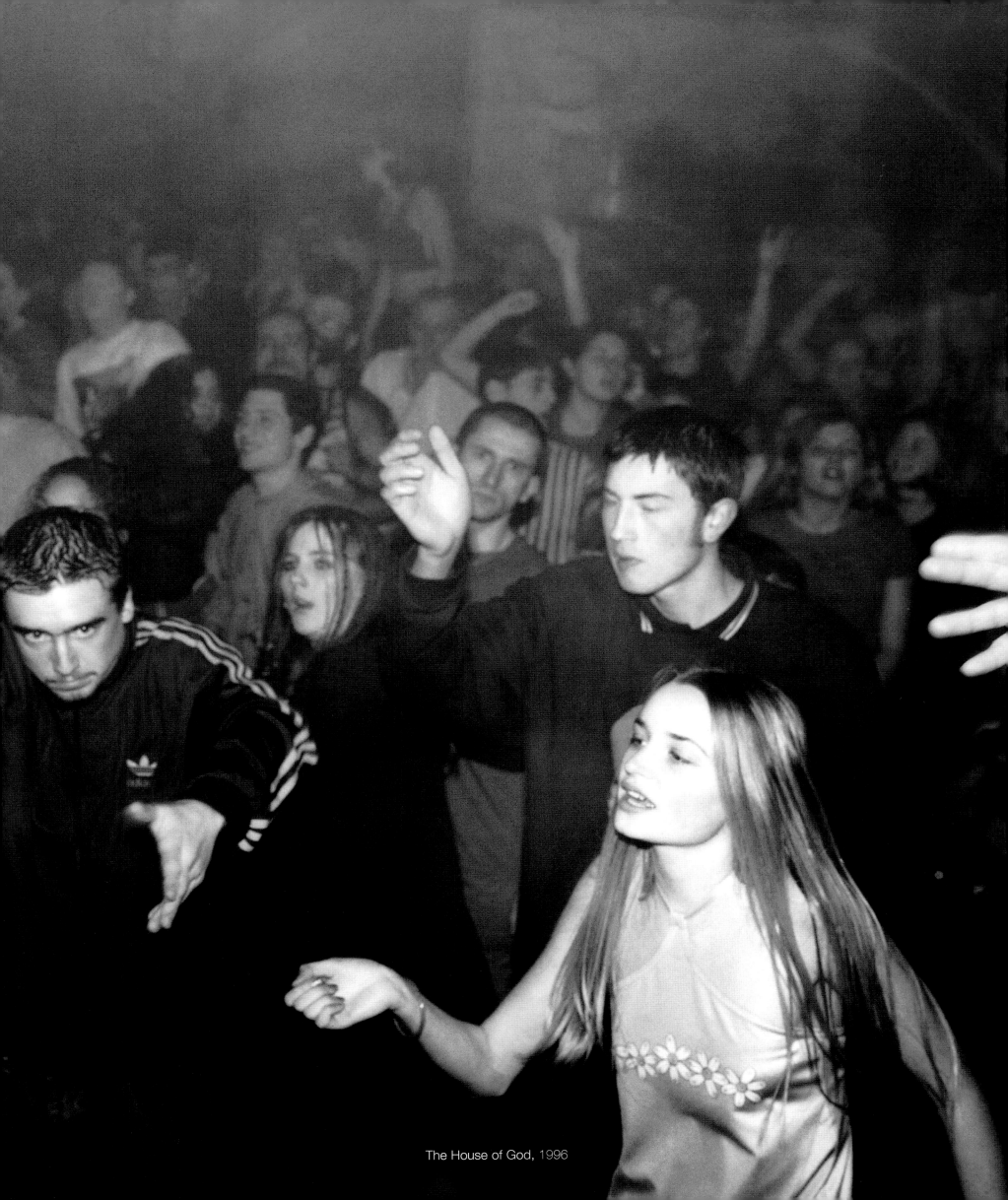

The House of God, 1996

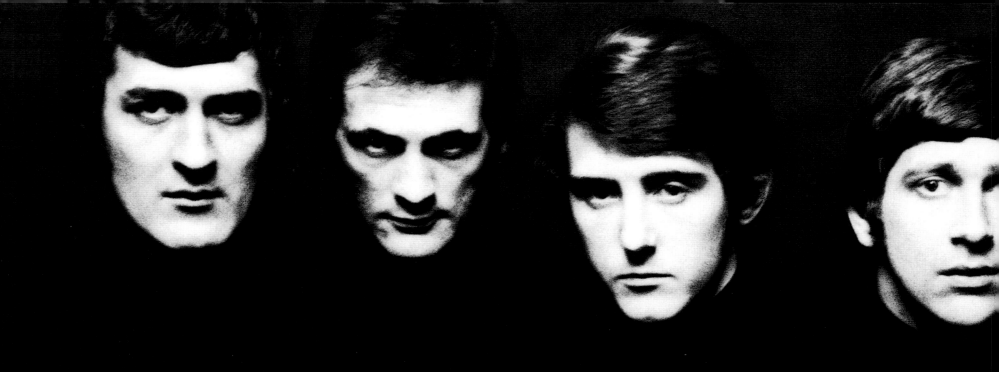

The Moody Blues, 1965

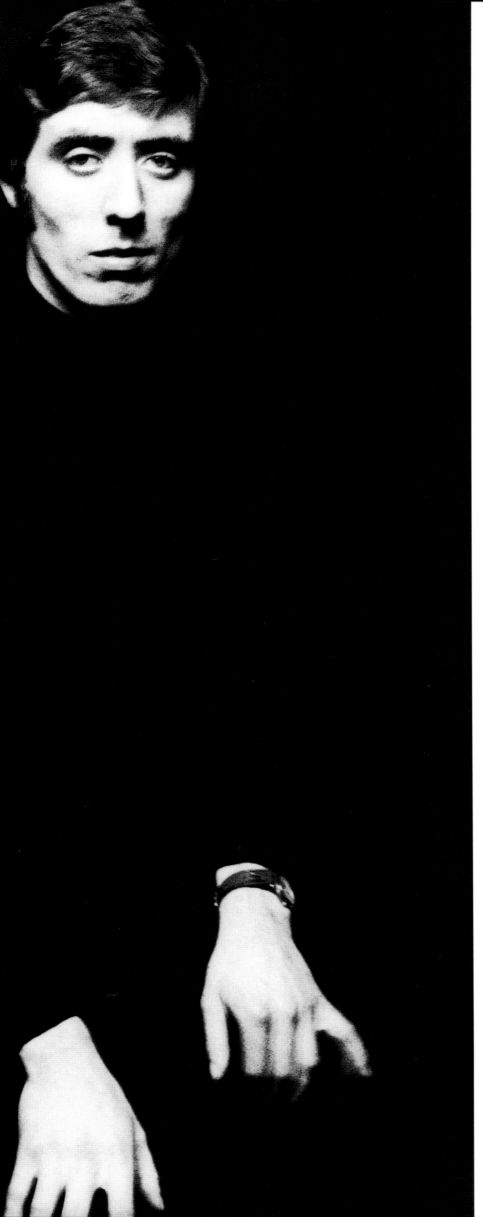
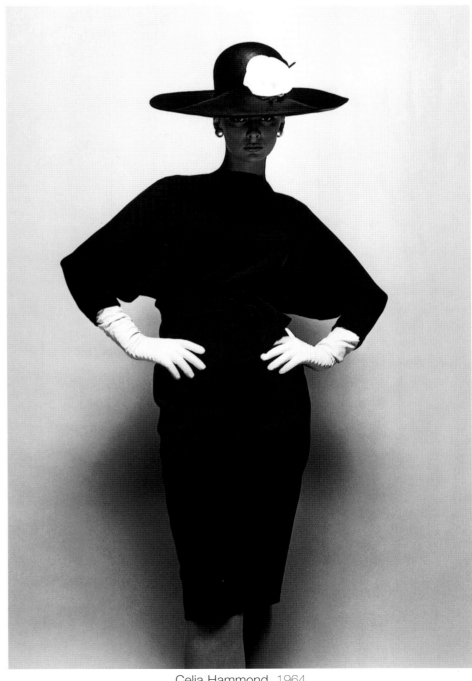

Celia Hammond, 1964

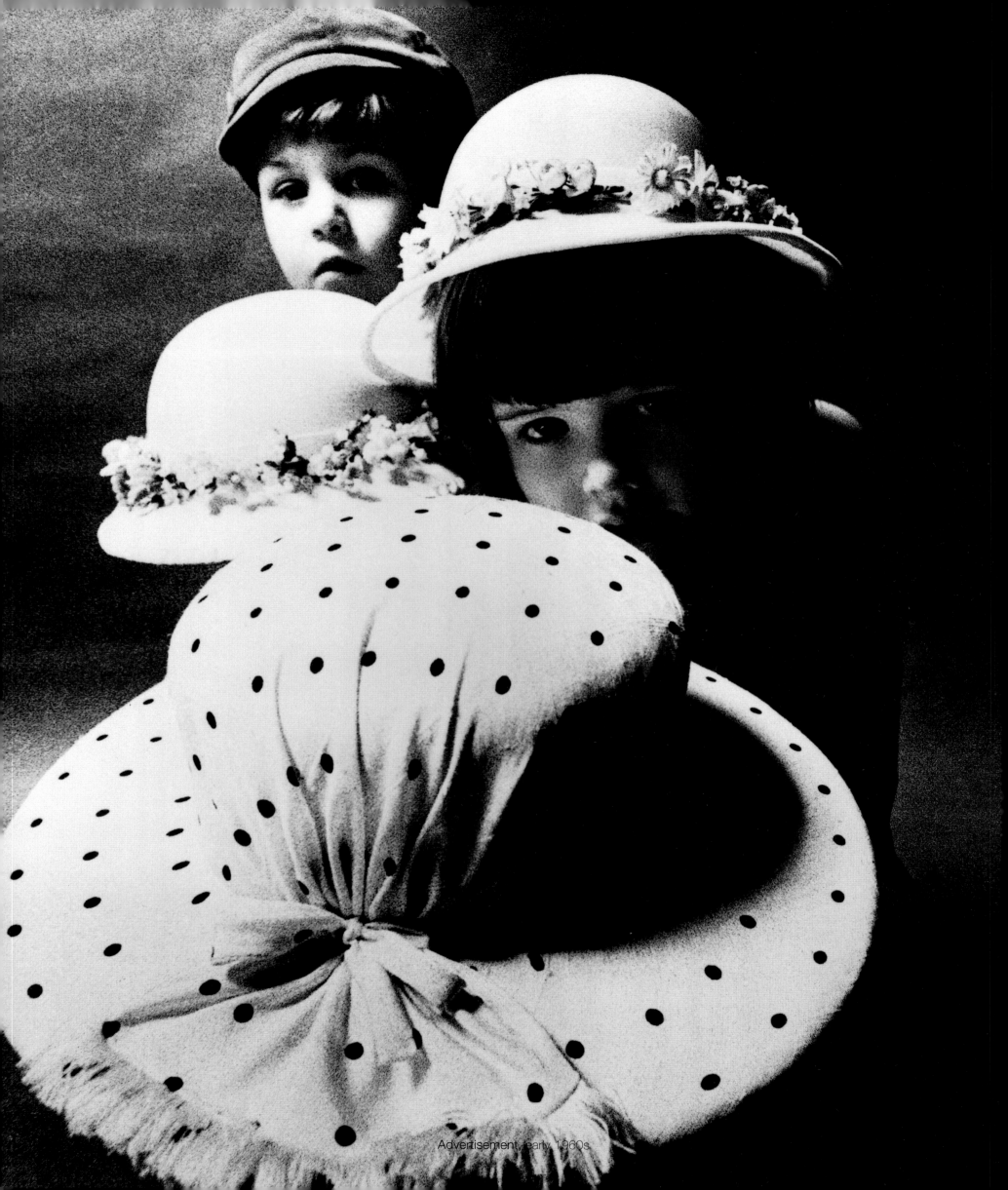

Advertisement, early 1960s

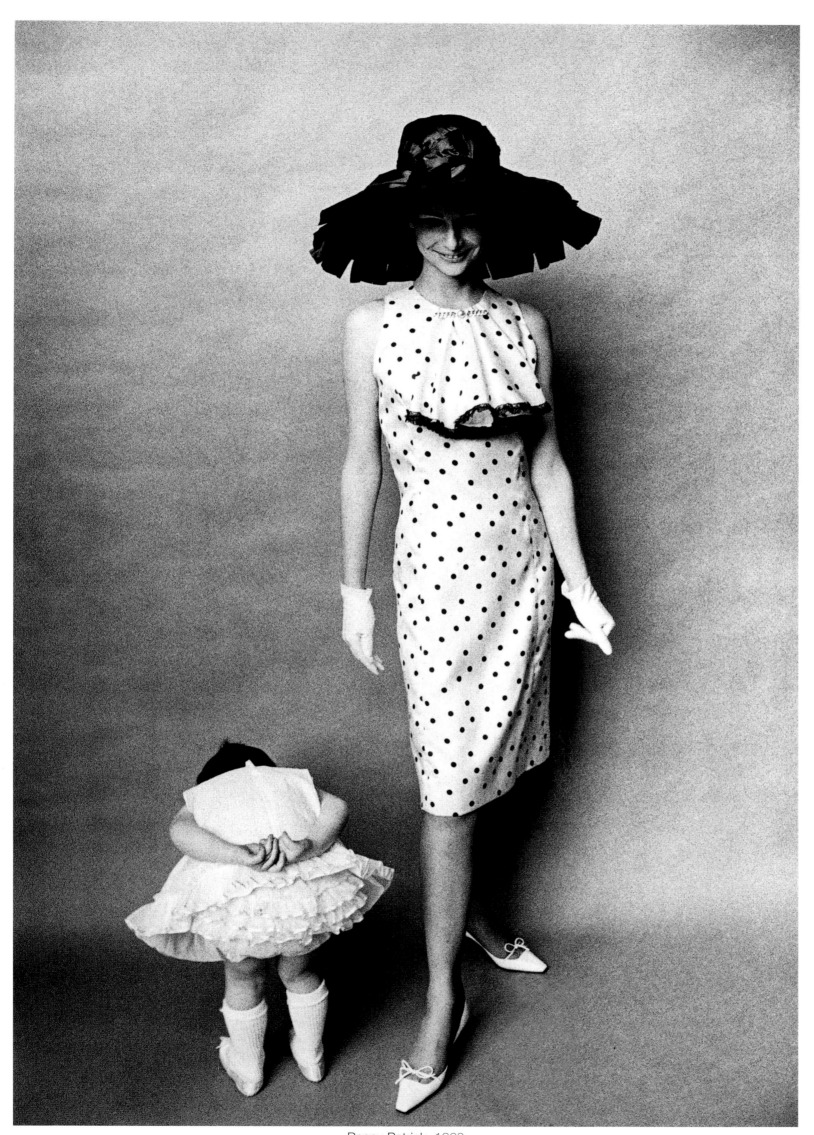

Penny Patrick, 1962

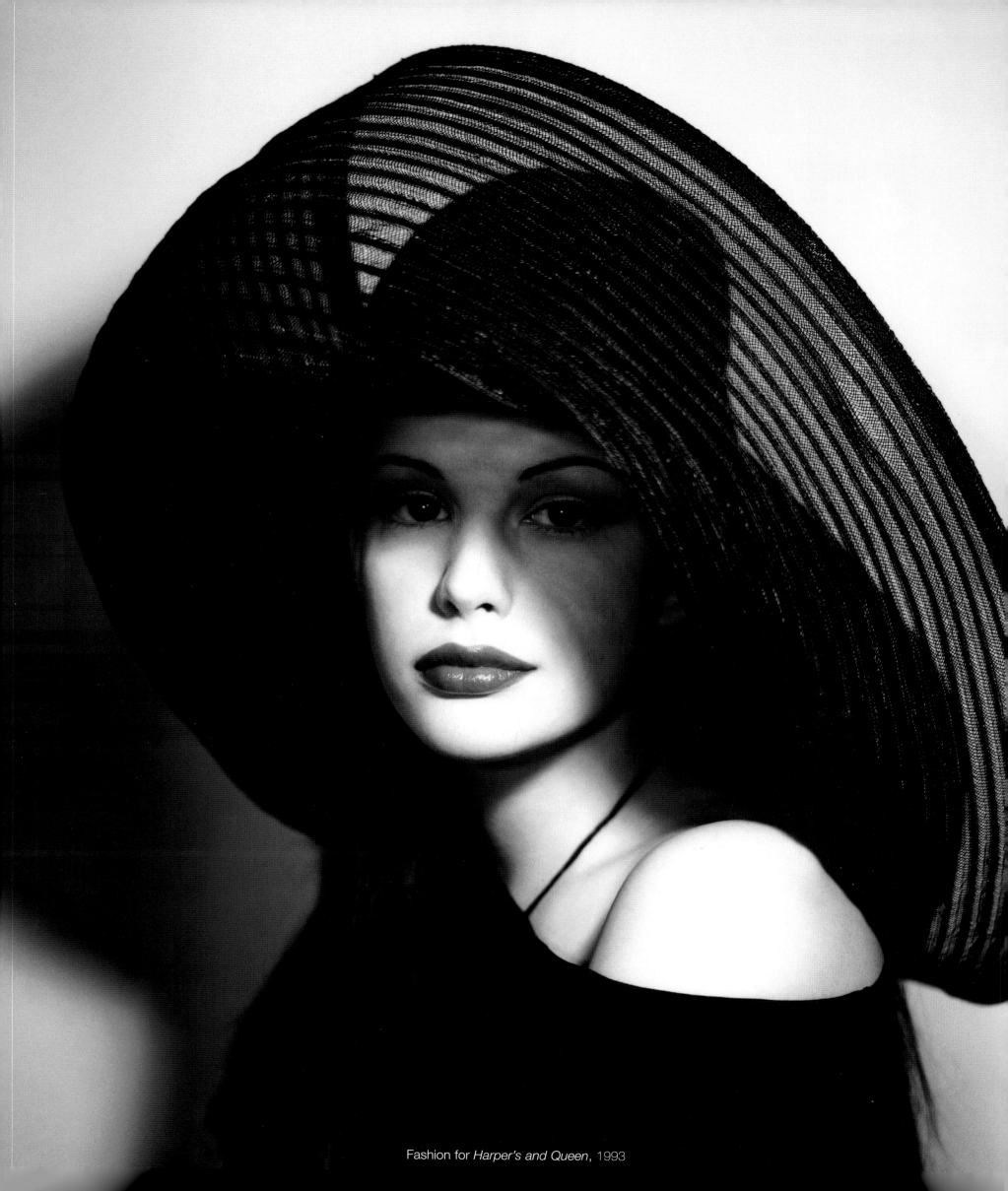

Fashion for *Harper's and Queen*, 1993

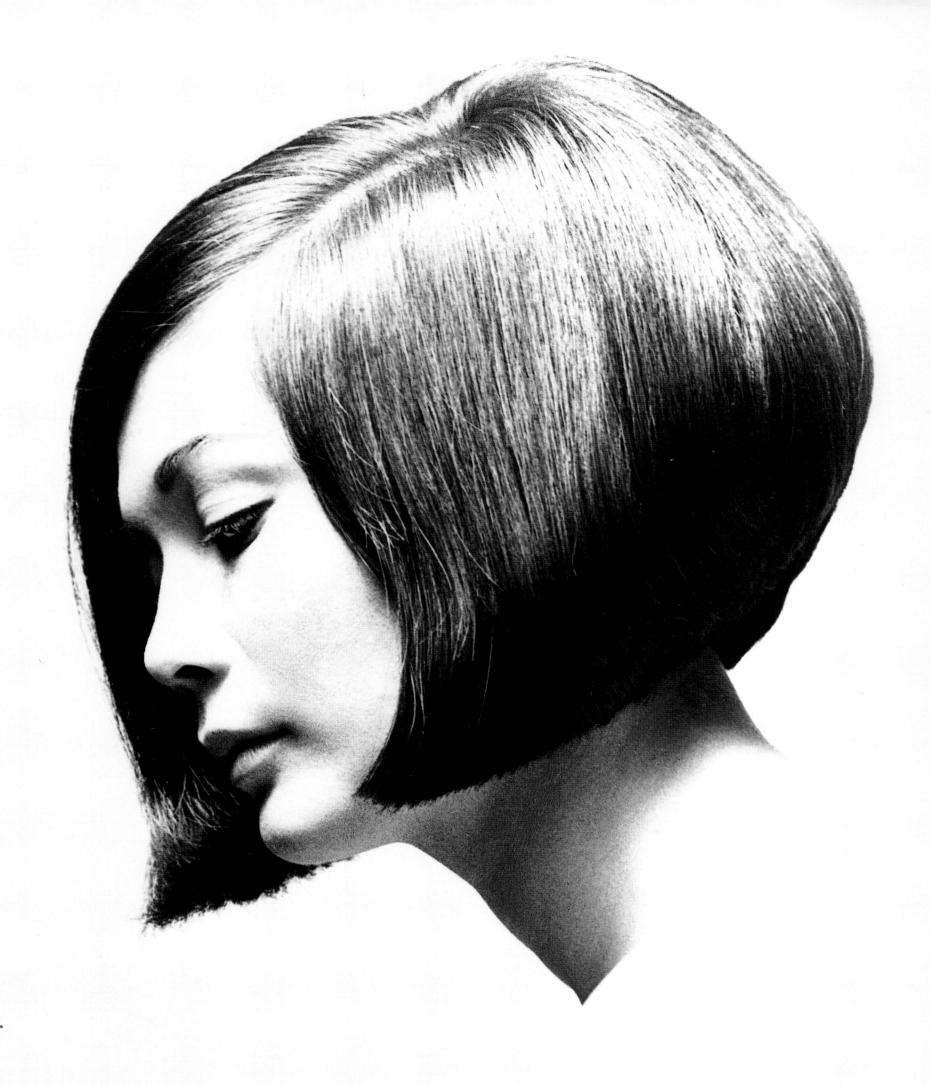

Nancy Kwan, 1963

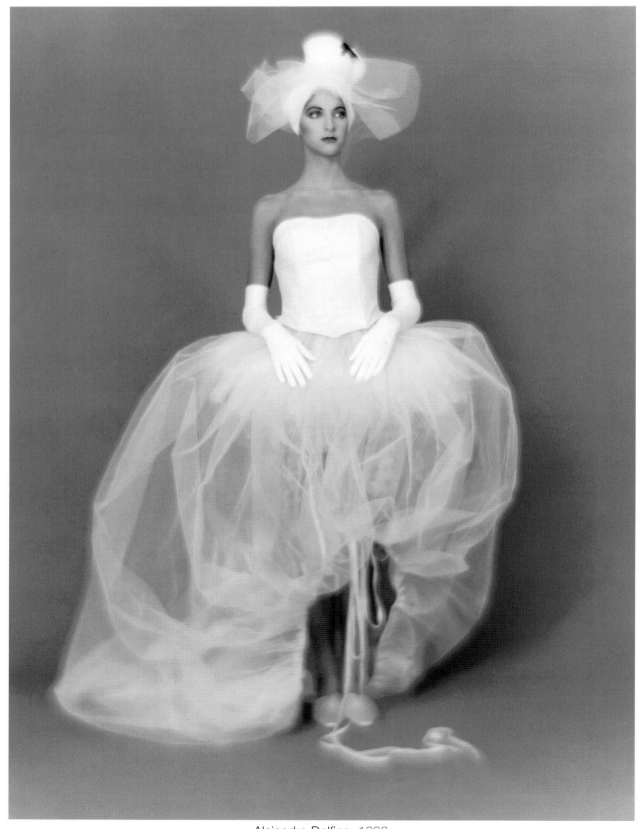

Alejandra Dolfino, 1986

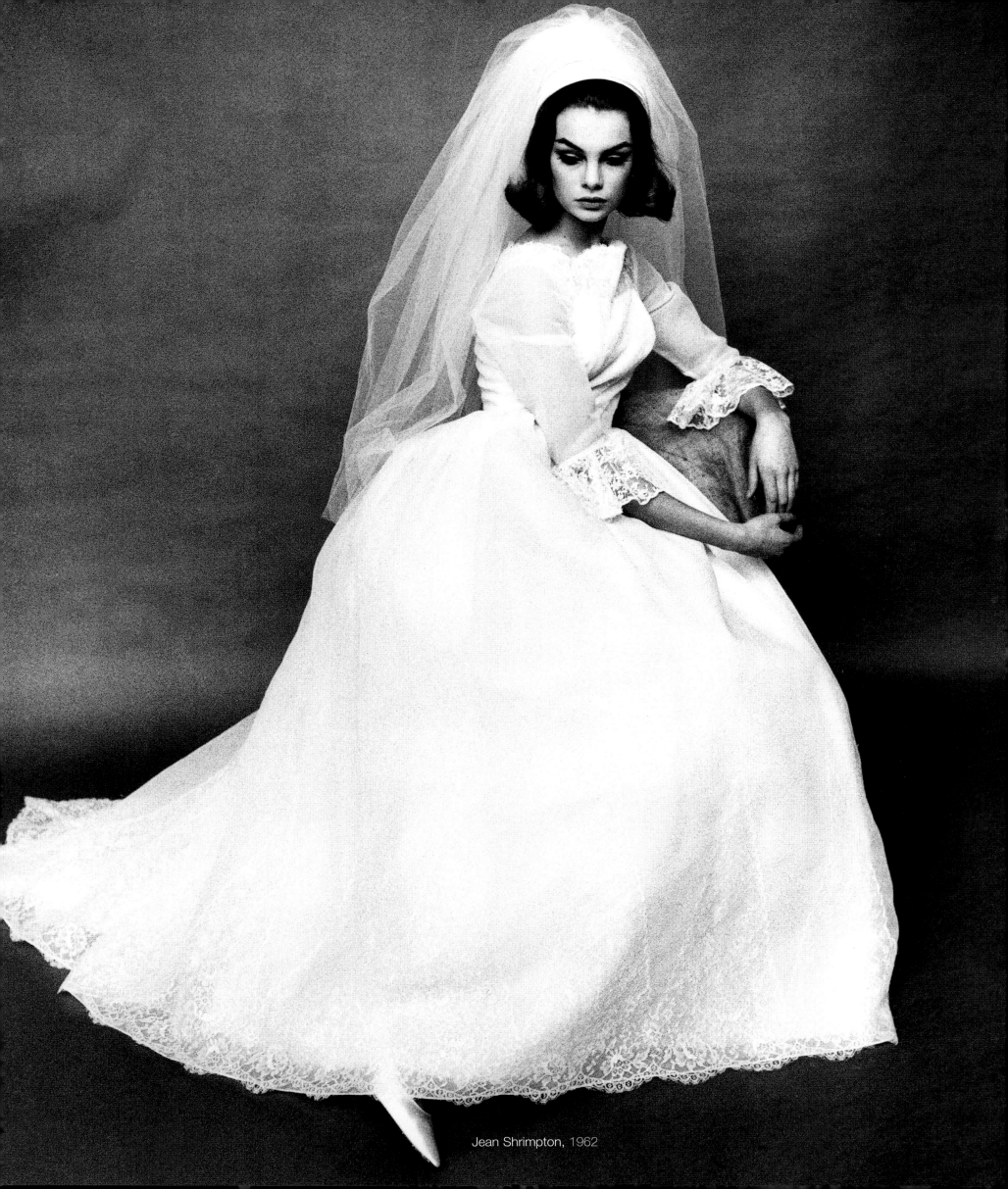
Jean Shrimpton, 1962

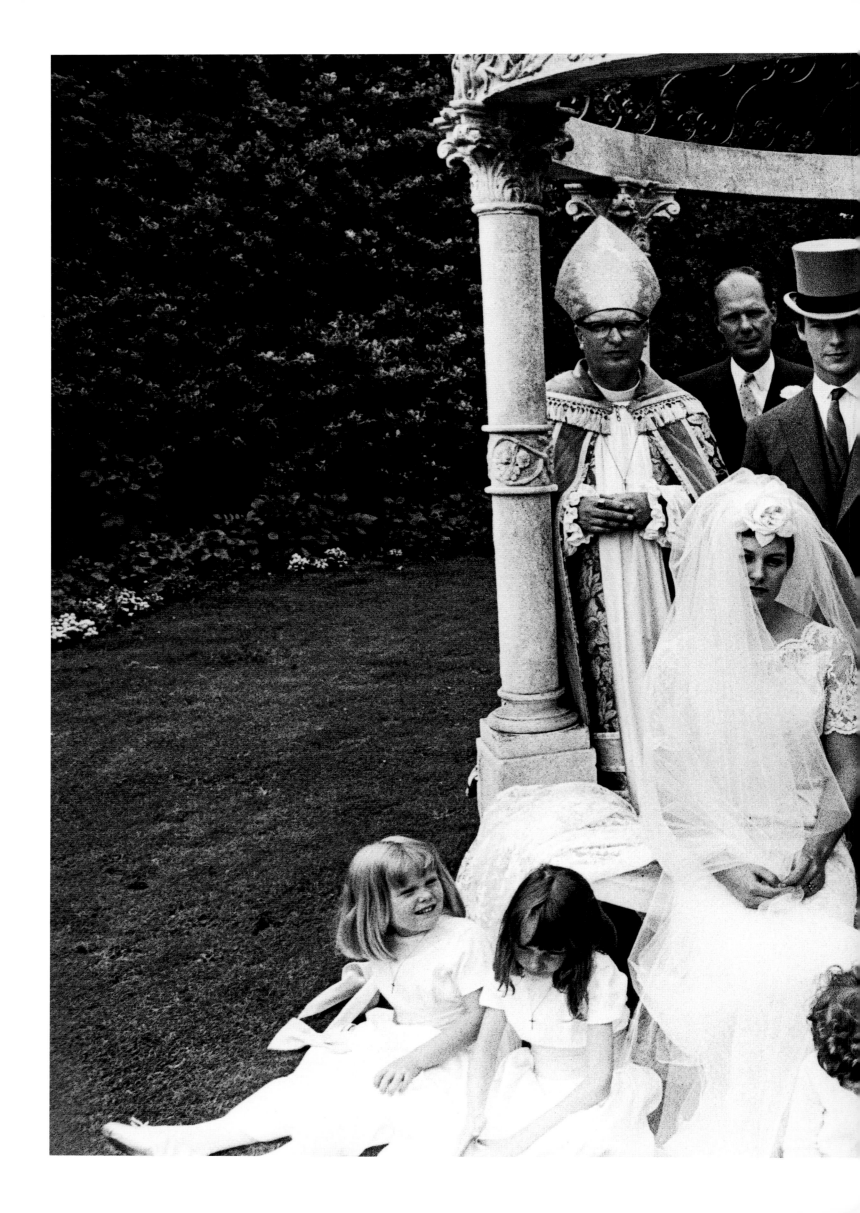

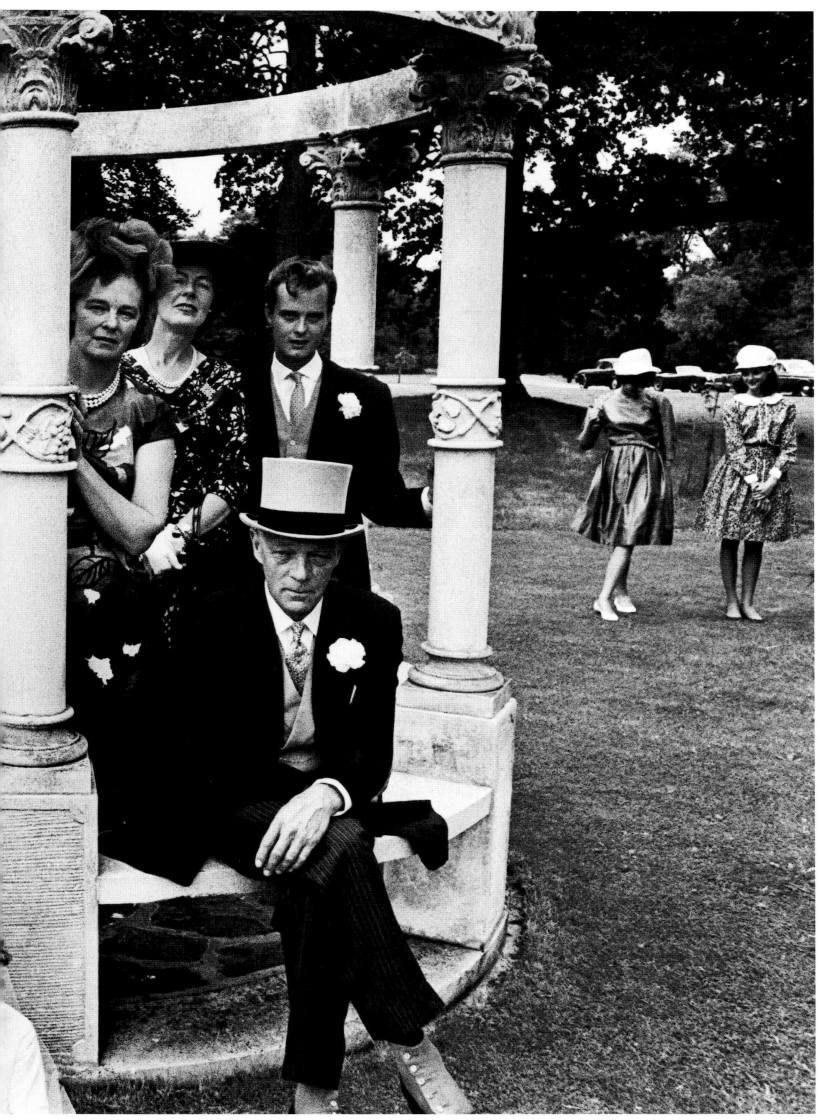

Dick Temple's wedding, 1964

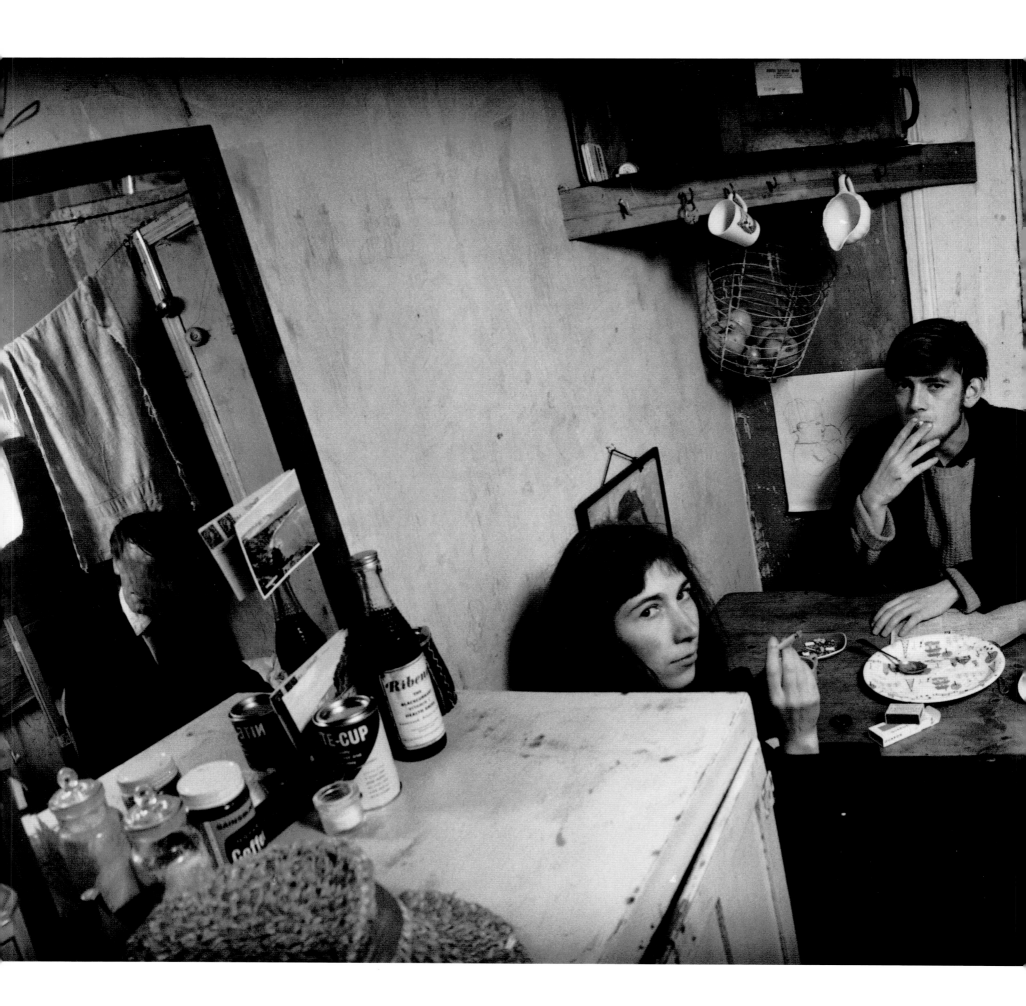

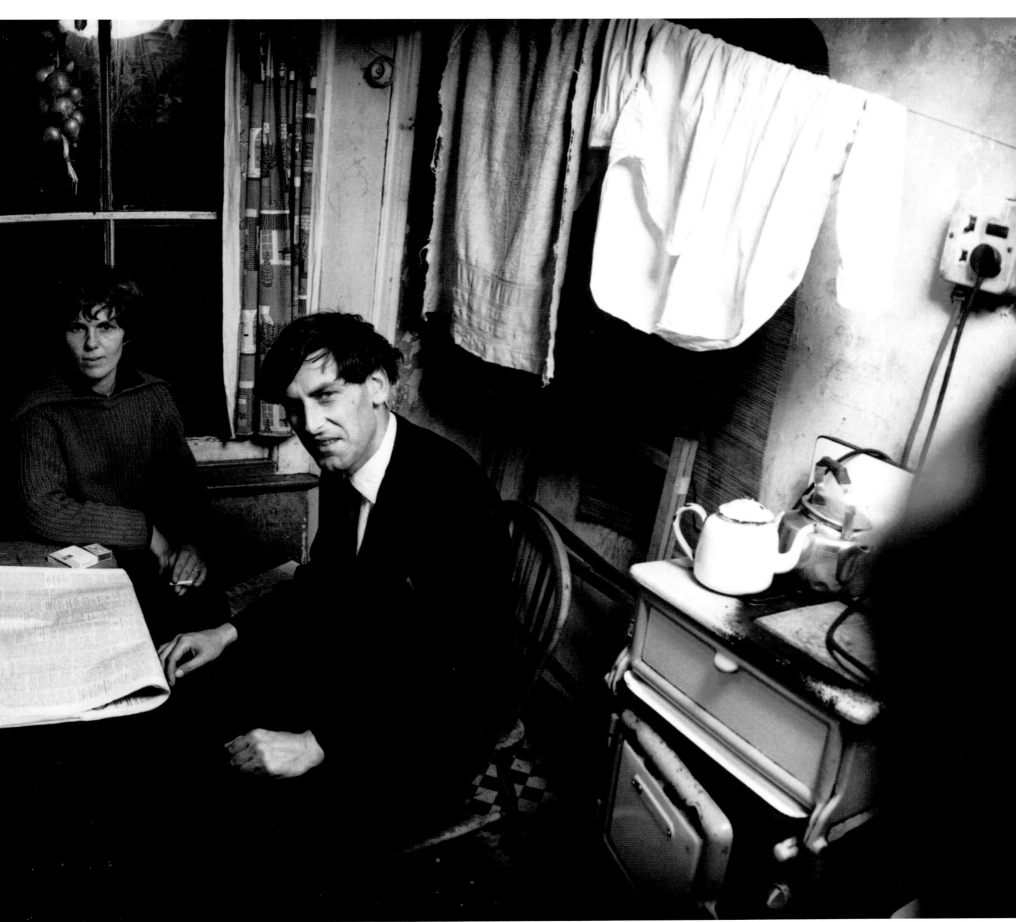

Photo-essay for *Man about Town*, 1960

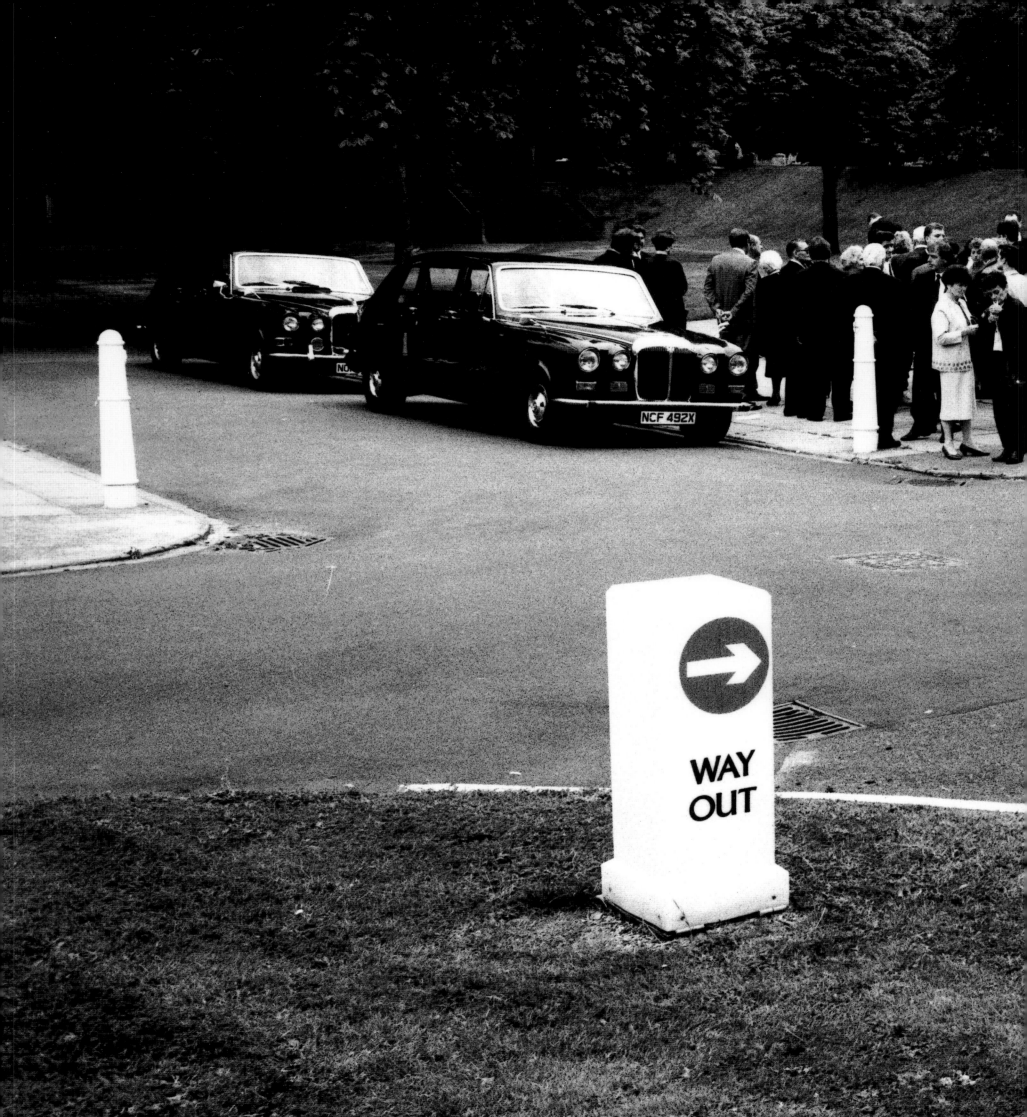

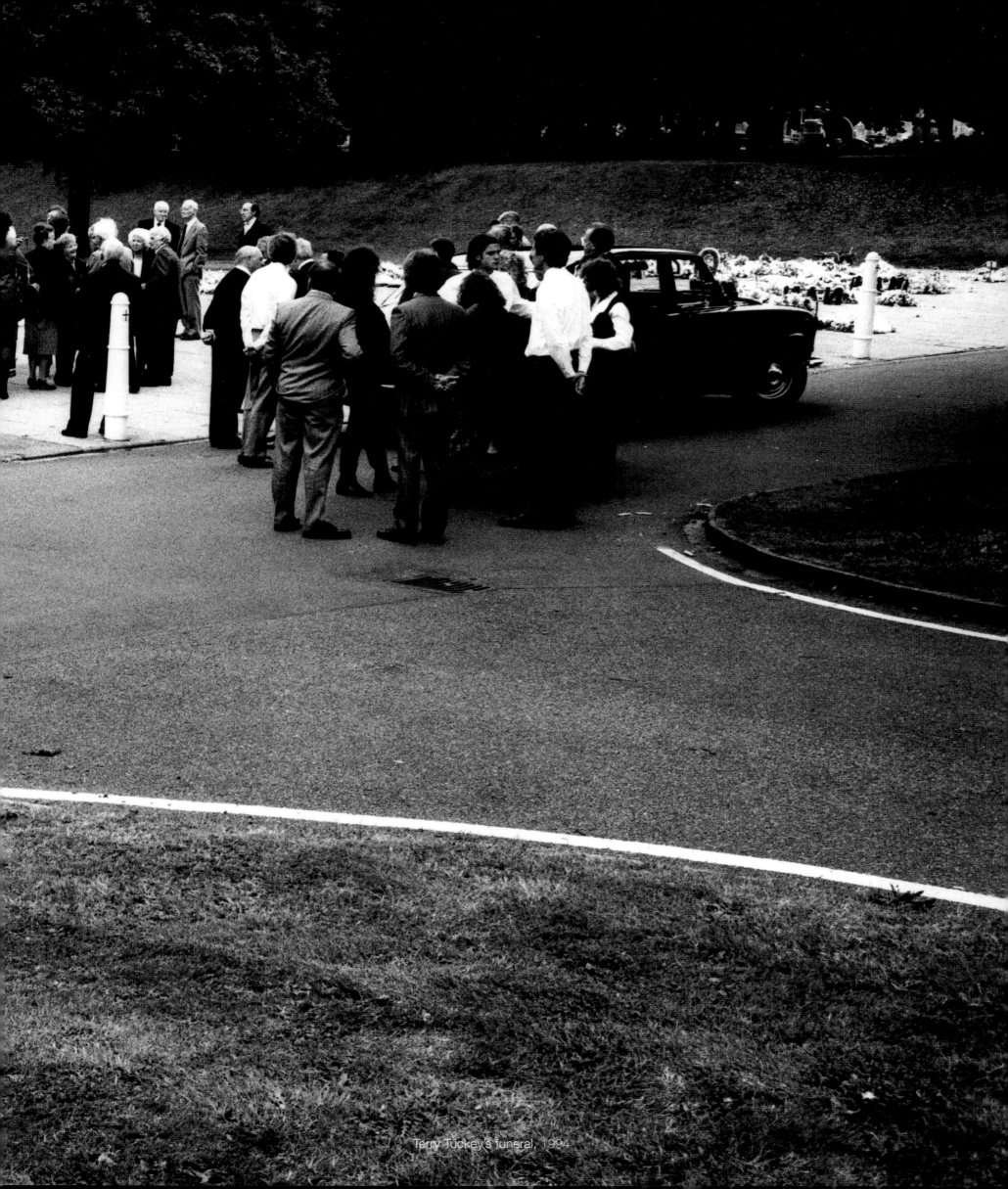

Terry Tuckey's funeral, 1994

Helen Bunney, 1959
Advertisement for Lurex London,
18 August 1959

Sophia Loren, 1963
Taken on the set of Anthony Mann's film
The Fall of the Roman Empire (1964)
Spain, 19-22 May 1963
Queen (unpublished).
See also Terence Donovan *women throo
the eyes...*(Kynoch Press, 1964)

Brett Anderson, 1996
Bourdon St, London, 19 June 1996
Grooming: Val Garland
Fashion editor: Jo Levin
Camera: Pentax 6x7
Film: Plus-X
GQ December 1996 'National Anthems'

Clive Corless, 1965
Advertisement for Wills cigars
London, 8 September 1965
Agency: London Press Exchange

Kendo Nagasaki wrestling, 1991
Lewisham Leisure Centre,
Tuesday 23 April 1991
Donovan accompanied Peter Palumbo
and the painter Peter Blake

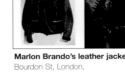

Marlon Brando's leather jacket, 1984
Bourdon St, London,
Friday 16 November 1984
Worn by Brando in László Benedek's
The Wild One (1953) and lent by the
Victoria and Albert Museum, London
Ritz

Nicky Haslam, 1992
Bourdon St, London,
23 April 1992
Camera: Nikon F4 and 10x8 plate camera

The Serpentine Gallery, 1994
Kensington Gardens, London,
29 June 1994
Photographers awaiting the arrival of
H.R.H the Princess of Wales

John French, 1965
Advertisement for Ilford film
London, 13 April 1965
Agency: Davidson Pearce Berry and Jack

Vanessa Angel, 1983
London, 4 January 1983
Hair: Nicky at John Frieda
Make-up: Francine at Caroline Thomas
Ritz

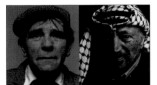

Norman Wisdom, 1988
Advertisement for British Telecom
Bourdon St, London, 5 October 1988
Grooming: Martin Pretorius
Camera: Fuji 6x8 and Gandolfi 10x8
Film: Plus-X and EPR
Agency: J. Walter Thompson

Yasser Arafat, 1996
Private portrait taken in the Hyde Park
Hotel, London, June 1996

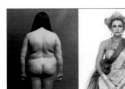

Beauty feature for *Nova*, 1969
London, 24 March 1969
Nova June/July 1969 'Fraility Thy Name
Is Woman' by Brigid Keenan

Pamela Stephenson, 1981
London, 20 January 1981

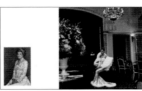

Diana, Princess of Wales, 1990
Bourdon St, London, 26 February 1990
Grooming: Barbara Daly and
Richard Dalton
Camera: Fuji 6x8 and Nikon F4

Fashion for *Harper's Bazaar*, 1985
Paris, Wednesday 4 to Saturday
7 June 1986
Harper's Bazaar (France)

The House of God, 1996
Birmingham nightclub 20 January 1996

Anga, 1991
Authon, France, Wednesday 5 June
to Monday 10 June 1991
Hair: Luc Drouen
Make-up: Ramon
Fashion editor: Valerie Baudy
Camera: Nikon F4
Film: EPR, Tri-X and Plus-X
Harper's Bazaar (France)

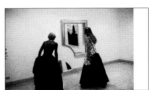

Venice. 1991
Diana Donovan and Lucy Nelson,
the Guggenheim Museum before
the Volpi Ball, Venice, 31 August 1991

Emily Holder, 1986
Bourdon St, London, 2 December 1986
Hair: Maxie Spazzioli at Joy Goodman
Make-up: Laurie Starrett at Faces
Fashion editor: Lucy Dickens
Brides March/April 1987 'A Hat for
all Seasons'

Liese Deniz, 1959
Test shots
London, 24 November 1959

Marie Lindfors, 1984
London, 26 November 1983
Fashion editor: Grace Coddington
Vogue February 1984 'More Dash
Than Cash'

Arizona, 1996
Monday July 22 to Thursday July 25 1996
Photographs taken during an advertising
shoot for Vodaphone

Henry Cooper, 1978
Charlotte St Studios, London,
Tuesday 31 January 1978
Ritz

Max Wall, 1979
Studio B, Holborn, London,
Friday 9 March 1979
Cosmopolitan

Sir Roy Strong, 1979
Charlotte St Studios, London,
Tuesday 6 March 1979

**Ralph Richardson, Laurence Olivier
and Alec Guinness, 1980**
London, Thursday 26 August 1980
Unpublished picture for *Vogue* December
1980. Separate portraits of each actor
were published.

Advertisement for Terylene, 1960
London, 10 March 1960
Models include: Peter Anthony,
Peter Christian and Jeremy Dempster
Agency: Mather and Crowther

Rod Steiger, 1965
London, 29 October 1965
London Life

Greta Scacchi, 1988
Bourdon St, London, 2 February 1988
Hair: Keith Harris
Make-up: Arianne
Fashion editor: Jackie Modlinger
Camera: Pentax 6x7
Film: Plus-X
Variant from *Daily Express*

Sophie Kiukonnen, 1976
London, c.August 1976
Fashon editor: Antonia Kirwan-Taylor
Vogue 15 October 1976
'Not Quite Cricket'

Maggie Smith, 1964
London, 10 April 1964
Harper's Bazaar

Susan Hampshire, 1967
London, 13 February 1967

Lisa B, 1989
Bourdon St, London, Saturday 11 and
Sunday 12 1989
Hair: Kevin Graham
Make-up: Martin Pretorius
Fashion editor: Caroline Kellett
Cameras: Fuji 6x8, Nikon F4 and Leica R5
Film: Plus-X and Neopan
Variant from *Tatler* February 1990
'Native Wits'

Celia Hammond, 1963
London, 12 September 1963
Queen

Terence Stamp, 1966
Taken on the set of John Schlesinger's
Far From the Madding Crowd (1967)
18 August 1966
Vogue July 1967 'Madding Crowd
Assembled'

Peter Anthony, 1960
Advertisement for Acrilan 'Starting Over'
28 March 1960
Agency: Foote Cone Belding

Nude, c.1976
London, c.1976

France, 1991
Taken on location for *Harper's Bazaar*
fashion shoot
Chateau de Beauregard, Authon,
France Wednesday 5 June
to Monday 10 June 1991
Camera: Nikon F4
Film: Plus-X, Tri-X, T-Max, EPR
Harper's Bazaar (France)

**Advertisement for Simon
of Knightsbridge, 1959**
London, 29 August 1959

Mike Irving, 1964
Advertisement for Terylene
16 September 1964
Agency: Mather and Crowther

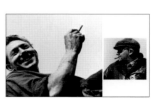

Advertisement for Wills Cigars, 1965
London, 7 September to
10 September 1965
Agency: London Press Exchange
Client: Wills Cigars
Models included the photographers
John Cowan and Brian Duffy and
the painter Peter Blake

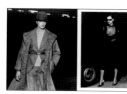

Shirley Anne Swayne, 1977
Euston station, London, 1 June 1977
Fashion editor: Liz Tilberis
Vogue 15 October 1977 'Changing
the Elements'

Josephine Florent, 1978
Grosvenor Hill Car Park, London,
Monday 21 August 1978
Boulevard issue one
c.September/October 1978 'Con-Front'
See also Plate 58 Terence Donovan
Glances (Michael Joseph, 1983)

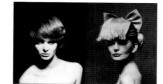

Grace Coddington, 1961
Advertisement for Vidal Sassoon London,
1 February 1961
Hairstyle by Vidal Sassoon

Hannelore Dehn, 1960
Advertisement for Vidal Sassoon London,
January 13 1960
Hairstyle by Vidal Sassoon

Mari Wilson, 1983
Bourdon St, London, 14 February 1983
Hair: Susie Nicolson
Make-up: Paula Owen
Fashion editor: Jackie Modlinger
Daily Express Thursday 10 March 1983
'Queen of the Beehives'

Michelle Geddes, 1988
Room 251 Park Lane Hotel, London,
Monday 6 June to Wednesday
8 June 1988
Hair: Kevin Graham
Make-up: Martin Pretorius
Harpers Bazaar (Italy)

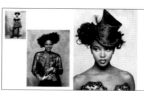

Naomi Campbell, 1988
Bourdon St, London, Friday 6 June 1988
Hair: Robertino Trovati
Make-up: Martin Pretorius
Fashion editor: Harriet Jagger
Camera: Fuji 6x8
Film: Plus-X
Elle September 1988 'A Shining New
Season for British Evenings'

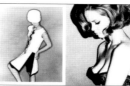

Advertisement for *Bazaar*, 1962
London, 13 December 1962
Clothes by Mary Quant

Celia Hammond, 1962
Test shots
London, 5 September 1962

Soccer Players, c.1980
London, c.1980

Susan Caselle's wedding, 1975
All Saints' Church, Poplar, London,
Saturday 26 April 1975

Laura Tikoo's Wedding, 1994
The Savoy Hotel, London,
September 1994

**Margaret and Bill Donovan's
wedding, 1960**
London, 17 September 1960
Margaret Donovan and Terence Donovan
were cousins. Their Aunt Mag can be
seen on the extreme right.

The Earl of Longford, 1976
London, 12 January 1976
Sunday Times

Richard Attenborough, 1987
Bourdon St, London, 21 October 1987
Camera: Pentax 6x7
Film: Plus-X and EPR
Sunday Express Magazine

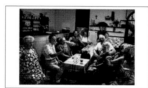

Edward Fox, 1979
Charlotte St Studio, London,
Friday 26 January 1979
Cosmopolitan

Jenny Gabor, 1970
London, 7 April 1970
Nova June 1970 'Being a woman
is like you're a shop or something...
you've got to have the biggest and
brightest sign outside'

Mark E. Smith, 1996
Bourdon St, London, 14 August 1996
Camera: Fuji 6x8
Film: Plus-X
Variant from *GQ* December 1996
'National Anthems'

Mary Jane, 1961
London, 26 October 1961

David West, 1964
London, 22 September 1964
Fashion: Skiwear
Town

Sonja, 1990
Test shots
Bourdon St, London,
Thursday 2 October 1990
Camera: Nikon F4
Film: Fuji 1600
Make-up: Martin Pretorius

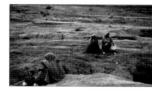

Sting, 1984
London, 1 March 1984
Vogue June 1984 'Sting'

**Advertisement for Vidal Sassoon,
1985**
Bourdon St, London,
Tuesday 14 March 1985
Make-up: Ed Stroud at Joy Goodman
Stylist: Nick Grossmark
Camera: 6x7
Film: Plus-X and E6

Margaret Lorraine, 1959
Advertisement for Lactron
London, 3 July 1959
Agency: Gee Advertising

Neil Adams, 1983
Bourdon St, London, 29 April 1983
Fashion editor: Michael Roberts
Tatler July/August 1983 'The Fall Guy'

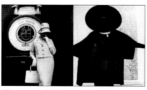

**Isobel Babianska, Jean Clements,
Joy Galloway and Pat Parrish, 1961**
Advertisement for Listers
London, 18 April 1961
Agency: McCann Erickson

France, 1990
Thursday 23 August to Tuesday
28 August 1990

**Children's fashion for the
Sunday Times, 1959**
London, 23 November 1959

**Advertisement for British
Aluminium, 1961**
Victoria Station, London, 27 August 1961
Agency: W.S. Crawford

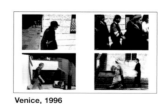

Fashion for *Man About Town*, 1960
Grove Road Power Station, London,
31 October 1960
Models: Peter Anthony and Tim Davis
Man About Town January 1961
'Thermodynamic'

Location for advertising shoot, 1959
25 August 1959
Client: Bairnswear
Agency: Gee Advertising

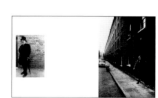

Morocco, 1994
Morocco, 1-11 April 1994

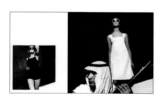

Karen Jensen, 1965
4 March 1965
Queen

Karen Jensen and Ahmed, 1965
4 March 1965
Queen

Clemence Bettany, 1959
Battersea Fun Fair, London, 28 April 1959
Sunday Times

Danielle Noël, 1965
Paris, 12 March 1965
Queen

Tessa Butler, 1964
Advertisement for Black and Whyte Whisky
London, 23 April 1964
Agency: G.S. Royal

Miss Allan, 1959
Advertisement for George Newnes
Brompton Road, London, 3 April 1959

Eastbourne, 1996
c. August 1996

Venice, 1996
2 May to 7 May 1996

Francis Bacon, 1990
Chelsea, London, 1 September 1990

Venice, 1996
2 May to 7 May 1996

Camilla Christensen's Wedding, 1995
Wiltshire, September 1995

Dick Temple's wedding, 1964
Leeds, Saturday 25 July 1964

Tim Davis, 1960
The East End, London,
25 November 1960
Man About Town February 1961
'Top Coats'

Ireland, 1962
Taken on location during fashion shoot
27 August to 2 September 1962
Town

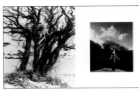

Joy Weston, 1959
Advertisement for Lactron
14 July 1959
Agency: Gee Advertising

Fashion for *Harper's Bazaar*, 1988
France, Sunday 31 January 1988
Models selected from: Alix and Christine
at Karins; Charlotte at Select
Make-up: Pierre Berube
Hair: Christian at Chez Carita
Camera: Pentax 6x7 and Fuji 6x8
Film: Plus-X and E6
Harper's Bazaar (France)

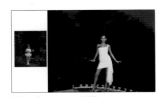

Daisy Donovan c.1978
Chepstow Villas, Notting Hill Gate,
London, c.1978

Fashion for *Harper's Bazaar*, 1988
France, Sunday 31 January 1988
Models selected from: Alix and Christine
at Karins; Charlotte at Select
Make-up: Pierre Berube
Hair: Christian at Chez Carita
Camera: Pentax 6x7 and Fuji 6x8
Film: Plus-X and E6
Harper's Bazaar (France)

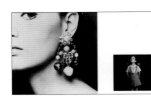

Celia Hammond, c.1976
London, c.1976

Advertisement for Terylene, 1960
London, 30 June 1960
Models: selected from Roger Abraham,
Jane Hancock, Rosalind Craik,
Melanie Steele and Patricia Money
Agency: Mather and Crowther
Client: Terylene 'Back to School'

Nude, 1967
London, 26 October 1967

Vida, 1971
Test shots
London, 26 May 1971

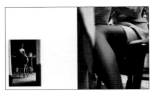

Julie Christie, 1962
London, 14 May 1962
About Town (A colour variant was
reproduced on the cover)
See also *women throoo the eyes...*
(Kynoch Press,1964)

Wedding Guest, 1992
3 October 1992

**Advertisement for the Salvation
Army, 1967**
Nottingham, 26 January 1967
Agency: KMP

Tony Hancock, 1963
Advertisement for British Railways Board
Waterloo Station, London,
11 January 1963
Agency: W.S. Crawford

David Puttnam, 1987
Advertisement for *Punch* magazine
South Kensington, London,
Thursday 4 March 1987
Camera: Rolleiflex and Proxar II
Film: Plus-X
Agency: Leagas Delaney

Eastbourne, 1996
c. August 1996

**Advertisement for the Salvation
Army, 1967**
Nottingham, 26 January 1967
Agency: KMP

Peter Blake, 1965
Advertisement for Wills cigars
London, 7 September 1965
Agency: London Press Exchange

Norman Parkinson, 1960
London, 22 December 1960
Sunday Times

Vidal Sassoon, 1959
London, 4 March 1959

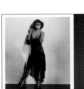

Vanessa Angel, 1984
Bourdon St, London, 13 April 1984
Hair: Bob Fink
Make-up: Sara Raebum
Camera: Pentax 6x7
Film: Plus-X
Ritz

Jean Shrimpton, 1967
Test shots
London, 17 January 1967

Carolyn Gardener, 1986
London, Monday 13 and Tuesday
24 October 1986
L'Officiel

Anne Anderson, 1960
Test shots
London, 23 August 1960

Lynn Costler, 1983
Bourdon St, London, Monday 11 and
Tuesday 12 April 1983
Hair: Nikki at John Frieda
Make-up: Mark Hayles
Variant from *Vogue* August 1983 'Skintight'

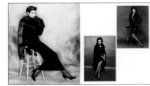

Nude, 1990
London, May 1990

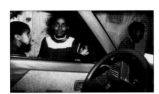

Nude, 1964
London, c. June 1964

Moses, 1988
Chepstow Villas, Notting Hill Gate,
London, 1988

Morocco, 1994
Children at Taroudant, Morocco
1-11 April 1994

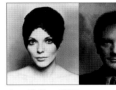

Advertisement for Doracor, 1960
London, 14 December 1960
Models include Simone Headley
and Gillian Hurd
Agency: J. Walter Thompson

Jennifer Barker and children, 1959
Test shots
London, 11 June 1959

Joan Collins, 1966
London, 10 August 1966
Hairstyle created by Vidal Sassoon

Terence Stamp, 1987
Bourdon St, London, Tuesday
17 February 1987
Camera: Pentax 6x7
Film: Plus-X

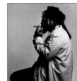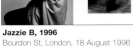

Jazzie B, 1996
Bourdon St, London, 18 August 1996
Camera: Fuji 6x8
Film: Plus-X
Fashion editor: Jo Levin
Variant from *GQ* December 1996
'National Anthems'

Cindy Crawford, 1988
Bourdon St, London, Tuesday
26 April 1988
Hair: Nicky Clarke
Make-up: Mary Greenwell
Fashion editor: Anna Harvey
Variant from *Vogue* August 1988
'Cut to the Night'

Fashion for *Vogue* (France), 1979
L'Hotel Trianon Palace, Versailles
Wednesday 28 March to Friday
30 March 1979
Hair: Chimène
Make-up: Tyen
Art director: Jocelyn Kargère
Vogue (France) May 1979 'Soir Petit
et Grand'

Alison Cohen, 1984
Bourdon St, London, Thursday 9
and Friday 10 August 1984
Hair: Sam McKnight
Make-up: Linda Cantello
Fashion Editor: Liz Tilberis
Variant published in colour in *Vogue*
(Germany) December 1984 'Mode
Alternativen'

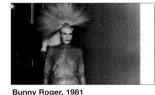

Bunny Roger, 1981
At his 'Lilac Ball',
Holland Park, London, 9 June 1981
Plate 72 Terence Donovan *Glances*
(Michael Joseph, 1983)

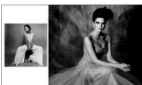

Celia Hammond, 1964
London, 10 to 11 March 1964
Harper's Bazaar

Kirsten Allen, 1986
Advertisement for Murray Arbeid
Bourdon St, London, Friday 7 March 1986
Hair: Kevin Graham
Make-up: Martin Pretorius
Fashion editor: Bill Reed
Camera: Pentax 6x7 and Rolleiflex
Film: Plus-X
Lighting: Ring Light
Advertisement ran in *Vogue* May 1986

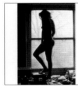

Malcolm McLaren, 1984
Bourdon St, London, 9 August 1984
Camera: Pentax 6x7
Film: Plus-X and E6
Melody Maker 25 August 1984
Donovan directed the promotional video
for McLaren's *Madame Butterfly* (1989)

Photograph for *Glances*, 1983
Plate 45 Terence Donovan Glances
(Michael Joseph, 1983)

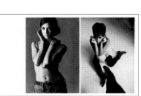

Moyra Swan, 1966
London, 15 and 20 June 1966
Portrait for a proposed book project

Claudia Cardinale, 1962
London, 26 February 1962
About Town
This portrait also appeared in Terence
Donovan *women throoo the eyes...*
(Kynoch Press, 1964)

Linda Cuneo, 1961
Advertisement for Acrilan
London, 28 February 1961

Jan Williams, 1960
Advertisement for Acrilan
London, 25 February 1960
Agency: Foote Cone Belding

Photo-essay for *Man about Town*, 1960
Notting Hill Gate, London,
10 October 1960
Man About Town December 1960
'The Lay About Life'

Sir Ralph Richardson, 1980
London, 26 August 1980
Vogue December 1980
'Sir Ralph Richardson'

Baroness Thatcher of Kesteven, 1995
Bourdon St, London, 9 November 1995
Grooming: Charlie Duffy
Camera: Fuji 6x8

Sir Harold MacMillan, 1961
London, 11 January 1961
This was used for a cover of
Man About Town

Sophia Loren, 1963
Taken on the set of Anthony Mann's film
The Fall of the Roman Empire (1964)
Spain, 19-22 May 1963
Queen (unpublished).
See also Terence Donovan *women throo
the eyes...* (Kynoch Press, 1964)

Vicki Ferda, 1987
Room 209, Park Lane Hotel,
Picadilly, London
Monday 2 March 1987
Fashion editor: Ayshe Yusuf
Ritz

Andie McDowell, 1979
East Sussex, Friday 6 July 1979
Fashion editor: Mandy Clapperton
From unpublished shoot for *Vogue*
Germany. See also plate 66
Terence Donovan *Glances*
(Michael Joseph, 1983)

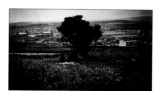

The Black Country, c.1982
The photograph, which was taken on
location for a teevision documentary, also
appeared at plate 16 in Terence Donovan
Glances (Michael Joseph, 1983)

Celia Hammond, 1963
28 August 1963
Queen 25 September 1963 'It's Going
to be Wet'

Brian Duffy, 1964
London, 31 March 1964
Sunday Times

Ireland, 1963
Taken during advertising shoot,
March 1963
Agency: Collett Dickenson

Fashion for *Man About Town*
The East End, London,
25 November 1960
Man About Town February 1961
'Top Coats'

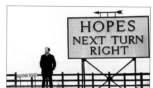

Fashion for *Man About Town*, 1960
Wolverhampton, 28 to 29 December 1960
Man About Town

Arizona, 1996
Monday July 22 to Thursday July 25 1996
Photographs taken during an advertising
shoot for Vodaphone

Fashion for *Man About Town*, 1961
London, 6 March 1961
Models include: Peter Anthony
Man About Town May 1961 'The Secrets
of an Agent'

**Richard Orme, Tony Newton and
Peter Christian, 1960**
Advertisement for Terylene
London 27 January 1960
Agency: Mather and Crowther

Advertisement for Trends
London, 12 and 18 April 1967
Models selected from Julian Brand,
Dominic Brand, John Foster and
Sara Stewart

**Victoria Stevens with Huddersfield
Mill workers, 1964**
Huddersfield Mill, 4 and 5 June 1964
Queen

Advertisement for Greenleys, 1961
London, 11 to 12 September 1961
Models selected from Steve Corey,
Douglas Hill, Suzy Kendall, Elizabeth
Harkness, Lynda Taylor and Pat Booth
Agency: Greenleys

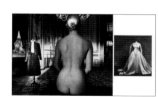

Advertisement for Alexon, 1983
Ritz Hotel, London, Friday 17 June 1983
Models: Claire Waugh and
Susie-Ann Watkins
Hair: Elliott
Make-up: Quentin
Stylist: Kari Allen
Agency: Saatchi and Saatchi

Dress by Jasper Conran, 1994
Bourdon St, London, 23 September 1994
Camera: Fuji 6x8
Film: Plus-X
Brides Jan/Feb 1995 'Designer's
Notebook' (published version includes
a portrait of Jasper Conran)

Mr Stevens, 1960
Advertisement for Shepherd Sweaters
30 March 1960
Agency: Gee Advertising

Maggie Benn, 1961
Advertisement for Harvey Nichols
London, 15 February 1961
Agency: Osborne Peacock

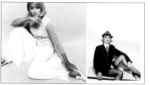

Fashion for *Vogue*, 1989
London, Tuesday 25 July 1989
From unpublished shoot for *Vogue*, 1989

Grace Coddington, 1987
London, Thursday 22 January 1987
Daily Telegraph Thursday 29 January
1987 'A Graceful Goodbye'

Kirsten Allen, 1986
Advertisement for Murray Arbeid
Bourdon St, London, Friday 7 March 1986

Carolyn Gardener, 1986
London, Monday 13 and Tuesday 24
October 1986
L'Officiel

Jill Kennington, 1964
London, 10 and 11 March 1964
Harper's Bazaar

Photograph from *Glances*, 1983
Plate 17 Terence Donovan *Glances*
(Michael Joseph, 1983)

Nadia, 1989
Wrotham Hall, Thursday 4 May to
Friday 5 May 1989
Agency: HJW
Client: Carisma Car Polish
Taken on location for Carisma commercial

Fashion for *Vogue*, 1983
London, Friday 9 September 1983
Fashion editors: Juliette Hugues-Mallett
and Caroline Kellett
Vogue December 1983 'High Society'

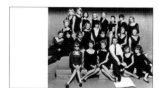

John French and his models, 1964
London, 22 October 1964
Taken to celebrate the twenty-fifth
anniversary of the John French Studios

Nude from *Glances*, 1983
Plate 60 Terence Donovan *Glances*
(Michael Joseph, 1983)

**Advertisement for Collett
Dickenson, 1961**
London, 20 February 1961

Celia Hammond, 1961
Test shots
London, 18 December 1961

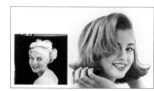

Karol Fageros, 1959
Advertisement for French of London
London, 1 July 1959

Susan Lamb, 1959
Test shots
London, 18 August 1959

Vivien Neves, 1970
London, 15 April 1970
Make-up: Mary Quant
Nova June 1970 'Does he love you
deeper than your eye shadow?'

Advertisement for Anabolex, 1961
London, 27 April 1961
Agency: J. Walter Thompson

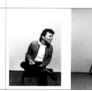

Ian Dury, 1981
London, 29 October 1981

**Advertisement for Cancer Research,
1988**
Hannah Ford Wing, St Andrews Hospital,
Bromley-by-Bow, London
Wednesday 5 April 1988
Models: Celeste Hart at Scallywags;
Tina Thomas at Top Models
Hair: Kevin Graham
Make-up: Martin Pretorius
Props: Mick Packer
Camera: Pentax 6x7; Gandolfi 10x8
Film: Plus-X
Agency: J. Walter Thompson

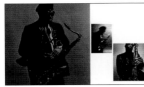

Roland Kirk, 1963
London, 27 September 1963

Courtney Pine, 1996
Bourdon St, London, 2 September 1996
Camera: Fuji 6x8
Film: Plus-X
Fashion editor: Jo Levin
Variant from *GQ* December 1996
'National Anthems'

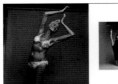

Margaret Morris, 1969
London, 21 August 1969
Nova November 1969 'This woman is 80.
So she's got wrinkles. But could you
keep a figure like this at her age?'

Sylvie Guillem, 1993
Advertisement for Rolex watches
Bourdon St, London, 4 June 1993
Hair: Kevin Graham
Make-up: Martin Pretorius
Props: Mick Packer
Agency: J. Walter Thompson

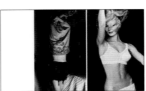

Rita, 1960
14 November 1960
Daily Mail

Jeanetta Harding, 1961
Advertisement for S. H. Benson
London, 11 December 1961

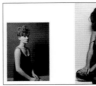

Liese Deniz, 1959
Test shots
London, 24 November 1959

Rosemary McGrotha, 1983
Plate 54 Terence Donovan *Glances*
(Michael Joseph, 1983)

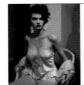

Michelle Geddes, 1988
Room 251, Park Lane Hotel, London,
Monday June 6 to Wednesday
June 8 1988
Hair: Kevin Graham
Make-up: Martin Pretorius
Camera: Fuji 6x8
Film: Plus-X
Harper's Bazaar (Italy)

Daniel Pearce, 1963
London, 12 September 1963

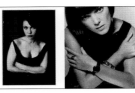

Maria Kazan, 1963
London, 23 February 1963
Portrait for Michael Joseph Publishing

Mary Quant, 1963
London, 18 July 1963
Portrait for Mary Quant's shop 'Bazaar'

Anthony Newley, 1961
London, 21 November 1961

Ruth Abromwitz, 1959
London, 5 June 1959
Portrait for theatre publicity

Beatrice Bradley, 1967
Advertisement for Mogadon
London, 28 December 1967
Client: Roche

Irene Handl, 1964
Advertisment for Horniman's Tea
London, 21 May 1964
Agency: Collett Prentiss Varley

Colin Stuart, 1959
Privately commissioned portrait London,
20 May 1959

Alejandra Dolfino, 1986
Bourdon St, London, 25 February 1986
Hair: Julian Verge
Make-up: Mary Greenwell
Fashion editor: Grace Coddington
Camera: Kodak 10x8
Film: Plus-X
Unpublished photograph for *Vogue*

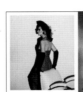

Fashion for *Ritz*, 1984
Bourdon St, London, Tuesday
16 November 1984
Models selected from Missy at Ziggi
and Sarah Cheeseborough at Askews
Ritz

Lucy Carr, 1985
Advertisement for Agfa
Bourdon St, London, Tuesday
23 April 1985
Hair: Greg Cazalet
Make-up: Martin Pretorius
Stylist: Lee Myers
Camera: Pentax 6x7

Daisy Donovan c.1978
Chepstow Villas, Notting Hill Gate,
London, c.1978

Steven Berkoff, 1977
London, 26 September 1977

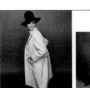

Grace Coddington, 1964
London, 10 January 1964
Harper's Bazaar

**Advertisements for Laura Ashley,
1990**
Holborn Studio 7, London, 22 and 23,
27 and 28 March 1990
Models: Lara at Models One and Maya
at Premier
Hair: Barbara Jones
Make-up: Frances Hathaway
Camera: Fuji 6x8
Film: Plus-X and EPR
Backdrop: Grey streaky, sunset and #10

Bryan Ferry, 1996
Bourdon St, London, 21 June 1996
Fashion editor: Jo Levin
Camera: Fuji 6x8
Film: Plus-X, 665 Polaroid, 5x4 Polaroid
Variant from *GQ* December 1996
'National Anthems'

Michelle Geddes, 1988
San Régis Hotel, Paris, 30 July 1988
Camera: Fuji 6x8 and 6x9
Film: Plus-X, and EPR
Harper's Bazaar

Lynn Costler, 1983
Bourdon St, London, Monday 11
and Tuesday 12 April 1983
Hair: Nikki at John Frieda
Make-up: Mark Hayles
Fashion editor: Liz Tilberis
Vogue August 1983 'Skintight'

Model Test, 1959
London, 20 March 1959

Nicola,1987
Room 209, Park Lane Hotel, London
Wednesday 15 July 1987
Hair: Jaffa at Pin-Up
Make-up: Jennifer Nolan at Pin-Up
Fashion editor: Jennifer Nolan
Camera: Pentax 6x7
Film: Plus-X
Country Life

Grace Coddington, 1960
Test shots
London, 7 December 1960

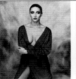

Lesley Smith, 1985
Test shots
Bourdon St, London, 18 May 1985
Hair: Frank Taylor
Make-up: Lewis

Shaun Ryder, 1996
Bourdon St, London, 24 June 1996
Grooming: Diane
Fashion editor: Jo Levin
Variant from *GQ* December 1996
'National Anthems'

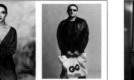

Vanessa Angel, 1986
Paris, Wednesday 4 to Saturday
7 June 1986
Harper's Bazaar (France)

Nicola,1987
Room 209, Park Lane Hotel, London
Wednesday 15 July 1987
Hair: Jaffa at Pin-Up
Make-up: Jennifer Nolan at Pin-Up
Fashion editor: Jennifer Nolan
Camera: Pentax 6x7
Film: Plus-X
Country Life

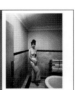

**Photo-essay for *Man About Town*,
1960**
Notting Hill Gate, London,
10 October 1960
Man About Town December 1960
'The Lay About Life'

**Photo-essay for *Man About Town*,
1960**
Notting Hill Gate, London,
10 October 1960
Man About Town December 1960
'The Lay About Life'

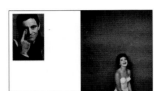

Arizona, 1996
Monday July 22 to Thursday July 25 1996
Photographs taken during an advertising
shoot for Vodaphone

Julie Christie, 1962
London, 14 May 1962
About Town (A colour variant was
reproduced on the cover)
See also *women throoo the eyes...*
(Kynoch Press,1964)

Ika, 1973
Deptford, London, 12 December 1973
Nova March 1974 'Dressed Overall'

Goldie, 1996
Bourdon St, London, 14 August 1996
Camera: Fuji 6x8
Film: Plus-X
Fashion editor: Jo Levin
Variant from *GQ* December 1996
'National Anthems'

Ambrose Congreve, 1989
Warwick House, London, 1989

Susan Hampshire, 1967
London, 13 February 1967

Celia Hammond, 1963
Advertisement for Starspray Lacquer
London, 26 September 1963
Agency: London Press Exchange

David Bailey, 1964
London, 31 March 1964
Sunday Times

Fashion photograph, mid-1950s
London, mid-1950s
The photograph was probably taken at
the John French studios, where Donovan
was an assistant until 1958

Gerry Robinson, 1996
Advertisement for the *Sunday Times*
London, May 1996

Tuffy, 1993
Chepstow Villas, Notting Hill Gate,
London,
December 1993

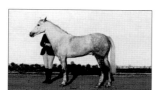

Ireland, 1973
2 January 1973

Jessica de Rothschild's twenty-first birthday party, 1995
The Royal College of Art, Kensington, London, 25 June 1995

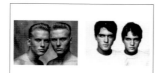

Matt and Luke Goss (Bros), 1989
Bourdon St, London, Wednesday 19 July 1989
Grooming: Dave and Lynn
Stylist: Al
Camera: Fuji 6x8
Film: Plus-X and T-Max
Backdrop: 'Old Faithful'

The Myers Twins, 1965
London, 20 July 1965
London Life 'New Faces'

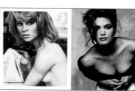

Julie Christie, 1962
London, 14 May 1962
About Town (A colour variant was reproduced on the cover)
See also *women throoo the eyes...* (Kynoch Press,1964)

Cindy Crawford, 1988
Bourdon St, London, Tuesday 26 April 1988
Hair: Nicky Clarke
Make-up: Mary Greenwell
Fashion editor: Anna Harvey
Camera: Pentax 6x7 and Fuji 6x8
Vogue August 1988 'Cut to the Night'

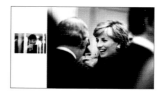

Elton John, 1996
Quaglino, Bury St, St James's, London
2 October 1996
Photographed at a party for the jeweller Tiffany

Diana, Princess of Wales, 1995
The English National Ballet School, Chelsea, London
Wednesday 6 December 1995

Boxing Match, 1994
London, Saturday 10 September 1994
Nigel Benn defeated Juan Gimenez

Alistair McAlpine, 1994
Venice, Tuesday 25 August to Tuesday 30 August 1994

Leslie Waddington and daughter Laura, 1994
Venice, Thursday 25 August to Tuesday 30 August, 1994

The House of God, 1996
Birmingham nightclub 20 January 1996

The Moody Blues, 1965
London, 23 February 1965
Vogue 1 April 1965 'Spotlight'

Celia Hammond, 1964
London, 10 to 11 March 1964
Harper's Bazaar

Advertisement, early 1960s
London, early 1960s

Penny Patrick, 1962
London, 13 March 1962
Queen

Fashion for *Harper's and Queen*, 1993
Bourdon St, London, 23 March 1993
Models selected from: Sophie, Ruth and Catherine
Hair: Jo Carney
Make-up: Micky Gardener
Fashion editor: Harriet Jagger
Camera: Fuji 6x8
Film: T-Max (100 ASA)
Harper's and Queen

Nancy Kwan, 1963
London, 9 August 1963
Hairstyle by Vidal Sassoon
Vogue October 1 1963 'Beauty Bulletin'

Alejandra Dolfino, 1986
Bourdon St, London, 25 February 1986
Hair: Julian Verge
Make-up: Mary Greenwell
Fashion editor: Grace Coddington
Camera: Kodak 10x8
Film: Plus-X
Unpublished photograph for *Vogue*

Jean Shrimpton, 1962
London, 8 January 1962
Tatler

Dick Temple's wedding, 1964
Leeds, Saturday 25 July 1964

Photo-essay for *Man About Town*, 1960
Notting Hill Gate, London, 10 October 1960
Man About Town December 1960 'The Lay About Life'

Terry Tuckey's funeral, 1994
City of London Cemetery, August 1994

A LITTLE, BROWN BOOK

First published by Little, Brown
and Company (UK) in 2000

Photographs copyright
© Terence Donovan Archive 2000
Photographs from *Brides*, *Tatler* and
Vogue pre-1988 © The Condé Nast
Publications Ltd
Design copyright © David Hillman,
Pentagram Design Limited
Text copyright © Robin Muir and
Lord Puttnam of Queensgate CBE

A CIP catalogue record for this book
is available from the British Library.

ISBN 0-316-85420-4

Edited by Diana Donovan
and David Hillman
Designed by David Hillman,
Liza Enebeis and Filipa Aguiar,
Pentagram Design Limited
Foreword by Lord Puttnam
of Queensgate CBE
Introduction by Robin Muir
Prints by Hugo Platt
Printed and bound in Italy
by L.E.G.O Spa

Little, Brown and Company (UK)
Brettenham House, Lancaster Place
London WC2E 7EN